A Living Exhibition

A volume in the series

Public History in Historical Perspective

Edited by Marla R. Miller

A Living Exhibition

The Smithsonian and the Transformation
of the Universal Museum

William S. Walker

University of Massachusetts Press Amherst and Boston

ISBN 978-1-62534-026-9 (paper); 025-2 (hardcover)

Designed by Dennis Anderson
Set in Dante by House of Equations, Inc.

Library of Congress Cataloging-in-Publication Data

Walker, William S., 1978–
A living exhibition : the Smithsonian and the transformation of the universal museum /
William S. Walker.
 pages cm. — (Public history in historical perspective)
Includes bibliographical references and index.
ISBN 978-1-62534-026-9 (pbk. : alk. paper) —
ISBN 978-1-62534-025-2 (hardcover : alk. paper)
1. Smithsonian Institution—History. 2. Museum exhibits—Political aspects—United States.
3. Public history—United States—History. 4. United States—Cultural policy.
I. Title.
Q11.S8W29 2013
069.09753—dc23

 2013009434

British Library Cataloguing-in-Publication Data
A catalogue record for this book is available from the British Library.

Publication of this book and other titles in the series Public History in Historical
Perspective is supported by the Office of the Dean, College of Humanities and Fine Arts,
University of Massachusetts Amherst.

Portions of chapter 4 were previously published as "'We don't live like that anymore':
Native Peoples at the Smithsonian's Festival of American Folklife, 1970–1976," *American
Indian Quarterly* (University of Nebraska Press) 35, no. 4 (Fall 2011).

For Kristin

Contents

Acknowledgments

Writing a book about an institution as complex as the Smithsonian would not be possible without assistance from many quarters. My largest debt is to the staff of the Smithsonian Institution Archives, especially archivist Ellen Alers and Pamela M. Henson, director of the Institutional History Division. Without Pam's sage advice and knowledge of the history of the Smithsonian, this book would not have been completed. She has patiently worked with me throughout the whole process of writing. Even as she balanced a demanding workload and endured personal challenges, she found the time to read the entire manuscript and offer extensive comments. Pam has mentored many Smithsonian pre-doctoral fellows, of which I was one. The Smithsonian deserves immense credit for funding research into its own institutional history. The well-organized and easily accessible collections of the Smithsonian Institution Archives not only make researchers' lives easier; they make possible this type of in-depth analysis of the history of the institution.

I would also like to thank the staff of the Smithsonian's Center for Folklife and Cultural Heritage, especially Jeff Place and Stephanie Smith of the Ralph Rinzler Folklife Archives and Collections. I am most appreciative that they took the time to assist me while juggling many duties related to mounting the annual Smithsonian Folklife Festival and packing for an unplanned move from one building to another. Some of my best finds were made with Jeff's assistance in pulling obscure files and recordings, opening uncatalogued boxes, and poking around the collections to see what was there. In addition, volunteering at the festival and talking about my research with Richard Kurin, Steve Kidd, Jim Deutsch, and Diana Parker greatly improved my understanding of folklife at the Smithsonian. Beyond the folklife center, a number of other Smithsonian staff members, both current and former, gave their time to speak with me. I express my sincere appreciation for the help of: the late Peter Welsh, the late Roger Kennedy, Ethel

Raim, Rayna Green, William Fitzhugh, Joanna Cohan Scherer, JoAllyn Archambault, Robert Sullivan, Spencer Crew, Fath Davis Ruffins, Thomas Kavanagh, Keith Melder, and the late Clydia Nahwooksy. In addition, several other staff members have provided advice and suggestions over the years. Indeed I have found it truly remarkable how open most people have been to sharing their thoughts about the history of the institution with me. Former curator Steve Lubar deserves special recognition for reading and commenting on both early chapter drafts and the entire manuscript. Marie Plassart, another Smithsonian fellow researching the history of the institution, helped me work through key arguments while they were still inchoate. I also thank Nathan Glazer for agreeing to speak with me at his home in Cambridge, Massachusetts, and Henry Glassie and Tom Harvey for sharing their memories of the festival with me.

In the early stages of this project I benefited immensely—both personally and professionally—from the support and friendship of faculty and fellow students in the department of history at Brandeis University. Brandeis is exceptional among graduate programs in history for the way it combines a rigorous intellectual environment with a remarkable collegiality among students and faculty. Denise Damico, Gabriel Loiacono, Eric Schlereth, Lindsay Silver Cohen, Emily Straus, Jessica Lepler, and Alexis Antracoli were not only great editors; they were (and continue to be) wonderful friends. Hilary Moss and Rob Heinrich provided comradeship and professional assistance in other areas. David Engerman, Michael Willrich, and Frederick Hoxie gave me years' worth of advice on how to improve the work as I revised it. Without their wisdom and insight I would have been lost in the wilderness. They reminded me what really mattered about my research and what was most compelling about the history of the Smithsonian. My sincere thanks also to Anthony Vaver, former humanities librarian at Brandeis, who suggested the Smithsonian as a topic.

The book has been immeasurably enriched by the experience and knowledge I have gained as a faculty member in the Cooperstown Graduate Program (CGP). A two-year master's degree program in history museum studies, CGP is the product of an unusual public-private partnership between the State University of New York–Oneonta and the New York State Historical Association. I am fortunate to work in such an ideal atmosphere for cultivating ideas about the past and present of American museums. Mentoring graduate students who hope to pursue careers as museum administrators, curators, and educators and collaborating with my fellow faculty has taught me much about what it really takes to operate a museum, develop an exhibition, and implement an educational program. I am much

better able now to understand and empathize with the trials and tribulations of the Smithsonian curators and administrators about whom I write. Special thanks to my colleagues Gretchen Sullivan Sorin and Cynthia Falk for taking time from their own research, teaching, and administrative duties to offer comments on early revisions of the manuscript. I have also received invaluable assistance from graduate assistants, particularly Cynthia Walker and Ashley Jahrling. Thanks as well to friends who have helped me in various ways through the process of researching and writing, especially Erica Spitaleri, Seth Bruggeman, Steve Light, and Emily Voss.

I would not be a professional historian without the mentorship of my undergraduate thesis adviser Larry Moore. Larry taught me how to write history well, and, more important, he provided me with a model of an exceptional college instructor, a model I strive to emulate with my own students. I'd also like to express my sincere appreciation to editors Clark Dougan, Marla Miller, and Kay Scheuer, who skillfully guided me through the late stages of revision.

Finally, I want to thank my family. I am incredibly fortunate to have a large family that values intellectual pursuits. Conversations at the dinner table were what first led me into the world of ideas, and I still relish talking with my family members every chance I get. My parents, Stephen and Gail Walker, are both educators, and they have instilled in me an understanding of the tremendous value of education and the vital role that teachers play in the lives of their students. Their love of ideas, their curiosity, and their enthusiasm for reading and writing have played a defining role in my life. My sister Mary, also an educator, has been a great friend and an even better auntie. To Eleanor, spending time with you is my favorite thing in the world. And, to Kristin, you are my best editor and my best friend. Thank you for everything.

Introduction
The Changing Universal Museum

Is it possible to collect all the contents of the world?
If the entire world is in your collection is it a collection anymore?
A question that has kept me up at night.

REIF LARSEN, *The Selected Works of T. S. Spivet*

The Smithsonian Institution is the world's largest museum and re-
search complex, and, remarkably, it is still expanding. I began researching
this book in 2004, the year that the landmark National Museum of the
American Indian (NMAI) opened in Washington, D.C. Excitement, and
perhaps some anxiety, was in the air as people looked forward to the debut
of a museum that held the promise of significantly transforming not only
the Smithsonian, but museums in general. It was an exciting time to be
studying the history of this sprawling institution, and I genuinely felt that
it, as well as the entire museum field, was undergoing a revolutionary
transformation. I still feel that way.[1]

My research has led me, however, to see the National Museum of the
American Indian as part of a longer institutional history. I now see the
museum less as a complete break from the Smithsonian's past and more
as an outgrowth of a long process of adding and revising museum space
that began in the nineteenth century and accelerated after World War II.
Although NMAI is certainly nothing like the Smithsonian museums that
preceded it, it is only the latest chapter in the history of an institution that
has experienced various periods of expansion over its more than a century
and a half of existence. Each moment of physical expansion has entailed
decisions about organization and has led generally to an increased splinter-
ing of collections, exhibits, and subject matter. Throughout the twentieth
century and into the twenty-first, the general drift of the Smithsonian has
been toward increased dispersal of materials into various spaces rather than

1

compression into a single space even as the overall institution has strived for a universal scope. The Smithsonian has embodied both the desire to put everything together and the need to take it all apart.

Examining the Smithsonian through this lens is particularly appropriate at this point in the institution's history because new museums are actively being added to its roster. The recent addition of culturally specific museums, such as the National Museum of the American Indian and the National Museum of African American History and Culture, has received strong support from both Congress and the American public. On the other hand, it has led to hand-wringing among some critics who wonder whether the Smithsonian may be presenting an excessively segmented portrait of American history and culture.[2] Meanwhile, a staunch group of advocates have made an aggressive case for the continued value of universal, or encyclopedic, museums, pushing back against critics who argue that such museums continue to be tools of colonialism and imperialism.[3] Universal museums, such as the Metropolitan Museum of Art or the British Museum, are those museums that display objects from a wide array of cultural groups, often in a single building. This debate is not confined to the United States, but rather is a global concern. In Europe, the Middle East, and elsewhere in the world, defenders of universal museums have clashed with those who see museums as primarily national or ethnic institutions and defenders of cultural patrimony.[4]

Public debates suggest a stark dichotomy between these two types of museums. Because it is a complex of nineteen museums, however, the Smithsonian is actually both. More accurately, it is a universal museum, or museum complex, that includes culturally specific museums. Interpreting the Smithsonian's history through the lens of a tug of war between the universal museum and culturally specific museums, then, is counterproductive and misleading. The history of the Smithsonian demonstrates that the forces of convergence and divergence in museums have a complex history that belies the collective wisdom of media pundits and polemical scholars. Large public museums combine the actual, physical division of space with the presentation of ideas about human society and culture and the natural world. The only way to truly understand them is to examine closely the shifts in organizational and epistemological frameworks that occurred over time.[5]

In thinking about the Smithsonian in this way I owe a debt to the pioneering historian of museums Eilean Hooper-Greenhill. In her 1992 book *Museums and the Shaping of Knowledge*, she urged historians to examine "the selection and ordering processes of museums" and to interrogate the factors

that govern decisions in "museums and galleries about how to position material things in the context of others."[6] Perhaps most important, she encouraged scholars to study the history of museums in a critical and historically specific way. Rejecting the whiggish institutional histories that the museum field had previously constructed for itself, Hooper-Greenhill effectively balanced the critical eye of a historian and cultural theorist with the practical wisdom of a museum professional. It is my hope that this book will follow her example in that regard.

Hooper-Greenhill and another influential pioneer in the field of museum history, the social and cultural theorist Tony Bennett, drew inspiration from Michel Foucault in analyzing the structures, organizing principles, categories, and social roles of museums.[7] It was these works that first led me to consider the dynamic relationship between museum space and cultural exhibitions. That said, I have not adopted a theoretical perspective drawn from Foucault—or any other cultural theorist for that matter. Instead, my book offers a fairly straightforward narrative of curatorial and administrative decisions made in a variety of institutional and epistemological contexts. It is a story of ideas in action. I take curators and museum directors seriously as intellectuals, carefully explicating their ideas and choices as well as the institutional factors that shaped them. In this approach, I am following historians Curtis Hinsley, who was the first to do an in-depth intellectual history of Smithsonian curators, and Steven Conn, who analyzed the larger relationship between "American intellectual life" and museums in the nineteenth century. Both Hinsley and Conn connected cultural exhibition to a broader search for order in the late nineteenth-century United States.[8] Like Hooper-Greenhill, they illustrated the importance of thinking about organization and space when analyzing the construction of ideas about culture in museums.

The historian H. Glenn Penny's work on German ethnographic museums has also refined and deepened my understanding of cultural display in nineteenth-century museums.[9] Crucially, Penny illustrates how the grand designs of museum curators were often thwarted by the practical dilemma of not having enough space to house and exhibit their materials. Thus, many ethnographic museums were doomed to be hodgepodges rather than the carefully ordered collections of objects their curators envisioned. Penny also encourages museum historians to see that nineteenth-century cultural displays were not limited to typological and evolutionary arrangements. This is a key argument because many scholars have interpreted this kind of display as representing the fundamental worldview conveyed by ethnographic museums. As with much museum history, these historians

have focused on the late nineteenth and early twentieth centuries—the period when museum anthropology was in its heyday and museums and world's fairs were seen as essential components of a broader culture of imperialism and colonialism in Europe and the United States. This overwhelming focus on the fin de siècle seems to suggest that the essential character of European and American museums of culture was fixed in this period and, by extension, that no one attempted to alter it until the late twentieth century. This book argues that our understanding of the history of cultural display in museums is incomplete if we do not examine how curators and museum administrators sought to transform the structures of universal museums throughout the twentieth century. A longer view is required if we are truly to understand both the successes and failures of large public institutions such as the Smithsonian. To that end, this book connects nineteenth-century cultural exhibitions at the Smithsonian to subsequent developments in the twentieth century, particularly in the post–World War II era.

In 2006 a widely read collection on museum history, theory, and practice contained a section titled "Remapping the Museum" that featured essays on museum concepts and issues that have surfaced at contested sites around the world in conjunction with decolonization efforts—that is, attempts to dismantle the ideologies and curatorial practices that made many museums such effective communicators of notions of racial hierarchy and Western cultural superiority.[10] The implication of the title was that those people interested in constructing and reorienting museums were making new spaces and redefining old ones in ways that rewrote the cartography of the field. Understanding the processes of decolonization in museums meant a fundamental reconceptualization of space. I suggest that this "remapping" will be more effective if we are able to create better maps of what older museum exhibitions actually looked like. Although it has grown exponentially over the past two decades, museum history is still fairly young as a discipline and, consequently, our understanding of past practices is often hazy.[11] To put it another way, our maps are incomplete and sometimes inaccurate. More accurate and detailed maps of the past will lead to a more productive remapping in the present. With that goal in mind, I hope that what this book provides is a balanced history of the changing geography of cultural exhibitions at the Smithsonian.

In 1881, envisioning the Smithsonian's future growth, Assistant Director George Brown Goode imagined a museum that would "show, arranged according to one consistent plan, the resources of the earth and the

results of human activity in every direction."[12] No small ambition here. The Smithsonian would be the place that not only had everything, but also explained it all. Such aspirations were not unusual in the late nineteenth century. Throughout Europe and the United States, scholars saw museums as ideal sites for gathering and explicating massive collections of scientific, technological, and cultural material. According to Glenn Penny, German ethnologists hoped in this period that museums would be places for developing nothing short of "comprehensive descriptions of the universe."[13] The same year that Goode set forth his ambitious goal, the Smithsonian opened the first United States National Museum building. It was here that the vast majority of the Smithsonian's growing collections were displayed and stored. Everything from reptiles, fossils, and minerals to pottery, steam engines, and George Washington's uniform went into this one building. As one might imagine, space filled up rather quickly and soon Smithsonian officials began lobbying for a new building. Predictably that one filled up as well, and the process began again. Each time the Smithsonian added a new building, staff members had to make decisions about organization.

One of the fundamental questions they had to face in organizing collections and designing exhibits was, which things belonged together? Which pieces of the collection should be exhibited, stored, and studied with others, and which demanded their own separate spaces? For all of their efforts to create a logical and coherent organization among the institution's various museums, collections, and exhibits, Smithsonian curators and administrators struggled to make totally clean divisions that might have made sense to outside observers. So, for example, the National Museum's Natural History building, which opened in 1910, contained until the early 1960s exhibits of colonial Euro-American material culture, European and Euro-American ceramics and glass, musical instruments, military history, and European and Euro-American art, as well as ethnographic displays of North and South American Indians, Africans, and Asians and exhibits of rocks, plants, and animals. Similarly, the Museum of History and Technology, which later became the National Museum of American History, included, as is apparent from its name, both history and technology. In other words, it was neither a pure history museum nor a science and technology museum. Smithsonian officials had lobbied for both, but they had to settle for one museum that combined the two subjects. Ultimately, despite curators' best efforts, the Smithsonian's various buildings often contained a hodgepodge of different materials. Although no single building was fully comprehensive or universal, they were also not narrowly focused on particular subjects or disciplines.

The hodgepodge nature of the Smithsonian's museums did not stop curators and administrators from attempting to impose order. Indeed, they often argued that more space would finally allow for a logical arrangement of collections and exhibits. The opening of the Museum of History and Technology in 1964 was a key turning point in this regard. Its creation led to a sorting process that removed all Euro-American historical and cultural materials from the Natural History building. Although Smithsonian officials had long desired the "segregation" of historical and anthropological collections, they had not achieved a total separation of these materials. Indeed, significant numbers of objects associated with historic Euro-American cultures were part of the Division of Ethnology's collections until the late 1950s. With the sorting that accompanied the opening of History and Technology, the racial lines in the institution's physical geography became clearer. Although it is an exaggeration to say that History and Technology was a lily-white museum, the polyglot mixing of cultural exhibitions that had occurred in the spaces of the Smithsonian's earlier museum buildings was greatly reduced. This is not to suggest that the earlier buildings were free of racialized divisions or cultural hierarchies. Indeed, such things were rife in these spaces. It is simply to point out that, overall, the buildings of the National Museum possessed a more diverse array of cultural materials—that is white, non-white, Euro-American, European, African, Asian, and Native American—prior to the construction of the Museum of History and Technology.

By the late 1960s, the leaders of the Smithsonian, especially Secretary S. Dillon Ripley, came to see deep problems with the institution's structure. For Ripley, the content of the Museum of History and Technology's exhibits was quite troubling. The museum's overwhelming emphasis on Euro-American history and culture was increasingly out of step with an American people who were, however begrudgingly, coming to accept the integrationist message of the Civil Rights movement. Moreover, he found the Museum of Natural History's anthropological displays to be out of date and inappropriate for an era that witnessed anticolonial movements sweep through Asia and Africa. Ripley assumed the secretaryship of the institution the year History and Technology opened, and he soon set about to fix the Smithsonian's displays of culture. From the beginning, he recognized that this was a problem not only of interpretation but also of space.

To address the troubling racial geography of the institution's museums, Ripley pursued four distinct strategies during his twenty years as secretary. The first was to move exhibits outside of the museums into the open air. As part of a broader effort to advance a philosophy of informal learning

he called "open education," Ripley supported the creation of the Festival of American Folklife in 1967. The festival, which continues today as the Smithsonian Folklife Festival, brought a diverse array of tradition bearers— singers, dancers, potters, weavers, sheep shearers—to the National Mall each summer to present their skills and talk about their lives. An innovative experiment in collaborative exhibit development, the festival relied on the dynamic interaction of visitors, tradition bearers, and Smithsonian staff to encourage dialogue among different cultural groups and undermine entrenched stereotypes.

The second strategy for addressing the Smithsonian's problematic racial character was the creation of culturally specific museums. The same year that the festival began, Ripley endorsed the founding of the Anacostia Neighborhood Museum in the southeastern region of Washington, D.C., a predominantly African American part of the city. Originally conceived as a mini-Smithsonian that would bring various historical, cultural, techno-logical, and scientific displays to an African American community whose members rarely visited the museums on the Mall, the Anacostia Neighbor-hood Museum quickly transformed into a museum of African American history and culture. It was the institution's first experiment with a culturally specific museum. Subsequently, Ripley would explore and eventually sup-port the incorporation of another such museum into the Smithsonian, the Museum of African Art. In addition, some of his assistants were the first to broach the idea internally for a National Museum of the American Indian.

The third strategy was to change the exhibits in the Smithsonian's exist-ing museums. A major effort in this regard came in the bicentennial year of 1976 with *A Nation of Nations*, a sprawling exhibition in the Museum of History and Technology that depicted the remarkable cultural plural-ism of the United States through a display of over five thousand objects. Subsequently, curators in History and Technology pursued various exhi-bition projects that addressed African American history and the histories and cultures of other peoples of color. Curators in Natural History also attempted to revise that museum's anthropological displays in this period with varying degrees of success. They made a concerted effort, for example, to significantly revamp the exhibits of American Indian cultures; however, they ultimately failed to achieve this goal.

Finally, the fourth strategy Ripley pursued to transform the institution's displays of culture was the creation of a Museum of Man. Ripley believed strongly that the Smithsonian needed a museum that would house col-lections from a diverse range of peoples and merge the various cultural research divisions of the institution. Such a museum, he argued, would

correct the problematic inclusion of exhibits of peoples of color in the natural history museum. Moreover, it would allow for broad-based analyses of human society that acknowledged both commonalities and differences among the world's peoples and probed the basic issue of how human beings interact with their environments. To his chagrin, Ripley was never able to secure funding from Congress for the museum, and Smithsonian officials struggled for years with both practical and conceptual issues surrounding the project. Nevertheless, intense discussions around this idea suggest an alternative trajectory for the Smithsonian—one that led back toward the compression of diverse materials into a single space as opposed to the dispersal of cultural materials into different spaces.

This book devotes the bulk of its attention to the period from 1945 to 1989, the year Congress authorized the National Museum of the American Indian. This temporal scope means that the familiar narratives of the "culture wars" battles at the Smithsonian during the early 1990s are not part of the story here. Much has been written about these controversies, especially the failed Enola Gay exhibition, and they have become essential case studies for the museum field.[14] This book, however, is concerned with a deeper institutional history, one that goes back to the origins of the Smithsonian and continues to shape the way the institution organizes and explains the world. Narrating this history is important not only because it is largely unknown to most students of museums but also because it is highly relevant to contemporary debates about the nature of universal and culturally specific museums.

A time of unprecedented growth for the world's largest museum complex, the latter half of the twentieth century witnessed tremendous changes both in museums and in broader society. The Smithsonian offers an ideal lens through which to examine this history not only because of its reputation as the nation's pre-eminent cultural institution, but also because of its position at the nexus of thought, culture, and politics in American life. Situated on the National Mall within sight of the Capitol and the Washington Monument, the Smithsonian has never been able to hide from the politicization of culture and ideas. Between 1945 and 1989, the institution opened nine new museums in Washington, and Congress authorized another. In addition, Smithsonian officials initiated a folklife festival, founded a magazine, and undertook countless other initiatives.[15] As it grew, the institution became much more complex. The placement of exhibitions in one museum versus another, the geography of buildings on the Mall, the assignment of responsibility for specific collections to this division or that department, the disciplinary categorization of certain areas of inquiry—these and other

related issues pushed increasingly to the fore as the Smithsonian multiplied its square footage exponentially. In the post–World War II era, Smithsonian curators and officials confronted the question of organization from numerous angles and devised many solutions—some more successful than others—to it. By turns, they both separated and joined the diverse array of histories and cultures that collectively make up human society. The internal debates, proposed projects, and actual exhibitions of these decades show a tug of war that, at its best, produced a creative tension between universal and particular ways of conceptualizing society and culture. Reality often fell short of this ideal, allowing racial ideologies, administrative wrangling, and other factors to disrupt and undermine the productive interplay of universal and particular. Occasionally, however, the Smithsonian succeeded in producing exhibitions that reminded visitors that human beings comprise simultaneously a family of humankind and a remarkable array of distinct groupings that deserve careful explication on their own terms.

Because the book addresses ongoing debates in the museum world, I do not purport to offer the final word on the subject, nor can I hope to be comprehensive. Instead, I explore key exhibitions and museum projects and the individuals who conceived them in the hopes of opening a constructive dialogue about the ways in which both museums and Americans in general have wrestled with the challenges of balancing the universal and the particular. The Smithsonian's richly preserved archives and institutional history division make this project possible. Memoranda, planning documents, curators' reports, exhibition scripts, and correspondence illuminate both the causes and consequences of institutional decisions regarding exhibitions. They show the complex interplay among the curatorial, political, and social imperatives behind the Smithsonian's exhibitions. In addition, the extensive collection of oral histories assembled and maintained by the staff of the Smithsonian Institution Archives offers invaluable insights into administrative and curatorial decisions. Carefully charting internal discussions and debates makes it possible to develop a nuanced understanding of the various factors involved in the making of exhibitions.

1

The Universal Museum
Shaping Cultural Exhibition at the Smithsonian

In the 1840s, the National Mall was a barren and unattractive stretch of land. Its most notable feature was the unusable Washington Canal that ran along its northern side to the Capitol before turning south toward the Anacostia River. Black and white Washingtonians knew it as the hub of the city's slave trading operations, which were clustered along its southeastern edge and a short distance to the north at the Center Market. Since the 1790s, several influential people had hoped to transform the Mall into a more inviting space, but none had yet succeeded.[1] Consequently, it was hardly the first location most observers would have thought of for the site of a world-class scientific and cultural research institution. London, the capital of the world's most powerful empire, already had the British Museum. Founded in 1753, the museum was a center for research and served as a repository for books and manuscripts as well as natural history, antiquities, and ethnographic collections.[2] Although Philadelphia had developed institutions with the potential of emulating the British Museum's model, nothing approaching that great public institution yet existed in the United States.[3] That was until an extraordinary bequest from English scientist James Smithson arrived with the stipulation that the young nation use his modest fortune "to found at Washington, under the name [of] the Smithsonian institution, an establishment for the increase & diffusion of Knowledge among men."[4]

A pioneer in the field of chemistry, Smithson was well regarded throughout Europe in the eighteenth and early nineteenth centuries for his work analyzing the properties of geological samples. Belonging to a community of scientists that crossed national borders to collect materials and conduct research, he traveled widely in his lifetime. Persisting in scientific journeys even after war convulsed the continent, Smithson could not help but be caught up in the sweeping social and political transformations of the period.

As an eyewitness to the wars the French Revolution precipitated, he saw both the promise and perils of that revolution. Given these experiences, as well as the fact that he was the illegitimate and ignored son of an English nobleman, his attitude toward republicanism was undoubtedly complex. His commitment to science, however, always remained steadfast. No one knows for sure why he chose to leave his fortune to the United States—a country he had never visited. Since most of his papers were destroyed in a fire at the Smithsonian in 1865 before being examined thoroughly, his personal and political thoughts, as well as many of his scientific discoveries, are lost. Nevertheless, he did leave the Smithsonian with a powerful and ambitious charge—"the increase and diffusion of knowledge"—and the resources to begin pursuing it.[5]

Defining what this phrase would mean in practice became the task of those who led the Smithsonian in its earliest years. Above all, it fell to the institution's first secretary, Joseph Henry. Born in upstate New York in December 1797, Henry had become well known for his pioneering experiments and discoveries in electromagnetism. When he took charge of the Smithsonian in December 1846, he was a professor of natural philosophy (physics) from the College of New Jersey (now Princeton) who was accustomed to balancing heavy teaching, research, and administrative duties. Leading the fledgling Smithsonian, however, would prove a far greater challenge than his professorial career. Fortunately, he was not only an accomplished experimentalist, but also an enthusiastic champion of science, and he embraced Smithson's charge with vigor. He envisioned an institution with grand ambitions and a nearly limitless reach. All subjects of human inquiry were fair game.[6]

Henry believed that the Smithsonian could best accomplish its goals of increasing and diffusing knowledge to all humankind by sponsoring research, distributing publications, and facilitating exchanges among international scientific institutions. Intriguingly, given the Smithsonian's current identity as primarily a collection of museums, the first secretary opposed making a museum the focal point of the institution's work. Some natural history and archeological collections to assist researchers were necessary, but nothing more. For Henry, a museum hindered the Smithsonian's pursuit of its central aim. Museums, he argued, did little to increase knowledge; they were simply venues for popular education. Moreover, they served a local audience and therefore did not fulfill the Smithsonian's purpose of benefiting all humankind through its work. To correspondents such as the natural historian Louis Agassiz and the botanist Asa Gray, Henry argued that the best, perhaps the only, way to achieve the mission embedded in

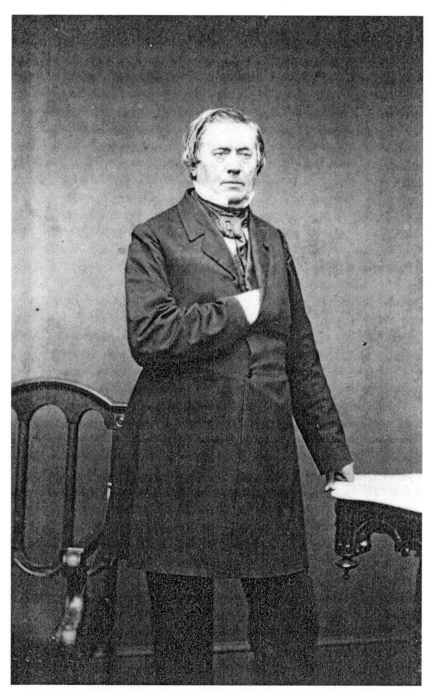

First secretary of the Smithsonian Joseph Henry, c. 1860, Brady & Co. (Washington, D.C.). Smithsonian Institution Archives, neg. #SIA2009-1253.

Smithson's bequest was to avoid the anchor of a physical space. A museum and its collections were expensive to maintain and drew the institution's funds away from research. Moreover, they restricted the scope of the Smithsonian's explorations. By tapping the potential of scientists and other scholars all over the United States and the world and serving as the conduit for this research through publications and exchanges, the Smithsonian, Henry believed, would truly increase and diffuse knowledge. Without being tied to a building or set of buildings, the institution could sponsor work in the full range of scientific and other scholarly fields while disseminating the fruits of that work as widely as possible through the printed word.[7]

Henry accepted leadership of the Smithsonian because he saw it as an unparalleled opportunity to foster the growth of American science.[8] The challenges of his more than thirty-year tenure in the position would come, however, not primarily from the world of science but rather from managing the administrative duties of a quasi-governmental official. Henry's task of building the Smithsonian into a viable institution was complicated by a number of factors, perhaps chief of which was the Smithsonian's unusual legal status. The United States government had learned in 1835 of Smithson's bequest, which it had received because his sole heir had died childless, and after a long debate Congress had finally created the institution in 1846. However, despite Congress's chartering of the Smithsonian, Henry insisted that it was a private institution. Complicating this assertion was the fact that prominent government officials including the Vice President, Chief Justice, and members of the House and Senate sat on its Board of Regents and the funds for the institution's endowment had been funneled through the federal government for a decade before its founding. Moreover, the institution was, according to its chartering legislation, supposed to serve as repository for the nation's collections in natural history, ethnology, and art.[9] Henry fought this particular provision vigorously, arguing that it would be financially damaging to accept the collections. Above all, he hoped to avoid subjecting the institution to "political influence and control," a consequence that he believed would most certainly ensue if the Smithsonian sought an annual congressional appropriation for the maintenance of large collections and a museum.[10]

Despite Henry's opposition, strong forces both inside and outside the Smithsonian pushed for the institution to develop a museum and collections. At its inception, the Smithsonian's Board of Regents splintered into three factions, each of which had distinct visions for the institution. The first group, which was led by Indiana congressman Robert Dale Owen and the mayor of Washington, William Winston Seaton, favored "constructing

a grand building, supporting a museum, and sponsoring an active program of popular lecturing and publishing." The second, led by Senator Rufus Choate, preferred that the institution become "a great national library"; while the third faction, headed by the superintendent of the United States Coast Survey, Alexander Dallas Bache, hoped that the Smithsonian would promote "scientific research and publication."[11] Henry aligned himself with the third faction, seeing this as the best way to advance his vision for the institution and the scientific community in general. He was pragmatic at first, including plans for a library and museum in his "Programme" for the Smithsonian and acceding, begrudgingly, to the construction of a large building. Nevertheless, he hoped to limit the scope of these appendages of the institution, in essence making them support facilities for the Smithsonian's true purpose, which was scientific research. With the library, he was successful in this goal, as eventually the Library of Congress, not the Smithsonian, became the "great national library." He was much less successful, however, in fighting against the museum and the "grand building."[12]

Visitors to the Smithsonian may have a hard time imagining it now, but the institution's first secretary never wanted the Smithsonian to occupy what has become its iconic structure—the Castle. He opposed its construction initially and then, after it was built, attempted to sell it to the federal government while hoping to secure more modest and cost-efficient quarters for the Smithsonian. In 1853, Henry entertained a proposal from the commissioner of patents, who wished to acquire the Smithsonian building for his agency.[13] Although nothing came of it, Henry continued to hope that the federal government would purchase the building from the institution. "Our principal encumbrance," he wrote in 1868, "is the Museum and the building connected with it. Could I succeed in transferring these to the Government, my mission in regard to the Institution would be fulfilled."[14] Henry argued that the building and museum were expensive to maintain and placed an undue burden on the institution's limited income. Maintaining the national collection was, in Henry's opinion, the proper duty of the federal government, not a private institution charged with the mission of serving all of humankind. In an 1868 letter to the Yale mineralogist George Jarvis Brush, Henry wrote: "It is now . . . generally admitted that the Government of the United States ought not to have put the support of a museum, especially of its own collections, on a fund bequeathed by a confiding foreigner . . . for the purpose of benefiting the whole community of civilized man."[15]

Henry consistently lamented the financial costs of the museum and building, but he also worried that these physical entities would sabotage

the Smithsonian's aims epistemologically. "Had it not been for my constant and strenuous efforts," he wrote to Brush, "the whole [Smithsonian] fund would have been entirely merged in local objects." For Henry, the museum and building served local purposes, which he defined in two ways: first, as literally providing education and entertainment for the residents of and visitors to Washington, D.C., and, second, as promoting the interests of the United States government as opposed to the universal interest of humankind in advancing knowledge. "It should be recollected that mankind in general are to be benefited by the bequest," Henry wrote in 1847, "and that, therefore, all unnecessary expenditure on local objects would be a perversion of the trust."[16] The Smithsonian, in Henry's mind, had a higher purpose than sheltering the nation's collections and propagandizing for its interests.

At the beginning of his tenure, Henry laid out his vision in the "Programme of Organization for the Smithsonian Institution." This document offered the public an overview of the aims of the Smithsonian as well as its basic composition.[17] Using James Smithson's charge as its guiding principle, Henry proposed that sponsoring original research and disseminating it through publications should be the Smithsonian's central tasks. The scope of this research was to be unlimited. "[Smithson's] will makes no restriction in favor of any particular kind of knowledge," Henry wrote, "hence all branches are entitled to a share of attention." Surveying the various fields in which the Smithsonian might sponsor research and publications, Henry listed, among others, "physics," "astronomy," "natural philosophy," "chemistry and meteorology," "natural history," and "ethnology." Although he was a scientist and viewed the Smithsonian as a scientific institution, Henry did not omit fields such as history, art, or even literature, including in his list: "particular history," "comparative philology," "antiquities," "political economy," "modern literature," and "fine arts and their application to the useful arts." The only way to address such a wide range of subjects was through publications, which Henry divided into two broad categories: "a series of reports" and "separate treatises on subjects of general interest," or what Henry called "Smithsonian Contributions to Knowledge." In this way, the institution could diffuse knowledge to both experts and laypeople.[18]

Not everyone connected with the institution agreed with Henry's recommendations. Commenting on his efforts to transfer the museum and building to the federal government, Henry wrote, "In this . . . I find considerable opposition, resulting from narrow views and the difficulty of comprehending how an Institution can affect the affairs of the world and

yet make no display of palpable objects."[19] A physical presence and the display of tangible collections seemed to Henry's critics to be essential to the institution's ability to influence the "affairs of the world." Although they disagreed about many things regarding the institution's function and purpose, the drafters of the act creating the Smithsonian all believed that the institution had responsibility for the government's collections and should be housed in a new building constructed expressly for it.[20]

Over time, Henry acceded to the demands of those who favored the accumulation and display of large collections at the Smithsonian and began to move in the direction of promoting museum work. First in 1850 at the urging of Louis Agassiz and George Perkins Marsh, an influential regent, he hired the natural scientist Spencer Fullerton Baird to be "assistant secretary with responsibility for the museum and publications" and directed Baird to care for the natural history collections, which at the time Henry considered important solely for their value to researchers.[21] Baird, however, was an enthusiastic collector and champion of a museum for the institution. Eventually, he would take charge of the United States National Museum and, in 1878, succeed Henry as secretary. Second, in 1857, Henry agreed to accept the transfer of the national collections from the Patent Office to the Smithsonian.[22] Since the early 1840s, the Patent Office building had housed and displayed the voluminous collections of the United States Exploring Expedition and other smaller government expeditions.[23] Although Henry had resisted the transfer of these materials for a decade, he acquiesced for a variety of reasons. The Smithsonian was already the recipient of collections from the army and navy exploring and surveying expeditions, and accepting the national collections ensured that the institution would receive an annual appropriation from Congress to maintain these materials. Although Henry feared the political entanglements such an appropriation would bring, he was more concerned about the prospect of expending the entirety of the funds from Smithson's bequest on the care of collections. Henry may have also accepted the transfer in order to secure adequate funding for the Smithsonian's meteorological program, which the Patent Office could provide in a quid pro quo.[24]

To accommodate all of this new material, Henry dramatically expanded the building's exhibition space. Following the fire in the Smithsonian building in 1865, which fortunately did not damage most of the museum collections—although it did destroy Smithson's papers and mineralogical collections as well as John Mix Stanley's portraits of American Indians and other works of art—he tripled the space devoted to exhibits. Still, the ever-expanding collections quickly outgrew the allotted space and threatened

to overwhelm the institution's activities. All the while, Henry continued to hope that the federal government would assume control of the museum and free the institution to focus on research. If it were released from this burden, Henry believed that the Smithsonian could expand on the scientific activities it had already begun—publishing monographs in fields such as meteorology, archeology, astronomy, geography, and ethnology, as well as sponsoring research and exploration in the United States and abroad, and facilitating the international exchange of scientific information.

Momentum continued to build, however, for expanding the museum. The key turning point came in the mid-1870s when the Smithsonian played a leading role in planning the government's displays for the Philadelphia Centennial Exhibition. In 1874, Henry asked Baird to be the Smithsonian's representative on a board charged with planning centennial exhibits for an array of government departments.[25] In this role, Baird flourished, helping to create dramatic displays of flora, fauna, engineering, industries, and ethnology that dazzled visitors to the exhibition's United States Government Building.[26] More significantly for the Smithsonian, Baird also used the Centennial Exhibition as an opportunity to acquire massive collections for the institution. "I have now succeeded in making a clean sweep," he wrote to Henry, "of everything that is desirable, in the way of mineralogy, geology, metallurgy, botany, zoology, ethnology etc., very much to the disgust of our numerous competitors."[27] The problem that Baird and Henry immediately confronted was where to put all this newly acquired material. In the short term, the institution was able to use the Armory Building, which was near the Smithsonian. In the longer term, however, it was clear that the institution would need a new building to house the collections from Philadelphia.

Henry hoped that, at long last, this development would lead to the desired separation of the museum from the Smithsonian:

> In view of the great extension to which the Museum is destined, and the magnitude of the appropriations which it will require annually, and the continued appeals to Congress for these appropriations, and the danger of merging the Smithson Bequest in a Government establishment, the question is, —*is not an entire separation between the Institution and the Museum advisable?*[28]

Advisable? Perhaps. But Henry's hopes would not be fulfilled. The Smithsonian would continue to be the repository for the nation's collections and a large new building would be constructed to house them.

For Henry, this outcome did not accord with Smithson's intent, and, more important, it undermined the institution's universal reach. In his 1876 "Report of the Secretary," he summed up his opinion of a Smithsonian-run museum to house the national collections. "The Institution should not," he wrote, "be merged in an establishment of the Government, but should stand alone, free to the unobstructed observation of the whole world, and keep in perpetual remembrance the name of its generous founder."[29] "The functions of the Museum and the Institute," he continued, "are entirely different." According to Henry, the purpose of the museum was to exhibit the nature, arts, and manufacture of the United States and "to form a great educational establishment, by means of which the inhabitants of our own country as well as those of foreign lands who visit our shores may be informed as to the means which exist in the United States for the enjoyment of human life in the present and their improvement in the future." The Smithsonian, on the other hand, "does not offer the results of its operations to the physical eye, but presents them to the mind in the form of new discoveries, derived from new investigations and an extended exchange of new ideas with all parts of the world." The museum's purpose was national; the Smithsonian's global. "Every civilized government of the world has its museum," Henry noted, but there was only one Smithsonian Institution. What made the Smithsonian unique, he argued, was the "conception of such an institution" not as "a local establishment intended to improve the intellectual condition of any single city or any single nation," but as an institution dedicated to the benefit of "mankind in general."[30] Universal in the scope of its work and in the audience it hoped to reach, the Smithsonian Henry envisioned transcended local concerns to conduct research that served the interests of humankind. Henry's casting of the Smithsonian as unbounded by the limits of the nation set him squarely in the tradition of the transnational scientific and philosophical networks that flourished during the Enlightenment. At the same time, it pointed to a key tension that public museums had long confronted: to what extent were they instruments of the nation, serving to burnish a nation's reputation and trumpet its level of civilization, and to what extent were they centers for the creation of knowledge, which knew no borders?[31]

After Henry's death in 1878, all opposition to a Smithsonian-run museum would disappear. Four days after Henry's passing, Baird was appointed secretary, and the next year Congress approved legislation for a new building to house the United States National Museum, which remained under the Smithsonian's purview. The challenge for the next generation of

Smithsonian leaders would be to reconcile Henry's vision with the display of tangible objects in physical spaces.

The original Smithsonian building—the Castle—had fairly limited square footage relative to the number of collections it possessed even after the expansion of exhibition space that occurred after the fire in 1865. According to William J. Rhees's *Visitor's Guide to the Smithsonian Institution and National Museum* (1880), the Castle's "general public museum" consisted of the following "apartments": "on the first floor a room 200 feet long and 50 feet wide," which was "not well adapted to the display of specimens" since it was "occupied through its whole length with two rows of colossal columns"; "another large room, in the west wing, 65½ feet long by 35 feet wide, with a semi-circular projection at one end"; a "connecting range of 60 feet long by 37 feet wide"; and, finally, in "the second story a single large room of 200 feet long and 50 feet wide."[32] Within these spaces, curators crammed all manner of mammals, birds, fish, fossils, animal products, reptiles, minerals, and ceramics, as well as archeological and ethnological artifacts.[33] "For want of space," the *Visitor's Guide* noted, "many objects have been temporarily placed on top of the Cases."[34]

By contrast, the new building had over 80,000 square feet of exhibition space.[35] Begun in April 1879 and completed in 1881, the building covered two and one-third acres and was adjacent to the Castle.[36] Its red brick exterior, high arched windows, and tall angular towers contrasted sharply with the white marble, neo-classical Capitol that loomed only a mile away. The new "modernized Romanesque" building complemented the Norman-style Smithsonian Castle.[37] Designed by architects Cluss and Schulze, it was constructed rapidly at low cost from a $250,000 appropriation from Congress.[38] Inside, long halls, high ceilings, and an airy dome seemed to make it an excellent venue for housing the types of exhibits popular at the museums and expositions of the late nineteenth century. Nevertheless, the space quickly filled up. Less than ten years after the new building opened, Secretary Baird reported that there had "been nearly 14,000 accessions to the Museum."[39] Many of these "accessions" were large collections, which included thousands of specimens. Some of the larger accessions Baird reported were the "Jeffries collection of fossil and recent shells of Europe, including 40,000 specimens; the Stearns collection of mollusks, numbering 100,000; the Riley collection of insects, containing 150,000 specimens; the Catlin collection of Indian paintings, about 500 in number; [and] the collection of the American Institute of Mining Engineers, for the transportation of which to Washington several freight-cars were required."[40] Overall, the

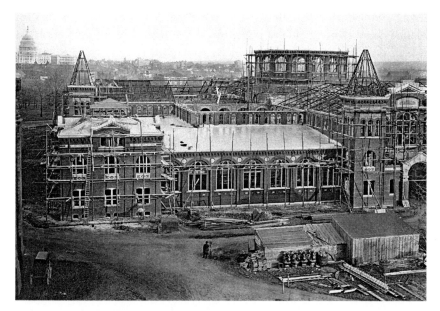

The United States National Museum under construction in December 1879. Smithsonian
Institution Archives, neg. #2005-8427 and SA-742.

institution's collections grew from approximately a quarter of a million
specimens before the Centennial Exhibition to one and a half million in
1884, and the number would continue to climb to almost five million by
the turn of the century.[41]

Henry's worst nightmares had come true; however, his successors, chief
among whom were Baird and his assistant George Brown Goode, embraced
the challenge presented by the expanding collections with confidence and
enthusiasm. Both were natural scientists and museum men who believed in
the importance of preserving, arranging, and displaying physical collections.
Unlike Henry, who feared that the Smithsonian could not achieve its aims
if anchored to physical collections, Baird and Goode maintained that the
institution could research, display, and explain the universe through objects.
"It is not unreasonable to hope," Goode wrote in 1881, "that examples of
every kind of object known to man may be acquired."[42] Freed from Henry's
qualms about the accumulation of collections, Baird and Goode charted a
new course for the institution, elevating the museum to a position of central
importance as they continued to strive toward Smithson's ideal.

When Baird had come to the Smithsonian in 1850 at age twenty-seven
from Dickinson College in Carlisle, Pennsylvania, where he had been pro-
fessor of natural history and curator of the museum, he had not traveled

light. Two boxcars containing his natural history collections, which included more than 4,000 bird skins, mammals from Europe and America, fossils, skeletons, and plant specimens, had made the trip to Washington with him. Taking charge of the institution's collections when he arrived, the new assistant secretary quickly set about organizing the existing materials and gathering natural history collections.[43] He was clearly someone who reveled in the accumulation of things. As the collections grew, however, even he must have felt like the sorcerer's apprentice, never quite able to master the objects that just kept multiplying.

Help arrived in the form of Goode, who provided the philosophical rationale and practical framework for the arrangement of materials in the National Museum. After studying natural history with Louis Agassiz at Harvard, Goode had become curator of the Orange Judd Hall of Natural Science at Wesleyan College in Middletown, Connecticut. His primary research was in ichthyology, and he published dozens of papers on various types of fish during his career. He was not one of those scientists, however, that confined himself to a narrow corner of the natural world. Fittingly, for someone who would come to oversee the National Museum's polyglot collections, he had catholic interests, studying biology and natural history broadly and becoming a well-regarded expert in the history of science and museums.[44] In 1872, he met Baird and began performing volunteer research under the assistant secretary's direction for the United States Fish Commission. Seeing the potential of the young natural scientist, Baird asked Goode to oversee the creation of exhibits on the United States' animal and fishery resources for the Philadelphia Centennial Exhibition. Accepting the challenge, Goode worked tirelessly for more than a year to collect specimens, prepare them for exhibition, and design a taxonomic exhibit to display them. After Philadelphia, he would apply these prodigious organizing skills to his work at the National Museum as well as to a series of international expositions, including those in Cincinnati, New Orleans, Chicago, and Atlanta.[45]

Goode was a keen observer of museums in Europe and the United States and a museological innovator who hoped that the National Museum would surpass the institutions that had preceded it. Inspired by the great museums of Europe—most notably those in England and Germany—many of which he had visited, he nonetheless saw flaws in their arrangement. Goode observed that museums tended to be divided broadly into two categories: science and art. His concern, however, was with the "middle territory" in between these poles. Although he acknowledged the utility of separating natural history collections, overseen by "the geologist, botanist,

and zoologist," from art collections, which he maintained were best left to artists, he contended that much material fell somewhere in the middle. "Between is a territory," he wrote, "which no English word can adequately describe—which the Germans call *Culturgeschichte*—the natural history of civilization, of man and his ideas and achievements." Existing museums, he argued, had "not yet learned how to partition this territory." It was precisely this problem to which Goode applied himself.[46]

In his 1881 annual report, he presented a sweeping plan, which envisioned the Smithsonian hosting the most comprehensive and well-arranged museum in the world.[47] The natural scientist did not limit his purview to natural history materials. Rather, he opened the museum to all manner of objects, hoping to bring natural history, art, technology, human history, and science together under one roof. At the center of Goode's plan of organization was a "Scheme of Museum Classification" that echoed the breadth of Henry's original "Programme." It included seven major categories: "Mankind," "The Earth as Man's Abode," "Natural Resources," "The Exploitative Industries," "Ultimate Products and their Utilization," "Social Relations of Mankind," and "Intellectual Occupations of Mankind."[48] To create this museum, Goode argued that the Smithsonian needed to collect "every kind of object known to man." Only by achieving such universal coverage could it present the full "history of mankind."[49] His museum would provide "a place for every object in existence which it is possible to describe, or which may be designated by a name," and when a particular object could not be obtained, its place would be filled by a "model, picture, or diagram."[50]

Like Henry, Goode did see a dichotomy between the museum of research and the educational museum.[51] However, he gave much more weight to the museum's educational function than Henry did, while still embracing its research potential. In the late nineteenth century, Goode and his contemporaries in museums in the United States and Europe believed strongly in the vital importance to both popular education and scientific and cultural research of gathering, studying, and organizing objects.[52] As Steven Conn has argued, the museum scholars of this period practiced an "object-based epistemology." When displayed and explicated properly, objects, they contended, held the key to understanding human society and nature. The accumulation of large quantities of objects allowed them to reveal the deepest truths about nature and civilization.[53] Where Henry had maintained that the Smithsonian's museum and research functions generally worked at cross-purposes, Goode argued the opposite. To his mind, the museum was essential to both the diffusion *and* the increase of knowledge.

In Goode's vision, the Smithsonian's collections, properly arranged, should "form a museum of anthropology, the word 'anthropology' being applied in [its] most comprehensive sense."[54] In this qualifying statement, Goode revealed his understanding of the word "anthropology" as the "science of mankind."[55] In this, his thinking was consistent with older definitions of the term dating to the late sixteenth century. In its infancy in the late nineteenth century, the modern discipline of anthropology focused its energies on gathering information about and formulating theories concerning "primitive" peoples.[56] Goode rejected such a limitation of scope, arguing that anthropology should examine all of humanity. Goode was well aware of the ethnographic museums of Europe, but he eschewed their exclusive focus on "primitive or non-European peoples." He did, however, draw on European precedent to conceptualize his museum scheme. "The ethnological collections in Washington are classified on a double system," he wrote. The National Museum combined the type of ethnographic survey of specific "races" according to geography that Goode observed in European, especially German, museums with the organizational structure of the "famous Pitt-Rivers collection at Oxford," which used typological displays to demonstrate cultural evolution.[57] In this way, the National Museum could "exhibit the physical characteristics, the history, the manners, past and present, of all peoples, civilized and savage, and . . . illustrate human culture and industry in all their phases."[58] This approach, Goode contended, would allow the museum to bridge the gap between "industrial museums" and "ethnological museums"—collecting, arranging, and displaying objects from western and non-western, white and non-white cultures.[59]

"Is it not as important to preserve in museums," Goode wrote, "the more humble and simple objects which illustrate the domestic economy and customs of the masses of the people of civilized nations, as to search for similar objects in distant lands. . . ?"[60] Goode had a direct interest in the preservation of materials from the antecedents of contemporary Euro-Americans. An enthusiastic genealogist who published an extensive record of his family called *Virginia Cousins* in 1887, he was deeply interested in the ties that bound people across generations. "The history of the country is a history of its people," he wrote, "and the people is but an aggregation of families."[61] For Goode, it was vitally important that the Smithsonian pay at least as much attention to accumulating and displaying materials from European and Euro-American sources as it did to collecting the products of so-called savage cultures. Only through a combination of both could the true history of civilization be revealed.

If Goode differed from anthropologists in the scope of his interests, he shared with them a particular worldview. As his statement quoted above about "peoples, civilized and savage" suggests, Goode imagined the world to be organized into hierarchies of race and culture, as did most Europeans and Euro-Americans in this period. "Civilized," in the racial parlance of the time, would have referred to peoples of Northern and Western European ancestry.[62] At the core of scientific ideas of race and culture was the belief that these peoples were superior to non-Europeans. A number of museums, most notably the Pitt Rivers, employed an organizational scheme ranging from savagery and barbarism to civilization to both illustrate racial hierarchies and dramatize the supposed universal development of human societies.[63] In the areas of the National Museum that were similar to the Pitt Rivers, this arrangement was much in evidence. These hierarchical schemes complemented and supported late nineteenth-century racial ideologies, which undergirded the colonial and imperial projects of Europe and the United States and served as justification for Jim Crow segregation in law and custom as well as the federal government's paternalistic policies toward American Indians.

Goode set the wheels in motion, but it was another curator who brought the National Museum's cultural displays to life. Assuming his duties as curator of the Department of Ethnology in July 1884, Otis Tufton Mason declared that it was his desire to make "the preservation and exhibition of specimens a prominent feature of [his] curatorship."[64] Not content to publish his research only in scientific journals, Mason saw the exhibition of material culture as central to his work as an ethnologist. Along with the natural scientist Goode, Mason became, in the 1880s, one of the most important voices in defining the philosophy of cultural exhibition in the United States. Within the framework Goode had established, Mason constructed several foundational exhibition forms for ethnology in the United States. During his tenure in the late nineteenth and early twentieth centuries, he developed ideas about exhibiting cultures that would persist in the field for decades.

Mason first became involved in anthropological work at the Smithsonian in 1869. Working as principal of the preparatory academy of Columbian College (now George Washington University), he volunteered his time to assist Baird in classifying the Smithsonian's collections.[65] According to Curtis Hinsley, during the twelve years he worked in this capacity Mason "absorbed the fundamentals of natural science taxonomy from Baird, applied them to the ethnological collections, and soon emerged as the

Museum's anthropology expert."[66] When he became a curator in 1884, therefore, he was well prepared to play a key role in shaping the Smithsonian's approach to cultural exhibition.

Early in his career, Mason drew inspiration from the ideas of the German collector Gustav Klemm, whose collection of objects formed, after his death, the basis of the Museum of Ethnology in Leipzig.[67] Klemm maintained that his collection should be used to illustrate the universal processes of cultural evolution and demonstrate the hierarchical arrangement of human society into three groups: "the savage, the barbarous, and the enlightened." In the first group were those peoples who "think only of their daily wants." For them, "permanent settlements, personal property in lands and herds, and organized governments have no existence." The second included peoples who had organized into tribes, developed religion and art, and begun to write. Finally, the third group—the "enlightened," or civilized peoples—were those who had broken free from superstition, constructed complex systems of laws and foreign treaties, engaged in research, and developed a desire for exploration. Historically, "the Persian, the Arab, [and] the Roman," were "examples of this," he wrote, "but above all the German race furnishes the most perfect examples of this condition of culture, having Christianity as its peculiar agency for the destruction of hierarchical rule."[68] A better example of ethnology rationalizing racial, national, and cultural chauvinism could not exist. This worldview appealed to Mason perhaps in large part because of its religious cast. In his own writings, he contrasted "natural man" with what he called "renewed man." "We have to study culture or the doings of the artificial man—the renewed man. . . . The higher any subspecies or race or nation has climbed into this renewed life the greater has been its culture."[69] In employing the phrase "renewed man," Mason revealed the influence of religious thought on his interpretations of culture. In nineteenth-century theology, this phrase referred to one who was a true follower of Christ.[70] In Mason's formulation, it referred to those who were at the top of the cultural hierarchy and had developed advanced technologies.

At the practical level what Klemm's framework meant for the Leipzig Museum when it opened in the early 1870s was that its exhibits, like those in the Pitt Rivers collection, were organized typologically—i.e., things were arranged by type. All the tools were in one place, the clothing in another, the fishing instruments in yet another, and so on. If they examined the displays closely, visitors could see within each one the hierarchical structure of savagery, barbarism, and enlightenment. Following these European precedents, Goode and Mason adopted a typological arrangement for many

of the National Museum's cultural exhibitions. Significantly, however, Klemm's original scheme lasted only four years at the Leipzig Museum before the collection was rearranged along geographical lines. This new mode of exhibition—by geography rather than type—accorded with the dominant approach in German museums, which was promoted by Adolf Bastian, the influential head of Berlin's ethnographic museum at the time. Instead of passing from a room full of weapons to a room full of tools and then on to costumes, visitors could now see exhibits of materials all from one place, such as Japan.[71]

Where the Leipzig Museum dispensed with one approach in favor of the other, Mason decided to incorporate both into the National Museum. When Mason discussed in an 1886 report the several ways in which "anthropologists in various parts of the world arrange their specimens," he reported that they organized collections by "material, structure and function" and "progress of invention" as well as by "race or tribe" and "geographical distribution."[72] Eventually, he would divide the National Museum's exhibits into two broad categories: 1) technology, or technography, and 2) ethnology, or ethnography. "Wherever the material is sufficiently abundant and from a great number of localities," he wrote, "the whole of mankind are considered to be of one species, and all objects belonging to a certain class are assembled and arranged." As with Klemm's collection and the Pitt Rivers, all the tools, weapons, and modes of transportation were grouped together. Mason labeled these displays the "technographic series." Where the museum did not contain an exhaustive collection of a particular type, or class, of object, it displayed "the specimens . . . in ethnographic groups" and arranged them "around the hall so that the spaces . . . belong to peoples that are in contact."[73]

Mason's approach to exhibition—particularly those aspects influenced by Klemm—did not go unchallenged. Early in his tenure, he received direct criticism from Franz Boas, a rising scholar who would fundamentally transform the field of anthropology in the early twentieth century. Boas first visited the National Museum in December 1884 and came away disturbed by what he saw.[74] Two years later in an article in *Science*, Boas made his criticisms public: "I cannot agree with Professor Mason's proposal of arranging the cases like a checkerboard." Criticizing the typological exhibits, Boas argued that their arrangement was fundamentally flawed. Charting cultural hierarchies of savagery, barbarism, and civilization and arranging by type were, according to Boas, not productive ways of exhibiting collections if one's goal was to enhance knowledge of particular cultures or broader cultural processes. "It would be almost impossible," he wrote, "to show in

this way all important ethnological phenomena, the historical development of tribes, the influence of neighbors and surroundings, etc." Boas favored the "tribal arrangement of collections," maintaining that it was the best way to present a detailed and accurate explanation of particular cultures. "In ethnology," Boas argued, "all is individuality." For him, the goal of ethnology was not to chart the evolution of civilization as a whole, but to unpack the mysteries of each individual civilization. Presaging the still nascent idea of cultural relativism that he would help bring to full flower in the early twentieth century, Boas wrote, "It is my opinion that the main object of ethnological collections should be the dissemination of the fact that civilization is not something absolute, but that it is relative, and that our ideas and conceptions are true only so far as our civilization goes."[75]

When Boas leveled his criticisms, the National Museum's cultural exhibits were still in the early stages of development. Ultimately, his critique would be applicable to only half of its ethnological displays. By the 1890s, Mason had arranged the museum so that exhibits of technology—those typological and synoptic displays to which Boas objected—were confined to the East Hall. On the other side of the museum, in the West Hall, Mason created ethnographic exhibits arranged by tribal or cultural grouping and geographical region, a mode of display that was more in line with Boas's vision for the ideal ethnological museum. Mason had thus developed a compromise approach—a "double system"—that allowed visitors to see culture from two quite distinct perspectives.

In the East Hall, visitors would have made their way through cases jammed with all kinds of technologies, ranging from hammers and plows to carts and steam engines. They would have seen, for example, displays of "all the material from various sources used in the transportation on land" organized so as to commence with the "simplest device for carrying burdens or for traveling over snow" and end with the "locomotive."[76] Related displays depicted the progress of specific inventions, a subject for which Mason had a particular passion. "Where a single object as a hammer, adze, wedge, hoe, spade, rake, plough, snowshoe, etc. stands alone as an implement or a product," he wrote, "specimens thereof may be exhibited in a series to illustrate the possible lines of inventive progress."[77] In the adjacent Northeast Range, or "Boat Hall," visitors would have found a "series of models illustrating the water craft of the world, beginning with the simple raft . . . and passing step by step through the successive grades of elaboration in hull, propelling devices and steering apparatus to the modern steamship." Overhead they would have seen hanging an impressive display of Native kayaks and canoes. Nearer to the ground, they would have

discovered an "extensive series of models of fishing craft" and a "group of exhibits illustrating the introduction of steam power and the specialization of modern steam navigation."[78]

On the other side of the museum, the West Hall contained the ethnographic exhibits. Like the revised Leipzig Museum and other German ethnographic museums, this area of the National Museum used geography along with race or tribe, rather than type, as the dominant mode of organization.

GROUND PLAN U. S. NATIONAL MUSEUM.

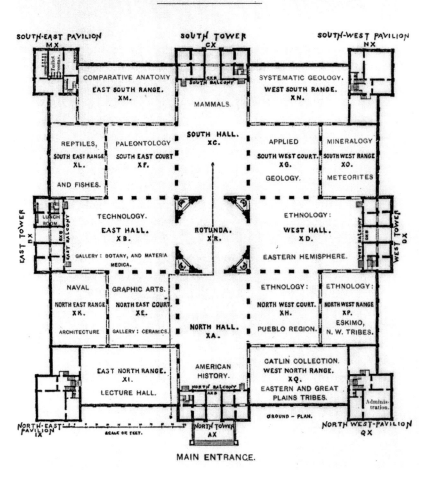

Floor Plan for United States National Museum, c. 1890. Smithsonian Institution Archives, neg. #SA-211.

Here, visitors would have encountered "collections illustrating the various people of Europe, Asia and Africa."[79] Looming over the hall's displays was a two-story, elaborately decorated Chinese gate, and in the gallery above were "materials from Australia and the Pacific Islands."[80] Turning to the Northwest Range, visitors would have discovered the museum's impressive collection of objects from Eskimo peoples and the Native peoples of the Northwest Coast, including several totem poles and a Haida house front.[81] They might also have stumbled into the Northwest, or Pueblo, Court, which contained the museum's unparalleled collection of pottery from the Southwest.[82] The displays in these areas were greatly enriched by the research of the Smithsonian's Bureau of American Ethnology (BAE). Founded in 1879, the BAE sent fieldworkers, such as Frank Hamilton Cushing, to study North American Indians throughout the late nineteenth and early twentieth centuries. Cushing and others collected artifacts for the National Museum and published many important monographs, which had a profound influence on the developing field of anthropology.[83] The head of the Bureau, John Wesley Powell, shared Gustav Klemm's worldview.[84] "Powell's evolutionary anthropology," according to Curtis Hinsley, "envisioned lines of human activity running from savagery to civilization (he later added 'enlightenment' as a fourth stage)."[85] Like Klemm, Powell encouraged an evolutionary and hierarchical perspective on human societies and cultures.[86]

To organize the West Hall, Mason pioneered what would become the single most influential anthropological exhibition form of the twentieth century: "culture areas."[87] The head curator of anthropology, William Henry Holmes, wrote of this arrangement in 1898: "The most natural assemblage of the materials illustrating the peoples of the world is in groups related one to another as are the peoples themselves in more or less well defined geographical divisions." The point of such an arrangement was to allow the "ordinary museum visitor" to see the cultures of the world as if he were "traveling from country to country." In this way, Holmes maintained, the museum became a "miniature world."[88]

This phrase nicely encapsulated the overarching aim of Goode, Mason, and the other curators of the National Museum. In its displays of culture and technology as well as its extensive collections of animals, plants, and minerals, the National Museum presented a "miniature world" to those who passed through its halls. Standing at the center of the museum in the rotunda, visitors could proceed east or west to view the cultural and technological displays. Or, they could head into the southern part of the building to see the museum's immense zoological and geological collections.

Or, they could turn into the North Hall, which displayed the collections in American history. In just 80,000 square feet, then, visitors could see not every type of object known to mankind, but many of them. Consistent with Goode's original plan, natural history, science, technology, ethnology, and history shared space in a single building. Goode had achieved his goal of combining the industrial museum and the ethnological museum. Moreover, he had succeeded in creating a museum of anthropology, broadly defined, which exhibited artifacts from both European and Euro-American peoples and non-European peoples.

Two photographs from around the turn of the twentieth century clearly illustrate the kinds of juxtapositions the museum's polyglot character enabled. An image of the museum's rotunda shows a hodgepodge of objects from around the world. The original plaster model of the Statue of Freedom that adorns the United States Capitol Building is surrounded by a giant Limoges vase made in France for the Philadelphia Centennial Exhibition, Buddhist statuary, a Chinese pagoda model, cannons from the Spanish-American War, and several cases of unidentified objects.[89] This unusual assemblage was partly due to space limitations, but was also the result of Goode's conceptualization of the museum in universal terms. This arrangement was not a mistake, the unintended consequence of having too much stuff. Rather, it was just the kind of interesting array of materials that Goode had imagined would occupy the museum's spaces. A photograph from the museum's lecture hall shows a similar juxtaposition of cultural materials. Lining the walls are paintings from George Catlin's Indian gallery while in the center of the room are several cases containing the Copp Family Collection, an assortment of colonial Euro-American everyday objects, including textiles, tableware, and books.[90] Although this was only a temporary arrangement, the idea that visitors should see such items in relation to one another was a fixture of Goode's museum, a central aspect of his effort to explain *Culturgeschichte,* or the natural history of civilization. Although Charles Willson Peale's museum in Philadelphia in the early nineteenth century had included similar juxtapositions of painting and American history with ethnology and natural history, Goode's National Museum was the first to make a systematic attempt to include history and culture in a broader depiction of the human and natural worlds.[91]

By the close of the nineteenth century, the order that Goode had envisioned had begun to take shape, and the museum's curators took pride in fulfilling their educational role. In 1895, Goode looked back over two decades of work and noted with satisfaction that the National Museum had become *"a museum of record,* in which are preserved the material

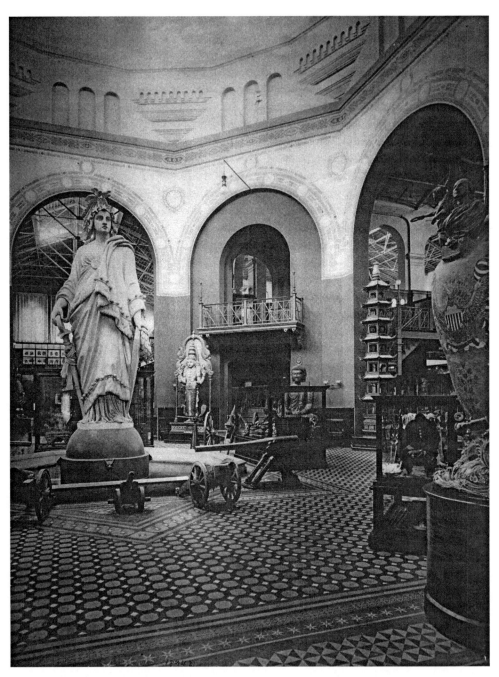

Rotunda of the United States National Museum, c. 1902–1910. Smithsonian Institution Archives, neg. #18942.

Copp Family Collection and Catlin Gallery in the lecture hall of the United States National Museum, c. 1900. Smithsonian Institution Archives, neg. #9098 and MAH-9098.

foundations of an enormous amount of scientific knowledge"; *"a museum of research,* which aims to make its contents serve in the highest degree as a stimulus to inquiry and a foundation for scientific investigation"; and, perhaps most important, *"an educational museum."* The museum fulfilled its educational role in large part, Goode argued, "through its policy of illustrating by specimens every kind of natural object and every manifestation of human thought and activity."[92] When Goode died of pneumonia in 1896, he left behind a museum that bore the imprint of his ambition and vision. The task of displaying and explaining the world would become increasingly difficult, however, as the museum's collections continued to expand and the institution ran short on space. Goode noted in 1895 that the museum's collections had increased nearly seventeenfold in fourteen years, and they would continue to grow exponentially in the years to come. The question of how to organize this mass of materials would fall squarely on the shoulders of his successors. Their solution—more museum buildings—would lead to crucial decisions regarding institutional structure and the organization of collections and exhibits.

Complaining about space was a favorite pastime of Smithsonian curators. Starting with Joseph Henry's trepidations about accumulating large collections and accelerating in the late nineteenth century as the institution received massive amounts of material from various quarters, Smithsonian officials expressed persistent anxiety over the lack of space. The construction of the first National Museum building was supposed to have resolved the institution's issues in this area. Within only a few years, however, cheap construction and growing collections would lead Smithsonian officials to argue that it was not meeting their needs. As early as 1883, the Board of Regents passed a resolution recommending that Congress appropriate funds for the erection of an additional building. Re-affirming the importance of this resolution in 1888, Secretary Baird wrote that "the overcrowded condition of the building, on account of which not only the current work but the proper development of the collections is greatly impeded, seem[s] to render immediate action necessary."[93] That year, Baird was successful in getting a bill passed by the Senate appropriating $500,000 for a new building, but it failed to pass the House of Representatives. According to Baird, the building would have been in a style similar to the 1881 structure, but would have contained approximately 220,000 square feet of exhibition and storage space.[94] This new structure would have placed the amount of space available for the National Museum on par with that of the American Museum of Natural History in New York City.[95] In response to pressure from the institution, the Senate again passed authorizations for a new building in 1890, 1892, and 1896, but all failed to pass the House of Representatives.[96] They did succeed in obtaining an appropriation to construct galleries (balconies) around the perimeter of three of the building's halls and four of its courts. Completed in 1898, these galleries added 17,000 square feet of available floor space.[97] Nevertheless, Smithsonian officials struggled to find even inadequate storage space for the materials they collected, placing a large number of objects in temporary wood and brick structures on the grounds of the institution as well as rented buildings elsewhere.[98]

Smithsonian curators added their voices to the chorus of discontent. Curator of transportation and engineering J. Elfreth Watkins lamented, for example, that his section could not accept donated items for lack of exhibition space, and "many objects that formerly occupied a position upon the floor of the Museum have been installed upon brackets, attached to the walls, or upon the tops of cases." Given the spatial limitations all of the museum's departments were experiencing, the only solution, he argued, was an expansion of the present building or the "erection of an additional

building."[99] Two years later, in 1893, the curator of historical collections A. Howard Clark reported, "The crowded condition of the exhibition halls has necessitated the withdrawal and temporary storage of the entire collection of medals and money, and the general series of autograph papers of eminent Americans."[100]

Within this claustrophobic environment, curators jockeyed for space to exhibit objects, store collections, and conduct research. Rearrangement occurred often as new collections arrived, and curators struggled to find the most logical way to display their materials. In the National Museum building, zoology, ethnology, and technology dominated most of the museum's square footage, with American history occupying only small portions of floor space. In 1899, however, history literally gained ground in response to outside events. As curator Clark reported, "the war with Spain caused public attention to be centered on the military as well as the political history of the country." In response, Smithsonian officials "permitted an extension of the space heretofore allotted to historical relics and encouraged the collection of as many objects as possible that pertained to the War." Where previously the American history exhibits had been "confined to a few cases in the North Hall" mixed among "collections of ceramics, lacquers, coins, and metal work," they now occupied almost the entirety of the floor space in the hall. In addition, they spread into the Rotunda, the geographical center of the museum.[101]

The combination of space limitations and vast collections made it difficult for curators to put into practice the logical arrangements they envisioned in their planning documents. Here, again, they argued that an additional museum building would be beneficial. William Henry Holmes lamented, for example, that "the collections relating to living tribes and nations are separated from those representing prehistoric peoples of the same areas, the latter occupying the great hall of the Smithsonian Institution [the Castle]." With some collections by necessity staying behind in the original Smithsonian building, the museum's curators of anthropology found it difficult to provide a full historical narrative of North American Native societies and cultures. Holmes's proposed solution was either "the construction of a new building, or a reassignment of the present museum spaces," which he hoped would "lead to the proper correlation of these important exhibits."[102]

Holmes would get his wish a decade later when the Smithsonian at last unveiled a new building. In 1904, Congress approved its construction at a cost of $3.5 million, and it opened to the public six years later in 1910.[103] Today, this building is known as the National Museum of Natural History,

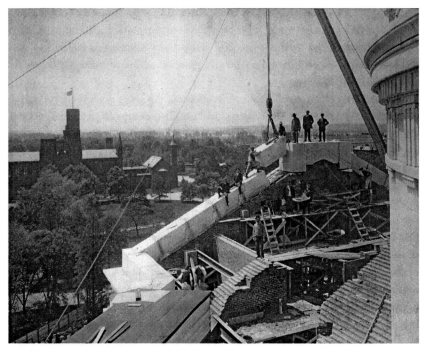

Workers constructing the new building for the United States National Museum, 1909.
Smithsonian Institution Archives, neg. #82-3231.

but at the time it was simply an extension of the National Museum. At first, Smithsonian staff members called it the "new building," but they soon began referring to it as the "Natural History Building." Still, it remained officially the United States National Museum. The project had received its impetus when, in 1902, the Senate Park Commission had set aside space for another Smithsonian building as part of its McMillan Plan, the goal of which was to bring dignity and beauty to the central landscape of the capital city. As the driving force behind the commission, Daniel Burnham, the father of the city beautiful movement, designed the comprehensive plan into which all future buildings, memorials, and landscape features would have to fit. Before the turn of the twentieth century, the area surrounding the first two Smithsonian buildings had included the Department of Agriculture building, a railroad station, and a canal. After the adoption of the McMillan Plan, the Mall would slowly become a more monumental and ceremonial space. By imposing a rational framework on the National Mall, the plan created order in what previously had been a relatively disordered or incoherent space. Inside their new building, Smithsonian curators hoped to follow suit.[104]

For the curators, more space meant relief from the limitations of the National Museum building; it also meant more decisions about organization and arrangement. The *omnium gatherum* needed to be divided up. The Smithsonian annual report for 1910 briefly summarized how this process would proceed: "all of the collections relating to natural history, including anthropology . . . will soon be segregated in the new museum."[105] In combining natural history and anthropology, the Smithsonian's curators again diverged from Franz Boas's recommendations regarding anthropological display. By this time, Boas was an acknowledged leader in the field who had become so discontented with museum anthropology that he had moved from the American Museum of Natural History to Columbia University, essentially bringing the entire field with him. From this point forward, the most important anthropological research would be conducted in universities, not museums.[106] In a 1907 article in *Science* titled "Some Principles of Museum Administration," Boas wrote:

> The essential point of view of the anthropological collection and that of the natural-history collection are entirely distinct; and, if the attempt is to be made to bring out coherently the ideas underlying the anthropological exhibit, there ought to be no necessity for the visitor to come into contact with the natural-history exhibits while passing through the anthropological halls. On the whole, this end is difficult to attain in a large complex museum building; and the question may therefore be very well raised, whether it would not be better to separate entirely anthropological collections from those relating to natural history.[107]

Questioning the relationship between natural history and anthropology placed Boas very much in the minority in the early twentieth century. Indeed, he may have been the only person challenging the idea that these fields belonged together. In Chicago in this period, the Field Museum was founded to house the biological and anthropological collections of the 1893 World's Columbian Exposition.[108] Similarly, Boas's former employer—the American Museum of Natural History in New York—combined exhibits of animals, plants, fossils, and rocks with exhibits of human cultures. Still, his question was an important one because it challenged the scientific approach on which the discipline of anthropology was based. Significantly, Boas's question concerned an issue of spatial organization. He understood that the placement of exhibits in physical space influenced the way both scholars and the public understood them. Boas's questioning of the placement of anthropological exhibits with natural history collections correlated with his own movement toward a historical, contextualized, and relativistic approach to the study of particular cultures.

Nevertheless, Smithsonian officials proceeded apace with their plans. Separating anthropology and natural history from the other collections and exhibitions turned out to be rather more difficult than they imagined, however, because of the realities of space at the institution. Smithsonian officials' basic plan was to keep "arts and industries" in the old building while giving anthropology the middle part of the new building, "biology the western side, and geology the eastern side."[109] Although it was a simple plan in the abstract, the complexity of finding space for so many collections made the actual process of organizing the museum rather untidy. The first and second floors of the four-story structure contained the bulk of the museum's exhibition space—with over 106,000 square feet available on the first floor and 79,000 on the second. Upon entering the museum from the Mall, visitors came into the rotunda where they could choose to go west to find exhibits of mammals and birds, north to see ethnological exhibits, or east to discover paleontology and geology.[110] Similarly, on the second floor, visitors could head to the western portion of the building to find biological exhibits, including reptiles, fishes, and invertebrates; the northern portion to view American and Old World archeology; or the east wing to see minerals, gems, and the "building and other useful stones."[111] Scattered among the anthropological, biological, and geological exhibits, however, were some important exhibits of other materials, including European and American paintings and sculptures, military items, and Euro-American material culture.

The most obvious complication to the characterization of the new building as a natural history museum was Smithsonian officials' decision to display the collections of the National Gallery of Art there.[112] The gallery had a long history that pre-dated the founding of the Smithsonian, occupying various homes before moving to the Smithsonian Castle in the mid-nineteenth century.[113] Subsequently, the collection was displayed haphazardly in various parts of the institution. With the construction of the new building, however, Smithsonian officials saw an opportunity to bring the institution's artworks together in one place—even if Secretary Charles D. Walcott considered the gallery an "intrusion" in the Natural History Building.[114] Although they preferred a separate building to house the collection, the institution's leaders were unlikely to receive another large appropriation from Congress in the foreseeable future. Instead, they devoted the central part of the new building's first-floor north hall, 50 feet wide and 130 feet long, to the display of a modest collection of paintings and sculptures by European and American artists. Interestingly, it shared this hall with exhibits from the division of ethnology.[115]

Overseeing the gallery was William Henry Holmes. Holmes had a re-markably varied career before assuming leadership of both the Depart-ment of Anthropology and the National Gallery. Born in the year of the institution's founding, he grew professionally along with the Smithsonian. Coming to Washington in 1871 to study art, Holmes found employment sketching fossil and mollusk shells at the institution. This led to a position with the U.S. Geological Survey of the Territories, where he worked for six years studying the landscapes and cultures of the American West.[116] Later, he joined the Bureau of American Ethnology—becoming chief in 1902—where his expertise in art, archeology, and geology made him an indispensable fieldworker. Holmes was particularly interested in the "gen-eral laws of aesthetic development," and, according to Hinsley, he "hoped to discover the origins of art." Deeply influenced by the evolutionary ideas of the BAE's John Wesley Powell, Holmes saw art as a measure of cultural progress.[117] Drawing on his artistic training, in the area of cultural exhibi-tions he pioneered a new type of display called the life group, which used life-sized models to depict cultural materials in context. Beginning with the Chicago world's fair in 1893, Holmes made these displays a central feature of the Smithsonian's anthropological exhibitions, both in the museums on the Mall and at various expositions.[118] Overall, in his scholarship and his exhibition work, Holmes blended the worlds of art and science and, there-fore, was well suited to be both head curator of anthropology and curator (and later director) of the National Gallery of Art.

Under Holmes's supervision, anthropology was a sprawling department that encompassed collections and exhibits in both the National Museum's old building (now called "Arts and Industries") and its new building (now called the "Natural History building"). Originally formed as part of a bu-reaucratic restructuring in 1897–1898, the Department of Anthropology included divisions or sections of ethnology, American history, historic archeology, prehistoric archeology, mechanical technology, primitive tech-nology, graphic arts, medicine, physical anthropology, ceramics, and musi-cal instruments. Following Goode's original conception of the Smithson-ian as a museum of "anthropology," which he defined broadly to include the study of all humanity, the department covered nearly the full range of human endeavors. This omnibus department was more than a quirk of bureaucratic administration—it reflected the museum's epistemologi-cal roots and Goode's desire to connect the ethnological museum with the industrial museum. With the construction of the new building, how-ever, and the "segregation" of the anthropology collections—meaning the materials of indigenous, primarily American Indian, and other non-white

peoples—from the historical and technological collections, this organizational scheme no longer made sense. The physical separation of collections and exhibits accompanied a deeper separation that would fundamentally recast Goode's universal museum.

Although not explicitly stated, the racial assumptions behind the sorting of collections and rearrangement of departments were apparent. Using the word "segregated" to describe the process of sorting would have had particular resonance in the first decade of the twentieth century, the period when Jim Crow became firmly entrenched in Washington, D.C. It was in this period that facilities in several government offices were segregated.[119] Moreover, as urban spaces throughout the country became more racialized, the increasingly divided structures, both physical and bureaucratic, of the Smithsonian would have found their parallel in the segregated quarters of the capital city.[120]

Physically, the Department of Anthropology was split in half with the opening of the new building. The divisions of ethnology, prehistoric archeology, historic archeology, and physical anthropology moved while the divisions of history, mechanical technology, and the sections of ceramics, music, medicine, and photography, and the new sections of art textiles and period costumes remained in the old building. Graphic arts moved to the Castle.[121] Administratively, these various divisions and sections still remained together under one department, but the physical separation presaged deeper fissures. The main rupture came in 1919–1920 when mechanical technology, graphic arts, and American history separated from the Department of Anthropology. Reporting on the separation of mechanical technology, Holmes wrote, "although the human activities and the products of these activities come within the scope of anthropology, the field had become too wide for convenient museum treatment." Practically, Holmes maintained, it had simply become too difficult for the anthropology department to oversee such a wide range of materials. Beyond this practical consideration, Holmes argued, "The subject matter of technology, although embracing the primitive stages of the mechanic arts, lies chiefly in the fast expanding and highly specialized field of the age of steam and electricity."[122] Holmes's statement suggests an important shift in the way Smithsonian curators interpreted and displayed technology. Although the evolutionary narrative still remained important—particularly to Holmes— a new emphasis on emerging technologies and their significance to the rapidly industrializing United States overwhelmed the older ideas of the nineteenth century. Whereas in the past curators had explored a continuum from primitive to advanced technologies, now the primitive seemed largely

irrelevant. As American industry came into its own, exhibiting the wonders of steam and electricity became more important than displaying the evolution of the hammer, adze, or plow. To narrate this story, the Smithsonian's curator of mechanical technology Carl Mitman lobbied hard in the 1920s and '30s for a museum dedicated to the subject.

Holmes offered a similar rationale for the separation of American history and graphic arts. Graphic arts did not belong with anthropology, he wrote, because it focused on drawing and printing "in their highly developed mechanical stages." As with mechanical technology, connecting the primitive and the advanced in exhibits was no longer a vital function of the museum. With American history, he seemed baffled as to why it had ever been included in the department in the first place. "The division of American history," he wrote, "is separated from the department of anthropology, under which it came into existence but with which it has no necessary connection."[123] In his original plan for the National Museum, Goode had argued vigorously that the museum should "illustrate the domestic economy and customs of the masses of the people of civilized nations."[124] Collecting and displaying artifacts of Euro-American history and culture was as vital to Goode's vision as gathering Zuni pots or Iroquois beadwork. By the early twentieth century, however, anthropology and history had become largely separate endeavors at the Smithsonian, and, as a result, Holmes could reasonably contend that American history was unconnected to anthropology, and vice versa.[125] Moreover, the physical separation of the two fields into different structures obscured any epistemological relationship between them.

Ironically, just as anthropology and history were severing their relationship administratively, outside events led to the placement of exhibits from both of these disciplines in the Natural History building. As during the Spanish-American War two decades earlier, World War I led to the acquisition of a large number of war-related items. Instead of assigning these exhibits, which included uniforms, equipment, and other materials provided by the War Department, to the old building, the division of history placed some of them in two halls on the ground floor of the new building as well as in the rotunda on the first floor.[126] Now when visitors came into the building, they would have immediately encountered exhibits from the United States Navy, including several ship models, as well as a large diorama depicting the Battle of Belleau Wood.[127]

History also gained ground back in the old building during this period. The removal of ethnological collections and exhibits to the new building meant that history was able to expand into the Northwest Range, which

had previously displayed objects from the Native peoples of the Northwest Coast, and the West North Range, or Catlin Hall. Into these spaces went the division's "collection of Washington relics and . . . relics of the period of the Revolution and the first quarter of the 19th century," historical documents, maps, costumes, stamps, coins, and medals.[128] Still, the division clamored for more space. As in the past, the solution seemed to be a new building. "The historical collections have multiplied greatly in recent years," Holmes reported in 1920, "and during the present year have increased as a result of the World War to such an extent that the erection of a separate building for their accommodation seems an imperative duty of the Government."[129] Such a project, however, was unlikely to be funded in the lean interwar years. Instead, the division would have to settle for a further expansion of space in the Arts and Industries building.

In 1929, the division of history provided an overview of its exhibitions and plans for rearrangement.[130] The hope was that curators could rectify the spatial issues that had, to that point, obstructed the division's efforts. "A lack of ample contiguous exhibition space," the division noted in its annual report, "prevents the arrangement of the historical collections in such a manner as to convey to the public a proper understanding of their historical importance."[131] A major step in rectifying this problem came with the relocation of the World War I military collections from Natural History to Arts and Industries. The transfer was not total, however, as the naval collections remained in the rotunda of the new building. The curator of history Theodore Belote reported in 1929, "The installation of the naval exhibit with all its glaring defects in this prominent space . . . blocking the main passageway of the public into the National Gallery of Art represents a situation which is deeply regretted by the Curator of the Division of History." In 1929, almost two decades after the opening of the Natural History building, a visitor could enter the museum and see American naval collections followed by an exhibition of European and American art before visiting any anthropological, zoological, or geological exhibits. At the same time, the division of history continued to work toward a more logical organization of its materials and a more complete separation of history from anthropology and natural history. By the late 1920s, the Arts and Industries building contained the vast majority of historical, not to mention technological, exhibits, and the division of history looked forward to the day when it would have its own museum. Nevertheless, the presence of American history in the Natural History building was not entirely extinguished until the early 1960s.

One new museum was constructed at the Smithsonian in the inter-war years—the Freer Gallery. In 1906, the industrialist Charles Lang Freer gave his collection of almost 10,000 "American, Babylonian, Byzantine, Cambodian, Chinese, Cypriote, Egyptian, Greek, Italian, Japanese, Korean, Near Eastern and East Indian, Palmyran, and Tibetan" art objects to the Smithsonian with the stipulation that it remain in his possession until his death. In 1915, however, he decided to accelerate the process, and construction on the gallery began in 1916; it eventually opened to the public in May 1923.[132] Adjacent to the Castle to the west, the Freer was primarily a museum of Asian art; however, it also held some Mediterranean and Middle Eastern artworks as well as Freer's outstanding collection of the works of James McNeill Whistler, including his famous Peacock Room. In some ways, the Freer was a harbinger of what was to come—its emphasis on Asian art presaging the culturally specific approach to exhibition that the Smithsonian's leadership would favor in the late twentieth and early twenty-first centuries. At the same time, its cross-cultural content—symbolized by the works of Whistler, an American artist who was deeply inspired by Asian imagery—gave the gallery a broader cast.

The Freer Gallery came into existence because of the generosity of a wealthy donor. Other museum projects, which were dependent on government funding, would have to wait. Separate museums of history and technology, although much desired by their respective curators at the Smithsonian, would not find traction with Congress until the post–World War II period. It would take the advent of the Cold War to inspire a new wave of building construction and a corresponding new era of cultural exhibition at the Smithsonian.

2

History and Technology
A New Museum, a New Era

By the mid-twentieth century, the United States National Museum was, by all accounts, bursting at the seams, overcrowded with poorly maintained, inadequately lighted, and insufficiently labeled exhibits. Articles in newspapers and magazines consistently referred to the Smithsonian as the "Nation's Attic."[1] It was an apt moniker as row upon row, case upon case of artifacts lined the walls of the institution's buildings, giving them the look of a cluttered and musty attic. A new building, or buildings, Smithsonian officials argued, would provide the space to create exhibits suitable for the institution's unparalleled collections and improve the effectiveness with which the Smithsonian educated its visitors.[2]

Ideas for three new museums—one dedicated to engineering and industry, another for history, and another to house the Smithsonian's art collections—as well as a proposal to add wings to the Natural History Building started circulating at the Smithsonian in the years following World War I, and discussions about each continued into the post–World War II period. In the interwar years, none of these projects were successfully brought to fruition, although some did make headway. After World War II, however, the coffers opened and a scramble commenced as the proponents of each project competed to make theirs the institution's priority. Still, getting a new museum built was not an easy task. It required deft management and skillful lobbying both on Capitol Hill and internally at the Smithsonian.

In the Smithsonian's bureaucracy, it was the secretary who provided the overarching vision for the institution, but it was often the assistant secretaries and a small number of influential curators who provided the innovative ideas and administrative know-how to accomplish big tasks. In Joseph Henry's era, Spencer Baird and George Brown Goode were the key figures in the rise of the National Museum. In the mid-twentieth century,

44

a new cohort of skillful administrators would make even greater expansions possible. To accomplish their objectives, they needed to build support simultaneously among their Smithsonian colleagues and members of Congress, especially those who held key positions on committees such as the House and Senate's committees on buildings and grounds. Without this combination of institutional and congressional support, no project could succeed. Those leaders who rallied both effectively, however, would usher in a new era of growth at the Smithsonian.

Carl W. Mitman was the earliest of this new wave of visionary leaders, playing a driving role in two museum projects that would eventually develop into the Museum of History and Technology and the National Air and Space Museum. Although he saw neither project to fruition, he was the spark that inspired others, especially his successor Frank A. Taylor, to promote museums of science and technology at the Smithsonian. Mitman had received degrees from Lehigh and Princeton universities before coming to the United States National Museum as an aide in the Division of Mineral Technology in 1914. Over the course of two decades, he progressed to become curator of the division of mechanical technology and later head curator of the Department of Arts and Industries.[3] From early in his tenure, Mitman was a strong advocate for a museum of engineering and industry at the Smithsonian.

He initially proposed such a museum in 1919 and continued to press for one over the next two decades. Mitman pointed with frustration to the fact that England had the South Kensington Museum, France the Conservatoire National des Arts et Métiers, and Germany the Deutsches Museum, but the United States, which was "the most advanced in the application of the engineering and mechanical arts," lacked a museum dedicated to science and technology.[4] He believed that the Smithsonian was the ideal place for such a museum, because the institution already possessed large technological collections and expertise in displaying them. In August 1922, Mitman addressed the leaders of the four national engineering societies—Civil, Mining, Electrical, and Mechanical—in New York and laid out his ideas for the museum, and they subsequently formed a corporation to promote a National Museum of Engineering and Industry.[5] The corporation's plan called for a museum that would be "The Greatest Industrial Museum for the First Industrial Nation," housing "thousands of valuable relics and inventions" from both government and private collections. Ambitious in their vision, they imagined the museum as a hub for a network of museums

of industry scattered throughout the country. New York, Chicago, and Pittsburgh would all have their own museums that emphasized the predominant industries in their regions.[6]

Even as the project gained momentum, however, Mitman recognized the significant obstacles it faced. In order to ensure that it received attention from Secretary Charles D. Walcott and Assistant Secretary Charles G. Abbot, he made himself "somewhat of a nuisance," an approach that was necessary because he was the "only one on the whole Museum staff who has been talking [about] it."[7] As a result, in March 1923 Abbot formally indicated the extent of the institution's commitment to the project, writing that he would recommend to Congress that a site be set aside near the present Smithsonian buildings and that the institution would transfer its engineering collections to the new museum. Subsequently, in December 1924, the Board of Regents adopted resolutions in support of a museum of engineering and industry.[8] Despite this institutional seal of approval, however, the project stalled.

There appear to have been several reasons it did not move forward. The National Museum of Engineering and Industry corporation was not well organized in these years and experienced turnover in its membership. Without an effective partner, the Smithsonian did not have the resources to advance the project alone. The commitment from the Board of Regents had required that three million dollars be raised for the museum before they would recommend a site for it. This responsibility fell entirely on the corporation, which did not have the capability to fulfill it. Furthermore, Mitman did not have a good working relationship with H. F. J. Porter, secretary for the corporation, complaining of Porter's impatience with and ignorance of the realities of bureaucratic wrangling. In addition to the challenges it faced with its external partners, the museum project met a major roadblock internally. In a 1925 letter to Porter, Mitman wrote that plans for museums of art and history had priority over other projects at the Smithsonian: "Each year these plans are coming more and more to a definite status but until that job is done the Institution can not afford to approach Congress with another proposition."[9] Despite his cheerleading, Mitman had failed to convince Walcott and Abbot to support his idea over others. Still, he continued to press for such a museum at the Smithsonian. In 1934, to further his proposal, he outlined a "Tentative Classification" which laid out a preliminary framework for the museum. It would take a decade, however, to revive the movement for its creation.[10]

While Mitman lobbied unsuccessfully for a Museum of Engineering, other projects that had more support from the institution's leadership also

stumbled. Reflecting the oft-repeated desires of Smithsonian officials, the Smithsonian annual report for 1928 contained proposals for museums of both history and engineering, as well as an art museum and additional wings for the Natural History Building.[11] In 1930, now Secretary Abbot again called for museums for the historical collections and the collections of "arts and industries." He also reported that Congress and President Hoover had authorized an extension of the Natural History Building, allowing the institution to add wings at the east and west ends.[12] Unfortunately, although Congress authorized $6.5 million for the project, no appropriation of funds was forthcoming in these early years of the Depression, and, as a result, Natural History would have to wait decades before it could add any space. Later, the institution did actually come close to securing funds for at least one new museum through federal New Deal programs. Ultimately, however, all new museum projects were shelved until after World War II.[13]

As the war neared its conclusion, Mitman began again to advance the idea of a Museum of Engineering and Industry. In 1944, Mitman and Assistant Secretary (soon-to-be Secretary) Alexander Wetmore appeared before the House Committee on Public Buildings and Grounds to press the case. They asked for a building in "the area between Independence, Maryland, and Virginia Avenues," a space which had been set aside at an earlier date by the National Capital Park and Planning Commission (the successor to the McMillan Commission) for a Smithsonian museum to house the science and technology collections.[14] Their efforts led to the inclusion of provisions in a bill "to provide for the construction of public buildings" for a "building for the engineering and industrial collections of the Nation." This bill also included provisions for a historical museum and "additional facilities at the National Zoological Park."[15] Referred to the Committee on Public Buildings and Grounds, the bill did not pass Congress. Subsequently, Mitman would turn his attention to another major new museum, the National Air Museum, leaving the museum of engineering and industry project to Frank Taylor.

Curiously, the first museum to receive authorization from Congress in the postwar period was not a Museum of Engineering and Industry, or a history museum, or an art museum. In 1946, Congress authorized a National Air Museum, which was intended to educate the public about the history of flight and military and civilian uses of aircraft. The Smithsonian had an unparalleled collection of airplanes and other materials related to flight— Lindbergh's *Spirit of St. Louis* had long been one of its most popular attractions. Moreover, many of the air collections were housed in an inadequate facility—a structure adjacent to the Arts and Industries Building. Still, a

separate National Air Museum had not been a high priority for Smithsonian officials before the war. Receiving strong support from General "Hap" Arnold and government and corporate interests, the museum was the result of expanded interest in air power during the war. Mitman was assigned to oversee the project and, as a result, thereafter was not involved with the Museum of Engineering and Industry. Despite congressional approval and Mitman's leadership, however, the museum went nowhere fast. It would take decades, in fact, for it to receive an appropriation for a building, and it would be thirty years before it would open to the public as the National Air and Space Museum.[16]

As Mitman turned his attention to other things, Frank Taylor seized the task of promoting the Museum of Engineering and Industry. Taylor was a remarkable administrator who was not only able to communicate effectively across the Smithsonian's many divisions and departments, but also was capable of building support in Congress and other federal agencies for his ideas. Much as Spencer Baird and George Brown Goode did in the late nineteenth century, he would play a central role in the Smithsonian's efforts to improve exhibits and create new spaces to house them.[17] The son of a pharmacist, Taylor grew up in the Capitol Hill neighborhood of Washington, D.C., and first came to the museum as a young man in 1922 to work as an apprentice in the laboratory of the Division of Mechanical Technology. After earning a B.S. in mechanical engineering from M.I.T. and a law degree from Georgetown, he continued his career with the Smithsonian, progressing steadily through the ranks to become head curator of the Department of Engineering and Industry and later director of the United States National Museum.[18]

In 1946, Taylor wrote articles for *Science* and *Scientific Monthly* that provided a detailed plan for the layout of a new National Museum of Science, Engineering, and Industry.[19] The new museum, Taylor wrote, would be a "museum of record as well as of exhibition" and would "include all of the sciences except the natural sciences and all of engineering and industry."[20] The building he proposed was to be located "between Independence and Maryland Avenues and Seventh and Ninth Streets facing the Mall," a location southeast of the Arts and Industries building. Inside, Taylor outlined a "parallel gallery plan" with an "easily traveled route" of public halls for the casual visitor alongside more in-depth study galleries. In this way, he envisioned combining the National Museum's older exhibitions—cluttered display cases filled to the brim with objects—with a format more conducive to educating the general visitor. With two floors and a basement that included exhibition space, the museum Taylor described included

twenty-four halls dedicated to topics such as "civil engineering," "textiles," "electronics," and "mining."[21]

As Taylor advanced discussions about the museum in the late 1940s and early 1950s, various ideas emerged. While advocating for a Museum of Science, Engineering, and Industry, Taylor made connections in the Public Buildings Service. That agency's commissioner, Winchester E. Reynolds, suggested to him that instead of pursuing several separate projects the Smithsonian should include all of its space needs in a request for one large building. Following Reynolds's suggestion, Taylor came up with another idea: a museum that would solve the institution's space problems by encompassing a wide swath of the Smithsonian's collections. A museum of man, Taylor thought, could bring together history, engineering and industry, and anthropology in one building. With this solution, history and engineering would get what they had long desired—a new museum—and Natural History would not need additional wings because its remaining collections could expand to fill the space vacated by anthropology.[22] Reflecting on the idea years later, Taylor said that the museum of man would have exhibited "the complete story of man, archeology, physical anthropology even, . . . and ethnology, then getting into ethnographic invention and development, and then into modern invention."[23] Reminiscent of Goode's conception of the National Museum as a museum of anthropology broadly defined, Taylor's idea ran counter to the centrifugal forces pulling the Smithsonian's various departments and divisions apart. Born of the practical desire to secure additional space for the collections in engineering and industry, the concept encouraged the National Museum to return to its roots.

A couple of significant roadblocks existed, however, to the advancement of such a project. The first was that Secretary Alexander Wetmore and other Smithsonian officials placed a higher priority on the wings for Natural History than on a new museum building.[24] It would take a couple of years before Taylor would be able to convince Smithsonian officials that a new museum should be an equal priority.[25] The second was that the Department of Anthropology needed to be convinced to leave the Natural History Building. For the anthropologists, remaining in Natural History offered more prestige within the institution.[26] There they bore the imprimatur of science, which since the days of Joseph Henry had held preeminent importance at the institution. Conversely, history was not given much respect within the Smithsonian bureaucracy.[27] The anthropologists feared that by moving to the new museum they would be excluded from the Smithsonian's "community of scientists." Instead of jumping at the

chance to have vastly increased territory, they continued to hope that the addition of wings to the Natural History Building would solve their space problems.[28]

As the museum gained momentum in the early fifties, Taylor and other Smithsonian officials circulated various ideas for names, including "National Museum of History and Technology," "Museum of America," "National Museum of Man, His History and Technology," "National Museum of Man and His Work," and "National Museum of Man and His Achievements."[29] In addition, alternatives to "Museum of Man" included "Hall of Humanity," "Gallery of Civilization," "Human History Hall," and "Human History Building (as opposed to Natural History Building)."[30] According to Taylor, the idea of calling it "History and Technology" came from Grace Rogers (later Grace Rogers Cooper), who was a curator of textiles.[31] Still, it took time to settle on the Museum of History and Technology as a name. The various monikers suggested indicated the degree of uncertainty over what the exact identity of the museum should be. No longer simply a museum of engineering and industry or a museum of history, it had become a hybrid, but what kind of hybrid was still unclear.

The proposed names reveal several divergent paths that Smithsonian officials might have chosen for the new museum—paths that were rooted in distinct epistemological, museological, and institutional histories. Although it began as a compromise solution to the Smithsonian's space problems, the Museum of Man concept had strong resonance with the history of the institution and the intellectual currents of the postwar era. Institutionally, a Museum of Man would not have been all that different from the original National Museum. Combining technology, ethnology, and history, the museum would have resembled the *omnium gatherum* of Goode's museum, although it would have lacked the natural history component. Epistemologically, the concept—or, at least, the name—accorded well with postwar intellectuals' affinity for universalist interpretations of human society and culture. A philosophical universalism prevailed in this period, as intellectuals reacted to what they perceived to be the folly of moral and cultural relativism in the face of the evils of the totalitarian ideologies of fascism and communism. "Cultural relativism in anthropology was a prime target [for postwar intellectuals]," historian Peter Novick writes, "since nothing could be more disarming in a global struggle of ideologies and social systems than to suggest that there was no universal, absolute standard by which belief systems and practices could be judged."[32] The alternative to cultural relativism was a universalism that placed all human societies and cultures on a single scale and declared cultural traits and moral standards

common to all humanity. A museum of man might have been one place to make such an argument to a broad audience. Perhaps not wanting to take such a hard line, Smithsonian curators could also have elected to use the new museum to present a friendlier version of universalism, along the lines of the Museum of Modern Art's landmark 1955 exhibition "The Family of Man," which used photographs to depict commonalities among the world's cultures. Touring thirty-seven countries over the course of eight years, the exhibit, which was immensely popular both in the United States and abroad, was emblematic of postwar optimism and popular ideas of universalism.[33]

The Museum of Man concept did not prevail, however, and, as a result, discussion of the character of such a museum must remain speculative. Instead, Smithsonian officials chose to pursue a Museum of History and Technology. Partly a marriage of convenience, the Museum of History and Technology concept had a particular logic to it, beyond institutional needs, that made sense in the postwar era. The combination of history and technology resonated with the American public as the nuclear arms race, and later the space race, fueled expanded interest in science and engineering and encouraged the correlation of American prowess in these fields with national pride (and survival).

The push to bring the museum project to fruition began in earnest in 1952.[34] Taylor had been receiving consistent support for the project from Assistant Secretaries John L. Keddy and John Enos Graf since the late 1940s, but the appointment of Leonard Carmichael as secretary of the institution in 1952 moved the project into high gear.[35] Carmichael, an expert in child psychology who prior to coming to the Smithsonian had served as president of Tufts University, shared Taylor's vision of a modernized Smithsonian. According to Taylor, in 1952, the "Smithsonian Institution Planning Board adopted the Museum of Man and the additions to the Natural History Building as the 'two first' objectives of the Institution."[36] Subsequently, Taylor worked closely with Keddy and Graf to develop a strategy for approaching Congress with the museum proposal. Keddy, who had formerly worked for the Bureau of the Budget, sought advice from a legislative expert at that agency on drafting a bill to send to the leadership of the House and Senate.[37] As Taylor worked through the practical logistics of bringing the project to fruition, he continued to ponder the conceptualization and naming of the museum. In a 1953 memo to Carmichael, Taylor referred to the "'Museum of Man,' so-called," and wrote, "I recommend that we call this museum the National Museum of History and Technology and ignore anthropology in the promotion." Taylor saw now how a museum

that combined history and technology could present an appealing narrative to potential supporters of the museum as well as the general public. "I believe that the business and engineering communities," he wrote, "will be intrigued with the idea of interweaving the story of American enterprise and technological development into a fresh panoramic treatment of political, military and cultural history."[38] Although he did not recommend removing anthropology from the new museum, his suggestion that they not include it in their promotional efforts indicated that the Museum of Man concept was losing steam. The decisive factor in this shift toward the Museum of History and Technology concept was the Department of Anthropology's decision to remain in the Natural History Building. The muting of anthropology's contribution to the new museum may have contributed to this decision.[39]

By the time Congress took up formal discussion of the museum in 1955, it was clear that the name would be the Museum of History and Technology. In January and February 1955, members of both the House and Senate proposed bills, and in April the House Subcommittee on Building and Grounds held a hearing to discuss the proposal.[40] At the hearing, Carmichael made the case for a new museum in overtly nationalistic terms. The museum, he told the representatives, would depict the "Nation's progress" from the colonial period to the present. Decrying the lack of funding the Smithsonian had long suffered under, he pleaded that now was the time to make a significant investment in such a museum. Remarking on his own New England frugality, he contended that the Smithsonian was stretched beyond its limits. Before them, the representatives had an illustrated prospectus for a new Museum of History and Technology that, Carmichael argued, would meet a "most pressing national need." Then he played his trump card. Recounting his experience at an international conference at The Hague, he told the committee members, "I was asked several times why the United States does not have better national museums in the fields of history or engineering and industry." "Almost every nation abroad," he continued, "now has fine museums of history, science and technology." For Carmichael, it was remarkable that the United States "which has given such substantial aid to cultural activities in other countries, itself does not have in its national capital a national museum at least equal to those of many of our less wealthy western neighbors." Finally, after setting them up, Carmichael delivered the crucial blow, invoking the Russians' plans to construct a "great national museum glorifying the Russian state."[41] He skillfully played on Congress's Cold War anxieties to make an effective case for funding. Less than a year removed from the peak of Joseph McCarthy's

anticommunist reign of terror, Carmichael's approach was shrewd and bold, and it hit the mark immediately.

The committee chair, Democratic representative Robert E. Jones Jr. of Alabama, recommended that the Smithsonian receive not only the planning money it was requesting but full authorization for the $36 million needed to construct the museum.[42] The location of the museum would be on Constitution Avenue between 12th and 14th Streets, a site that, according to the director of the National Capital Planning Commission, had been set aside for the Smithsonian more than two decades earlier. At present, the site contained temporary government structures and it had earlier been used as a quarantine station for the Department of Agriculture.[43] Interestingly, almost exactly a year earlier a similar temporary structure located two blocks away at 16th Street and Constitution had provided the setting for Robert Oppenheimer's dramatic security clearance review before the Atomic Energy Commission.[44] There, at the peak of the McCarthyite hysteria, America's greatest scientist had been humiliated, branded a traitor, and denied security clearance. It is not without irony that the federal government finally endorsed a national museum dedicated to science and technology on a site so near to the place where its agents drove the leader of the Manhattan Project out of public service.

Oppenheimer was deemed unsuitable for government service in part because of his communistic fellow traveling in the late 1930s, but also because of his overt advocacy of international openness in nuclear physics after the war. Hoping to stave off an arms race—and perhaps feeling guilty over the deadly force he had helped to unleash—Oppenheimer, along with other prominent scientists such as Niels Bohr, argued vigorously that the American nuclear program should not be shrouded in secrecy. Instead, he contended that knowledge in this area should be shared among nations, so it could be put to peaceful use in the form of nuclear energy. Such an internationalist perspective was heretical in McCarthy's Washington, and some pundits suggested, without evidence, that Oppenheimer was secretly working as a Soviet agent to disrupt the American nuclear program. Perhaps Oppenheimer's public shaming was on the minds of Smithsonian officials when they executed their strategy for selling the museum to Congress. Unlike Oppenheimer, Smithsonian officials dutifully played their part in the Cold War tragicomedy. Emphasizing a nationalist, rather than internationalist, perspective, they sold the museum to Congress and the American people as an essential arm of the "cultural Cold War."[45]

Moving rapidly, the House passed the bill authorizing the Museum of History and Technology on June 8, 1955, and the Senate followed nine

Frank Taylor during construction of the Museum of History and Technology, c. 1964.
Smithsonian Institution Archives, neg. #83-2074 and SIA2009-0003.

days later. By the end of the month President Eisenhower had signed it into law, and only a few days later he approved an appropriation of $2,288,000 to begin the project.[46] Taylor had succeeded in getting the approval and funds he needed, but his work had only just begun. It would be nine years before the museum opened its doors to the public.

One of the first major hurdles Taylor faced concerned organization. When the Natural History Building opened as part of the United States National Museum in 1910, Smithsonian officials had hoped to segregate the anthropology and natural history materials from the historical and technological collections. However, this separation was never fully consummated. As a result, visitors touring the Natural History Building in the 1950s would have found among the Native American, Asian, Middle Eastern, and African, as well as zoological and geological, materials, displays of United States military history, European and American arts and crafts, and European and American musical instruments. In addition, they would have encountered a colonial American period room, which had been donated to the museum in 1924.[47] The breadth of the building's collections was vividly illustrated by its pottery displays, which included

early Euro-American, American Indian, and medieval and later European pieces in exhibits on the first and second floors.[48]

Even after the separation of the departments of anthropology and history had occurred, a large number of Euro-American cultural artifacts had remained among the collections of the Division of Ethnology. Separated from objects with more traditional historical significance, such as George Washington's uniform and Thomas Jefferson's portable writing desk, which belonged to the Division of History, these were everyday objects such as utensils, textiles, and ceramics from historic Euro-American cultures.[49] In its annual report for 1954–1955, the Division of Ethnology described the scope of its collections, writing that the division is "concerned with man's material culture—the things he shapes from nature's products to implement his will, the impulse of his spirit, and his cultural traditions." The all-encompassing scope of the division's mission was made possible by the reach of its collections. "The materials accessioned in the division," the report read, included both "the primitive and exotic in tribal life" and "the primitive and antique in historical European and Asiatic cultures." Broad cross-cultural collections allowed the materials of "the world's peoples" to be treated "as manifestations or facets of the universal pattern of human culture."[50]

Whereas the segregation of historical and anthropological materials into Arts and Industries and the Natural History Building respectively was never completed, the creation of the Museum of History and Technology precipitated a sorting process that resulted in the removal of all Euro-American cultural collections from the Division of Ethnology and, eventually, the Natural History Building. Of course, the sorting of collections was only a physical manifestation of a larger divide that existed between the subject matter of history and anthropology. During the fifties and early sixties, the scope of most historical studies was limited to analyses of white men and their political activities. Only gradually in the late sixties and seventies did history as a discipline open itself to more diverse subject matter. In anthropology, the situation was nearly the exact opposite. Taking "primitive" societies and non-white peoples as their subjects, anthropologists in this period did not typically apply their insights to industrialized, "modern" societies. The discipline had always explored multiple cultural groups; however, it drew the line at examining Western, "civilized" peoples. Separating the subject matter of anthropology from the subject matter of history, then, would have seemed natural and entirely appropriate to most scholars of the period.

In late June 1955, the day before Eisenhower signed the act creating the Museum of History and Technology, Secretary Carmichael circulated a memo that created committees to discuss the "location of collections and reorganization of sections."[51] The use of committees consisting of curators and other staff members was, under Carmichael, a typical approach to managing complex tasks such as departmental reorganization and exhibits renovation. Within a few weeks, a committee on cultural history adopted a unanimous resolution recommending the transfer of Euro-American cultural artifacts to the new museum. The committee, which included, among others, C. Malcolm Watkins, associate curator of Euro-American materials in the Division of Ethnology, Grace Rogers, curator of textiles, John C. ("Jack") Ewers, associate curator of ethnology, and Margaret Brown, curator of the Division of Civil History, represented those Smithsonian staff members who worked at the intersection of cultural history and anthropology. In explaining the separation, the acting head curator of the Department of History, Mendel L. Peterson, argued that the mission of his department was "to tell the history of our country's civilization based on Greek and Roman antecedents. . . . Anything essentially Western European belongs in the Department of History, anything having to do with other areas belongs in Anthropology."[52] Peterson, who was a military and naval historian, offered such a stark distinction between history and anthropology that one might have expected his colleagues who saw important connections between the two disciplines to have balked. Nonetheless, they went along with a plan that made this division manifest in physical space.

Ironically, even as they participated in the bureaucratic restructuring that pulled these disciplines apart, two of the curators on the committee took the unusual approach of marrying the methods of history and anthropology in their research and exhibition work. Jack Ewers and Malcolm Watkins were enthusiastic proponents of cross-disciplinary research. Ewers, who came to the Smithsonian in 1946, was on the leading edge of a new hybrid discipline called ethnohistory that combined anthropology and history.[53] Watkins, who arrived three years later in 1949, was an expert in the everyday material culture of early American life who had previously served as founding curator of Old Sturbridge Village.[54] He would become one of the pioneers in the field of historical archeology, which applied archeological and anthropological methods to the study of historic Euro-American cultures.

Prior to coming to the Smithsonian, Ewers had studied with the anthropologist Clark Wissler at Yale, conducting research on historic Plains In-

dian cultures. After receiving his master's degree, he had worked for the National Park Service and then become curator of the new Museum of the Plains Indian on the Blackfoot Reservation near Browning, Montana. The museum was part of a broader Bureau of Indian Affairs effort to construct museums on or near reservations.[55] In the early 1940s, as most of the country had its attention firmly fixed on Europe and the Pacific, Ewers developed museum exhibits and conducted extensive research on the cultures of the Northern Plains. Living and working with the Blackfeet for four years profoundly influenced his scholarship. Combining ethnographic fieldwork with the close examination of historical documents and artifacts, he was able to study the ways in which Plains cultures changed over time from the period before European contact to the present.[56] After the war, Ewers continued this work as a Smithsonian staff member.

In 1955, he published his research in *The Horse in Blackfoot Indian Culture* under the auspices of the Bureau of American Ethnology. The monograph traced the diffusion of horses in Plains Indian society and the cultural changes that their presence wrought. A rigorous work of both ethnology and history, it combined in-depth research in historical documents and material culture with the testimony of living Native people. The central argument of the book was that the presence of horses had a profound influence on the Blackfeet. Refuting the interpretations of earlier ethnologists, such as his mentor Wissler, who maintained that Plains Indian culture in the "pedestrian" and "horse culture" periods was essentially the same, Ewers presented a strong argument for social and cultural change over time.[57] Using oral testimony and historical documents, he not only detailed aspects of Blackfoot culture that emerged in response to the presence of horses; he also identified a rough outline of when these changes occurred and what connection they had to social, economic, environmental, military, and political shifts. Without his time in Browning at the Museum of the Plains Indian, Ewers would not have been able to complete the book. "Much of the factual information on which this study is based," he wrote in the book's introduction, "was supplied by elderly . . . Indian informants whose knowledge of the functions of horses in the late years of buffalo days was solidly grounded in personal experiences."[58]

In addition to his publications, Ewers attempted to bring an ethnohistorical perspective to his work in exhibits—albeit in a limited and unsystematic way. As curator in charge of renovating the Natural History Building's North and South American Indian halls in the mid 1950s, he had tremendous power to influence public understanding of Native peoples. Following his predecessors, he chose the familiar culture area arrangement. Several

factors explained his decision to organize the exhibits in this way. One important reason was that this arrangement had the weight of precedent behind it.[59] Not only had the Smithsonian previously organized ethnological exhibits along these lines; Wissler had arranged the American Museum of Natural History's exhibits using culture areas, and, over the intervening decades, numerous other museums had adopted the approach for their exhibits of Native cultures.[60] For Ewers, the culture area arrangement had become so pervasive that no other alternative warranted consideration. "Even writers of children's books," he maintained, "had adopted [the concept of the culture area] in their descriptions of American Indian cultures, devoting separate chapters to the Indians of the Woodlands, of the Plains, of the Northwest coast, and others."[61] Ewers thus had the preponderance of academic and popular opinion behind his decision to organize the "Indian Halls" by culture area. Despite an overarching frame that emphasized geography, however, he was able to work some historical narratives into his exhibits. In a case on Navajo shepherds, for example, visitors could learn how the introduction of certain domesticated animals transformed Indian societies and cultures. "In the 18th century," the case label read, "the Navaho lived much like their Apache neighbors—by hunting, gathering and raising some food crops. . . . After Spanish colonists introduced sheep into the Southwest the Navaho became shepherds and skilled weavers of woolen garments."[62] Another case included a brief history of Navajo silverwork, describing how Navajo peoples adapted the craft from Mexicans after 1850. In this manner, Ewers brought the ideas and methods from his research to bear on the exhibit's displays. Such inclusions suggest an alternative form for the hall that was more sensitive to ethnohistorical ideas and methods. Subsumed under the culture area framework, however, historical narratives such as these probably had little effect on visitors.

The lack of more prominent historical narratives in the "Indian Halls" troubled Ewers throughout his career. In a memo to the Secretary of the Smithsonian in 1969, he wrote, "Probably no one is less satisfied with our anthropological exhibits than I am."[63] Ewers admitted that he did not think the halls adequately or accurately presented Native history. To improve them, he once again suggested a greater emphasis on history and living Native cultures. "Lets [sic] . . . improve our traditional organization to make it more meaningful. One way this can be done," he contended, "is by combining archeology and ethnology and history and bringing our cultures down to the present."[64] He made similar complaints about the exhibits' lack of a historical component to colleagues in subsequent years.[65] Such exhibits as he described in 1969 would have dramatically revised the Smithsonian's

exhibits of Native cultures. For a variety of reasons, however, exhibits along these lines were never produced.

While Ewers struggled to bring anthropology closer to history, his colleague Malcolm Watkins attempted to do the same from the opposite end. Watkins was the son of the well-known early American pottery and glass collector Lura Woodside Watkins, from whom he had absorbed an abiding interest in the social roles of objects. As curator of the Wells Historical Museum, the precursor to Old Sturbridge Village, Watkins presented early American materials in the context of their original usage. He was fascinated with things as evidence of past ways of life, not as relics or aestheticized objects divorced from their original functions, a perspective he carried into his work at the Smithsonian.[66]

In the early 1950s, Watkins wrote in a memo to Secretary Carmichael, "The Smithsonian . . . is now attempting to apply the techniques developed in anthropology as well as in history to an over-all comprehension of American life of the past, particularly in its pioneer phases. In so doing it has adopted the methods of documentation and research that are traditional with the Smithsonian's old and famous Department of Anthropology."[67] Clearly influenced by his colleagues in the Division of Ethnology, Watkins applied anthropological and archeological ideas and methods to the study of Euro-American cultural history. In this period, he began research on early colonial craft production and settlement in Virginia.[68] The most significant outcome of this work was *The Cultural History of Marlborough, Virginia* (1968), which traced the rise and fall of a failed Virginia port town. The study revealed that the founding of Marlborough had been an attempt on the part of colonial authorities to diversify Virginia's economy and overcome the tyranny of tobacco production. For a variety of reasons, this effort failed, and a large estate belonging to a single family sprouted in the town's place. Watkins reconstructed a detailed and complex portrait of a long-forgotten colonial town, using his findings to develop a broader narrative about the social, cultural, and economic history of Virginia. With this work, he was on the leading edge of a new discipline called historical archeology. In his pathbreaking book *In Small Things Forgotten*, James Deetz defined the field this way: "Historical archaeology studies the cultural remains of literate societies that were capable of recording their own histories." It is "the archaeology of the spread of European culture throughout the world since the fifteenth century and its impact on indigenous peoples."[69] This was the definition Deetz proffered in 1977, a time when the historical profession had embraced social history and the study of ordinary people. Two decades earlier, Watkins was working in an environment in which people

were far less accustomed to seeing the archeology of "literate peoples" as a valid area of study. Through bold experimentation, however, he made important strides that would contribute to the birth of a new field.

His research was limited, though, in a significant way. It ignored both the Native peoples who interacted with and fought against the English colonists and the African Americans who worked as slaves in Virginia's tobacco fields. These lacunae in the history of colonial Virginia were not unique to Watkins. In 1957, Virginia celebrated the 350th anniversary of the founding of Jamestown. In commemorations at the site, state officials ignored the presence of Native peoples and blacks in the early colony entirely. Moreover, white officials, who were currently engaged in a "massive resistance" campaign against desegregation, excluded contemporary African Americans from the state-sponsored ceremonies celebrating the legacy of Jamestown. As a result, blacks held a separate ceremony commemorating the arrival of Africans at Jamestown, which white officials did not attend.[70] On a lesser scale, Watkins's narrow focus on Euro-American colonists in his research, even as he embraced anthropological and archeological methods, reflected a racially divided way of viewing the past. His role in the removal of Euro-American collections from the Division of Ethnology reinforced this separation. Interestingly, by the late 1960s, Watkins would question this narrow perspective and would become one of the first curators to press for the inclusion of more materials from African Americans and other people of color in exhibits in the Museum of History and Technology. (This will be explored in depth in chapter 5.)

After their removal from ethnology, the Euro-American collections found new homes either within the Department of Civil History or the Department of Arts and Manufactures. Civil history was defined as the history of "our society organized for peace, including political and social history but excluding those phases associated directly with industry and commerce."[71] Prior to the restructuring in the early fifties, the most significant project of what was at the time called the Division of Civil History was the renovation of the First Ladies Hall, which exhibited the dresses of the wives of American presidents in the Arts and Industries Building, under the direction of curator Margaret Brown.[72] In addition, the division oversaw materials such as the Adams Clement Collection, which was "a collection of miscellaneous relics from the families of Presidents John Adams and John Quincy Adams and the succeeding generations of the Adams family," the "Woman Suffrage" collection, which included "medals awarded to Miss Carrie Chapman Catt for her work in the suffrage movement," and many other significant historical materials.[73] Following the dominant approach

to history at the Smithsonian, Brown focused primarily on collecting and exhibiting objects associated with well-known historical figures and significant events in American history. In 1952, for example, the Division of Civil History received a walnut chest of drawers that had belonged to Connecticut minister Jonathan Edwards.[74] At the same time, she maintained that the work of the Division of Civil History was "not biographical history alone," because it held "type collections of furniture, dolls, glass, and so forth."[75] After the restructuring that accompanied the approval of the Museum of History and Technology, the Division of Civil History became the Department of Civil History, and it included three subsections: the Divisions of Cultural History, Political History, and Numismatics.[76] The introduction of cultural history signaled an expansion of history's scope to include the everyday life of ordinary Euro-Americans.

The other repository for Euro-American material culture was the Department of Arts and Manufactures, which was established in 1957 and included Divisions of Textiles, Graphic Arts, Industrial Cooperation, and Ceramics and Glass. Here again, materials that had long been under the purview of ethnology were separated into a new section associated with the Museum of History and Technology. Creating the department entailed the transfer of over 11,700 ceramic and glass objects and 8,000 period art textiles from anthropology.[77]

Thus, contrary to Goode's original plan, anthropology at the Smithsonian no longer encompassed the everyday materials of both "savage and civilized" peoples. Instead, the Department of Anthropology collected and exhibited objects from Native American and other indigenous groups as well as Asian and African peoples; while, Cultural History and Arts and Manufactures took responsibility for materials of primarily European and Euro-American origin. This departmental reorganization corresponded to a broader institution-wide restructuring. Beginning in July 1957, the United States National Museum was officially divided into two units: the Natural History Museum and the Museum of History and Technology. By 1968, Robert Multhauf, a former curator of engineering who had become director of the Museum of History and Technology, could write, "The collections of the Museum of History and Technology arose out of the more or less accidental intrusion of relics of civilized man into the Smithsonian's anthropological collections."[78] There was, of course, nothing accidental about it. The original inclusion of objects from "civilized" peoples in the National Museum's anthropological collections had been intentional.

In addition to bureaucratic restructuring and the relocation of collections, Taylor and other Smithsonian officials working on the Museum of

History and Technology faced the issue of renovating older exhibits and constructing a large number of new ones. The new museum offered an ideal venue to expand and complete the institution's exhibits modernization program, which had begun in earnest in the late 1940s, although institution-wide discussions about improving exhibits had occurred as early as the 1930s. Through this program, Smithsonian curators and exhibit designers replaced crowded, poorly lighted, and inconsistently labeled cases, many of which dated back to the late nineteenth century, with displays that reflected modern museum techniques and philosophies.[79] Following the lead of museums around the country, such as the Milwaukee Public Museum, which had commenced a similar program in this period, the Smithsonian brought its exhibits into line with contemporary standards of exhibition.[80] Beginning in the 1930s, many museums in the United States and Europe engaged in exhibits renovation programs. Exhibits modernization programs around the world represented an effort on the part of museums to become more relevant, professional, and appealing to broad audiences.[81] An ambitious endeavor, the modernization program ultimately transformed the look of the Smithsonian from that of an outdated relic of an earlier era to a vibrant, contemporary institution.

As with the Museum of History and Technology project, exhibits modernization required a great deal of money and institutional support to complete. In 1954, the Smithsonian received $360,000 from Congress to improve its exhibits.[82] This followed several years of formal and informal discussions among Smithsonian officials, led by Taylor, regarding how best to renovate the institution's many outdated exhibits. The level of discontent among curators with the state of exhibits was high. An October 1948 preliminary report on exhibitions stated, for example: "Exhibits generally are poor. A few are adequate by partial standards but these are offset by others that are pitiable." The report included an appendix that discussed examples of the worst exhibits. Describing the exhibit halls of American Indian archeology, the report complained that the cases were dirty, poorly lighted, and overcrowded. Moreover, the arrangement of objects provided "no story of the artifacts in terms of the total cultures from which they were drawn."[83] By the time Smithsonian officials secured funding from Congress for the project, they had begun to formulate a comprehensive plan for improving exhibits. The first modernized exhibit halls to open were Latin American Archeology in 1954 and the South American Indian Hall and the First Ladies Hall in 1955. Subsequently, over the course of a decade, dozens of new or renovated exhibits of natural history, technology, science, history, and anthropology were constructed.

Undertaking both an exhibits modernization program and a new museum project at the same time entailed substantial logistical complications. In a number of cases, this dual system meant that Smithsonian staff constructed modernized exhibits in one place—either Natural History or Arts and Industries—and then a few years later reconstructed them, often in heavily revised form, in the Museum of History and Technology. The modernized First Ladies Hall debuted in Arts and Industries, for example, before it was moved to History and Technology. For curators, this was often an opportunity to learn from their mistakes and improve the effectiveness of their exhibits. However, those divisions that did not move to the new building—most notably anthropology—had only one chance to modernize exhibits.

As with the building project, exhibits modernization provoked a reconsideration of institutional space. Significantly, one of the exhibits committee's early recommendations was for a reorganization of cultural exhibits in the Natural History Building. In a 1950 report, the committee recommended moving the National Collection of Fine Arts to the second floor and making it the centerpiece of an "art and cultural history unit." In this area, the report read, "the cultural history of Western Europe and America (i.e. Western Civilization) will be interpreted." The halls would display period rooms, furnishings, ceramics, glass, heating and lighting devices, musical instruments, and period art objects. The Department of Anthropology would then be free to construct a series of exhibits on the first floor narrating "The Story of Man," which integrated materials from physical anthropology, archeology, and ethnology. One hall would be dedicated to "introductory exhibits on man and culture" followed by two halls depicting the Native Peoples of the Americas" and two additional halls interpreting "pre-industrialized Old World Peoples."[84] Of course, the authorization of the Museum of History and Technology in 1955 made such an arrangement unnecessary, but the fact that it was discussed demonstrates that Smithsonian officials had considered a reorganization of space in Natural History that separated "Western Civilization" from the material culture of other peoples but kept them within the same building.

In renovating its exhibits, the Smithsonian benefited from the work of a talented group of designers—led by chief exhibit designer John Anglim— who were commercial artists that had secured temporary employment with the institution. Not bound by older conventions of museum display, these designers brought a flair for color, experience with plastics and other synthetic materials, and a great deal of creativity to their work.[85] Taylor and his fellow curators on the exhibits modernization committee, such as

Jack Ewers and curator of ornithology Herbert Friedmann, believed that such an approach to exhibition was necessary because visitors had become used to "more and more attractive methods of graphic presentation of ideas in the world outside museum walls."[86] The guiding philosophy behind exhibits modernization was the idea that museums should be educational institutions and that the Smithsonian had a responsibility to speak to as broad an audience as possible through its exhibits. Discussing his efforts to revise the ethnological exhibits, Ewers wrote, "We must remember that the museum audience is composed of people of varied backgrounds. The museum is the most democratic of all educational institutions. It demands no prerequisites of age or understanding for admittance."[87] By crafting appealing new exhibits that were pitched at the level of an "intelligent child," Ewers and his colleagues hoped to improve the educational effectiveness of the Smithsonian's displays.

If the Smithsonian's attendance is any indicator, they succeeded impressively in this goal. Certainly, they succeeded in crafting displays that were appealing to a large number of American and foreign visitors to Washington, D.C. From 1946 to 1963, attendance at all of the Smithsonian's museums increased steadily from two million to over ten million.[88] And, with the opening of the Museum of History and Technology in 1964, visitation continued to skyrocket, with the new museum logging five million visitors in its first year.

Speaking at the dedication ceremony for the Museum of History and Technology in January 1964, President Lyndon B. Johnson said that the museum represented a place where the "children of the nation" could come to experience the "victory of the freedom and genius of our country." Casting the museum as a tool in Cold War–era ideological battles, he argued that it held the potential to serve as "an open window through which could look the children of Asia, Western Europe, South America, and the Soviet Union" so they could learn "what kind of people we really are and what sort of people we really come from." This, he believed, would counteract the propaganda of the United States' enemies by demonstrating that Americans had started with very little and worked hard to build a powerful nation. The museum "would show visitors from newly emerging nations that their labors are not in vain—for the future belongs to those who work for it." By exhibiting not only America's modern achievements but its formative years, the museum presented a model of development for both the citizens of the United States and foreign visitors from around the world. If the most powerful nation in the world had

started from nothing, Johnson contended, so could all the struggling, developing nations one day enjoy the success, comfort, and plenty of the modern United States.[89] The title of an article in Washington's *Evening Star* summed up Johnson's message: "New Smithsonian Unit to Be a Palace of Progress."[90]

LBJ relied on Cold War–era conceptions of modernization to define progress. Similar ideas guided his administration's policies in Vietnam and other regions where the United States sought to counteract the appeal of communism.[91] In his public statements, Secretary Carmichael framed the museum similarly. The Museum of History and Technology offered, he wrote, "a panorama of our progress from a little colony to a world power."[92] For Smithsonian curators, however, defining what progress meant—and how to depict it through displays of objects—was more challenging. Unlike politicians, they were not driven primarily by the exigencies of the Cold War. For the curators of technological collections, for example, narratives of national progress did not make much sense, as technological (and scientific) innovation tended to transcend national boundaries. At the very least, they needed to show that the roots of the United States' technological prowess lay in the discoveries of other societies and cultures in Europe, Asia, and Africa. Curators in charge of cultural and historical collections also found it difficult to represent progress in their exhibits. Interested in the patterns of everyday American culture, they struggled to balance continuity and change. What, for example, constituted progress in religion or social organization—or even food and beverage consumption?

The idea of progress as the overarching narrative theme, therefore, was really imposed on a museum that struggled to present a coherent message. As an amalgam of history and technology, it was in many respects a hodgepodge like the buildings of the National Museum that had preceded it. Four years after the museum opened, Director Robert Multhauf wrote that History and Technology was a "general museum" that dealt with "life and culture in all its aspects," and he created a basic scheme to organize its activities. In three concentric circles—"Daily Life," "Intellectual Life," and "Socioeconomic Life," Multhauf placed the various departments of the museum. In the center of the inner circle—"Daily Life"—was the Division of Cultural History. Between "Daily Life" and "Intellectual Life" were "Ceramics and Glass," "Graphic Arts," "Costume," "Music," and "Textiles." "Political history," "Numismatics," and "Philately" fell between "Intellectual Life" and "Socioeconomic Life." Finally, "Medicine," "Military History," "Engineering," "Electricity," "Transportation," "Manufactures," and "Agriculture" fell into the outer circle—"Socioeconomic Life." Although

a lot less compelling than President Johnson and Secretary Carmichael's narrative of progress, this scheme was a more accurate description of how the parts of the museum fitted together. Multhauf acknowledged that his attempt to provide a rationale for the museum's collections and exhibits was flawed, because the museum concept had lacked coherence from the start. "The Museum of History and Technology," he wrote, "is no realization of a theoretical ideal."[93] It was a compromise born of the dynamics of an institution that desperately wanted—and needed—more space. Smithsonian officials had to settle for that which was achievable.

In his speech at the opening, President Johnson had begun by quoting Francis Bacon—"I have taken all knowledge to be my province"—as he praised the wide breadth of the museum. Here, the hybrid character of the museum led to confusion. The name of the museum implied a sweeping breadth—"History" and "Technology," not American history and American technology. In reality, although the museum did encompass more than simply American history and American technology, it fell far short of taking all of history and technology as its "province." The excision of anthropology created the largest gap in the museum's universal reach, leading to historical and cultural exhibitions that were predominantly focused on Euro-American peoples. Other parts of the museum were significantly broader. The Hall of Physical Sciences, for example, included a second-century courtyard erected by the Greeks in Alexandria, which contained reproductions of astronomical instruments used in that period. Moreover, an exhibit of timepieces included a Chinese sundial of the Ming dynasty, a reproduction of an Egyptian water clock, and German watches from the sixteenth and seventeenth centuries.[94] The breadth of the original National Museum remained most present in the scientific and technological exhibits.

Despite Multhauf's effort to pull everything in the museum together under a single scheme, it was really two, or even three, museums in one.[95] The first floor was a museum of technology—and some science—with halls such as Heavy Machinery, Tools, and Civil Engineering. Here, visitors would have found an impressive array of objects, from locomotives and automobiles to steam engines and looms. The narratives that curators presented in these halls were primarily technical, explaining, for example, how inventors and mechanics developed and improved the internal combustion engine over time. The breadth and depth of the collections suggest that had Taylor's original vision been fulfilled the Smithsonian might have possessed one of the world's great museums of science and engineering. Since they occupied only one-third of the museum, however, it was impossible for these exhibits to fulfill their full potential.

Moving to the museum's second floor—the level on which people entered from the Mall—visitors would have shifted gears entirely. Now, the exhibits' dominant narratives were of American social, cultural, and political history. Visitors would have immediately encountered the Star Spangled Banner. Turning west, they would have entered *The Growth of the United States* exhibit, a survey of American culture from 1640 to 1851. Designed as an index to the collections of the museum, the exhibit occupied two large halls. Crossing over to the east side of the museum, visitors would have found a companion to *Growth of the United States* called the *Hall of Everyday Life in the American Past,* which Malcolm Watkins curated. Here they would have encountered an array of objects illustrating Euro-American society and culture from the seventeenth through nineteenth centuries. Continuing their tour, visitors could then have chosen to proceed into the Hall of American Costume. The costumes displayed here were those worn primarily by the middle and upper classes during the nineteenth and twentieth centuries. Displays depicting a dressmaker's salon of the 1880s and a tea party during the Edwardian period, for example, illustrated the fashionable tastes of wealthy Euro-Americans. Visitors could then have proceeded into the Hall of Historic Americans or the First Ladies Hall, both of which displayed objects associated with the political history of the United States. From John Jay's Supreme Court robe to Mary Todd Lincoln's gown, these exhibits dramatized the intersections of American social and political life.

Finally, visitors could have gone up to the third floor, which was truly a hodgepodge worthy of the original National Museum. It contained armed forces and ordnance exhibits along with displays of ceramics, glass, philately, musical instruments, photography, and monetary history. Wandering its exhibits, visitors would have found items such as a headquarters tent and camp chest used by George Washington during the Revolution, as well as an Italian lute, a Syrian wine glass, and an English porcelain sweetmeat dish.[96]

Despite this variety, those visitors who focused on the cultural exhibitions on the second and third floors would have found the overwhelming emphasis to be on Euro-American culture. Predictably, given the separation of Euro-American cultural collections from anthropology, the diversity of materials available to the curators in these areas was greatly diminished. This did not mean that the exhibits were devoid of objects from non-European peoples; however, the number of such items was limited. On the third floor, for example, the halls of ceramics and glass contained a select number of pieces from Asian and African cultures. In the showcase exhibitions on the second floor, however, non-European material culture

would have been even more difficult to locate. In Watkins's *Hall of Everyday Life in the American Past* as well as *Growth of the United States* only a handful of displays were devoted to African American, American Indian, and Latino peoples amidst an avalanche of Euro-American material. Ironically, Watkins and historian Anthony Garvan, the main curator behind *Growth of the United States,* were deeply influenced by anthropological ideas and methods. Their embrace of this discipline did not, however, lead to a corresponding inclusion of much material culture from the traditional subjects of anthropology—American Indians and other people of color—in their exhibits.

Malcolm Watkins's exhibits demonstrate the consequences of the National Museum's change in structure from an institution that gathered a large number of European, Euro-American, and non-European materials in one building—Natural History—to one that largely separated these materials into two separate museums. In 1957, Watkins unveiled a large-scale exhibit titled *Everyday Life in Early America* in the Natural History Building. While Ewers revised the "Indian Halls" on the first floor of the museum, Watkins crafted this exhibit of early Euro-American culture on the second floor. Only a few years later in the early sixties, however, the museum closed the exhibit and, in 1964, it was replaced with an expanded version—renamed the *Hall of Everyday Life in the American Past*—in the Museum of History and Technology. Both the original exhibit and the new hall covered roughly the same territory—Euro-American society and culture in the seventeenth through nineteenth centuries. Combining archeological, anthropological, and historical methods, they detailed the ordinary lifeways of Euro-Americans and, in this way, brought the perspective of Old Sturbridge Village inside the museum's walls. Although not offering an entire community through which to wander, the exhibits did contain a series of period rooms. In addition, cases portrayed how people obtained and prepared food and displayed the containers from which they drank, the pipes which they smoked, and the silver on which the wealthy dined.[97] They presented lighting devices, a favorite subject of Watkins's, and tools that colonists brought with them from Europe in the seventeenth century. They also displayed the dolls that young children played with and the books these children read. They did not, however, display famous Americans—political and religious figures—or well-known events. John Winthrop and George Washington did not appear in the hall; nor did the American Revolution. Rather, case after case emphasized ordinary people and everyday culture.

It was not as easy to show objects in action within the confines of a museum building as it was in the outdoor setting of Sturbridge. Watkins

solved this problem by including illustrations and explanations that gave visitors some sense of the ways in which people used the objects in their lives. A case displaying a cresset, or torch basket, for example, included an illustration of fishermen using the device to illuminate their boat at night. In another exhibit case titled "Colonial Beverages," a label read, "Beer and cider were consumed with meals, while more elaborate beverages were dispensed in the numerous taverns which were centers of village social life. . . . Nearly everyone, from infancy to death, drank hard cider—at home, funerals, weddings, vestry meetings, or barn-raisings." This label not only presented a functional explanation for early American containers, it also suggested the social role of beverages in Euro-American society. Another label in a case showing pottery from Eastern Massachusetts read, "'Thrown' on the potter's wheel and 'fired' in simple kilns by craftsmen trained from childhood, earthenware vessels were made in America much as they had been for centuries in Europe." This text pointed to craft processes and the continuity of traditions from old world to new.

Other displays dealt with more complex aspects of society and culture. Two exhibit cases pointed to a sexual division of labor in the eighteenth-century household. "Duties of the Housewife" and "Domestic Duties of the Husbandman" associated certain objects with specific gendered forms of labor. In a case on "Religion," Watkins outlined the uses of an array of objects collected from churches. In another titled "Community and Social Organization," the main label text read, "British traditions of rank governed the earliest organization of colonial society. . . . Later, property and wealth, instead of social status and occupation, became the criterion for rank in the colonies." Discussing an important regional difference, the label also pointed out that "In the South ownership of property . . . established the rank of a person in the community. There, as slaves were introduced and the plantation system developed, authority became more and more centralized in the wealthy land owners." Here, Watkins was at his best, combining historical insights about changes in southern society and economy with anthropology-inspired observations about social structure and authority.

A number of cases in the exhibit explicitly discussed the archeological process and featured the results of excavations. "Archeology is the science by which material evidence of human life of the past," a label text read, "is recovered from the ground and interpreted. Applied to sites of early colonial settlement it gives us information about useful objects, architecture, and manners of living that cannot be obtained from written records." The objects in the case that contained this label came from an excavated site in coastal Virginia. In another case displaying pottery, a label read, "Sites

of colonial kilns give the best evidence of early potters' work." Revealing that the items on display did not come only from the institution's musty collections, Watkins opened the process of archeological detective work to visitors. He did this even more explicitly in a case that detailed the archeological excavations at Marlborough, Virginia. The case presented objects—plates, bottles, pipes, and numerous shards—from the site, and arranged the objects not by type or date, but according to the location of their excavation. This arrangement encouraged visitors to see the objects on display through the eyes of an archeologist and suggested to them that the methods of archeology could be fruitfully applied to the comprehension of historic Euro-American cultures.

The original *Everyday Life* was an exhibit that fitted comfortably into the space of the Natural History Building. Drawing on history, archeology, and anthropology, it reflected the interdisciplinary proclivities of Malcolm Watkins and Jack Ewers. It was appropriate for a building that also contained large exhibit halls on American Indians to address Euro-American settlement and contact between these groups, even if it did so by using many of the negative stereotypes of the 1950s. Rather than being presented as independent actors, Native peoples appeared as both aiding and hindering Euro-American social and cultural growth. A docent's tour described how the exhibit portrayed Native Americans: "Indians meant both peril and comfort to the settlers, for although they taught them many things, friendliness with one tribe usually meant the settlers were enemies with a rival tribe." This brief speech was delivered in front of the hall's depiction of colonists interacting with Squanto, or Tisquantum, the New England Native who assisted the settlers at Plymouth. In a large cartoonish illustration, the display showed white colonists trading with him. The settlers appear bemused and unintimidated by the exchange. One colonist scratches his head and smirks knowingly as Squanto squats beneath him, holding a fish and some corn. The other colonist seems to be studying the Native man, with an air of disdain on his face. None of the desperation the colonists felt as they tried to secure food is evident; nor is there any sense of the precariousness of their position in North America. According to the docent, colonists soon moved beyond their early reliance on Native peoples. "After the necessities were taken care of in the first few years of settlement," the docent's script read, "the colonists established a way of life that brought comforts and greater security."[98] Native peoples in this formulation, then, were a disposable aid to advancement. In a case displaying early "Indian massacre" posters and captivity narratives, Native peoples became frightening "savages" that threatened the colonists' peaceful, civilized way of life.[99]

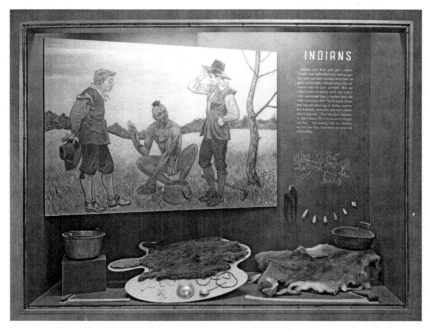

Early colonists interacting with Squanto, from *Everyday Life in Early America* exhibit in the Natural History Building, 1957. Smithsonian Institution Archives, Record Unit 95, box 44A, folder 8, neg. #94 389-B.

Conveniently, however, visitors could purge any fear or anxiety resulting from viewing the "massacre" posters at the end of the hall by examining a "cigar-store Indian"—a symbol of the conquest of Native peoples in American culture.[100]

When Watkins moved *Everyday Life* to the Museum of History and Technology, he left the sections on Native peoples behind. This decision was emblematic of the broader rupture between history and anthropology at the Smithsonian. Although Watkins continued to work in an interdisciplinary manner, he was separated from Natural History's anthropological collections and its experts on American Indian cultures. Moreover, visitors could no longer move quickly from displays on Euro-American culture to exhibits on Native cultures. Naturally, the story of Native-European contact would seem less important as these collections no longer occupied the same building.

In other ways, however, Watkins attempted to make the exhibit more inclusive. The new hall included displays on the Chinese in California and Spanish influences on American culture, which the older exhibit had not. The new hall also contained a case titled "African Backgrounds and Negro

Slavery"—subjects that the earlier exhibit had also avoided. In this effort to include non-European peoples in the hall, Watkins was limited by the scope of the Division of Cultural History's collections. In order to depict Hispanic and African American cultures, therefore, he had to actively collect materials, such as a period room from New Mexico. His efforts, particularly regarding African American culture, however, were not enough to overcome the criticisms of the exhibit—and the Museum of History and Technology in general—that it did not adequately display the cultural diversity of the United States.[101]

Perhaps the strongest evidence of this lack of diversity in the museum's cultural exhibitions came from *Growth of the United States*. This centerpiece exhibit of the Museum of History and Technology had as its goal to bring together the museum's disparate parts into a coherent whole. Here the narrative of progress was to be simply and elegantly displayed through objects from all of the museum's departments and divisions. There was nothing simple, however, about the creation of this exhibit. Indeed, it had a long and difficult road to completion, not opening until three years after the museum's debut. Conceived in the mid-1950s as a way to exhibit the museum's most important cultural artifacts while narrating a basic and inspiring version of American history, by 1967 it had transformed into a sprawling exhibit that detailed tastes, values, modes of communication and transportation, industry, diet, tools, education, building techniques, and other aspects of American culture. Originally intended as an index to the Museum of History and Technology's collections, as well as an introduction to the museum's overarching theme, it became something entirely different.

An early proposal for the exhibit sketched three central goals: 1) "To interpret the story of our national progress from colonial settlement to world power"; 2) "To emphasize in each hall the dominant character of the period that hall seeks to interpret"; and, 3) "To present the visitor the inspiring opportunity of beholding the most significant original relics in the collections in meaningful chronological and cultural contexts."[102] "We should seek," the proposal stated, "to point out the positive values of the American way of life." The exhibit "should enhance the citizen's pride in his country, in its accomplishments and ideals." Moreover, "It should increase the foreigner's appreciation and understanding of the American way of life."[103] Reflecting a Cold War–era desire to project a positive and inspiring image of the United States to the world, *Growth of the United States* accorded with Johnson and Carmichael's vision for the museum. Despite the exhibit's

simple patriotic guidelines, however, it was clear early on that the exhibit would be extremely difficult to design. Such a vast number of objects and wide breadth of subject matter proved challenging to synthesize.

As one of the curators charged with organizing the exhibit in its early stages, Jack Ewers was familiar with the challenges designing large-scale cultural exhibits presented. Ewers was appointed Planning Officer for the Museum of History and Technology in 1956 while he continued to work on the "Indian Halls" in Natural History. In notes written in June 1956, he argued that *Growth of the United States* offered the opportunity to present a large-scale historical narrative to a broad audience. He hoped the exhibit would offer a synthesis of American history that would be "intensely interesting" and "concrete and understandable to many people who have little taste for textbook and classroom history."[104] This synthesis had limits, however. Beyond practical problems such as a lack of certain types of objects in the institution's collections, the difficulties of presenting abstract concepts in museum exhibits, and the danger of oversimplification, Ewers's vision for the exhibit was limited in the scope of American culture it sought to represent. Strikingly, Ewers, the dedicated ethnohistorian, did not advocate putting Native Americans or the history of contact between Indians and whites at the center of the exhibit's narrative. Rather, he suggested that Native peoples be included as one of the "discoveries" of Europeans. Moreover, he offered his expertise to further push Native Americans out of the main narrative of American culture by providing evidence of what he called the "sparseness" of the Native population on the North American continent at the time of contact.[105] Ewers, like his non-ethnologist co-curators, embraced a version of American history that focused almost exclusively on Euro-Americans.

The outline of the exhibit remained vague, however, in this early phase. Not until the arrival of curator Anthony Garvan in 1957 did it really begin to take shape. When Garvan came to the Smithsonian, he took over the reins of the exhibit and charted an ambitious course for it. Actively recruited by the institution, he was at first hesitant to leave his position at the University of Pennsylvania. The opportunity to work with the Smithsonian's collections and to create an exhibit that would reach a broad audience ultimately convinced him, however, to take the position as head curator of the Department of Civil History.[106]

Garvan was born on October 7, 1917, in upstate New York.[107] His family was wealthy, and his father, Francis Garvan, was a famous collector of Americana. He attended Yale, where he received his B.A. in 1939 and M.A.

in history in 1942 and began research on his doctoral dissertation, which would later become his first book.[108] In 1943, however, he decided to interrupt his studies to contribute to the war effort. Like many of his Ivy League peers, he joined the Office of Strategic Services (OSS), the predecessor to the CIA, and worked processing intelligence for the military. With OSS, Garvan stayed in New Haven and evaluated information about the Axis powers.[109] During this time, he gained exposure to the Cross-Cultural Survey, a project begun in 1937 for Yale's Institute of Human Relations. The goal of the Survey, according to one of its publications, was to "organize in readily accessible form the available data on a statistically representative sample of all known cultures, primitive, historical, and contemporary." A clearinghouse of ethnographic information, it had as its purpose "testing cross-cultural generalizations, revealing deficiencies in the descriptive literature, and directing corrective field work."[110] Under the direction of anthropologist George Peter Murdock, the Survey became a useful reference for the government, military, and scholars about the cultures of the world.[111] Exposure to the Survey had a profound influence on the direction of Garvan's scholarship, and over the next two decades he would use it to organize two large-scale projects of his own.

After the war, Garvan returned to his studies and completed his Ph.D. in 1949. The book that grew out of his dissertation traced European precedents of the architecture and town plans of colonial Connecticut and charted continuities and changes in the colony's housing over the seventeenth and eighteenth centuries.[112] By merging cultural insights with an analysis of material culture, Garvan pressed historical studies in a new direction—one that would not be fully realized for another generation. Also in 1951, he became professor of American Civilization at the University of Pennsylvania, where he taught the university's first survey course on the subject.[113] The same year, he became editor of *American Quarterly*, the fledgling journal of the American Studies Association.[114] Through these positions, he was an important leader of the burgeoning American Studies movement. Although the first American Civilization degree programs appeared in the 1930s, it was not until the postwar era that the discipline gained a prominent place in the academy.[115] Combining literature, history, and political science, American Studies was a hybrid discipline dedicated to describing and analyzing American culture. The most visible arm of the American Studies movement was known as the "myth and symbol school"—some of the best-remembered products of which were Henry Nash Smith's *Virgin Land*, R. W. B. Lewis's *American Adam*, and Leo Marx's *Machine in the Garden*. These studies analyzed the formation and dissemina-

tion of "myths" in American culture and their significance to the history of the American people. Despite the popularity of "myth and symbol," however, American Studies was a discipline that throughout its history often had difficulty defining itself. Drawing inspiration from literary, historical, anthropological, and sociological methods, most of the discipline's proponents maintained that no single approach was sufficient to fully explain American culture.[116]

A small group of scholars argued for a close alliance between American Studies and anthropology. In a 1963 article in *American Quarterly*, Richard Sykes wrote that American Studies "is a branch of culture studies, and as such is closer to the social sciences theoretically than to the humanities. It is a specialized branch of cultural anthropology."[117] For Sykes, the effort to study culture in a scientific manner would move the field beyond what he labeled the impressionistic approach of scholars such as Henry Nash Smith.[118] Sykes proposed a method that involved observation, hypothesis, testing, and presentation of findings to a community of scholars. In this way, scholars could more precisely define American culture. His approach corresponded to a similar move within the discipline of anthropology toward the ethnography of modern society. "There has been an inclination to shift ethnographic studies from . . . non-literates and primitives," wrote the anthropologist Alfred Kroeber, "to linguistically or geographically defined communities within literate civilizations."[119] Sykes saw no distinction between American Studies and cultural anthropology—other than perhaps the latter's association with so-called primitive peoples. American Studies, like anthropology, was a science of culture.

Garvan was the most visible proponent of this approach. Although not nearly as influential as the "myth and symbol school," it was nonetheless significant because of its intentions of reorienting the study of "literate" peoples in an anthropological direction. Garvan applied this approach to a project called the Index of American Cultures, which he pursued under the auspices of the University of Pennsylvania and Winterthur beginning in 1953. Modeled on the Human Relations Area Files (HRAF)—the expanded successor to the Cross-Cultural Survey—the Index represented an attempt to catalogue specific cultural features of historic American cities: Boston 1675–1725, Philadelphia 1725–1775, New York 1776–1825, New Orleans 1825–1875, and Chicago 1875–1925.[120] To organize it, Garvan used *The Outline of Cultural Materials* developed for the HRAF, which included about seventy-five major categories defining specific attributes of cultural groups, such as "Travel and Transportation," "Political Behavior," and "Food Consumption."[121] This, then, was the first major project that came

out of his wartime experience with the Cross-Cultural Survey. "The file," Garvan wrote, "brings the historian measurably closer to development of a genuine laboratory and in fact as a new instrument holds promise of new types of research as yet only dimly realized."[122] In his estimation, the Index offered not only a useful reference source but a tool through which historians might entirely reinvent their field. Using the Index as a starting point, historians could produce new explanations for vexing social questions and frame historical problems within the context of broader "social laws."[123]

Hoping to prove its usefulness, Garvan employed the Index in an essay he authored titled "Proprietary Philadelphia as Artifact."[124] To comprehend a culture, Garvan argued, one must evaluate not only texts and actions but also material culture and other products of a society. In the essay, he recommended an anthropological perspective for urban historians and planners. Colonial Philadelphia, he maintained, could be evaluated in a manner similar to the way anthropologists analyzed "primitive" societies. Clearly drawing inspiration from structuralist anthropologists such as Claude Lévi-Strauss, Garvan maintained that: "Past historical cultures . . . must be examined in their own light as full and valid working systems." By examining its individual parts, scholars could begin to understand "the whole of the culture."[125] Turning to prescriptive pronouncements, he contended that if contemporary urban planners were to understand original city plans they needed to "explore each aspect of its remaining structure, understand as an anthropologist its cultural role and the whole culture of which it is a part, and only then with a full and mature philosophy endeavor to alter and improve it."[126] Despite Garvan's efforts, the Index never became a major source base for historians, anthropologists, or city planners. Only two of the five cities were completed as he struggled to secure funding to continue the project.[127] Nevertheless, the experience of developing it would provide a foundation for his next large-scale project: *Growth of the United States*.

After arriving at the Smithsonian in 1957, Garvan drew up a concept statement for the exhibit. In this statement, he offered two assumptions that undergirded the basic philosophy of the exhibition: the first was that "each object included in this museum has two levels of meaning—the one technological the other cultural," and, the second was that "material objects . . . produced in a given area at the same or nearly same time . . . [can be] . . . closely associated in a meaningful pattern."[128] Under Garvan's watch, *Growth of the United States* would strive to wring deeper levels of meaning from its objects. The question, however, was how to organize the vast array of material culture that would be on display. In an early progress report, he wrote, "I have worked principally on this problem of

organization"—chiefly, how to balance a sense of historical change with a portrait of a culture.[129] Arguing that a political chronology was impossible to implement, he instead chose a broader, less specific chronology. In his plan, within century-long periods, the arrangement of objects would be cultural rather than historical.[130] He explicitly rejected "individual chronologies of technology" along the lines of the displays of tools developed by Otis Mason in the nineteenth century.[131] Hoping to balance geographical and chronological frameworks, he thought the exhibit might be divided into culture areas within broad temporal periods. This approach, he maintained, had been "used constantly in the museum since its foundation both formally and unconsciously."[132] Ultimately, however, he chose a national rather than a regional scope, thus sacrificing any consistent depiction of distinct American culture areas.

Fellow curators added their opinions to the mix. In the summer of 1958, Garvan outlined four different ways of organizing the exhibition: "sampling," "chronological," "comparative," and "cultural," and Malcolm Watkins analyzed the merits and drawbacks of these approaches, comparing them to his own exhibits.[133] In clipped language, he wrote, "Broad chronology, yes, in terms of periods or epochs. Within them, 'many lines of human activity' shown side by side."[134] Watkins added that this organizational frame "presupposes the comparative approach." For him, focusing on culture in a comprehensive and comparative way was the best option for museum exhibits. "Environmental factors, beliefs, attitudes, social institutions, and artistic expressions are the proper and significant subject matters of G. of US exhibits," he wrote, "not chronological events."[135]

Eugene Kingman, director of the Joslyn Art Museum in Omaha, Nebraska, and a consultant to the Smithsonian, offered comments on Garvan's plan. He wrote that "the unifying thread of the hall is the growth of the Nation" and argued that each object should be selected "to demonstrate the character of our nation at important stages of its history."[136] To illustrate the growth of America, Kingman suggested a strategy similar to that employed in the *Hall of Everyday Life in the American Past*. "A few well chosen period settings," he wrote, would identify each major period in the exhibit and signal important changes in American society and culture. As this period room approach was already employed in the exhibit's sister hall, it was highly unlikely, however, that Garvan would choose it.

Garvan continued to wrestle with the problem of organization, but some time late in 1958 or early in 1959, he determined that the Human Relations Area Files outline might provide an excellent solution to this problem. Here was the overarching framework he had been searching for.

The categories from the *Outline of Cultural Materials,* which he had used in the Index of American Cultures, would again serve to anchor his organizational scheme. This plan did not go unchallenged, however. In February and March 1959, Ewers reacted to Garvan's proposal to use the HRAF as a framework. Ewers agreed that with some modification the cultural categories in the HRAF's *Outline* would be helpful in organizing the exhibition.[137] For Ewers, however, this solution did not solve all of the exhibit's organizational problems. Chronology still remained an issue. Although he wrote that he was "completely in accord with the adoption of the anthropological concept of presenting the historical materials in terms of aspects of culture in preference to the presentation of the historical materials in terms of historical narrative," Ewers did not favor entirely abandoning a narrative of historical change. "Murdock's outline," he wrote, "does not give us a great deal of assistance in subdividing the cultural history of the United States into periods."[138]

For Ewers, the problem was that "American cultural history was both more complex and more dynamic than the cultural history of an Indian tribe or group of related tribes." As an ethnohistorian, he understood the complexities of cultural change. "Basic changes in our culture," he maintained, "did not take place overnight, nor did changes in all aspects of culture take place simultaneously or at the same rate." Dividing American cultural history into century-long epochs, in Ewers's view, was misleading to visitors. If this was to be done, however, he proposed altering Garvan's chronological divisions to better reflect significant and definable eras in American history. Since his earliest proposals, Garvan had suggested simple chronological divisions—1640–1740, 1740–1840, 1840–1940, with an introductory section on discovery and a concluding section on recent history— that bore little relation to important turning points in American history. Ewers proposed replacing these divisions with three periods more aligned with historical events: colonial America through the Revolution, national expansion (1783–1865), and "the United States becomes a world power (1865–1940)." Like Garvan, he also suggested including an introductory section on the European discovery of the New World and a concluding section on the post-1940 period. For him, a compromise plan, which connected cultural changes to significant social and political events in American history, was the best solution to the dilemma of organization.[139]

Garvan had explicitly rejected a political chronology from the beginning, however; and, as a result, Ewers's plan did not prevail. Instead, Garvan decided to maintain a loose chronology, which emphasized cultural continuity and change. This approach privileged a structural-functional

perspective on culture rather than a historical narrative based on political events. At the turn of the new decade, then, the exhibit's organization was finally set. Within broad chronological boundaries, the exhibit would use HRAF's categories to organize *Growth of the United States'* displays. The selection of objects, writing of labels, and construction of display cases, however, would not be completed for another seven years. Complicating this task was Garvan's decision to leave full-time work at the Smithsonian. In 1960, he returned to the University of Pennsylvania and turned over the curatorship of the exhibit to Peter Welsh, who had been assisting him since 1959.[140]

Two years after leaving full-time work at the Smithsonian, Garvan published an article in *American Quarterly* titled "Historical Depth in Comparative Culture Study" that detailed the central problem he faced in organizing *Growth of the United States:* how to reconcile cultural and historical approaches.[141] As a historian, Garvan recognized the value of studying cultural change over time. On the other hand, as an admirer of anthropological ideas and methods, he understood that insights might also be gained from studying essentially static cultural systems in isolation. In the article, as in the exhibit, he did not find a completely satisfactory answer to the problem of representing historical change while at the same time defining a distinct cultural system. He discarded an evolutionary approach, but in its place substituted a framework that only vaguely associated culture and historical change. Ewers pointed to this flaw in the exhibit's organization, but, for Garvan, detailing specific features of American culture was more important than a strict adherence to historical narrative.

Under the new curator, Peter Welsh, the plans for *Growth of the United States* retained the framework that Garvan had established. Welsh was a student of material culture and a historian of American business, technology, and culture. The first Hagley Fellow at the University of Delaware, he had studied early American industries as a graduate student. Initially developed in 1954 as a joint venture with the Hagley Museum, the Delaware-Hagley Program allowed students to combine an interest in material culture with the study of the history of industrialization.[142] After obtaining a master's degree in the program, Welsh carried these interests into his work as associate curator in the Division of Civil History.[143] Deeply influenced by Garvan, Welsh did his best to fulfill Garvan's vision for *Growth of the United States*. In fact, Garvan was not completely disconnected from the project in this period. Serving as a consultant, he helped to write exhibit scripts while Welsh managed the details of exhibit construction.[144] As a result, by the mid-sixties, the exhibit finally neared completion.

The Growth of the United States, from Exhibits in the Museum of History and Technology
(Smithsonian Institution Press, 1968), 6–7.

In June 1967, after more than ten years of preparation, *The Growth of the United States* opened on the second floor of the Museum of History and Technology. In the press release announcing its debut, Smithsonian officials called it a "Museum within a Museum." "Each [hall] covers roughly one century of American development," the release read, "and illustrates the interrelationships of such areas as religion, government, transportation, agriculture and science." The exhibit was the flagship of the museum's historical, cultural, and technological displays. In its halls, visitors found hundreds of objects from the seventeenth through nineteenth centuries arranged by categories derived from the HRAF's *Outline of Cultural Materials*. Taken together, these objects made up a broad overview of Euro-American culture.[145] Although Garvan had originally planned five halls ranging from the age of discovery to the twentieth century, only two—1640–1750 and 1750–1851—made it to the final exhibit. The difficulty of organizing the exhibit and the expense of constructing it were likely the determining factors in this decision.

Many of the case titles came directly from HRAF's *Outline of Cultural Materials*. In the first hall (1640–1750), "Exact Knowledge," which displayed scientific instruments, took its title from category number 81 in the *Outline*. Other cases were almost exact matches, such as the second hall's "Diet, Drink, and Indulgence," which was clearly inspired by category number 27, "Drink, Drugs, and Indulgence."[146] "Water Transportation," "Communication," "Agriculture and Subsistence," "Tools," and "Clothing and Adornment" were just a few of the other titles adapted from the HRAF. Nearly all of the hall's fifty display cases, in fact, were inspired by categories in the *Outline*.

Amidst the cases were large-scale displays, including a house frame, a mill, a pioneer wagon, and a railroad engine. Immediately upon entering the exhibit, visitors would have encountered the first of these—a full-sized, reconstructed colonial house frame. Saved from demolition in Ipswich, Massachusetts, the house actually incorporated two different structures— a seventeenth-century ell and an eighteenth-century Greek Revival main house. For display, the exhibit's curators removed its exterior to reveal the underlying framework.[147] In this way, they were able to illuminate specific categories from the HRAF: "Building and Construction," "Structures,"

"Diet, Drink, & Indulgence" case from *Growth of the United States*, 1967. *Growth of the United States* photo binders in the Division of Domestic Life, National Museum of American History.

"Tools and Appliances," and "Equipment and Maintenance of Buildings."[148] Alongside the house frame was another large-scale display that reinforced the centrality of building to American culture: three life-sized models of sawyers splitting beams like those in the house. Just past the sawyers, visitors saw a grist mill built by Isaac Thomas in Chester County, Pennsylvania, in the eighteenth century, which included a functioning water wheel powered by a stream stocked with live Muscovy ducks.[149] Here again, the exhibit offered visitors an object that could be neatly fitted into categories from the HRAF, such as "Food Processing," "Exploitative Activities," and "Processing of Basic Materials."

All around the perimeter of the hall were cases with objects arranged by their HRAF category. In "Communication," for example, visitors saw printed and handwritten documents as evidence of the varieties of modes of communication in American culture and their importance to the functioning of society.[150] In "Medical Science," they found a "bleeding bowl," containers used to store drugs, and medical texts. In "Money and Wealth," they saw account books, paper currency, gems, and shipping logs. In "Religion," visitors encountered a church pew, icons, and bibles, and in "Law and Government," they saw colonial charters, legislative acts, and images of flags. Astute visitors would have found this categorization impossible to ignore. Indeed, it would have provided a frame for them to arrange not only the objects in *Growth of the United States,* but all of the objects on display in the Museum of History and Technology. Perhaps the most attentive would have even carried this way of seeing outside the museum walls to their daily lives. They would, if Garvan succeeded, begin to see American life anthropologically. What the exhibit's organizing framework would have done more than anything else was to enable cross-cultural comparisons. Once visitors were able to compartmentalize the dizzying array of objects in the institution's collections, they could begin to make explicit comparisons between the features—medical practices, religions, governmental structures, tools—of various cultures. Like the HRAF and the Index of American Cultures, then, the exhibit had the ultimate goal of facilitating comparative cultural analysis.

Growth of the United States encouraged this way of seeing by repeating case titles in its two halls. "Agriculture and Subsistence" from the first hall, for example, found its partner in the second hall's "Agriculture," and "Communication" in the first had its exact counterpart in the second. "Exact Knowledge" partnered with "Instruments of Precision" and "Medical Science" with "Medicine and Health." Because of this symmetry, visitors would have been able to make comparisons between old and new. The

second hall (1740–1851) showed a society that was expanding, becoming more refined, and developing scientifically and technologically. In a case on "Education," for example, the label noted: "The base of primary education continued to broaden and the purpose of advanced education continued to widen."[151] This progress was dramatically illustrated by the "John Bull" locomotive and pioneer wagon displays. Here, technological innovation and westward expansion found concrete expression in material culture. Although English-made, the "John Bull," which was one of the earliest steam-powered locomotives, represented the transformation of the American economy and transportation that occurred in the nineteenth century.[152] Meanwhile, the wagon illuminated another significant transformation in American life—the migration of settlers into the western territories. Reinforcing this narrative of progress was the exhibit's culminating display of the Great Exhibition of 1851 held at Crystal Palace in England. Here the exhibit looked ahead to the industrial revolution, implicitly pointing the way for visitors to History and Technology's scientific and technological exhibits.

Overall, however, the exhibit's cultural organization did not really lend itself to simplistic narratives. More often, it revealed the complexities of cultural transformation, as in "Instruments of Precision," which read, "In the determination of weights and measures, individuals' experience was often a substitute for accuracy and exactness. Not until 1840 did Americans approach European standards of precision." Or, this one from "Diet, Drink, and Indulgence": "The American diet improved in variety and quantity, although the preparation of food remained basically unchanged before 1840." Continuity and change existed side by side in the exhibit's displays, complicating visitors' sense of the steady linear evolution of American culture. Although some displays charted clear progress, others were more measured in their assessment. What *Growth of the United States* did best, then, was not to narrate the upward movement of American history so much as to provide an interesting framework by which individuals might evaluate specific aspects of American culture and thereby come to a more detailed and realistic assessment of how the United States developed. By analyzing the parts, people would be better able to comprehend the whole.

Growth of the United States was an ambitious exhibit that experimented with new ways of displaying American culture. It proved that the methods of anthropology, long the purview of scholars interested in indigenous cultures, could be adapted to another cultural group—Euro-Americans. The exhibit's methodological ecumenicalism did not, however, translate into diverse content. Native Americans, African Americans, and other non-whites

found themselves largely excised. Where they did appear, the exhibit clearly marked them as different by placing them outside its main framework. One display in each hall focused on the cultures of non-whites—specifically, Native Americans and African Americans. However, neither of these took its title from HRAF. Thus, even as it encouraged cross-cultural ways of seeing, the exhibit projected the idea that Euro-American culture was distinct from and superior to non-white cultures.

In the first hall, "The Indian and the Negro" focused on the degree to which American Indians and blacks embraced Christianity in the seventeenth and eighteenth centuries.[153] It contained very few objects, which was at least explicable in the case of African American culture because the institution lacked any significant collections of artifacts documenting black cultural life, but not for Native Americans, as the Smithsonian was one of the world's premiere collectors of Native cultural materials.[154] The separation of the Division of Cultural History from the Division of Ethnology was the key impediment here, as it made the sharing of cross-cultural objects more difficult. Placing both Native Americans and African Americans in the same, unimpressive case seemed to mark them as an afterthought, things to be ignored or only glanced at briefly.

The second hall had a more eye-catching display of non-white culture: paintings from George Catlin's Indian gallery. The gallery had been displayed in several places throughout the institution since coming to the Smithsonian in 1879, most recently in a temporary exhibition in the National Collection of Fine Arts at the Natural History Building in 1965.[155] Its title in *Growth of the United States*—"Natural Man"—signaled to visitors that Native peoples stood apart from the civilized, Euro-American culture exhibited in the rest of the hall. Indeed, by labeling Native Americans "natural," the exhibit encouraged visitors to view them as being without culture. It echoed Otis Mason's distinction between "natural man" and "renewed man" in the evolutionary typologies of the nineteenth century. The location of Native American exhibits in the Natural History Museum would have reinforced this perception. Ironically, an exhibit that used the HRAF framework, which had begun as an organizing scheme for ethnographic data about indigenous cultures, deliberately excluded Native peoples from its purview.

The exhibit's lack of diversity proved to be its undoing. By the late sixties, American society and culture had begun to move toward a recognition of the remarkable pluralism of the United States. As a result, an exhibit devoted almost exclusively to a singular Euro-American culture was increasingly unacceptable to a broad audience. Under the influence of a new

secretary, S. Dillon Ripley, the Smithsonian began to transform its exhibits in a way that acknowledged cultural diversity, and by the late sixties, the institution's officials were already developing an exhibit to replace *Growth of the United States*. This exhibit, which was titled *A Nation of Nations*, took pluralism as its central conceit. Debuting in 1976, the Bicentennial year, *A Nation of Nations* signaled the Smithsonian's willingness to incorporate representations of cultural diversity into its museums.

The opening of the Museum of History and Technology represented a watershed moment in defining the spatial and racial dynamics of the institution. For many years, the drift of the Smithsonian's leadership had been toward more clearly racially segregated exhibition spaces. It was not until the debut of the Museum of History and Technology, however, that such a separation was almost completely realized. Ironically, it occurred just at the moment when many Americans, both black and white, embraced an integrationist ethos through major legislation such as the Civil Rights Act of 1964 and broad acceptance of the aims of civil rights leaders such as Martin Luther King Jr. In this respect, the Smithsonian seemed to be moving backward as the rest of American society made great strides forward. In subsequent years, the Smithsonian's physical geography would prove to be a major problem for curators as they strove to create more culturally diverse exhibits and ultimately to decolonize the institution. By constructing a shrine to Euro-American history and culture and technological achievement, Smithsonian officials ensured that subsequent efforts to add space for cultural exhibitions would be more likely to emphasize the particular than the universal.

3

Open Education
The Festival of American Folklife and the Transformation of Space at the Smithsonian

In the early 1920s, when Smithsonian Secretary S. Dillon Ripley was a young boy he lived with his mother in Paris. Years later he recalled fondly his experiences wandering the Tuileries Gardens, freely encountering all manner of youthful wonders. Ripley remembered watching Punch and Judy shows, building sand castles, and then slipping into the galleries of the Louvre where he discovered mesmerizingly intricate ship models. Evoking Proust's madeline, he even recalled "looking for the old woman who sold *gaufres,* those wonderful hot wafer-thin, wafflelike creations dusted over with powdered sugar." Perhaps his favorite activity, however, was riding the carousel "hoping against hope to catch the ring."[1] The memory of these revels, although almost certainly sprinkled with a heavy dose of nostalgia, nonetheless had a profound effect on his vision for the Smithsonian as he took the helm of the institution in 1964.

Replacing the retiring Leonard Carmichael, Ripley, an ornithologist and director of Yale's Peabody Museum of Natural History, brought transformative ideas about museum exhibition and education to the institution while at the same time dramatically expanding the number of Smithsonian museums, programs, and other initiatives. One of Ripley's main priorities was to enliven the National Mall—in a sense to make it more like the Tuileries. In this vein, he installed a carousel, held events such as kite flying and concerts, and organized festivals.[2] The purpose behind this reimagining of the Mall space was more than simply aesthetic or nostalgic. At the core of Ripley's philosophy was the concept of "open education"—the idea that museums should not attempt to instruct visitors formally in the style of a classroom teacher but should encourage independent exploration.[3] His childhood experiences in the museums and gardens of Paris had

shown him that museum visitors—especially children—should be able to direct their own experiences through exploration and freedom of move-ment both inside and outside museum spaces. The carousel, Punch and Judy shows, *gaufres,* and paintings and ship models in the Louvre were pieces of a larger whole within which one might find all manner of educa-tion, entertainment, and inspiration. The undirected nature of this type of informal learning held, for Ripley, the key to making the Smithsonian a more educational space. Open education—or what today we might call free-choice learning—was, he believed, more effective in a museum set-ting than direct instruction. This attitude echoed the opinions of progres-sive educators who sought to explode the rigid and pedantic strictures of American education in this period.

Born in 1913 into a well-to-do Connecticut family, Dillon Ripley was by all accounts a rather patrician figure. Graduating from Yale with a degree in history, he had considered attending law school. Instead he followed his heart, pursuing a Ph.D. in zoology at Harvard. As a professor in the biology department at Yale, he developed a specialty in ornithology and in 1960 became director of the university's Peabody Museum of Natural History. To the superficial observer, he may have seemed an unlikely champion of open education. The product of an elite schooling, he was nonetheless committed to educational opportunities for all. In this sense, he was very much a Great Society liberal, seeing tremendous opportunities for the United States government to improve standards of living not only within this country but abroad as well. After coming to Washington, he argued strongly for the power of large institutions such as the Smithsonian to have a positive influence on people's lives. Through its cultural, scientific, historical, and artistic work, the Smithsonian, he believed, could play a central role in the making of the Great Society.

President Johnson, the architect of the Great Society, made this connec-tion explicit when he spoke on the occasion of the bicentennial celebration of James Smithson's birth in 1965. "The institution financed by Smithson," Johnson said, "breathed life into the idea that the growth and spread of learning must be the first work of a nation that seeks to be free." Praising the work of the Smithsonian, Johnson argued passionately for the impor-tance of ideas and education in transforming the world for the better. He saw the Smithsonian as providing a model of how to extend the benefits of knowledge and education to all peoples. With the optimism of a liberal Democrat in the years before the crises of the late sixties, he intoned, "The knowledge of our citizens is the one treasure which grows only when it is shared."[4]

Perhaps fueled by Johnson and other optimistic liberals, a lively discourse concerning museums and education took hold within the field in the 1960s. In this period, museum staffers engaged in many practical and theoretical discussions about how best to design exhibits and programs so that they both educated and entertained the public.[5] These discussions were part of a broader movement toward professionalization. The 1960s saw the founding of the first museum studies programs, increased attention to professional development for current staff members, and renewed dialogue across the field about key issues. It was also in this period that a museum accreditation system was developed, ensuring certain uniform standards of quality. In 1967, Johnson asked the Federal Council on Arts and Humanities to prepare a study of the country's museums. The resulting report, "The Condition and Needs of America's Museums," or Belmont Report, argued that museums were in need of greater federal support as the public's demands on them increased. To provide assistance for needed improvements, both the American Association of Museums and the Smithsonian advocated for the National Museum Act, which Congress passed in 1966 and funded in 1972, to assist museums in addressing management, exhibition, education, and conservation issues.[6]

In a 1964 speech at the Freer Gallery, Ripley urged museums to analyze their educational processes: "I believe that we should . . . conduct research on the problem of interesting everybody in something." Museums, Ripley maintained, were ideally suited not to the systematic instruction of classrooms but to the sparking of people's fascination with the world around them and "making people aware of themselves." To be effective in this, museums needed to learn more about how exhibits communicated information and the ways in which people learned. "The casual turning to the left instead of to the right when one enters a museum or faces an exhibit, the seeing and hearing of something with eyes that see and ears that hear. This is the simplest, most direct area," Ripley maintained, "in which a spark may be struck . . . which may make later education possible and meaningful." In his view, museums were an indispensable component in the modern educational system, and, by exploiting their potential, American society might further democratize education. "We feel that museum research on contact and communication with all our people," Ripley argued, "is a strategic imperative in the formation of the great society." Invoking President Johnson's initiatives, Ripley made a pitch for museums' place in transforming American society through education.[7]

The following year he expanded these arguments, and other museum leaders joined the chorus. In a 1965 address to the International Council

of Museums (ICOM), Ripley exhorted, "Museums to my mind are the principal unrecognized arm of education." "Museums must establish themselves," he maintained, "as essential and top-rank educational institutions equal to or supplementary (but still essential) to all levels of educational activities from preschool to post-doctoral."[8] The challenge Ripley and his fellow museum directors faced, however, was how to approach museum education. Unlike schools, museums did not have formalized pedagogical standards. The informal education that occurred in their exhibit halls had not been studied or evaluated, and volunteer docents rather than professional educators bore the bulk of responsibility for face-to-face teaching duties.[9]

As a result, theories and recommendations surfaced in this period that addressed the educational processes of museums and how to assess them. In a fascinating exchange from 1967, the philosopher of media Marshall McLuhan and the cultural historian Jacques Barzun weighed in on museums and education. Coming at this issue from diametrically opposed perspectives, McLuhan and Barzun mirrored broader cultural debates over pedagogy. On one side were the heirs to the progressive education model of the early twentieth century, who valued children's capacity for self-education through independent exploration, while on the other were those traditionalists who favored direct instruction and adherence to the canon. The initiative for this debate came when McLuhan was invited to speak at a conference at the Museum of the City of New York. He urged museum professionals to conceive of ways to empower visitors and to encourage them to move beyond passivity. "In order to create involvement," he contended, "you have to take out story line. . . . The reader becomes co-producer, co-creator." For McLuhan, museums had the potential to facilitate a new way of learning. Challenging the curators and museum directors in attendance, he asked, "How can we arrange a museum or an art gallery so it gives people that sensation of power, of tremendous new discovery, of insight and perception? I think it is possible."[10] In an essay in *Museum News,* the publication of the American Association of Museums, Barzun responded to this idea with skepticism. He believed that overwhelming people with an array of objects and information and then suggesting that they sort it out for themselves was a recipe not for empowerment but for apathy and confusion. With this model, he argued, "Public education stalls and social fabric disintegrates to an accompaniment of the spiritual malaise that is bound to come with isolation in the midst of Babel." He acknowledged, however, that no ideal educational alternative existed in modern society, cautioning that oversimplification was also dangerous.[11] The challenge of

museum education as framed by Barzun was to balance straightforward instruction with more complex modes of learning.

Ripley's concept of "open education" was designed to meet this challenge. It acknowledged that museums bore a large responsibility for instructing citizens in a democratic society but left ample room for visitor freedom and empowerment. Beginning in the sixties and accelerating in the seventies, Ripley and other museum leaders embraced the challenge of developing educational approaches that fulfilled the needs of a new generation of museumgoers.

Open education was a concept ideally suited to the baby boom generation. As television blossomed and mass consumption exploded, a new generation of students brought the consumer's ethos of free choice into the realm of education as well as new ways of thinking that were less text-based than visual and experiential. Perhaps influenced by McLuhan, Ripley acknowledged this shift, writing, "I have a conviction that young people today are more capable of learning in relatively unstructured situations."[12] In this social and cultural environment, museums became extremely popular venues for education and entertainment. Although they were not nearly as influential as the new medium of television, museum visitation rose swiftly in this period as parents sought educational outlets for their burgeoning broods of children. As this occurred, museum leaders realized they needed to compete with other forms of entertainment in order to remain popular destinations. Writing in *Museum News* in 1964, Henry D. Brown warned, "Potential visitors to an historical museum are drawn from the general public; therefore, museum personnel must recognize that visitors are under no obligation or requirement to render studious attention to museum exhibits, nor even to enter your building. Consequently, it is expedient to intrigue before you instruct!"[13] An early salvo in the museums-as-education versus museums-as-entertainment debate, Brown's article argued that museums should not attempt to compete directly with amusement parks for entertainment value; at the same time, he reminded curators, "Exhibits do not have to be sterile to be accurate." "The intriguing exhibit," he wrote, "is one which offers the visitor information without affront, in such a manner as to capture his interest and continue his attention."[14] The Smithsonian, through its exhibits modernization program, had been pursuing exhibitions of this sort for a decade by the time Ripley joined the institution. Ripley's ideas, however, went beyond the reconceptualization of exhibits that occurred during an earlier period. He was not content to see the institution simply improve its existing displays. Instead, he envisioned a revolution in museums and education.

Ripley was, of course, not alone in rethinking education in this period. University of California president Clark Kerr famously outlined the coming changes in American higher education in his Godkin lectures at Harvard in 1963. Kerr predicted a higher education system that would increasingly support the growing "knowledge industry." The production of knowledge, he accurately foresaw, would become the single most important activity of the American economy. Describing a synergistic relationship among industry, the state, and universities, Kerr argued that higher education had entered a new era in which the university, or "multiversity," would play a central role in economic development.[15] Although an acknowledged innovator in the educational field, Kerr suffered withering attacks for his ideas from an increasingly radical student movement that accused him of involving universities too deeply in the military-industrial complex. In contrast, Ripley's vision for the Smithsonian relied on a much looser connection between education and the growth of industry. "So many universities today," he wrote, "are agonizing through the welter of indecision created by the conscious craving of those young who wish to be educated, contrasted with the others who seek only training and the transfer of information and the acquisition of skills." The Smithsonian, Ripley maintained, offered an approach to education that appealed to the former type of student. "Open education," he argued, "is akin to the maxims of those sensible people who have always known that the only education is self-education achieved through discipline and motivation."[16]

Open education not only entailed an embrace of self-education; it was also a way of thinking of the totality of the Smithsonian's spaces as working in harmony with one another. Proselytizing for open education led Ripley to think about ways of reinventing space at the Smithsonian. He understood implicitly that space shaped and defined the experiences of visitors to the institution and that some of his most important decisions as secretary would concern the allocation of space for specific purposes.

At the most basic level, Ripley was an expansionist. By growing the number of museums at the Smithsonian, he dramatically increased the range of subjects the institution could explore. During his tenure, the Smithsonian added seven museums—the Anacostia Neighborhood Museum (1967), the Cooper-Hewitt National Museum of Design (1968), the National Portrait Gallery (1968), the Renwick Gallery (1972), the Hirshhorn (1974), the National Air and Space Museum (1976), and the Museum of African Art (1979)—and initiated an annual folklife festival. Ripley's tenure also witnessed the birth of *Smithsonian* magazine, which extended the reach of the Smithsonian far beyond the physical space of the institution's museums.

In addition, Ripley pressed hard—but, ultimately, unsuccessfully—for the addition of a Museum of Man, a subject to be explored in chapter 6. Beyond simply adding space, Ripley urged a fundamental reconceptualization of the ways in which Smithsonian curators and administrators organized and utilized spaces. To help facilitate this process, he restructured the Smithsonian's bureaucracy, creating large bureaus of Science, History and Art, Public Service, and Museum Programs that were overseen by assistant secretaries. Each of these bureaus contained a host of museums and offices. Science, for example, included the National Museum of Natural History, the National Zoological Park, and the Smithsonian Astrophysical Observatory, among others; while, History and Art included the Freer Gallery, the National Collection of Fine Arts, and the National Museum of History and Technology.[17] Although still an imperfect structure—placing Natural History in Science, for example, meant that the anthropologists were not in the History and Art category—it nonetheless encouraged broader, institution-wide communication. These communications were often facilitated by the assistant secretaries on whom Ripley relied for fresh ideas for the institution. By adding space, rethinking the Smithsonian's organizational and administrative structure, and promulgating a philosophy of education that encouraged movement and interaction, Ripley transformed the institution into the sprawling and multi-textured complex that exists today.

In Ripley's vision, what occurred outside of and between museums was just as vital as what occurred inside the buildings. Thus, the National Mall became a crucially significant space. Hearkening back to his experiences in the Tuileries, Ripley imagined his ideal visitor passing effortlessly from one building to the next, stopping along the way to have some refreshment, play a game, or hear a concert. The daunting ceremonial space of the Mall presented significant challenges to this vision. Unlike the Tuileries, it was a wide-open, rigidly ordered space that lacked the charm (and the shade) of European royal gardens. Ripley was determined, however, to make it work.

One of Ripley's first acts as secretary was to install a carousel on the Mall, an act that invited controversy but also signaled the importance of the spaces outside the museums. A more far-reaching effort in this regard came when Ripley decided to support an idea for a Festival of American Folklife, an annual event that would bring practitioners of traditional cultures to the National Mall each summer to present their skills and talk about their lives. When the festival debuted in 1967 it was like no exhibition the Smithsonian had ever created. It demonstrated clearly how a creative rethinking of education and space could lead to a wholly new

S. Dillon Ripley at the 1974 Festival of American Folklife. Smithsonian Institution Archives, neg. #74-6461-9.

approach to displaying culture. If the monumental barriers between museums on the Mall had limited the efforts of the previous generation of curators to decrease segregation, perhaps the solution was to step outside the museums. There, in the open air of the Mall, new combinations could be made and unmade and new possibilities explored without the strictures of museum buildings. By creating a temporary outdoor exhibition, Ripley and the festival's organizers were able to challenge the lines that had developed in the Smithsonian's physical geography.

Ripley's innovative museological ideas set the stage for the festival concept to emerge. The actual idea, however, was not his. In late 1966, Ripley, on the recommendation of James R. Morris, director of the Smithsonian's Division of Performing Arts, consulted the collector, musician, and connoisseur of traditional crafts Ralph C. Rinzler about the possibility of creating an ethnic band concert series at the Smithsonian. This series would expand on a program begun at the institution that year by Morris called "Music Making American Style."[18] Refining this idea, Rinzler and Morris recommended that the institution develop a festival instead, which would feature artists, musicians, dancers, and craftspeople from diverse backgrounds.[19] It would not be the first such folk festival held in Washington, D.C.—that distinction goes to the National Folk Festival, which was held in the city from 1938 to 1941 before moving elsewhere. It would nonetheless be a

pioneering exhibition that would have an influence not only in Washington but nationally for decades to come.

To oversee the festival, Ripley hired Rinzler to work in cooperation with Morris. The festival combined Ripley's interest in developing new, more open exhibition types with Rinzler's desire to craft a festival that

Ralph C. Rinzler, S. Dillon Ripley, and James R. Morris at the 1974 Festival of American Folklife. Smithsonian Institution Archives, neg. #74-6447-23.

improved on the folk festival model famously pioneered at Newport. In
Rinzler, Ripley found a dynamic leader who understood how to identify
and present traditional cultural practitioners in a way that was appealing
and accessible for Smithsonian visitors. He was also someone Ripley could
relate to on a personal level, and the good relationship the two men de-
veloped over the years was an important factor in the long-term success
of the festival.

In the sixties, the most famous folk festival in the United States was the
Newport Folk Festival in Newport, Rhode Island. Remembered today as,
among other things, the site of Bob Dylan's controversial switch from
acoustic to electric guitar–based music in 1965, the festival was a major
venue for folk music performers in the late fifties and sixties. Along with
Greenwich Village in New York City, Newport was synonymous with
the folk revival of this period. Performers from Pete Seeger to Joan Baez
entertained thousands of fans each year at the popular gathering.[20] Ralph
Rinzler developed his skills as a folklorist on the staff of the Newport festi-
val. His conceptualization of the Smithsonian festival was a direct reaction
to Newport's flaws and, more generally, to the limits of the folk revival.
Rinzler aspired to a richer engagement with traditional culture than the
revival provided. As both an intellectual and an activist, he sought to un-
derstand, preserve, and popularize America's folk cultural heritage.

Although Rinzler ultimately became discontented with the folk revival,
his participation in it was, nevertheless, crucial to his intellectual develop-
ment. The revival began in the mid fifties among young men and women
in places such as Greenwich Village and Harvard Square, and on college
campuses. It saw amateur and professional musicians who had not inher-
ited any traditional culture learning and performing folk songs originally
recorded in places such as the Appalachian highlands in the early twen-
tieth century. The revival built on the popularity of folk music that had
developed among the radical left in the 1930s and '40s.[21] The main engines
behind it, however, were the thousands of young people who embraced
folk music in the postwar period. Young people joined in the folk revival
on various levels. Most limited their participation to buying popular com-
mercial records of folk tunes made by performers such as the Kingston Trio,
Harry Belafonte, and later Bob Dylan and Joan Baez; others attended folk
festivals and participated in jam sessions and "hootenannies."[22] A relatively
small group, however, craved a deeper exposure to "authentic" traditions.[23]
Ralph Rinzler was a revivalist of this sort. He not only trained himself to be
a professional performer but also became a promoter of traditional music
and a collector of folk songs and crafts.[24] Inspired by radical song collectors

of the preceding generation, Rinzler evidenced an activist spirit that sought to preserve traditional cultures.

From the early fifties to the late sixties, Rinzler evolved from a young folk enthusiast into an important, if somewhat unconventional, folk scholar. As a boy in Passaic, New Jersey, Rinzler listened to Library of Congress recordings of American folk music and talked with his uncle, who had studied with George Lyman Kittredge, the Harvard folklorist. It was not until he went to college in 1952, however, that he became completely immersed in folk music. As a student at Swarthmore in the mid fifties, Rinzler began performing folk songs and worked as an organizer of the campus's annual folk festival. During this period, he made a number of important contacts in the world of folk music performance and scholarship, developing close friendships with fellow student Roger Abrahams, who would later become a well-known academic folklorist, and Mike and Peggy Seeger, the half siblings of famous singer and banjo player Pete Seeger. Both Mike and Peggy Seeger were actively involved in collecting and performing folk music in this period. Through them, Rinzler met their father, the musicologist Charles Seeger, who was the first to expose him to folk music scholarship. Reading Seeger's article, "Folk Music in the Schools of a Highly Industrialized Society," provided a spark that suggested he might be able to have a career studying and analyzing folk culture. Rinzler chose not to pursue graduate education in this field, however. After graduation from Swarthmore, he went to France to study French literature, though rather than concentrating on his studies, he spent most of his time in England recording and playing folk music. While he was there, A. L. Lloyd and Ewan MacColl, radical British folk song collectors, mentored him, and he met the famous American folklorist Alan Lomax for the first time. It was also in this period that he made his first field recordings of traditional musicians—Irish workers who frequented the pubs of London's Camden Town.[25]

When Rinzler returned to the United States, he joined a trio of young folk revivalists, The Greenbriar Boys, with whom he sang and played mandolin. In 1960, while on tour with The Greenbriar Boys at the Union Grove Old Time Fiddlers' Convention in North Carolina, Rinzler met a traditional Appalachian banjo picker and singer, Clarence (a.k.a. Tom) Ashley, whose name he recognized from a recorded collection of old-time music—Harry Smith's *Anthology of American Folk Music*.[26] This chance encounter was a turning point in Rinzler's career. In the fall of 1960, he traveled with record collector Eugene Earle to Appalachia to record Ashley and other local musicians, one of whom was Doc Watson, a blind guitarist, banjo player, and singer. These and other sessions with Ashley, Watson,

and their family members and friends, which were issued on the *Folkways* record label, convinced Rinzler that he preferred collecting, documenting, and championing traditional culture to performing a revivalist version of it.[27] After leaving The Greenbriar Boys, Rinzler devoted himself full-time to collecting and promoting folk culture. Though no longer a performer in the revival, he continued to use his connections to promote his finds. In this period, Rinzler served as manager for Ashley, Watson, and Bill Monroe, the creator of bluegrass music, and he organized concerts with these and other traditional performers under the auspices of a group called Friends of Old Time Music.[28]

In 1964, the Newport Folk Foundation, which organized the Newport Folk Festival, created a field research program and invited Rinzler to be the director. In his position at Newport, Rinzler performed extensive field-work throughout the United States and Canada documenting and collecting traditional music and crafts.[29] Some of his key "discoveries" were the now-legendary Cajun performer Dewey Balfa and African American Sacred Harp Singers from northern Alabama.[30] In the program for the 1965 festival, Rinzler outlined his main goals as a "culture broker."[31] "Through these festivals," he wrote, "we hope to broaden the horizons of the folk-song enthusiast and at the same time channel some of the financial gains of the industry into neglected areas."[32] Rinzler hoped to expose his fellow revivalists to a wide range of traditional performers and, at the same time, provide an economic basis for the persistence of specific traditions. In this way, he was continuing the work of his mentor at Newport, Alan Lomax.[33] From the 1930s until his death in 2002, Alan Lomax was America's best-known song collector and popularizer of traditional music. Along with his father John, Alan Lomax began his career collecting folk music for the Archive of American Folk-Song at the Library of Congress. In songbooks and recordings, the Lomaxes introduced Americans to a broad range of musical styles and songs that formed an important part of the country's rich cultural heritage.[34] Rinzler drew inspiration from Lomax's commitment to traditional culture and embraced the philosophy that Lomax detailed in his 1972 article "Appeal for Cultural Equity." "How can we maintain the varied musical styles," Lomax asked, "which help to make this planet an agreeable place to live?" Lamenting the homogeneity of mass-produced, commercial music, he called on scholars, cultural producers, and governments to advocate policies that enabled traditional music to be revived and to flourish. "If the human race is to have a rich and varied musical future," he wrote, "we must encourage the development of as many local musics as possible." The way to accomplish this, he maintained, was to provide

funding, enable exposure in mass media, and develop educational curricula that featured diverse cultures. Through this three-pronged approach, communities could succeed in "providing a clear existential rationale for . . . the local and regional musical traditions of the world" and could reduce the "threat" that modernization posed to "the human imagination and to the human variety." The alternative, according to Lomax, was "oppressive dullness" and "psychic distress" caused by "centralized music industries."[35]

Read critically, this article illuminates the irony of cultural interventionism. According to Lomax, scholars and policymakers should actively protect specific traditional cultural forms. By "protecting" them, however, they inevitably altered the traditions they hoped to preserve. Indeed, in many cases, they ended up constructing, or inventing, traditions that had not previously existed, or had existed in very different forms. Moreover, in some cases, "culture workers" manipulated traditional cultures in order to achieve specific ends connected to social reformist goals, often with negative results. In Appalachia in the early twentieth century, for example, elite social reformers enlisted the folk culture of the region in larger projects to transform the social and cultural life of its people.[36] In Lomax's activist model, these transformations were perhaps the acceptable costs of maintaining cultural diversity in the face of pressing homogenization. Such interventionist approaches, however, often had unintended consequences. Lomax's work with Leadbelly, for example, though succeeding in popularizing African American music, consciously manipulated the image of the performer. As a result, Huddie Ledbetter, who was remarkably skilled at a range of musical styles, found himself viewed in the popular consciousness as an unsophisticated folk musician rather than the cosmopolitan performer he truly was.[37]

While working for Newport, Rinzler applied Lomax's approach not only to music but to crafts. This led him to open "Country Roads," a traditional crafts store in Harvard Square in Cambridge, Massachusetts.[38] He founded the shop along with Nancy Sweezy, a revivalist potter and art teacher, and Norman Kennedy, a singer, weaver, and storyteller from Scotland who had performed at Newport. Here, as in his work managing and promoting traditional musicians, Rinzler recognized the importance of connecting cultural practitioners with markets for their products. Offering an array of items, from baskets to pots and quilts collected in rural areas throughout the North and Southeast, "Country Roads" was a non-profit venture that was more culturally than economically motivated.

Rinzler's interest in crafts also inspired him to pursue in-depth studies of traditional cultures, and he began seeking out other scholars who were

working in a similar vein.[39] In February 1966, Rinzler visited two outdoor historical museums—The Farmers' Museum in Cooperstown, New York, and Old Sturbridge Village in Central Massachusetts. At these sites, he met with experts in American folk culture, including Louis C. Jones and Bruce Buckley, and gathered ideas about presenting crafts at Newport.[40] Jones, Buckley, and others were pioneers in the folklife studies movement, which was distinct from the folk revival. Inspired by European scholars of traditional rural culture, a small group of folklorists and historians in Pennsylvania and upstate New York had begun pursuing folklife studies in the 1940s.[41] According to the University of Pennsylvania professor Don Yoder, an expert on Pennsylvania Dutch culture and one of the discipline's early practitioners, folklife studies in this period represented "the application of the techniques of cultural anthropology—used so successfully with primitive cultures—to the folk levels of the literate cultures of Northern Europe, the British Isles, and . . . the United States."[42] Different from the discipline of folklore, which was largely limited to verbal folk expressions (songs and tales), folklife studies sought to encompass the totality of folk culture—crafts, architecture, cooking, medicine, clothing, work, as well as songs and tales. This new academic discipline offered a complement to the revival, which in its enthusiasm for uncovering and popularizing folk sources often neglected the richness and complexity of traditional cultures. It also promised a more holistic view of traditions that was not limited to folk music. Moreover, it suggested that anthropological ideas and methods might be applied to the study of non-Native, or Euro-American, traditions. This perspective appealed to Rinzler and influenced his conceptualization of the Festival of American Folklife. It also offered a term, which allowed the Smithsonian Festival of American *Folklife* to distinguish itself from the Newport *Folk* Festival.[43]

A month after his visits to Cooperstown and Sturbridge, Rinzler floated an idea to Lomax for a "folk life museum" in Cape Breton, an important site of North American "Celtic" traditions and a place where Rinzler had performed extensive fieldwork. Rinzler credited Lomax with motivating him in this direction. "Hearing your story about the folk life museum in Hungary to which the older members of a community took the youngsters on Sunday to point out the history of their people with pride," he wrote, "fired me with a new store of energy." Undoubtedly his own experiences the previous month had also shaped this idea. Filled with inspiration, Rinzler proposed ways to spur a "revival of interest" in traditional culture in Cape Breton. One idea was for "the restoration of [a] farm house as a folk life museum." Another idea emphasized the "revival of old crafts as a

means of supplementing meagre [sic] incomes." Alongside these projects, Rinzler envisioned "a huge collecting process . . . so that the genealogy of each singer, craftsman, story teller . . . can be [assembled as part of a] complete picture of [the] community." "Songs, implements, tales, clothing, superstitions and customs" were all within the purview of Rinzler's proposed project. Significantly, he saw an important role for the community in shaping the process: "I would like to get a feeling for which aspects of the project would appeal most strongly to the people themselves rather than over direct them."[44] Rather than dictating a program of cultural revival, Rinzler hoped to be a facilitator. By providing access to resources and intellectual support, he would tap local interest in traditional culture and spur a grassroots movement.[45]

Thus, by mid 1966, Rinzler had already conceived of new ways to present traditions to the public. Tired of the commercialism of Newport and its folk-pop performers, he felt that his work, particularly in the area of traditional crafts, was not being appreciated by its audiences.[46] When the Smithsonian called, he eagerly embraced the opportunity to create a festival that, different from Newport, would present crafts and other traditions alongside musical performances and would place primary emphasis on presenting cultural practitioners in context.[47]

The 1967 festival was experimental and informal. Its primary goal was to present "living traditions" that served as a complement to the static, historic cultures on display in the Smithsonian's museums and to showcase the range of American traditional cultures.[48] In the late sixties and early seventies as the festival garnered increased public attention, however, it expanded in range and complexity. Staff members invited larger numbers of cultural practitioners and created interpretive frames that guided both the selection and the presentation processes. In addition, in these years the festival started to attract attention from government and corporate sponsors. By 1976, it had transformed into a massive production that involved complicated conceptual frames, large-scale government and corporate sponsorship, and broad public visibility. The Bicentennial Festival of American Folklife (discussed in chapter 5) was a cultural event of national significance, which offered the American public a stunningly diverse portrait of the cultures present in American society. With thousands of cultural practitioners from all over the world and millions of visitors, "Bicenfest" represented a high water mark of the festival's size and influence.[49] Today, the festival continues under a new name—the Smithsonian Folklife Festival—but it has retained the essential approach that Rinzler pioneered. The dynamic

interaction of visitors, festival staff members, and cultural practitioners is the key ingredient that distinguishes it from other museum exhibits.

Throughout its history, the festival has taken place on the National Mall—either in the large open space surrounded by the Smithsonian's museums between the Washington Monument and the Capitol Building or around the Reflecting Pool, which lies between the Washington Monument and the Lincoln Memorial.[50] The symbolic importance of the spaces in which the festival occurred—as sites of both memorials to American government and numerous protests against the government—would have been clear to both festival participants and visitors, especially in the volatile years of the late sixties. Adding to its significance was the fact that it was held on and around the Fourth of July each year. It was, however, quite different from a staid pageant displaying patriotic fervor or an organized political rally; it was similar to a county fair.[51] Unlike the air-conditioned exhibit halls and meticulously designed displays of the new Museum of History and Technology, the Festival of American Folklife was dusty and hot but also exciting and alive. Outside in the summer heat, musicians and dancers performed, craftspeople worked, and visitors moved freely among them. Some presentations took place in tents, temporary structures, and on stages; others were in the open air or under a tree. The fact that the festival occurred primarily outdoors gave staff and cultural practitioners freedom from the structural limitations of museum buildings. In addition, it likely added to visitors' sense that the festival was not a conventional exhibit and that standard patterns of museum behavior did not apply. There was no compulsion, for example, to act in a reserved manner without shouting, running, or talking to companions too loudly.[52] The space of the festival encouraged down-to-earth interactions between individuals. A reporter put it succinctly: "Although masses of people come to the Folklife Festival, it is not a mass event. It is a compatible string of events, of neighbors with their own individuality. It is people being pleasant to each other for the squarest of reasons."[53]

Describing a scene at the first festival in 1967, a *Washington Post* reporter wrote that while a brass band from "New Orleans marched around the tents making bright brassy music, Mrs. Edd Presnell was picking a dulcimer, playing 'Wildwood Flower' very softly and beautifully." Next to her was her husband who was "making dulcimers of walnut and cherry and curly maple." The reporter also recounted talking about sand painting with "Harry Belone, a [Navajo] Indian from Arizona, who was wearing a red shirt and beads and a silverwork belt."[54] Another reporter observed

S. Dillon Ripley and Mary Livingston Ripley, with festival participant, at the 1974 Festival of American Folklife. Smithsonian Institution Archives, neg. #74-6464-2.

that "One woman stepped up boldly to the hammer-dulcimer player and asked to play the bass of 'Red River Valley.' A large, intent circle applauded her performance."[55] The festival also featured performances by a string band from Virginia, the national champion folk dance group from North Carolina, "Mesquakie Indian Dancers of Tama, Iowa, and the King Island Eskimo Dancers of Nome, Alaska," along with many other groups from around the country. One visitor to the festival—Congressman Thomas Rees of California—marveled that "many visitors actually square-danced to the call of Maurice Flowers of Baltimore."[56] Another observer noted that in two tents erected in the stand of trees in front of the Museum of History and Technology, craftspeople, weavers, quilters, sand painters, and whittlers worked as visitors watched intently. Across the street from the tents was a small platform where singers and dancers performed during the day, while at night, performances took place inside the museum.[57]

These snapshots reveal much about the nature of the festival. The wide range of cultural practitioners was typical. The festival presented a multiplicity of traditions that mirrored the actual cultural diversity of American life. The experience was both overwhelming and intimate at the same time. Visitors basked in the array of cultures presented while being entertained by talented performers. Occasionally they even joined in

presentations that invited participation, such as the square dance. The goal
of the festival, however, was not only to entertain. Rather than bolster-
ing stereotyped perceptions of cultures that stood outside the dominant
culture of middle-class, white Americans, the festival encouraged active
engagement among real people to circumvent stereotyping, ignorance, and
ethnocentrism.[58] Contact between visitors and cultural practitioners, such
as the interaction between the reporter and Harry Belone, was the festival's
main achievement. Through conversation, the reporter and Belone likely
formed contingent, flawed, and at the same time rich impressions of each
other. Exchanges such as this one at the festival were starkly different from
visitor interactions with the life group displays of Native craftspeople in
the Museum of Natural History and the display cases of Euro-American
cultural artifacts in the Museum of History and Technology. These con-
ventional exhibits not only muted the voices of the peoples on display, they
denied visitors the opportunity to question and converse with contempo-
rary cultural practitioners. The festival, on the other hand, presented the
dynamic nature of culture and offered a forum where it was possible to
develop understandings of culture cooperatively. In this sense, its organiz-
ers anticipated contemporary curators' emphasis on collaborative curation
and shared authority in exhibition development.[59]

The interaction of individuals formed the core of the festival's approach
to cultural exhibition. At the 1969 festival, for instance, Mrs. Sally Triplett
of Boone, North Carolina, discussed soap making with festival visitors. In
response to a question, she told them, "How do I make it? Well, I put in
some scraps of meat and let it cook in water [in] which I have . . . dissolved
lye. I always add extra lard 'cause I can't spare enough beef for the fat." This
information, which may or may not have found its way into a conventional
museum exhibit, likely made more sense to visitors when conveyed by Mrs.
Triplett in response to a specific question than it would have on an exhibit
label. She also added information that might not have been included in a
conventional exhibit. "If it doesn't come together," she said, "don't you go
blaming me. The moon isn't right. The moon is full now. Everybody knows
you can make soap only when the moon is new." At the festival, the co-
operative nature of exhibition allowed multiple interpretations to emerge
through conversation. Triplett's interaction with visitors also revealed the
negotiation process that went on at the festival between staff and cultural
practitioners: "I told them I'd give it a try, but I couldn't promise. The trou-
ble is, as you can see, the grease stays on top and the lye on the bottom."[60]
She explained to visitors her reservations about making soap at the festival,
revealing the gap between staff members' expectations and practitioners'

ability to meet those expectations in the festival setting. Such problems were not unique to the festival. For decades, anthropologists in the field faced similar issues as they sought access to and information about certain traditional practices and rituals. Cultural practitioners constantly subverted their expectations, and ethnographers and other cultural researchers were forced to choose between artificially constructing "traditions" or recording the flaws and limits of their research.[61] The Smithsonian festival's approach opened these dynamic processes to the public and, as a result, created new ways of understanding cultures through cooperative interaction.

The folklorist Barbara Kirshenblatt-Gimblett who worked on the Smithsonian festival in the 1970s has carefully deconstructed the "curatorial problem of folk festivals," that is, the problem of how to select participants and present their traditions in ways that lead visitors and participants to deeper understandings of the fluid and dynamic nature of living cultures.[62] In the Smithsonian festival's early years, however, staff members were often making it up as they went along and experimenting with new modes of exhibition. At the festival, staff members exercised varying degrees of control over representation. Beforehand, they selected the cultural practitioners to be included in the program and advised the singers, dancers, and craftspeople on presentational styles and repertoire. During the festival, they were both active interpreters and passive observers. In formal, concert-like settings, they acted as masters of ceremony and cultural interpreters. Between songs they translated lyrics if necessary, explained the significance of certain kinds of songs and dances, gave biographical information about the performers, and suggested repertoire to be performed.[63] In less formal settings, such as in the craft displays, visitors had the opportunity to have more direct contact with the cultural practitioners. Sometimes a staff member was present to explain things, but at other times participants and visitors were left to interact on their own.[64]

An example from the 1969 festival where Rinzler served as presenter for Cajun musicians from the Balfa and Ardoin families illuminated the role of staff at the festival. Announcing that the program would be informal, Rinzler encouraged the audience to interrupt and ask questions. He then explained: "There's a large body of French language music . . . and both white and black musicians play a lot of the same tunes and then in each family or community there's a lot of material that is distinctive with only the family or the community."[65] By setting up a program with the Ardoins, who were black, and the Balfas, who were white, Rinzler was able to make a point about the similarities and differences in Cajun music across racial lines. As the musicians performed, he discussed the instrumentation of Cajun music,

translated lyrics, and suggested songs to perform. He also fielded questions from the audience. One audience member was not pleased with Rinzler's choice of having the Balfas perform before the Ardoins. Rinzler responded to this criticism by saying, "Now, let's not make a preposterous issue out of this. We would have started with the blacks if there had been amplifiers for them here. They weren't here. That's the only reason we didn't start with them."[66] This encounter demonstrated that in the lively atmosphere of the festival staff members were unable to hide behind exhibit cases and labels. Visitors were active agents in the process of presenting culture and were free to question curatorial choices.

In the crafts displays, staff members were also sometimes present to facilitate discussions between visitors and cultural practitioners. At the 1970 festival, a male presenter introduced a female practitioner during a discussion of cheese making. Making a point about Americanization and the persistence of traditions, he said, "This is one of the [strange] things about food and that is that people when they came to the United States became . . . for all intent and purposes Americans, you couldn't tell them from any other American, and yet if you go into their homes, they would still be cooking their traditional foods or at least some of their traditional foods."[67] The presenter then proceeded to ask questions of the woman as she worked. She described the steps in making cottage cheese with occasional prompting from the male speaker. One of the things he asked her was how she obtained rennet for separating milk. She responded that she usually purchased it at the drug store. The presenter, however, was looking for a different answer. He explained to the audience that the traditional way of obtaining rennet was from the lining of calves' stomachs. This disparity between the staff member's hoped-for response and the practitioner's modernized method demonstrated the benefit of the festival's discursive approach to exhibition. Through a simple question-and-answer format, visitors understood the ways in which traditions were modified in a modern, commercial society. The woman was able to convey to the audience that making cottage cheese was not necessarily part of her everyday life anymore: "I don't live on a farm right now, but if I go to my son's I can make cottage cheese." This statement exposed visitors to the challenging and negotiated nature of locating and interpreting traditions. Here we can imagine the staff member's ideal practitioner being a backcountry farm woman who still produced cottage cheese the way her great-grandmother had for her family and community. Instead, he found a woman who no longer lived on a farm practicing a tradition that was not part of her everyday life and had been modified because of access to modern consumer goods.

The festival's approach pulled back the curtain on the disparity between ideal and reality and allowed visitors to see traditions more as they really were than as people imagined them to be.

Logistical challenges and the complexity and polyvocality of the festival often thwarted staff members' efforts to fix a coherent frame on the festival's presentations. The gap between staff members' intended interpretive frames and the reality of the festival suggested that the knowledge produced there was contingent. Although staff members were present and exercised interpretive authority, both practitioners and visitors were free to challenge them. Examining the festival from the practitioner's perspective demonstrates that it was a more complex and nuanced exhibition than other types of cultural exhibits. The festival's cultural practitioners were as diverse as the many different places from which they came.[68] Journeying from virtually every state and also from many foreign countries, the musicians, dancers, storytellers, weavers, carvers, potters, and cooks found the experience of being at the festival confusing, exciting, exhausting, monotonous, uncomfortable, and thrilling.[69] The active engagement of practitioners in the interpretation of their traditions was vital to the festival.

At the 1968 festival, a blacksmith talked with visitors about his work. "Some people may think I'm a regular [gentleman]," he said to them, "but I actually do these things."[70] In this way, he explained to visitors that blacksmithing was not a hobby or pastime for him, but a regular occupation. A visitor chimed in that his "grandfather had a [blacksmith] shop." This statement prompted the blacksmith to talk about his own grandfather. Through conversation, the visitor and cultural practitioner moved beyond the cold distance of conventional museum exhibits to a more personal level that allowed them to relate their families' traditions. Such interactions were the hallmark of the festival's approach to cultural exhibition.

The 1968 festival also witnessed less cordial exchanges. The festival that year included a concert honoring the Lomax family. The concert concluded with Reverend Frederick Douglass Kirkpatrick, cultural affairs director of the Southern Christian Leadership Conference (SCLC), giving a short speech in which he quoted the recently assassinated Martin Luther King Jr. and leading the audience in a rendition of "This Little Light of Mine."[71] This event complemented festival staff members' efforts to organize cultural presentations for the "Poor People's Campaign," which brought underprivileged people from all over the country to a tent city on the National Mall in order to focus national attention on their plight.[72] Ace Reid, a white storyteller and humorist from Kerrville, Texas, complained bitterly about Rev. Kirkpatrick's appearance at the concert. Refusing to sing along with

"This Little Light of Mine," Reid left the stage during the performance, telling other performers that he believed that Rev. Kirkpatrick's remarks had "'no place in a government-sponsored program.'"[73] A sound recording captured Reid's presentation earlier in the concert. Starting his routine, he said, "Ohhhh, I'll tell you it is really something to be here in Washington with all these coonies [he laughs and some people in the crowd laugh], our Mexicans, our Indians, we're the most integrated bunch of people you've ever seen in your life. See, all of you that think that Lyndon ain't done nothing right, well this is his last big deal, he sent all the poor white folks up here now." Referring to President Lyndon Johnson's policies directed toward improving minority rights and combating poverty in the United States, Reid poked fun at the festival's diversity. From there, he continued his act by telling tall tales from Texas and singing a classic cowboy song, "Pity the Poor Cowboy." Paying tribute to John Lomax, who had started his career by collecting cowboy songs in Texas, Reid added, "We're [Texans] a bunch of cultured mothers, don't think we ain't. . . . [B]y golly we're up here and we intend to keep culture no matter whether you like it or not."[74] In this folksy and somewhat crude way, Reid expressed both pride in his culture and a sense that his traditions were threatened. Although he did not overtly name the threat, his actions suggested that he believed minority social, political, and cultural movements to be infringing on the traditional culture of white Texans.

Despite Reid's rant, the primary concern for the majority of cultural practitioners at the festival was presenting their cultural traditions, not voicing social, political, or economic concerns. The American Indian programs, which the next chapter will examine in depth, were an exception to this rule. Treaty rights, federal recognition for tribes, the federal policy of termination, and land claims were routinely discussed during Native American presentations at the festival.[75] Overt political discussions were a part of these programs in a way that they were not in the festival's other areas. Sometimes, however, non-Native cultural practitioners expressed their opinions about social and political issues in subtle ways. At the 1969 festival, Willard Watson of Watauge County, North Carolina, showed visitors how he distilled moonshine whiskey. Speaking to a *New York Times* reporter, Watson said, "Now up in the mountains . . . nowadays they's more afraid of the ABC (Alcohol Beverage Control) than the Internal Revenue."[76] A perceptive visitor might have recognized from this statement that distilling moonshine was an important economic activity for contemporary poor whites in North Carolina. The dangers of making a living in this way were quite real for Watson, and he related a story from his childhood about a

close call with the authorities. "I've never been caught making moonshine whisky," he said, "[but] when I was a boy, helping my granddaddy one time, we liked to 've got caught. But I lay flat when the flashlight was midways up and I ran when the flashlight was on the ground. They got the still, though." Some visitors may have taken this anecdote as a quaint tale from a bygone age, but it is not clear that Watson intended it this way. The loss of the still would have been an economic blow to a poor Appalachian family and the arrest of two family members might have had disastrous consequences for the rest of their family. The festival offered Watson the opportunity to share not only his traditions with visitors but to give them a small glimpse of rural poverty.

In addition to describing how traditions operated in their daily lives, cultural practitioners frequently pointed to the challenges of presenting their traditions accurately on the Mall. At the 1969 festival, Willard Watson said: "I don't have any sour mash in [the still]. The law wouldn't let me. They's already been down here to look at it to be sure I was putting nothing but water in it." Of course without sour mash, the still would not produce whiskey. Similarly, at the 1967 festival, Navajo sand painter Harry Belone said after the breeze damaged his work, "It is better in the hogan [Navajo dwelling] . . . No wind."[77] Belone's statement communicated to visitors the fact that the festival setting was not suitable for the practice of some traditions. Although the festival's staff struggled to craft interpretive frames that contextualized the traditions on display, the practitioners worried about more mundane, but equally important, issues: Would they have the proper materials to demonstrate their traditions properly? Would the space provided be sufficient to do their work? Festival staff members were not always cognizant of or sympathetic to these concerns, so they often had to fend for themselves and make do with what they were given.[78]

Cultural practitioners frequently viewed the festival as an opportunity to expand markets for their work and gain national recognition as skilled tradition bearers. In this area, the activist goals of staff members and the goals and expectations of cultural practitioners were similar. Although Rinzler came to the Smithsonian to escape the overly commercial atmosphere of Newport, he did not entirely abandon commerce at the Smithsonian festival. He recognized that connecting traditional artists and craftspeople with markets for their work was an excellent way of ensuring the persistence of their traditions. At the inaugural festival Carl Fox, head of the Smithsonian's museum shops, displayed crafts for sale that he had collected on a ten-day trip through Appalachia.[79] Fox's tent represented the beginning of a commercial aspect of the festival that continued in subsequent years. Although

the organizers carefully separated commercial activities from the other presentations, the sale of crafts, food, and sound recordings was a staple of the festival from its inception. Much of the profit from these sales went to the cultural practitioners. In addition, the commercial exposure that the festival provided allowed many tradition bearers to make the production of traditional culture their primary source of income. At the 1969 festival, Mrs. Roy Harris explained to a reporter that she and her husband had a shop near Rogers, Arkansas. "We sell my husband's carving and the dolls," she said, "I crochet, knit, weave, sew—all of it. We can't hardly keep the shop stocked, people want to buy it so much." Mrs. Harris told the reporter that she had learned to carve dolls with a pen knife because Carl Fox said she could not come to Washington with her husband "unless [she] could do something."[80] By developing a new "traditional" skill, Mrs. Harris was able to attend and promote her shop. The festival represented an economic opportunity for the Harrises because it allowed them to reach a national market for their work.

On the ground at the festival, staff members, cultural practitioners, and visitors could make their voices heard, and all three groups played different roles in shaping the representations of culture the festival produced. Although the staff held the preponderance of interpretive authority, it was not absolute and unquestioned. Practitioners pursued their own interests and made their ideas, opinions, and complaints clear. Whether it was Ace Reid's gripes about the voicing of civil rights rhetoric or Willard Watson's narrative about rural mountain life, cultural practitioners often distinguished their ideas and interests from the goals of festival staff.

In the dynamic interaction of individuals, Ripley's concept of open education found its fulfillment. Although different from the Tuileries, the festival was a variegated space that offered nourishment for all the senses. Visitors wandering through the space were overwhelmed by the life that surrounded them and, like Ripley in Paris, reacted extremely positively to the experience. Congressman Thomas Rees, for example, praised the festival profusely in a speech before the House of Representatives. "My family and I found the entire festival both enlightening and educational," he said, "and I hope to see it again next year when we may have an even bigger and better all-American Fourth of July Festival."[81] Not only members of Congress, but also the general public reacted positively. Smithsonian officials received a flood of responses to the 1967 festival, many containing rave reviews. Mrs. William M. Weinbach Jr. wrote, "We all—my husband, our 3- and 5-year-old daughters, and I—enjoyed it so much we'd be remiss if we didn't tell you so!"[82] And, Lila Fendrick, a young girl from Chevy

Chase, Maryland, wrote, "I think having all the craftspeople on the mall was just wonderful. *Please,* please do it again next year."[83] These and other responses demonstrated that the festival was enthusiastically received by Smithsonian visitors.

Visitors' responses, moreover, ranged beyond simple expressions of appreciation. Some letters pointed to positive feelings about American society that the festival inspired. Commander and Mrs. Sylvan Tanner from Falls Church, Virginia, wrote, for example, "Having returned this autumn from three years of living in Europe . . . it is a *special* treat for us, to enjoy our fellow American[s] as they were during the Festival—so well behaved to each other, and with so much evident feeling of good will expressed toward each other."[84] And in another letter to James Morris, the Tanners wrote, "The mood of the people on the Mall was relaxed the feeling of goodwill and decent behavior toward each other was almost palpable. And such a look of fulfillment on the faces of old people, the in-betweens, the young children—and even the 'teen-agers'. A miracle on the Mall."[85] For the Tanners, the festival presented a strong contrast to the disharmony that pervaded American society in the late 1960s. Some newspaper columnists echoed this sentiment. In the *Washington Post,* Martin Weil wrote of the 1970 festival, "Wearers of 'Love It or Leave It' buttons and bearers of the peace symbol met without friction as they enjoyed the sights, sounds and smells representing aspects of the American past for which both groups feel affinity."[86] According to Weil, the festival inspired people with deeply divided political views—supporters and opponents of the Vietnam War— to "mingle happily." In a largely non-political atmosphere, people from a variety of backgrounds were able to appreciate the richness of American traditions. Although it was not an accurate reflection of the divided nature of American society in this period, the fact that the festival inspired such feelings demonstrated the appeal of its approach to educating the public.

For Ripley, the success of the festival validated his philosophy of open education. It also pointed up flaws in the Smithsonian's existing cultural exhibits. In developing the festival concept, Rinzler had argued that the exhibits in the Museum of History of Technology were misleading to visitors because they lacked diversity and failed to connect past cultural forms with contemporary living traditions.[87] The festival, he maintained, would demonstrate to visitors that the hand-woven fabrics, pottery, and other traditional arts and crafts on display in the Smithsonian's museums were not relics of a distant past but, in many cases, were still being produced in similar ways throughout the country.

Perhaps understandably, the festival met with skepticism from Smithsonian curators. Although Rinzler and James Morris consulted a number of the institution's curators in 1967 for their recommendations, many of them believed they were excluded from the process of designing it.[88] Moreover, the curators contended that the festival unnecessarily duplicated work that the Department of Cultural History and the Museum of History and Technology's other divisions were already adequately performing and claimed that it did not match the institution's normally high standards of scholarship. Silvio A. Bedini, deputy director of the Museum of History and Technology, questioned its intellectual standards: "Does the summer Folk Life Festival fit properly within the framework of the Institution's concern for 'the increase and diffusion of knowledge,' or is it enough to have it as a popularly successful promotional activity? In its present form, there may be some question of its legitimacy as the former, although there is no doubt about the latter."[89] This criticism of the festival's intellectual credibility was a persistent refrain and reflected conventional museum curators' discomfort with the festival's approach to exhibition.[90] Ceding interpretive authority to non-professionals appeared to them to be an abrogation of the Smithsonian's responsibility to increase and diffuse knowledge. In response to these criticisms and their own perception of its shortcomings, festival staff continually strove to create interpretive frames to assist visitors in better understanding the cultures on display.

The curators' objections may have also been a response to festival staff members' unconventional type of scholarship. They practiced what was called "applied folklore."[91] This field had its origins in the work of popular song collectors such as Alan Lomax and other culture workers who used traditions to effect social, cultural, political, and economic change outside the narrow bounds of academia.[92] By the late 1960s, a distinct sub-discipline of professional folklorists had emerged who worked in an applied, rather than a purely academic, vein. The festival offered a broadly visible platform for scholars of traditional culture to pursue this kind of work. Proponents of applied folklore argued that its academic and activist goals could not be separated from one another. This "false dichotomy," they contended, was misleading, because it suggested that academic folklorists practiced a purely objective form of scholarship while applied folklorists' work was tainted by ideological, social, or political biases.[93] Reflecting a general decline in the belief that scholars could pursue wholly objective studies of culture, proponents of applied folklore boldly proclaimed their social, cultural, political, and economic aims.[94] At the same time, they pursued intellectual work the

goal of which was to deepen public understanding of traditional cultures. The historian Howard Brick has identified this apparent contradiction in the intellectual history of the sixties: "Although it was essential to challenge the feigned disinterestedness of official knowledge and disclose the actual biases and commitments of conventional wisdom, it was impossible [for intellectuals] to deny the hope of attaining something one could trust as truth."[95] Lacking confidence in the culture science of their predecessors, festival curators nonetheless believed that the intellectual had a role to play in presenting cultures to a broad audience and expanding public knowledge about these cultures.

Rinzler hoped that presenting certain traditions and giving them the Smithsonian's "*Good Housekeeping* seal" would enable them to find a broader audience.[96] In that way, American culture would be enriched and cultural practitioners would gain a means of supporting themselves through the practice of their traditions. In an early proposal, the festival's organizers wrote, "Folk art has suffered from the gradual process of erosion caused by mass media since the beginning of this century. This erosion process must be checked and this area of creativity encouraged through a long range program which is educationally, culturally, and economically oriented."[97] A consistent theme among collectors of traditional culture, the perceived rapid disappearance of certain cultural forms motivated the festival's organizers. The festival, they believed, would facilitate the preservation and even expansion of traditional cultures.

Alongside the goal of expanding public appreciation of traditional cultures, Rinzler did have some more purely academic aims. In 1967, on the recommendation of his friend folklorist Henry Glassie, an expert in folk architecture and adviser to the festival, Rinzler conducted an in-depth study of a traditional potter from Georgia, Cheever Meaders. This study, which resulted in a documentary film and monograph, indicated that Rinzler hoped to pursue scholarly research on traditional cultures as a complement to his work organizing the festival.[98] The inaugural festival also included a companion folklife conference, which brought folklorists and other scholars of traditional culture to the Smithsonian to discuss the state of folklife studies and the role of the festival in encouraging the analysis of American traditional cultures.[99] The festival's organizers hoped that the festival would provide the basis for a national folklife institute to coordinate efforts to collect, study, and promote traditional cultural production. Smithsonian officials summarized the role of the folklife institute: "Unifying our efforts to define, preserve and present American folk culture will enable us to plan for the extension of services, to provide for the orderly growth

of research and to strengthen the Smithsonian['s] ties with the scholarship which has developed regionally in museums and universities and which lacks national focus."[100] In this formulation, the Smithsonian would have become the national clearinghouse for information on American folk culture. The institute idea represented a desire to expand the Smithsonian's longstanding work with Native American cultures through the Bureau of American Ethnology and the Department of Anthropology to other traditional cultures.[101] Although it never materialized at the Smithsonian, it was eventually created under the auspices of the Library of Congress. The American Folklife Center was authorized by Congress in 1976, and today it is one of the most important institutions in the United States for studying and collecting traditional culture.[102]

The festival developed and matured over time. In its early years, the primary aim of its leaders was to present living traditions that complemented and also served as a corrective to the exhibits in the institution's museums. As the festival expanded and became more sophisticated, however, they sought to contextualize the cultures on display. Rather than presenting cultural practitioners in a setting entirely alien to their home environment, staff members created frames that situated traditions in their appropriate contexts, conveyed ideas about cultural transmission, and debunked cultural stereotypes. "The Festival, avoiding an entertainment approach to culture," wrote Ralph Rinzler, "seeks to serve as a window into community."[103] Staff members determined that the most effective way to present communities at the festival was by re-creating social gatherings—weddings, feasts, and holiday celebrations.[104] Rinzler referred to this approach to exhibition as "induced natural context."[105] The idea reflected current theories in anthropology and folklore which maintained that understanding culture was impossible without fully contextualizing cultural practices.[106] Festival staff aimed, in the words of Rinzler, to "re-create an environment on the National Mall which suggests the familiar surroundings of the performer's home or community."[107] Although the festival often fell short of this ideal in practice, the concept reflected staff members' desire to present traditional cultures not as exotic spectacles but as comprehensible cultural systems.[108]

In the field, festival staff members followed Rinzler's model of identifying and recruiting cultural practitioners. Working with local folklorists, ethnomusicologists, anthropologists, and community organizations, they surveyed the traditions of a particular region or group of people and identified potential candidates. From there, staff members visited these people, spending from a few days to several weeks with them. The time constraints

imposed by the need to put on an annual festival, however, limited the amount of intensive fieldwork staff members were able to perform. Most of the festival's fieldworkers relied on their taste and experience to identify promising cultural practitioners to be part of it.

The festival's basic requirement for selecting cultural practitioners was that they be "authentic." Fieldworkers generally avoided revivalist performers as well as folk troupes. These kinds of polished professional "folk" performers were antithetical to Rinzler's goal of presenting cultural practitioners who had learned their traditions within their families and communities. Ranking the types of traditional performers, the festival's organizers rated "national or professional companies" as the least desirable. "Folk professionals who come from traditional communities" were more acceptable, while the most desirable cultural practitioners were semi- and non-professional performers who rarely if ever practiced their traditions for pay. Festival organizers were, in other words, seeking cultural practitioners similar to Doc Watson and Dewey Balfa—the talented, but unknown, traditional musicians that Rinzler had "discovered" early in his career. Also like Rinzler, festival curators hoped to spur expanded recognition of traditions and to develop means of sustaining traditional cultural production. Along with this activist aim, festival staff had the more academic goal of fully contextualizing cultural practices. "It is essential," read festival fieldworkers' guidelines, "that the field survey include details on the context, physical and behavioral, of performance."[109] Staff members emphasized context so that festival visitors might view the cultural practitioners on display as they appeared in the field. This mode of display was intended to reduce stereotyped or romanticized portrayals of traditions. More important, it re-created, if imperfectly, the dynamic and often confusing nature of fieldwork for festival visitors. The resulting understandings of culture, it was hoped, would be more nuanced and complex than those produced by conventional museum exhibits.

Although the power of selection generally rested solely with the festival's staff, occasionally cultural practitioners were able to exert influence over the process. While auditioning Italian American musicians in New York City in January 1975 for the festival, a Smithsonian fieldworker noted "my phone has been almost constantly ringing with complaints that the music requested of them is not their music and that what is really their music has been rejected." Evidently, the Italian Americans were angered by the fieldworker's insistence on finding musicians who performed "pure and esoteric music." During the auditions many musicians had simply refused to perform. Others wanted to perform songs that were of more recent

origin than the traditional tunes most desired by the Smithsonian. "Of those who did have the courage to perform," the Smithsonian fieldworker recorded, "many insisted (and some aggressively), that their songs were indeed old songs and merited hearing." Responding to this pressure, the fieldworker reported that "representation [should] be given also to the music which corresponds to the hybrid identity of the Italo-American whose residence in this country for the last 70 to 84 years has evolved its own character." If these songs were not included, the fieldworker feared that it would "materially effect [sic] attendance at the festival." Italian American groups threatened not to attend, because they argued that the festival would not "relate to them personally."[110] In this instance, the Smithsonian's emphasis on finding authentic traditions caused a backlash among the cultural practitioners themselves. By loudly expressing their displeasure, they were able to affect the selection criteria for the festival.

It is not clear, however, that this give-and-take was characteristic of all of the festival's fieldwork. Indeed it may have been the exception rather than the rule. Because the festival was held annually, fieldworkers were under immense pressure to identify and recruit participants quickly. This left little time for in-depth research. Fieldworkers were supposed to fill out reports with extensive background material on each participant.[111] However, in practice, they often recorded only the most basic information and made snap judgments about people's suitability. In one field report, for example, fieldworker Suzi Jones noted that carpenter and cook James Kinney Hulsey of Prineville, Oregon, was "fantastic. He is very knowledgeable, largely self-educated individual, in many ways, reminiscent of the old mountain men, but he is not a mountain hermit. His skills are really quite representative of the NW [Northwest] and undeniably traditional."[112] With this glowing review Hulsey found himself invited to participate in the Bicentennial festival.[113] Many prospective participants were rejected out of hand, however—especially those who tried to apply directly to the festival staff. A letter sent by Division of Performing Arts staff member Sarah Lewis to Mrs. Thomas Hunter of Ellicott City, Maryland, was representative of the responses often sent to such applicants:

> Thank you for letting us know about your [cousin] and his beautifully crafted work. We are always pleased when people who have attended the Festival are interested enough by what we are doing to suggest participants to us.
>
> The Festival of American Folklife, however, employs a highly rigid definition of "folklife" and we look for participants (ordinarily identified by our field workers) who not only use traditional forms but

also have acquired their skills in ways which meet certain criteria of authenticity.[114]

Festival staff members generally found revivalists to be inauthentic and therefore inappropriate. They also looked with skepticism on participants who were too polished or professional. It was here that they exerted their clearest authority over the shape of the festival. Yet, because the selection process was often haphazard and rushed, many "unacceptable" participants found their way into the festival.[115] Once they arrived on the Mall, all bets were off. The festival's polyvocal nature and its de-centralized format opened innumerable spaces for cultural practitioners to express their individual ideas and opinions. Thus, although staff members helped to interpret the traditions on display, they lacked the degree of control that they had initially exercised through the selection process. Overall, the role of staff members differed considerably from that of curators inside the Smithsonian's museums. Instead of crafting exhibits of objects, they worked with subjects who spoke for themselves and had agency to question authority.

Despite its success, the festival remained the rebellious stepchild of the Smithsonian, and the institution's officials viewed it by turns as an out-of-control experiment in need of reform and a vital asset that burnished the Smithsonian's reputation. Its success, however, was undeniable. From 1967 onward, the annual festival attracted hundreds of thousands, and sometimes millions, of visitors and always received positive reviews. From an institutional perspective, the festival's impact was threefold. First, it demonstrated that conventional exhibitions were not the only way to present culture to the public. Living exhibitions could, the festival showed, be more effective—that is, educational and entertaining—than static displays and could convey messages that other exhibits could not. Second, the festival illustrated that the physical space of the institution was malleable and that an openness regarding space could lead to productive solutions to some of the Smithsonian's most challenging problems. And, third, the festival pointed toward new models of presenting the rich diversity of American life. African American, Native American, Asian, Hispanic, and Euro-American cultures found spaces within the festival structure. In a sense, the festival allowed for the combining of the subject matter of the Museum of Natural History with the subject matter of the Museum of History and Technology. Moreover, it opened the door for additional cultures, not included in any Smithsonian museum, to be presented. The ephemeral nature of the festival meant that vexing questions of what belonged where could be revisited each year and revised as necessary. Space and structure were not fixed, but instead were

fluid and could be changed from year to year. In the festival, the Smithson-ian found the ideal solution to its problem of space—remake it every year. Unfortunately, this lesson was not applicable to the static, monumental structures lining the Mall. The expense of fundamentally reconfiguring the Smithsonian's exhibits each year, not to mention the chaos that would have ensued from such perpetual motion, would have been unsustainable. Moving forward, the museums' leaders would need to devise alternative solutions to this problem.

4

Inclusion or Separation?
The Anacostia Neighborhood Museum and the Festival of
American Folklife's American Indian Programs

Ripley was not content simply to transform the educational processes
that transpired within and among the Smithsonian's museums. He was also
committed to creating a more inclusive institution. He saw clearly that the
Smithsonian's museums did not adequately or accurately represent the rich
cultural diversity of American society, and he pursued various remedies
for this problem in his first decade as secretary. The spark that drove him
to make these changes undoubtedly came from the many people of color
who demanded not only civil rights but also respect for cultural difference
in this period. Ripley had a front row seat for the great achievements of
civil rights leaders in the mid 1960s as well as the unrest in cities in response
to continued social and economic inequality. The riots in Washington,
D.C., following the assassination of Martin Luther King Jr. in April 1968
would have had a particularly strong influence not only on Ripley but on
the entire institution. In the Smithsonian annual report that year, Ripley
wrote passionately about the issue of cultural pluralism, communicating
his intention to make improvements in this area. "The principal facts of
the history of our nation," he wrote, "revolve around the cultural plural-
ism of our people. . . . Far too little has been done to delineate the history
of the ethnic minorities of our country or to single out and describe their
achievements." Recognizing the need for change was the easy part. The
challenge, of course, was how and where to present the history and culture
of "ethnic minorities."[1]

Ripley criticized the existing Smithsonian museums for their treat-
ment of non-white cultures, arguing that the anthropological work of the
past, though important, was insufficient for a new age in which African
Americans, American Indians, Mexican Americans, and others were de-
manding civil rights and self-determination. In the Museum of History and

118

Technology, he maintained, "it appears as if innovation and intellectual and technological achievement were either racially anonymous or were the prerogative of Anglo-Saxons from western Europe, essentially Protestant of course." At the same time, he continued, "American Indians, along with Chinese or Mexican Indians find their culture and their mode of life discussed in the Natural History Museum as curious subjects for anthropological research, related somehow to zoology and other parts of the world of nature. African history is similarly discussed and recorded in depth in the halls of African technology and anthropology." Here, Ripley saw with clear eyes the problem that previous generations of Smithsonian leaders had created with their decisions regarding epistemology, organization, and the segregation of cultural materials. By associating Euro-American history and culture with technological achievement in the Museum of History and Technology while connecting non-white cultures with the natural world in the Museum of Natural History, Ripley's predecessors had constructed a hierarchy of race and culture. "Here and there in the historical museum there may be a reference to slavery or to wars against the Indians," Ripley noted, "but for the most part our ethnic subcultures, our minority groups, come off very badly indeed."[2]

The problem, as in the past, had much to do with space. Under Ripley's leadership, Smithsonian curators and administrators developed three solutions: one solution was to create separate spaces for non-white peoples to present their own histories and cultures, another was to develop new exhibits in the old spaces that did a better job of interpreting the histories and cultures of these groups, and still another was to create a new space that included exhibitions on a wide range of cultural groups, both white and non-white. From the late 1960s through the 1980s, Ripley and his staff attempted all three of these approaches with varying degrees of success. This chapter and the following two examine these efforts in depth, probing the successes and failures of the Smithsonian's attempts at addressing the new landscape of race, ethnicity, and cultural pluralism that emerged in response to the civil rights, Black Power, and cultural nationalist struggles of the late 1960s and early 1970s.

This chapter explores the Smithsonian's early experiments with constructing separate spaces for African Americans and American Indians to interpret their own histories and cultures. In the late 1960s and early 1970s, two pathbreaking projects—the Anacostia Neighborhood Museum and the Festival of American Folklife's American Indian programs—emerged at the Smithsonian that, for the first time, placed African American and Native curators in charge of developing exhibitions about the communities

to which they belonged. Although part of the overarching Smithsonian structure, these exhibitions occupied distinct spaces that were apart from the museums at the core of the institution's physical geography. By occupying separate spaces, these projects avoided the turf wars that might have ensued within the existing museums, and their progenitors were able to start fresh in their efforts to create new exhibition paradigms. At the same time, their position outside the Smithsonian's core museums meant that they were peripheral to most visitors' experiences of the institution, and their influence on the overall direction of the Smithsonian was limited.

Decisions regarding where to place exhibits of African American and Native peoples and cultures mirrored broader societal debates over the relative merits of integration versus separatism. Symbolized by two of the central figures of the period—Martin Luther King Jr. and Malcolm X—the poles in the debate each drew strong supporters among African Americans. Although he had modified some of his attitudes before his assassination in 1965, Malcolm X argued that whites would never grant blacks full equality in the political system and that socially and economically blacks would remain oppressed unless they created their own separate nation. Inspired by the ideas of Marcus Garvey and Elijah Muhammad, the leader of the Nation of Islam, Malcolm X preached his message to receptive audiences of largely underprivileged urban blacks. At the same time, he debated leaders of the Civil Rights movement, such as Bayard Rustin, who organized the March on Washington, and James Farmer of the Congress of Racial Equality (CORE), who contended that dreams of a separate black nation were unrealistic and blacks should focus on reforming the existing social, political, and economic systems in the United States through direct action protests, grassroots organizing, and legislative lobbying.[3] By the late 1960s, many, particularly young, activists involved in the black freedom struggle had become disillusioned with the integrationist approach of King, Rustin, and Farmer and turned to the words of Malcolm X for inspiration. Fired by the slogan "Black Power," which Stokely Carmichael coined in 1966, these young activists evidenced a militancy characterized by armed self-defense and black cultural and economic self-determination. The idea was not a new one for African Americans—not only Malcolm X but other leaders such as Garvey, Robert Williams, and Richard Wright had articulated similar ideas in previous decades. Nevertheless, Black Power gained widespread notoriety in the late 1960s, generating a great deal of controversy as well as sparking concrete action.[4]

The idea of self-determination for an oppressed minority group had resonance beyond the black freedom struggle. It was also particularly inspiring

to young American Indian activists frustrated by the federal government's mistreatment of Native peoples. The long history of the violation of treaties with tribes along with paternalistic policies that had had devastating consequences for Native communities led American Indian activists in the late 1960s and early 1970s to reject government interference and claim sovereignty and the right of self-determination for Native peoples. Beginning with the dramatic takeover of Alcatraz Island in November 1969, American Indian activists used direct action to provoke confrontation, elicit sympathy for their cause, and argue for the right of self-determination.[5] It was in this heated environment that the Smithsonian began addressing the question of how to devise new modes for the display of African American and American Indian histories and cultures.

On September 15, 1967, less than four years after the debut of the Museum of History and Technology, the Smithsonian's newest museum opened its doors. Located away from the Mall in the section of Southeast Washington, D.C., known as Anacostia, the Anacostia Neighborhood Museum was, according to its public relations materials, "a new experiment" and "a combination of museum, community center, arts and crafts workshop, [and] recreation center."[6] Occupying a former theater, the museum superficially in no way resembled the monumental structures on the Mall. Like a storefront church, the museum repurposed an existing community space and made a point of connecting to the people in its immediate vicinity. The Anacostia section of Washington was an area with a predominantly low-income, African American population. Many of its residents never ventured to the imposing ceremonial spaces of the Mall or visited the Smithsonian's museums there. Bound by fears of encountering racial bias and possessing a sense that the Smithsonian's exhibitions did not have any relevance to their lives, African Americans in Anacostia and other sections of Washington chose to avoid the Museum of History and Technology, the Museum of Natural History, and the institution's other structures. Ironically, then, a city with a majority black population contained many world-class museums that had virtually no African American visitors. Indeed, most of the Smithsonian's visitors were white, middle-class, and from the suburbs.[7]

Early in his tenure, Ripley recognized this as a problem and set about trying to rectify it. He was not alone in this endeavor of course, as a small number of leaders in the museum field began working on the project of connecting urban communities and museums in this period. The Anacostia Museum was the flagship project in the effort and a harbinger of things

to come. Remarkably for a large, public institution, the Smithsonian was able to advance a pioneering, experimental project that challenged the staid foundations of American museums. In 1972, members of the museum profession summed up the new approach to the relationship between museums and communities that the Anacostia Museum embodied in a report titled *Museums: Their New Audience*. Officially submitted as a "Report to the Department of Housing and Urban Development by a Special Committee of the American Association of Museums," it signaled a dramatic shift in museum philosophy and connected the museum field to broader trends among government officials and other experts who were seeking to address the challenges facing cities. Describing the changes in urban communities of recent decades, the report detailed two separate migrations: the first of middle-class whites to the suburbs and the second of African Americans and Latinos into the cities. "The two movements have complemented and furthered each other," the report continued, "but both together have left the museum, an urban institution, to some extent a beached whale." With its traditional audience—middle-class whites—leaving the cities, museums

Carver Theater, first home of the Anacostia Neighborhood Museum, 1967. Smithsonian Institution Archives, neg. #92-1790.

faced the challenge of connecting to urban residents and relating to this "new audience in ways which shall be meaningful for both the institution and its audience."[8] According to the report, the solution to this problem was for the museum to become "an active instrument for social change." Rejecting the image of the museum as a conservative institution dedicated solely to the preservation of objects, the report's authors identified a counter-tradition of the museum as an "activist force . . . an educative force in its community" and called for the museum to be an "instrument for desirable social change." The way to accomplish social change was not, however, through top-down programs that told people what to do. The report did not recommend urban renewal of the sort that had occurred through so-called slum clearance. Instead, it suggested that museums develop relationships with "community representatives, learn from them by consulting with them and, after some sort of exploration of compatibilities, employ them as consultants and directors."[9] An ideal place for this process to occur was in a neighborhood museum such as Anacostia.

One of the co-authors of the report was John R. Kinard, the first director of the Anacostia Neighborhood Museum. Kinard, who was a resident of Southeast Washington, had worked in Africa on development and exchange projects before returning home to become a Neighborhood Youth Corps counselor and program analyst for the Office of Economic Opportunity. He had studied at Howard University and had received degrees from Livingstone College and Hood Theological Seminary, historically black institutions in Salisbury, North Carolina.[10] Kinard was decidedly not a member of the museum establishment; instead, he brought a community organizer's skills and a civil rights leader's vision to the project. His involvement with the Anacostia Museum illuminates how the museum field was changing as new actors, inspired by the Civil Rights movement and Black Power, pressured established institutions to adjust their representation of non-white peoples and, more important, created their own institutions that provided counter-narratives to the dominant narratives of American history and culture.

The Anacostia Museum was the rare project that brought together an established institution and community activists in a productive relationship.[11] It was the product of a Smithsonian led by an entrepreneurial leader and a community hungering for both access to cultural resources and a venue to present historical and cultural narratives relevant to their lives. In the fall of 1966, Ripley delivered remarks to fellow museum directors gathered in Aspen, Colorado, for a meeting of the American Association of Museums in which he suggested that museums set up exhibits in buildings

John R. Kinard, c. 1987. Smithsonian Institution Archives, neg. #2002-32299.

in low-income neighborhoods in order to connect with new audiences. In response to newspaper coverage of the speech, the Smithsonian received requests from different communities in Washington for such a neighborhood museum and subsequently forged a partnership with the Greater Anacostia Peoples' Corporation, a community group that had been formed in 1965, to develop a museum in the old Carver Theater.[12] The Smithsonian then formed the Anacostia Advisory Committee, which met with local residents on a regular basis to gather their input on what the museum should display and what programs it should offer. Although some local residents were skeptical, many in the community turned out to express their opinions and offer ideas. Up to fifty people attended meetings each week during the summer of 1967—a summer better known for being the "Summer of Love" and witnessing the explosive Detroit riot—and, eventually, six of the museum's original staff of ten would come from the community.

Together, Smithsonian officials, led by Assistant Secretary for History and Art Charles Blitzer, along with consultant Caryl Marsh, the museum's staff, the advisory committee, and community members developed a concept for a hands-on museum—a place where visitors, especially children, could touch the objects and explore independently. Based on the suggestions of local residents, the museum's first exhibits were a "full-scale mockup of a Mercury space capsule," a set of "shoebox exhibits" that contained

"small items such as arrowheads, shells, [and] rocks" that could be closely examined, a room with bones (including a large dinosaur bone) that could be handled, a closed-circuit television camera and monitor that allowed visitors to broadcast themselves, a small zoo with "squirrel monkeys, hamsters, gerbils, guinea pigs, tropical fish, an indigo snake, and a talking parrot," and an "1890 Country Store and Post Office."[13] Primarily a space for children, the museum provided opportunities for learning through play.

As a hodgepodge of natural history, technology, physical anthropology, and history, the museum resembled the Smithsonian as a whole. This accorded with Ripley's original vision for neighborhood museums. He saw them as outreach for the larger institutions of which they were a part. Anacostia was, in this sense, a kind of mini-Smithsonian. In an odd way, however, it resembled the original National Museum more than the current institution. In its juxtaposition of squirrel monkeys and a space capsule, a country store and television, the museum echoed the sweeping exhibits of the nineteenth-century Smithsonian. Photographs from its early years show young African American visitors climbing on a life-sized model of a triceratops and crowding around a fighter jet.[14] The museum lacked the strict compartmentalization of the contemporary museums on the Mall. Like the larger institution, though, it experienced a tension between universal and particular.

Shortly after the museum's opening, Kinard and the museum's other staff members found that exhibits of African and African American art, history, and culture were very popular with visitors. In February 1968, the museum marked Negro History Week with an exhibition of portraits of prominent African Americans, as well as other events. In addition, in response to a visitor's suggestion, the museum developed an exhibition on African art and culture titled "This Is Africa," which included traditional and contemporary African art objects, textiles, and costumes borrowed from Columbia University, African embassies, and private collectors. During the exhibition's six-week run, the museum also hosted an African music and dance program, a fashion show, films about Africa, a panel discussion, and a "Food Fair." Interest in these exhibitions and programs was high. With such a strong response, Kinard and his staff moved away from the initial concept of a mini-Smithsonian and confidently pursued a plan for a permanent exhibition on "Afro-American History and Culture." Over time, the museum would focus increasingly on African American social and cultural history and contemporary issues facing African Americans.[15] Key exhibitions on African American history developed by the museum's staff in these early years were "The Sage of Anacostia, 1817–1895," which

examined the life and times of Frederick Douglass, "Black Patriots of the American Revolution," and "Toward Freedom," an overview of the Civil Rights movement since 1954. In addition, the museum addressed challenging social issues, such as prison life and rats in urban communities. "The Rat—Man's Invited Affliction" featured live rats in a simulated backyard environment and discussed the history and ecology of these pests as well as efforts to control them. A traumatic subject for many of the museum's visitors, the exhibition reflected the museum's commitment to presenting the realities—both positive and negative—of life in Southeast Washington, and is now considered a landmark in the history of museum exhibitions. In 1972, the museum opened "The Evolution of a Community," which used oral histories from over fifty area residents as well as photographs, documents, and objects to narrate the community's history.[16] With this exhibition and others that explored the past and present of African American lives in D.C. and beyond, the museum cemented its position as a pioneer in the field. In terms of both philosophy and content, the museum was unlike any other that existed at the Smithsonian or anywhere else in this period.

By the early seventies, then, the Anacostia Neighborhood Museum had transitioned from presenting a hodgepodge of subjects that appealed primarily to young visitors into a community museum with a strong emphasis on African and African American history and culture. It was the only Smithsonian museum that presented this subject in a consistent and sensitive way, and for those who visited, it filled a gaping hole in the institution's offerings. The problem, of course, was that significantly fewer people visited the Anacostia Museum than visited the museums on the Mall. In its first year the Anacostia Museum attracted over 40,000 visitors—a good showing for a relatively small community museum, but nothing compared with the five million annual visitors to the Museum of History and Technology.

History and Technology, as well as Natural History, struggled in these years to present even basic narratives of African American history and culture. In a paper for the American Association of Museums in 1966, Keith Melder, who was an associate curator in History and Technology and was in charge of the division of political history, said: "Historical museums in this country have treated the Negro as though he did not exist. It is little wonder that many Negroes are indignant at such treatment."[17] To address this problem, he suggested exhibits on slavery, Jim Crow, the Great Migration, and other aspects of African American history. Moreover, as part of a broader effort to document social and political movements in the United States, Melder collected materials related to the Civil Rights movement. Such efforts, however, were not representative of the work of the museum

as a whole, and it would be two decades before a major exhibition was created on any of these topics.[18]

In July 1968—in response to the riots that only three months earlier had ripped the city apart—Frank Taylor initiated a process whereby Smithsonian curators were directed to document "items relating to the Negro" in existing exhibits. Moreover, he wrote, "Every curator is urgently requested to re-examine the history of his subject and the histories of the Negro to determine the events, people, institutions, and achievements, that can be added to his exhibits immediately to illustrate Negro history and Negro contributions." At the same time, at the urging of Carroll Greene, a pioneering African American museum professional who worked with Taylor, officials developed a plan to create a leaflet that would guide visitors to African American materials throughout the Smithsonian's various museums. "The objective," Taylor wrote, "is to be certain that Negro history is noted wherever it is shown or referred to, and to do this without separating Negro history from the context of the history in which it is exhibited."[19] In Taylor and Greene's vision, Anacostia would not be the sole exhibitor of African American material culture. Instead, all of the Smithsonian's museums would include at least some objects associated with African Americans.

Progress on this front was slow, particularly in the Museum of History and Technology, despite the urging of Taylor and Greene. In early 1969, curator Peter Welsh reported to Silvio Bedini and Taylor on the efforts within the museum to "make the Negro a more visible part of exhibits." Although he was able to point to some small achievements, he stated that the larger projects, such as revising the "African Backgrounds" case in the *Hall of Everyday Life in the American Past* and "The Indian and the Negro" display in *Growth of the United States,* would "require an extended amount of time to complete." He also made a series of rather ambitious recommendations concerning exhibits that the museum might consider developing. In the agriculture exhibits, for example, he suggested installing a nineteenth-century cotton gin along with "a Negro mannequin, and appropriate prints . . . to make clear the institution of Negro slavery and the forces which perpetuated it." He made similar suggestions for the armed forces, water transportation, and costume exhibits. For *Growth of the United States,* he recommended making space for a display on "the impact of protest and dissent . . . over Negro slavery." He also thought that one of the mannequins in the house display might be changed to represent "a black man" and suggested that a black soldier and cowboy could be represented. In "Medical Science," he questioned whether it was not possible to "make some visible statement regarding Dr. Drew and blood plasma," and in

"Musical Instruments," he thought an exhibit on jazz could be tied into "Music Making American Style." Finally, he wrote that he was prepared "on very short notice to prepare an exhibit on the Negro in America in the 19th century as seen in popular lithography." He noted that this exhibit would not offer a "pleasant picture" as it would be littered with negative stereotypes; however, he argued that it would "surely [fulfill] the mandate 'to tell it as it was.'"[20] Despite Welsh's recommendations, it would be over a decade before the Museum of History and Technology made any real headway in presenting African American history.

Meanwhile the Anacostia Museum struggled in a different way. If History and Technology had plenty of visitors but very little African American history, Anacostia had precisely the opposite problem. Marginalized by its location—three and a half miles from the Mall and on the opposite side of the Anacostia River—the museum connected well with people in its immediate vicinity but did not attract the mass audiences that visited the Smithsonian's other museums. Many visitors to the Smithsonian were unaware that the Anacostia Museum even existed. Bringing in such audiences was not, of course, part of the museum's original mission. The Smithsonian overall had done such a poor job of presenting African American history and culture to its visitors, however, that Kinard became a vocal advocate for an institution-wide discussion regarding how to present this subject matter more effectively. For many years, he publicly voiced his displeasure with the Smithsonian's treatment of African American history and culture, eventually bringing his complaints to Congress in the late 1980s where he received a sympathetic hearing from Illinois representative Sidney R. Yates, chairman of the subcommittee that oversaw Smithsonian appropriations. Kinard was quite frank, blaming the Smithsonian's failures on racism. The institution's leadership was not receptive to this message, however, and Kinard's criticisms were given only token attention before his untimely death in 1989 at the age of fifty-three.[21]

Although Kinard, Ripley, and other Smithsonian officials discussed the possibility of the Anacostia Museum becoming the African American history and culture museum for the Smithsonian, it was decided that another museum was needed on the Mall, a goal that would not be fulfilled for decades. Meanwhile, the Anacostia Museum would stay focused on serving its community. Kinard favored a plan for expanding the museum that involved moving from the storefront location and constructing a larger building in a park on the Anacostia River. In the mid-1980s, the museum did move, but to a renovated facility at Fort Stanton Park—not the river location Kinard desired—where it remains today. The challenges of the

Anacostia Museum and its evolving character were reflected in its name changes. In 1987, it changed its name to the Anacostia Museum, dropping "Neighborhood" to reflect the national and international reach of its exhibitions. Then, in 1995, it became the Anacostia Museum and Center for African American History and Culture, and finally, after the authorization of the National Museum of African American History and Culture in 2004, it became the Anacostia Community Museum.[22] For all of its trailblazing significance, it struggled to find its identity in the Smithsonian complex. Although various factors contributed to this situation, a major issue was space. Having their own space allowed the Anacostia Museum's staff to do many things that more traditional curators never would have attempted in other museums, but it also made their work marginal, almost invisible, in the larger complex of which it was a part. The other determinative factor was a paternalistic attitude on the part of Smithsonian officials toward the community museum, which was seen as not being on the level of the Smithsonian's other museums in terms of research and exhibitions. Kinard and other museum staffers fought this characterization vigorously but were unable to overcome it.[23]

Although Anacostia was marginalized because of its location and community-based nature, it did have a permanent, year-round space in which to present exhibits and programs. The Festival of American Folklife was centrally located on the National Mall, but it was an ephemeral event and, as such, could only reach visitors who came during a brief window of time in the summer. Nevertheless, the festival garnered many more visitors than the Anacostia Museum with hundreds of thousands—and in 1976, millions—of people taking part in its programs. Here, then, the Smithsonian had a real opportunity to fundamentally transform the way a large number of visitors viewed and interpreted non-white cultures. In its American Indian programs, the festival offered a significant alternative to traditional museum exhibits.

When American Indian activists occupied Alcatraz Island in San Francisco Bay in November 1969, one of their central demands was for the federal government to cede the island for the construction of an "All-Indian University and Cultural Complex." The proposed complex reflected the desire on the part of the island's occupiers for Native control over the study of American Indian society, culture, and religion and was part of a burgeoning trend among American Indians both on reservations and in cities toward revitalizing Native cultures and reorienting scholarship on American Indians.[24] It demonstrated the widespread attitude among Native

peoples that conventional, white-dominated institutions did not fairly or accurately represent their lives and traditions. One such institution was the Smithsonian. In July 1970, while the occupation of Alcatraz continued, however, the Smithsonian experimented with a new approach to the exhibition of Native cultures, one that held the promise of fundamentally transforming the institution's relationship with American Indians. That summer, the Festival of American Folklife premiered a new American Indian program, which combined presentations of Native traditions with panel discussions of contemporary social, political, and economic issues facing Native communities.[25] More than three decades before the National Museum of the American Indian opened in Washington, the Smithsonian debuted a type of exhibition that involved American Indians interpreting their own histories and cultures.

This period of turmoil was the beginning of a long journey for the Smithsonian—and American museums, in general—toward new modes of exhibiting and interpreting Native histories and cultures. It was also the start of a journey for Native scholars and activists such as George Horse Capture, who found inspiration and empowerment through participation in the Alcatraz occupation and whose career path eventually led to an important position as a curator and administrator at the National Museum of the American Indian. Horse Capture was part of a rising generation that drew on the impetus that Alcatraz provided to pursue new cultural, political, and intellectual projects that ultimately moved Native scholars and activists to the center of national conversations about American Indians.[26] From the 1960s onward, American Indian leaders, scholars, and communities embraced the social and political goal of self-determination at the same time that they embarked on cultural renewal and revitalization projects. Tribal museums and cultural centers often played important roles in these efforts, and, over time, particular tribes, cultural organizations, and individuals were able to construct powerful narratives of Native history and culture that challenged dominant representations at institutions such as the Smithsonian.

Starting in the 1970s and accelerating in the '80s and '90s, Smithsonian officials began responding to internal and external pressures to revise dated representations of American Indians in the institution's museums and initiate programs that drew more Native peoples into the process of collecting, preserving, and interpreting Native objects. This process took decades and was deeply contested.[27] Smithsonian officials not only wrestled with the major issue of whether and how to create a separate American Indian museum; they were also at the center of the repatriation controversy

and debates over how to repair the discipline of anthropology's relation-ship with Native peoples and communities. Moreover, curators struggled with how best to incorporate Native histories into the broader narrative of American history. Despite the relatively large (and growing) body of lit-erature on the Smithsonian and American Indians in the late twentieth and early twenty-first centuries, however, one of the Smithsonian's earliest, and most intriguing, projects in this broader effort to accommodate the shifting landscape of Native representation has not received much attention. The Festival of American Folklife's American Indian presentations offered an experimental, even radical, alternative to conventional museum displays. No doubt inspired by what was occurring among Native communities on reservations and in cities in the late 1960s and 1970s, the festival's Ameri-can Indian programs from 1970 to 1976 invited Native people to interpret their own cultures and traditions on the National Mall for hundreds of thousands, even millions, of Smithsonian visitors.

Conceptualized by Clydia Nahwooksy, a Cherokee woman from Okla-homa who worked in the federal bureaucracy, the festival's American Indian programs marked a significant departure from the Smithsonian's previous modes of displaying Native peoples. Instead of static ethnographic displays designed by white male curators, the festival was a dynamic "liv-ing exhibition" curated by both Native and non-Native peoples.[28] Because it relied on presentations by actual people, rather than featuring exhibits of objects, the festival bore a superficial resemblance to the ethnographic displays popular at the world's fairs of the late nineteenth and early twen-tieth centuries, which the Smithsonian had played a large role in organiz-ing. Indeed, in its inaugural year, a member of Congress worried that the festival would be a "midway on the Mall"—evoking the famed midway of Chicago's 1893 World's Columbian Exposition. In actuality, however, the festival was something entirely new—not an exploitative display of exotic Others, but an effort to encourage dialogue and cultural understanding among disparate groups of Americans.[29]

Working with tribal representatives, national Indian organizations, and scholars, Nahwooksy designed presentations that featured demonstrations by cultural practitioners along with discussions of pressing issues such as the federal policy of termination, land claims, state and federal recogni-tion for unrecognized tribes, and treaty rights. These presentations, she hoped, would serve both to counter stereotyped portrayals of American Indians in mass culture and to focus attention on important issues in Native communities. The American Indian program at the 1970 festival—and subsequent festivals through the Bicentennial year of 1976—challenged the

idea that politics and culture existed in separate spheres. Studying traditions in isolation, according to Nahwooksy, led to pernicious stereotypes of Native peoples. Stereotypes of Indians had long had a strong hold on Americans' imaginations, from the "Vanishing Indian" of James Fenimore Cooper's novels and the bloodthirsty "savages" depicted in dime novels of the nineteenth century to the popular Westerns of the mid-twentieth century and the New Age spiritualism of the hippies.[30] Museums along with popular media, she argued, had purveyed images of Indians that had had a devastating effect on social attitudes and government policies. It was essential therefore to provide detailed information about contemporary Native communities when arranging exhibits of traditions. A direct challenge to romanticized and therapeutic notions of tradition, the festival's American Indian programs in these years offered an unflinching portrait of the contemporary lives of Native peoples.

Situating traditions in the context of the communities from which they emanated was a challenging task. It involved balancing a range of political opinions and social concerns, which meant that Nahwooksy had to devise modes of presentation that were flexible enough to address competing ideologies as well as local, regional, and national issues. Nahwooksy was ideally suited to this role, and she succeeded in coordinating annual presentations at the festival that offered space for a range of opinions during her tenure as coordinator of the festival's American Indian programs from 1970 to 1973. In such a tempestuous period, this open atmosphere was difficult to achieve, and her successors from 1974 to 1976 struggled to maintain it. Still, for a brief period the festival provided a space where the disparate blocs of American Indian politics could air their grievances, lobby for their interests, and find common ground with one another.

Native peoples voiced a wide range of opinions, stretching across the political spectrum, in the post–World War II era. Several national organizations addressed American Indian social, cultural, political, and economic issues in this period. Founded in 1944, the National Congress of American Indians (NCAI) played a central role in challenging the federal government's policy of termination—the effort to end the government's trust relationship with individual tribes—in the fifties and sixties. Moreover, the organization took the lead in convincing the federal government to embrace self-determination as its governing principle when dealing with Indian tribes.[31] Where the NCAI favored the approach of lobbying the federal government to change its policies, other organizations emerged in the 1960s that preferred to take their grievances directly to the people. The National Indian Youth Council (NIYC) and its Ponca leader Clyde Warrior

embraced direct action as a means of challenging the white power structure as well as tribal leaders whom they viewed as too acquiescent in the face of the oppression of Native peoples.[32] Similarly, the American Indian Movement (AIM) eschewed asking the federal government for concessions, choosing instead to orchestrate boycotts and protests to challenge racial discrimination and violations of Native rights. Promoting the principles of sovereignty and traditionalism, the leaders of AIM rejected the United States government's authority over American Indians, argued that American Indian tribes were sovereign nations, and urged Native peoples to return to traditional ways of life.[33]

In addition to these national organizations, each tribe had its own leaders and governing bodies that had particular interests and priorities. In 1969, the historian and American Indian political leader Vine Deloria Jr. tallied "315 distinct tribal communities" in the United States, and the 1970 census counted 115 reservations.[34] The interests of these political units did not necessarily accord with the goals of national organizations; indeed, tribal leaders sometimes actively opposed the ideas and actions of AIM and the NIYC.[35] Moreover, many Native peoples simply found the tactics of those organizations to be distasteful. Deloria lamented this lack of unity in his landmark 1969 tract, *Custer Died for Your Sins: An Indian Manifesto.* "A national Indian meeting . . . bears more resemblance," he wrote, "to the Tower of Babel Improvement Association than it does to a strategy planning session."[36] As executive director of NCAI, Deloria had witnessed first-hand the difficulties of balancing competing tribal and community interests. Unity, at least in the way that white government officials and scholars imagined it, was not achievable nor was it desirable for most Native leaders. Comparing American Indian activism with the Civil Rights movement, Deloria conceded that "Indians . . . will never have the efficient organization that gains great concessions from society in the marketplace. We will never have a powerful lobby or be a smashing political force." Unity among Native peoples, he contended, was closer to ideas of brotherhood or fraternity than something resembling a monolithic political organization. Because of the diversity of tribes, clans, bands, and Native communities, American Indian politics would always be fragmented.[37] It was into this arena that Clydia Nahwooksy stepped as she attempted to launch a new program of American Indian presentations at the Festival of American Folklife. Before we explore Nahwooksy's efforts to create a new approach to the display of Native cultures at the 1970 festival, however, it is necessary to examine festival organizers' earlier attempts at presenting American Indian traditions.

Issues of race and cultural diversity were a concern of the festival's or-
ganizers from the beginning. Although not directly involved in the Civil
Rights movement, Rinzler had participated in sessions at the Highlander
Folk School where issues of race were discussed and was part of a milieu,
which included Pete Seeger, Guy Carawan, and Joan Baez, rooted in the
folk revival that strongly supported the African American freedom struggle.
In founding the festival, he had envisioned it as a corrective to the Smith-
sonian's nearly exclusive focus on Euro-American cultural history in the
Museum of History and Technology. As a result, from the beginning,
white, black, Asian, Native American, and Hispanic tradition bearers shared
space each summer in its programs.

The central issue that the Smithsonian faced when addressing issues of
race on the Mall was how to balance the largely celebratory nature of its
displays with a more sober and realistic perspective on the past and present
of racial dynamics in the United States. In a special issue of the *Journal of
American Folklore,* which examines the Smithsonian festival, the American
studies scholar Heather Diamond writes: "If visitors do not get below the
celebratory [festival] surface, diversity can be artifacted as benign, cohesive,
and depoliticized, qualities that belie the actual histories and socioeconomic
circumstances of many of the groups whose experiences are presented and
performed."[38] The challenges of presenting these histories were consider-
able. As a government-funded institution, the Smithsonian had to be sure it
was not offending too many of its constituents, and therefore it had to tread
lightly when addressing potentially controversial issues. Moreover, under
the Hatch Act of 1939, federal employees were prohibited from participat-
ing in political activity, especially if that activity advocated the "overthrow
of our constitutional form of government in the United States."[39]

The festival's presence on the National Mall—the hotly contested,
meticulously designed symbolic grounds at the nexus of Washington's
"monumental core"—offered both opportunities and challenges to festival
organizers.[40] The proximity of the festival to the Capitol Building and the
White House opened the very real possibility that its presentations could
have a direct influence on lawmakers. The Smithsonian, of course, had to
share the Mall with successive waves of large demonstrations beginning
with the March on Washington in 1963 and continuing through the massive
protests against the Vietnam War, as well as other large political gatherings,
such as the Poor People's Campaign in 1968. These demonstrators clearly
saw the Mall as a site for making both symbolic and practical demands of
the federal government and the nation as a whole. As Judy Scott Feldman,
president and founding member of the National Coalition to Save Our

Mall, has written, "The Mall is not just a park; it is a democratic idea. What happens to it, and on it, is a physical expression of the nation's historical memory, its cultural values, hopes, and sense of the future."[41] At the same time, the Smithsonian was not a political organization and, therefore, festival organizers' first priority was the education of their audience. The Mall, in this sense, became an open-air classroom as well as a meeting space where civil dialogue could occur.

Although the festival included Native cultural practitioners from its inception in the summer of 1967, before 1970 it did not have a specific program to organize American Indian presentations. Native practitioners demonstrated their skills on the same stages and under the same tents as black, white, Latino, and Asian participants.[42] In its early years, Ralph Rinzler and the festival's other non-Native curators found organizing presentations of Native traditions particularly challenging. Without training in ethnographic methods or much first-hand experience interacting with Native communities, they lacked the knowledge or skill to work effectively with Native cultural practitioners on successful presentations. Examining the shortcomings of these early presentations illustrates why Nahwooksy believed a new approach was essential.

While organizing the 1968 festival, Ralph Rinzler conducted fieldwork among Lummis in Washington State and Tiguas in Texas. In Texas, he witnessed a community event in which Tiguas danced from a Catholic church to ovens where they baked bread and held a ceremony based on the Catholic service. For Rinzler, this event was remarkable because it seemed to give direct evidence of cultural syncretism, and he decided to re-create it on the Mall so that visitors might garner the same lesson from it. Similarly, while visiting the state of Washington, Rinzler saw that Lummis had made spinning wheels out of foot-operated dentist drills and sewing machine motors to spin yarn for knitted products that contained traditional patterns. Finding traditional craftwork created on modern, electrified machinery fascinating, he invited the weavers to present their skills at the festival. Rinzler hoped that by observing these craftspeople visitors to the festival would gain an understanding of how cultural practitioners adapted traditions in modern society without discarding them altogether. His aim in bringing Lummi and Tigua dancers and craftspeople to the festival, then, was not primarily to expand the public's knowledge about specific communities but to make a more general statement about the ways in which traditions transformed over time through the development of new technologies and contact with other cultures. He was concerned with the nature of tradition, not with making a statement about the contemporary social, political, and

economic issues facing Native communities. This desire to use American Indian culture to illuminate broader arguments about how traditions operated in modern society reflected Rinzler's priorities as well as his ignorance of Native peoples' ideas about their particular cultures and his distance from American Indians' social and political concerns.[43]

Another example from the 1968 festival symbolized the difficulties Rinzler faced in directing presentations of American Indian traditions and, ultimately, served as a catalyst to convince him to seek assistance in presenting Native traditions at future festivals. That year, Rinzler worked closely with Joe Washington (Lummi) on a presentation of Native basketry that depicted creation myths and important cultural symbols. The disparity between Rinzler's plan for the presentation and Washington's execution of it demonstrated the gap between Native and non-Native expectations for the festival's American Indian programs. Beforehand, Washington, who was coached by Rinzler, practiced discussing slides projected onto a large screen.[44] In Rinzler's idealized vision, the talk would have resembled an academic lecture. In front of the festival audience, however, Washington took a different approach. He began by thanking the Smithsonian for inviting the Lummis to take part in the festival and then talked about how he had been working with an anthropologist for the past three years to document Lummi traditions. Instead of turning to a description of basketry at this point, he began discussing the plight of American Indians in general terms, alluding to the violation of treaties and court decisions about land issues. Only after singing a song and discussing a Lummi stick game did he begin talking about basketry, explaining how one basket depicted a famine while another showed great plenty. He then spoke more generally about the Great Spirit and turned again to contemporary issues, expressing despair about the challenges facing Native peoples in American society. After singing two more songs and mentioning his military service during World War II, he thanked Rinzler and the festival staff and concluded his presentation.[45]

For Rinzler, the program was a complete disaster. Instead of providing a focused and detailed explanation of Lummi basketry, Washington had interspersed social and personal commentary, the Native cultural practice of honoring, and a generalized discussion of American Indian religion. Visitors, Rinzler feared, gained little specific knowledge about Lummi traditions from this presentation.[46] For Washington, however, the presentation served a different purpose. Speaking at a widely visited event on the National Mall in Washington, D.C., offered him a rare opportunity to discuss a variety of issues important to him and other Lummis. By lecturing only on Lummi baskets, he would have lost the chance to influence festival visitors'

attitudes about Native issues and to express his personal opinions. More-over, he would have effectively removed the baskets and their symbols from the larger social and cultural context in which they were produced.

Rinzler's perception of the presentation's failure was rooted in his con-ception of what constituted ideal exhibit practice as well as his unfamiliar-ity with Lummi cultural practices and the pressing issues facing Native communities in the Pacific Northwest, such as fishing rights. After this presentation, Rinzler realized he needed help for future festivals, and so he turned to Clydia Nahwooksy. Working as a volunteer on the 1969 festival, she began developing ideas about how to improve its American Indian presentations.[47] According to Rinzler, Nahwooksy called him and they "discussed the need to do something with Native American programming which was more comprehensive than simply placing Indians in a program in the midst of a lot of ethnic and Anglo material."[48]

Clydia Nahwooksy's background and training made her the perfect candidate to organize a large-scale presentation of American Indians. She had grown up in a traditional Native community in Oklahoma, and, in the early fifties, attended the University of Oklahoma, where she met her husband, Reaves Nahwooksy (Comanche-Kiowa). In 1961, they and their three young children moved to Washington, D.C., where Reaves attended a federal management training program. In 1964, the family relocated to Fort Hall, Idaho, when Reaves secured a position with the Bureau of Indian Affairs (BIA) working with the Shoshone and Bannock tribes. In Idaho, Clydia and Reaves gained valuable experience improving strained local relations between whites and Indians. In 1967, the Nahwooksys returned to Washington and Clydia went to work for the Indian Health Service.[49] Here, she was exposed to a large-scale picture of the social challenges facing Native peoples. Also in this period, Reaves was appointed to the National Council on Indian Opportunity, headed by Vice President Hubert Humphrey—a position that signaled his importance as an American Indian leader in Washington—and, in 1969, he joined the Department of Housing and Urban Development, where he worked on federal housing policy for American Indians.[50] Through her own and her husband's work in the fed-eral government, Clydia Nahwooksy became familiar with a host of issues facing Native American communities and acquired contacts that became invaluable in her position with the Smithsonian.

The Nahwooksys were part of a liberal movement within the federal Indian bureaucracy, which sought to change the status quo in Washington and improve the ways in which the federal government served Native peoples.[51] In this period, President Nixon signaled a willingness to support

the principle of self-determination. As part of these reforms, he appointed a new Commissioner of Indian Affairs, Louis R. Bruce (Mohawk-Sioux), who brought a team of young administrators to the BIA to implement significant changes.[52] Bruce was sympathetic to the complaints of American Indian activists and sought practical gains that would improve Native social and economic conditions and increase control over tribal policies. In this period, Bruce's task was a challenging one. He had to convince Native leaders to cooperate not only with the BIA, an agency that many deeply distrusted because of its history of paternalistic policies, but also with each other across tribal and political lines. At the festival, Nahwooksy faced a similar challenge in persuading Native peoples to join an exhibition at the Smithsonian, an institution that had an equally long history of questionable policies and practices toward Native peoples. Her dynamic personality and bureaucratic experience served her well in this capacity as she effectively navigated the interests and demands of diverse groups.

Over the course of the fall of 1969 and the spring of 1970, Nahwooksy, Rinzler, and other Smithsonian staff members worked out a new approach to presenting American Indians at the folklife festival. Meeting with Smithsonian staff in the Department of Anthropology and the Center for the Study of Man, Nahwooksy sketched a plan for the program. It would, they agreed, include both presentations of traditions and discussions "on some aspect of [American Indian] culture and the problems of being Indian in order to offset the stereotype image of Indians as people who only dance and make moccasins." It was also decided that each year's festival would focus on a different region.[53] Meanwhile, Nahwooksy cultivated her contacts among Native leaders in the federal bureaucracy and across the country and, through fieldwork in Oklahoma and Kansas, located prospective participants.[54] In January 1970, she was listed as part of the executive committee of the newly formed National Council on Indian Awareness. Commissioner Bruce hosted the group's organizational meeting, the stated purposes of which were to provide a forum for discussion, "to promote a national awareness of the conditions . . . among the American Indians," and "to project the American Indian as he is today [while] recognizing his rich heritage." Dubbing 1970 the "Year of Indian Awareness," the Council balanced a recognition of the presence of strong Native traditions with an awareness of the realities of contemporary Indian life.[55]

Finally, after months of intensive preparation, Nahwooksy directed the festival's American Indian presentations in July 1970.[56] The festival featured Indians of the Southern Plains—a logical choice for Nahwooksy but also an ironic one given her emphasis on counteracting stereotypes. The

decision to focus on the Plains was made in consultation with Jack Ewers, who encouraged featuring the region to which he had devoted so much of his research.[57] For many Americans, the image of the Plains Indian, which included war bonnets, teepees, and horse riding, had come to symbolize all Indians.[58] The festival's presentation of Plains cultures, however, did not reinforce the stereotyped depictions in films, television shows, and other popular media. About thirty Osage, Delaware, Kickapoo, Ponca, Potawatomi, Comanche, Cheyenne, Kiowa, Choctaw, and Apache craftspeople demonstrated traditional crafts, while more than twenty-five singers, dancers, and narrators performed songs and dances.[59] They presented, among other things, teepee raising, cooking, a traditional hand game, crafts such as beadwork, and a war dance.[60] They also held a nightly powwow on the Mall. Interviewed at the festival, Clydia Nahwooksy said, "At most fairs and exhibitions white people see Indians out of context . . . Here we've tried to arrange a program more representative of the life style of a people."[61] Putting traditional cultural practice in proper context was a vital goal of Nahwooksy's for the program. She believed that this mode of presentation countered the stereotypical view of American Indians as peoples frozen in a primitive past.

Set apart from the festival's other craftspeople and performers, the American Indian participants presented in the "Indian Area."[62] Whereas in earlier festivals, Native participants had shared tents and stages on the Mall with non-Native participants, this year's American Indian program created a clear demarcation between Native and non-Native presentational space. Unlike in the Smithsonian's museums, however, where white curators and officials decided to separate Native and non-Native cultures into racialized spaces, the festival's organizers made this decision in consultation with Clydia Nahwooksy. In their view, a separate space was necessary to show Native cultures in their proper context. Nevertheless, this space was still very much a part of the broader context of the festival, which presented a wide range of cultures. Visitors, for example, were able to pass freely from musical performances by white musicians to American Indian dances to craft demonstrations by black craftspeople. Unlike the Smithsonian's buildings, where large permanent walls and long city blocks separated exhibits of Euro-American culture in the National Museum of History and Technology from exhibits of Native cultures in the National Museum of Natural History, the festival presented a culturally diverse exhibition in a relatively small and easily navigable space.

Along with craft demonstrations and performances, the festival featured panel discussions. These discussions explored both Native traditions and

social, political, and economic issues. Addressing the topics of: "Medicine and Religion," "Traditional Indian Crafts in Contemporary Life," "Indian Rights," "Ceremonial Songs," "History and Legends," and "Leadership and Indian Youth," the panels drew participants from tribes from all over the country.[63] Some of these participants were national leaders of Indian organizations or federal bureaucrats; others were tradition bearers or local leaders.

At the crafts panel, Jack Tointigh, a Kiowa-Apache silversmith, talked about learning his craft. "I haven't been [doing] this very long," he told the audience, "but I try to keep this up. I was surprised to know that there [weren't] very many silversmiths among our tribe."[64] Challenging the common assumption that Native traditions had been passed down in an unbroken chain for generations, Tointigh spoke about learning a new traditional craft. His motivation was both cultural and economic. "When I got into this work," he said, "I was surprised at how much in demand it was." Also part of this panel was Bertha Little Coyote, a Cheyenne craftsperson. She spoke about moccasin making, for which the Cheyenne were noted, and other traditions related to clothing, such as beadwork. In the course of speaking with audience members, Little Coyote discussed how contemporary Cheyenne craftspeople bought commercially tanned buckskin because tanning work was difficult and because deer and antelope were not native to Oklahoma as they had been to their traditional plains homelands. She recalled that in the past some of the older people had tanned hides, but very few people, if any, were currently doing it.[65] From this statement, audience members received a realistic portrait of traditions in a modern age. Most Native peoples did not have the time, knowledge, or resources to produce traditional crafts exactly as their ancestors had. Instead, they used more readily available materials while preserving older forms.

Not all interactions with the audience were this productive and informative. Audience members sometimes pressed the panelists for information that was outside their expertise. A female audience member, for example, persistently questioned the panelists about preparing feathers for clothing. This question had little to do with the craftwork being discussed and reinforced a stereotypical view of Native traditions. Eventually, though, an audience member asked an intriguing and respectful question about the symbolism of beadwork. In response, the panelists stressed individuality. Generally, they said that they did what was pleasing to them as individuals. Again, this response offered festival visitors a complex portrait of traditions in contemporary society. The tradition bearers focused on individual taste, rather than broader cultural significance when discussing symbols in their

work. At the conclusion of the panel, Clydia Nahwooksy addressed the audience and offered a broader lens through which to view the program. She spoke about how the traditional apparel on display was at one time part of the everyday dress of Native peoples but now was used only for ceremonial occasions. Attempting to offer visitors a snapshot of contemporary Native life, she said: "We like to get together and share in ceremonies and festivals and dances and most of what we're making now in the Southern Plains group is used for those occasions. Some is used as a means of an increase to the economy of a particular family or an individual. . . . But very often we have people who make things only to give to their family [or] to give to their friends for use in the ceremonies or in the powwows." Another participant, Rusty Wahkinney (Comanche), summed up the place of cultural traditions, such as powwows, in contemporary life: "I work five days a week, sometimes six, and Saturday night I'm ready to go to a powwow just for enjoyment. And this is what we want you folks to know instead of some people have the idea that an Indian on TV you know chasing and shooting arrows at somebody or something like that. We don't live like that anymore."[66]

While some panels addressed traditions, others took aim at social, political, and economic issues facing American Indians. One panel, for example, addressed the subject of "Indian Rights."[67] Moderated by Reaves Nahwooksy, the panel included Frank Ducheneax (Cheyenne River Sioux), a BIA official; Sylvester Tinker, newly elected chief of the Osage tribe; Browning Pipestem (Osage and Otoe), a lawyer who handled Indian rights cases; and Loretta Ellis, Minneapolis Regional Vice President of the National Congress of American Indians.[68] They addressed a wide range of issues, including health care, racial discrimination, housing, land claims, termination, the relocation of reservation Indians to cities, and treaty rights.[69] Although the panelists did not discuss any of these topics in depth, they introduced festival visitors to some of the significant social challenges facing American Indians.

One specific issue that the panelists did address was the Apostle Islands controversy. In 1970, Congress was considering a bill to create the Apostle Islands National Lakeshore in Wisconsin. Native American activists such as Loretta Ellis vehemently opposed this bill because it included the annexation of large tracts of Indian reservation land.[70] Speaking about the issue at the festival within clear sight of the Capitol Building, Ellis clearly hoped to influence public and congressional opinion on the subject. This coordination of panel discussions with bills under consideration in Congress would become a pattern at subsequent festivals. The Apostle Islands issue also

surfaced outside the sanctioned parameters of the festival. Holding a sign that read: "All Indians Oppose Apostle Island Park Bill," young Indian activists protested the proposed government action at the festival. The activists' ire, however, was not only directed at the park bill. They took issue with the festival's presentations of Native traditions, arguing that they did not accurately depict contemporary Native life. In an action that characterized her ability to communicate effectively with Indians who held differing social and political views, Nahwooksy spoke with the protestors and convinced them to join a panel on "Leadership and Indian Youth." "We want to get as much representation from all of the Indian people as possible," she said to one of the protestors who was a member of the National Indian Youth Council, "we see this as a forum to speak out." Her effort at persuasion was successful, and the activist leaders willingly joined the panel.[71]

Overall, the festival's first attempt at presenting a new American Indian program had been a success. Merging social and political commentary with demonstrations of traditions, it offered an alternative form of cultural exhibition where Native peoples took the lead in presenting their cultures and communities. Hoping to capitalize on this success, Nahwooksy drew up a plan for an "American Indian Awareness Program" to be located at the Smithsonian. The program she outlined suggested a complete reorientation not only of the way the Smithsonian presented Native cultures but also of how the institution engaged with Native communities. In order to increase public knowledge of contemporary Indian life, Nahwooksy's proposal included continued Native presentations at the Festival of American Folklife, touring programs, symposia and workshops, and educational and outreach programs. The American Indian Awareness Program had seven objectives: 1. to encourage Indian writers and artists to produce media on contemporary Indians; 2. to serve as a liaison between various governmental and private Indian organizations; 3. to recognize the rich heritage and contributions of Native cultures to American society; 4. to enrich and extend the Smithsonian's programs and coordinate efforts with other museums and cultural centers; 5. to correct "stereotyped misconceptions of the Indian's position in the community and nation"; 6. to promote tribal cultures and identity as a valid way of life; and, 7. to encourage better understanding between Native and non-Native peoples. These objectives demonstrated Nahwooksy's ambition to make the Smithsonian a national center for transforming public perceptions of Native peoples and revitalizing American Indian cultural heritage.[72]

Commissioner Bruce enthusiastically supported Nahwooksy's proposal and offered to provide funding for the program.[73] The Smithsonian also em-

braced it and by late 1970, it had been officially established at the institution. Speaking about it with a reporter from the *Baltimore Sun,* Nahwooksy said, "We're trying to offer the Indian people through various mediums an opportunity to share their culture in their own way and their own words." For Nahwooksy, the program both recognized the diversity of Native peoples in the United States and spoke to a common Indianness that transcended tribal boundaries. Balancing social and political advocacy with an attention to traditions was Nahwooksy's goal. "If you gain money and health," she told the reporter, "but lose the feeling of well-being and satisfaction [that traditions offer], I really don't know how worthwhile it is."[74] In this way, she offered a middle ground between the hard-core traditionalism of AIM and the moderation of tribal representatives who sought ways for American Indians to improve their material condition in American society.

The 1971 Festival of American Folklife, which featured Native peoples of Washington, Oregon, and Alaska, was the newly minted American Indian Awareness Program's first major undertaking. As at the 1970 festival, beadworkers, carvers, basketmakers, singers, dancers, and others presented traditional skills. At the same time, panels addressed social, cultural, political, and economic issues. Also as with the previous year's festival, the festival's organizers continued to challenge stereotypes of Native peoples by offering a setting for contemporary Native people to talk about their lives. "We're not encouraging the stereotype," Nahwooksy said, "but showing that the Indian is involved in modern life in many different ways."[75]

In contrast to the more general 1970 panel discussions, the 1971 festival included extensive and often highly politicized discussions of specific issues. In a panel on Alaska Native land claims, for example, an impressive group of political actors discussed the long history of Native-white legal disputes over land in Alaska and contemporary struggles to resolve the issue.[76] The panel consisted of moderator Raymond Paddock (Tlingit) of the NCAI and panelists John Borbridge, president of the Tlingit-Haida Central Council, LaDonna Harris (Comanche), founder of Americans for Indian Opportunity and wife of Oklahoma senator Fred Harris, Charlie Edwardson, executive director of the Arctic Slope Native Association, and Willy Hensley, an Alaska state legislator representing northwest Alaska.[77] Since 1867 when the United States purchased Alaska from Russia, the Native peoples of that state had been battling with the federal government over land ownership, but the issue had never been resolved. In the early seventies, however, Congress was finally seriously addressing Alaska Native land claims. Throughout the summer and fall of 1971, this issue was before Congress as both the House and Senate passed bills settling the land claims. Finally,

in December 1971, Congress approved a final bill and sent it to the White House to be signed. With President Nixon's approval, the act awarded Alaska's Native peoples 40 million acres and $962.5 million.[78] The festival's panel discussion, then, must be viewed as part of a broader campaign to influence Congress and the American public to support Alaska Native land claims. Speaking on the Mall, the panelists used the space of the festival as a platform to advocate for a specific local issue.

Other panels addressed issues that had a similar immediacy. In a session moderated by Vine Deloria Jr., panelists discussed the federal policy of termination.[79] On the panel were members of the Choctaw, Klamath, Menominee, and Colville tribes, all of which either had been terminated or had faced the threat of termination. Panelists such as Jim White (Menominee), who was the leader of DRUMS (Determination of Rights and Unity for Menominees), mixed anger and indignation with a detailed enumeration of the negative consequences of this approach to federal-Indian relations.[80] Among other consequences, termination had led to economic strife, land dispossession, health crises, and loss of identity. Presenting at the festival was particularly important for the Menominee, who had been terminated in 1961 and were actively working to secure the restoration of their status with the federal government in this period. At the 1972 and 1973 festivals, the Menominee again had a representative pleading their case to festival visitors. At those festivals, Ada Deer, the tribe's chairwoman, combined appearances in the festival's panel discussions with active lobbying of Congress. Like any effective political leader, she sought to rally grassroots support for the bill: "We'd appreciate any letters of support that you can write to your senators and to your congressmen on behalf of the Menominee restoration act. We particularly need letters to Mr. Wayne Aspinal, who is the chairman of the . . . House Committee on Interior and Insular Affairs. We also need letters to Senator Henry Jackson, who is the chairman of the full Interior and Insular Affairs Committee."[81] Clearly, Deer hoped that her participation in the festival would lead to direct political action on the part of festival visitors.

While panel discussions addressed controversial issues, dance and craft demonstrations mixed social commentary with the presentation of traditions. During a dance performance at the 1971 festival that included Yakimas, Klamaths, Makahs, Umatillas, Warm Springs, and Lummis, a male speaker announced:

> Too many of our people in the United States are looking at our Indians on the basis of what they see on TV. Here today we're trying to show you that we're not that kind of an Indian; that we are a very happy

people, we enjoy all of our dances. When we call it a war dance, a lot of times, it should be called basically a victory dance, this could be a victory in a job where you got better employment, this could be victory in getting rid of a wife, or it could be getting a wife. I don't know if that's victory or not. So a war dance is a misnomer because our Indian people no longer war dance in the sense that we're going to war, but this is a traditional . . . [one of the dancers warningly, if jokingly, says 'hey' and others laugh] I just got shot down by a Makah. We'll go to war with words.[82]

In a conversational and somewhat comical way, this short speech illustrated that complex dynamics were at work at the festival. The dancers were not simply demonstrators of tradition; rather, they were individuals who, in the festival's dialogic atmosphere, were able to express opinions about the way the festival framed them and how they framed one another. In this instance, a participant took issue, if only jokingly, with the announcer's characterization of the War Dance no longer being literally about going to war. During the same program, singers also performed a "Flag Song," which they dedicated to "all of our veterans, all of our Indian people in Vietnam, all of our people that have died, all of our people that are living as veterans from the various wars."[83] This performance demonstrated the continued importance of a warrior culture in many Native communities, as well as the intense patriotism that some Native people expressed even as they endured poor treatment from the federal government.

Because of the open atmosphere that Nahwooksy fostered, the festival was able to host both patriotic tributes to veterans and more militant perspectives. In a panel discussion on "Indian Organizations," Russell Means (Oglala Sioux), a leader of AIM and a founder of the Cleveland American Indian Center, spoke alongside Jim Bluestone (Mandan-Hidatsa-Arikara), who was an economic development specialist for the National Congress of American Indians, Sam Cagey, vice chairman of the Lummi Business Council, and Willy Hensley. While Bluestone, Cagey, and Hensley made critical remarks about the plight of Native peoples in contemporary society, they were extremely mild beside Means's forceful presence. After briefly describing the foundation of the Cleveland center, Means turned his remarks to AIM and a litany of crimes and injustices perpetrated by whites against Native peoples. Means's impassioned speech no doubt captured the attention of his audience and perhaps even thrilled them:

We do not want civil rights or equal rights with the rest of America. We want our sovereign rights. And we want it also to be done in the traditional Indian way. . . . [W]e believe and we advocate that all Indian

Russell Means and Clydia Nahwooksy, Festival of American Folklife, 1972. Photo by Diana Davies, courtesy of the Ralph Rinzler Folklife Archives and Collections. Smithsonian Institution, neg. #78-9500.14a.

people should become spiritually oriented in the traditional Indian way. . . . We were conquered by the people from Europe in the guise of Christianity, and then they attempt to Christianize us heathens and they told us thou shall not kill. Then they proceeded to wipe out 56 Indian nations from the face of the earth. . . . The Christians also told us, thou shall not steal, and proceeded to rip off our land. . . . Thou shall not lie, and they proceeded to abrogate Indian treaties with fraud, coercion, deceit, misrepresentation, everything, and thou shall honor thy mother and thy father, and then they forced us into their schools and taught us not only to disrespect our tribe but our elders. . . . [T]he American Indian Movement's aim is not only for our sovereign rights but to teach non-Indians the meaning of the word respect. . . . The Indian does not have respect in the eyes of the non-Indian. We're feathered freaks who dance for your pleasure and practice primitive religions, if we practice religion at all. You must remember, however, that our religion taught us respect and you wouldn't have been here and you would not be here today, if we didn't have respect.[84]

Means's statement represented a powerful vision of a pan-Indian movement centered on the themes of sovereignty, tradition, and respect. For some American Indian leaders, however, Means's ideas may have seemed naïve and unrealistic—even objectionable. The goals of convincing Con-

gress to pass the Menominee restoration bill, or resolving Alaska Native land claims, or securing adequate social services for one's reservation may have seemed more tangible and achievable. Due in large part to the effective leadership of Clydia Nahwooksy, the American Indian Awareness Program managed to accommodate such diverse opinions within the bounds of the festival. This cooperation would not last for long, however, in the contentious and rapidly changing environment of the early seventies.

The 1972 festival featured Native peoples of the Southwest and followed the model of its predecessors. Before the next year, however, complications arose outside of the Smithsonian that threatened the feasibility of coordinating a large-scale American Indian program at the festival. In November 1972, the "Trail of Broken Treaties," a cross-country caravan of Native American activists from a variety of organizations including AIM and NIYC, arrived in Washington to deliver a letter concerning American Indians' relationship with the federal government to the President. Poorly organized, the group lacked sufficient housing accommodations in Washington and, in an unplanned move, ended up occupying the Bureau of Indian Affairs building. Over the course of the occupation, the activists hung a banner that read "Native American Embassy," vandalized the building, and stole or destroyed BIA documents.[85] Then in February 1973, another major act of Indian civil disobedience occurred—the takeover of Wounded Knee by AIM activists. In this seventy-one day uprising, which took place on the Pine Ridge Reservation in South Dakota at the site of the 1890 massacre of Sioux men, women, and children by American soldiers, members of AIM as well as Oglala Sioux from the reservation confronted government and tribal law enforcement who had laid siege to their position.[86] This standoff and the BIA takeover represented the apex of American Indian activism in this period.

Festival staff members were not militant in the way that the BIA occupiers or the participants in the Pine Ridge uprising were. There were, however, connections between the American Indian Awareness Program and these events. Clydia Nahwooksy loaned a teepee from the festival's collection to the "Trail of Broken Treaties," which they set up on the BIA grounds.[87] Moreover, Russell Means, one of the leaders of the Pine Ridge uprising, had spoken at the 1971 and 1972 festivals. At the latter festival, in fact, he spoke about AIM's work at Pine Ridge *before* the takeover. "My brothers and I," he said, "have returned home after experiencing the white man for a while. . . . [O]ur land is situated in the remotest area of the [Pine Ridge] reservation and it's only accessible by horseback or by walking. . . . [W]e . . . have . . . started building [a] spiritual youth center."[88] Because of

the BIA takeover and Wounded Knee, Nahwooksy and her fellow curators had to negotiate a highly charged atmosphere when organizing the 1973 festival. Complicating matters was the fact that Nahwooksy was attempting to secure a renewal of the American Indian Awareness Program's contract with the Smithsonian. This process was made especially difficult by the forced resignation of Commissioner Bruce after the BIA occupation. Without Bruce, the program lost its main funding source, and, consequently, the Smithsonian chose not to continue it.[89] Despite organizing highly successful presentations of Native peoples at the folklife festival as well as a traveling exhibit of photographs and a weeklong program of American Indian cultures in Montreal, the American Indian Awareness Program would cease to exist after 1973.[90] The festival's presentations of Native cultures would continue, but not under the larger umbrella of the program.

An additional challenge in organizing the 1973 festival was the fact that the planned regional group to be featured was Indians of the Northern Plains, an area that included Pine Ridge. The uprising threatened to upset the balance of the festival's panel discussions, which heretofore had comfortably accommodated a wide range of social and political opinions. The organizers took pride in successfully providing a forum for Indian leaders who spanned "the entire range of Indian culture and viewpoints." In an internal memo that year, they boasted that "the American Indian Movement has been represented several times by Russell Means on panel[s] dealing with Indian organizations, Rights and Cultural Programs . . . [and] the National Tribal Chairman's Association, through Charles Edwardson and Buffalo Tiger, has participated in panels on Alaska land claims and Indian Treaty Rights."[91] AIM and NTCA were at opposite ends of the political spectrum and yet had managed to coexist within the festival's framework. In the same memo, however, Indian Awareness's organizers worried that the BIA takeover and Pine Ridge, along with the attendant changes at the BIA resulting from these events, would have a disruptive effect on their program. They also feared that in an atmosphere of intense American Indian activism, the institution would become a target for protestors. In response, Smithsonian officials considered canceling Native participation in the festival that year but quickly rejected the idea because it would have disappointed visitors and called AIM's attention "to the scarcity of Smithsonian programs [actively] involved in Indian cultural activities." Instead of dropping American Indian participation, festival curators proposed a series of discussions "to be held away from the main Festival grounds, upon the general topics of Indian Affairs. This type of conference," they argued, "is in keeping with the precedent of the Festival in discussing Indian questions

openly and non-politically."[92] Even in this most contentious year of Indian activism, then, the festival's organizers hoped to provide a neutral forum for an informed discussion of issues facing Native peoples.

At the festival, however, they were not particularly successful at presenting differing social and political viewpoints. Crow, Northern Cheyenne, Arapaho, Cree, Sioux, and Blackfeet singers, dancers, and craftspeople demonstrated their skills as other tribes had at previous festivals.[93] On the festival grounds, the conflict at Wounded Knee surfaced in subtle ways. At a dance performance, a male announcer said, "I am a Sioux Indian from South Dakota. Whenever we hear about the Indian people, we usually read about them or see their activities on the television in a way that none of us really don't care to be identified as."[94] Without naming AIM, the speaker clearly rejected their approach. On the other hand, the festival also included a presentation by medicine man Henry Crow Dog, father of Leonard Crow Dog, also a medicine man, who assisted the wounded during the Pine Ridge uprising.[95] In this way, the festival's presentations achieved some balance of viewpoints. The panel discussions, however, failed to engage the complex and urgent issues raised by Pine Ridge.

Only one panel discussion, in fact, took place that year and, as planned, it was held away from the festival grounds. The relatively harmonious and optimistic atmosphere of the American Indian program's early years had disappeared. The events of the past year had overshadowed the work of liberal Washington intermediaries who sought to garner support for reforms from across the political spectrum. Clydia Nahwooksy's opening statement at the panel revealed the frustrations she felt at not being able to represent the full range of Indian perspectives. She told the audience that she had hoped to include spokesmen from AIM and NTCA in the discussion along with leaders who presented "viewpoints which are not quite so polarized."[96] The AIM and NTCA spokesmen failed to appear, however. Without them, the panel had little hope of creating a rapprochement among Indian leaders. Instead, the panelists included only members of the liberal Indian establishment. The recently deposed Commissioner Bruce, for example, moderated the discussion. In addition, Reaves Nahwooksy participated along with Ada Deer and Louis LaRosa, chairman of the Winnebago Tribe. All of the panelists shared the militants' anger at the treatment of Native peoples, but they favored practical strategies for achieving change. LaRosa expressed the ambiguity these leaders felt about their position: "In many cases, I'm a sellout to both sides . . . I have to be as realistic as possible." The diverse and tolerant atmosphere that Nahwooksy had imagined when she created the American Indian Awareness Program

had given way to a polarized environment that was, at least for the time being, not conducive to such a forum.

In 1974, Nahwooksy left her position as coordinator of American Indian programs, although she stayed on as an advisor through 1976. In the 1980s, she would become a Baptist minister and return to Oklahoma, where she lived until her death in January 2010.[97] The festival's American Indian presentations continued despite the change in leadership and the loss of the American Indian Awareness Program. Most important, the model Nahwooksy had created remained the guiding framework for the festival's American Indian programs through the summer-long Bicentennial Festival of American Folklife in 1976, a landmark exhibition in the Smithsonian's history that is the subject of the next chapter.

Under the leadership of Lucille Dawson (Narragansett), the festival's American Indian programs—now dubbed "Native Americans"—continued to include both presentations of traditions and discussions of contemporary issues. Dawson was assisted by the anthropologist Thomas Kavanagh, who had been involved with the festival for a number of years, and advised by a newly convened Native American Advisory Group.[98] Over the course of two years, Dawson, Kavanagh, and their staff and advisors confronted the daunting task of organizing presentations for the twelve weeks of the Bicentennial festival while continuing to oversee smaller programs at the 1974 and 1975 festivals. With new leadership, the main change from earlier festivals was an increased reliance on tribes to develop their own presentations. Where Nahwooksy had drawn on her extensive connections in Washington and throughout the country to assemble participants for the festival's craft demonstrations, performances, and panel discussions, Dawson and Kavanagh turned to tribal leaders to recruit participants and design programs. Although festival staff continued to conduct field-work, issue guidelines, and oversee the presentations, the sheer size of the Bicentennial festival required that they relinquish some control.

In 1974, the festival featured tribes of California and the Great Basin, and in 1975, it focused on the Northeast. It was in this latter year that festival organizers turned most clearly to tribal organizers to develop presentations. Evaluating previous festivals' shortcomings, they decided that the 1975 festival should "highlight only one group in depth"—the Six Nations of the Iroquois—while including other tribes from the region through presentations in a Learning Center, a space on the festival grounds that would feature exhibits and regularly scheduled talks.[99] The idea of ceding curatorial responsibility to Iroquois representatives came

after Kavanagh conducted fieldwork in upstate New York in December 1974. Through conversations with several Onondaga and Tuscarora leaders, Kavanagh was convinced that they should be the ones to organize the program and, subsequently, brought this idea back to the "Native Americans" staff, who after some discussion embraced it.[100] One of the concerns of the Native Americans Advisory Group about focusing exclusively on the Iroquois was that other eastern tribes would be unhappy with the decision. In her capacity as advisor, Clydia Nahwooksy mentioned that "she had already heard some people express disappointment over the selection of the Iroquois, because they had hoped to come."[101] The compromise that the group agreed upon was to work with the Coalition of Eastern Native Americans (CENA), an organization for which Dawson served as secretary, to locate individuals from other eastern tribes who could present in the Learning Center. This tribal/regional model would become the basic organizing structure for "Native Americans" the following year. As they set about organizing the Bicentennial festival, Dawson and Kavanagh contracted with specific tribal organizations to assemble tribal and regional presentations. In March 1976, for example, the Oklahoma Plains Apache Tribe passed a resolution, which stated that it was dedicated to "providing a high quality of education about the cultures of the Apache and other tribes, such as the Kiowa, Comanche, Arapaho, Cheyenne, Wichita, Caddo, Delaware, Osage and Fort Sill Apache, during the 1976 Festival of American Folklife." To accomplish this goal, they would "develop a program series of daily educational lectures," establish arts and crafts exhibits, "cook traditional Indian foods," present Southern Plains Indian dances, music, games, and clothing, "set up Plains Indian teepees," and "display information on each tribe[']s accomplishments in today[']s society."[102] Other groups, such as the Sac and Fox Tribe of Oklahoma and the Alaska Federation of Natives, submitted similar proposals. The end result was that the "Native Americans" section featured selected tribes from different regions of the United States each week throughout the summer. Powwows, tribal dances, games, stories, songs, and crafts were part of each presentation. In addition, tribal leaders, scholars, and community representatives led discussions in the Learning Center.[103]

Designed by architect Dennis Sun Rhodes (Northern Arapaho), the Learning Center housed photographs and panels, which supplied background information on the tribes featured each week, and provided a space for panel discussions.[104] Each tribe had designated times during which their representatives spoke and fielded questions from the audience. These presentations ranged from banal recitations of pre-prepared statements to

engaging and free-ranging speeches about the challenges facing Native peoples. A number of the speakers spoke frankly and bluntly about the history of broken treaties, land confiscation, and racial discrimination Native peoples have faced.[105] They also described their own lives in an effort to subvert longstanding stereotypes of Native peoples that had been disseminated by movies, television, and other popular media.[106] Furthermore, the festival's organizational framework, which allowed each tribe to have its own time for presentations, provided for the airing of specific, local issues. Representatives from the Klamath tribe of Oregon, for example, discussed the consequences of termination for their tribe.[107] Similarly, other participants from the Pacific Northwest talked about the controversial question of Native fishing rights, which, they argued, superseded environmental and commercial regulations established by Washington State.[108]

Overall, the spirit of the earlier American Indian programs remained in evidence even in the midst of such an enormous exhibition. The vibrancy of the discussions, however, had dulled somewhat since the peak years of "Red Power" in the early 1970s. It would be another three decades before the Smithsonian would again mount exhibitions that offered a direct challenge to the dominant white power structure.

The Anacostia Neighborhood Museum and the Festival of American Folklife's American Indian programs were two experimental museum projects that pushed the boundaries of the museum field. Ahead of their time, they experienced early successes only to be challenged by growing pains that gradually limited their influence. Still, their significance for the museum profession in a time of great upheaval in American society should not be underestimated. These projects blazed a trail that others would follow during the more sweeping transformation of museums' relationship to American Indians and African Americans that occurred during the last decade of the twentieth century and the first decade of the twenty-first. Despite their pioneering status, within the Smithsonian's institutional structure these projects were marginalized. Their positioning in separate spaces provided their curators more freedom and flexibility to experiment, but also made it easy for others at the Smithsonian to ignore them. If more sweeping change was to come to the institution, it would need to take place in the heart of the Smithsonian—the Museum of History and Technology and the Museum of Natural History.

5

Finding National Unity through Cultural Diversity
The Smithsonian and the Bicentennial

In July 1970, Republican political strategist Kevin P. Phillips published a column in the *Washington Post* titled "President Should Consider Festival of U.S. Folklife and History for '76." In it, he urged President Nixon to scrap the "usual pompous, commission-like proposals" being suggested to commemorate the Bicentennial of the American Revolution and instead embrace a national celebration patterned on the Smithsonian's Festival of American Folklife. For Phillips, the appeal of the festival was not only that it portrayed the vibrancy of American cultural traditions but, more important, that it seemed to foster a feeling of unity among festival visitors. "Wearers of 'Love It or Leave It' buttons," Phillips wrote, "mingled in friendly fashion with long-haired hippies as they enjoyed the sights, smells and sounds of the past they share." This kind of unity inspired by the recognition and celebration of the country's diverse cultural traditions, Phillips maintained, should be an important goal of the Bicentennial.[1]

Such rhetoric might have seemed incongruous to an audience familiar with Phillips's other writings. Only a year before, he had published his prescient study *The Emerging Republican Majority,* which maintained that understanding and exploiting regional, ethnic, and racial divisions would give an enduring electoral majority to the Republican Party.[2] Nonetheless, Phillips's opinion piece reflected the hope of some that the Bicentennial might foster a sense of national unity among the American people. A lack of political and ideological consensus, persistent racial tensions, and widespread pessimism about the country's future, however, made this an unlikely outcome. Many Americans reeling from economic recession, war, urban upheaval, and Watergate saw little to celebrate in 1976.[3]

The irony of Phillips's call for unity as he simultaneously espoused divisive politics as a Republican strategist illuminated the central tension in

Bicentennial celebrations of cultural diversity. These celebrations could either present a therapeutic portrait of pluralism or address the complexity of diversity, which was messier, more nuanced, and more rife with conflict and contradiction than most Americans typically acknowledged.[4] The vast majority of public commemorations gave superficial recognition to the many different ethnic, racial, and cultural groups in the United States but masked deeper fissures and inequalities and trumpeted the degree of consensus in American society. Popular representations of diversity, the historian Matthew Frye Jacobson writes, "made for a fairly sanitized and happy national narrative: diversity as feast, the nation as smorgasbord."[5] Although a small percentage of Bicentennial observances—proffered by Native peoples and African Americans—challenged this narrative, arguing instead that the true history of the nation was marked by discrimination and oppression often along racial lines, most celebrants chose to ignore or downplay this history in favor of a celebratory and therapeutic pluralism. "The most important Bicentennial undertakings," according to the official government organizers of the celebration, "would bring dissidents as well as neighbors and friends together in common purpose."[6] Although reconciliation was an admirable goal, such paeans to cooperation were far from the reality of the racial, ethnic, and ideological conflicts that characterized this period. In battles over busing, housing, and affirmative action, Americans in the 1970s showed themselves to be deeply and angrily divided.

The fact that Americans often embraced a therapeutic conception of pluralism in the 1970s is not surprising given the society's near obsession with personal well-being. As the historian Christopher Lasch argued in 1979, many people enthusiastically embraced individual efforts to find inner harmony during this decade.[7] Although Lasch focused his ire toward the individual "narcissist," his argument can be read as a critique of American society and culture as a whole. Turning inward, Americans developed a therapeutic culture that made good feelings its highest objective. Accordingly, during the Bicentennial era, leaders of cultural institutions fashioned a positive image of American society in an effort to help people feel good about themselves. A therapeutic conceptualization of diversity eased people's anxieties over persistent, and indeed dramatically increasing, cultural differences.

The Smithsonian created several major exhibits to mark the Bicentennial, including two depicting the pluralism of American cultures. One of these exhibits was *A Nation of Nations,* a large-scale permanent exhibit located in the National Museum of History and Technology. The other was the Bicentennial Festival of American Folklife, an expanded version

of the festival that the institution had presented on the National Mall each summer since 1967.[8] Both *A Nation of Nations* and the festival were feasts of diversity, and both offered a therapeutic message to their audiences. Ralph Rinzler, the head of the folklife festival, for example, billed it as a "festival to cherish our differences," and the historian—Daniel Boorstin— who developed the original concept for *A Nation of Nations* envisioned the exhibit as an antidote to the angry protests of student radicals and Black Power advocates during the late sixties and early seventies.[9] At the same time, both exhibits devoted some attention to the problem of racial and ethnic discrimination in the United States, and both pushed the Smithsonian toward fuller representations of American society and culture than had existed previously at the institution. *A Nations of Nations* and the Bicentennial festival, then, embodied the larger tension between therapeutic representations of pluralism and the complex dynamics of a pluralistic society. As is the case with most exhibits, they tended to be more celebratory than critical; however, neither completely ignored the challenges Americans faced because of their race or ethnicity.

In a 1973 letter to Ralph Rinzler offering his thoughts on the festival, the historian David Whisnant wrote, "Pluralism is a *messy* condition . . . politically, culturally, and in other ways. The problem for the Festival is to reflect the real *dynamics* of a pluralistic culture."[10] Whisnant's comment encapsulated the challenge curators of both the Bicentennial festival and *A Nation of Nations* faced. The messiness, conflicts, contradictions, and inequalities of a plural society did not necessarily lend themselves to display. A romanticized and therapeutic portrait of cultural diversity was an easier and more attractive way to mark the nation's bicentennial. Figuring out how to balance the two perspectives was the key to developing appealing, yet unromanticized cultural exhibits that depicted not therapeutic fantasies but complex realities.

Although the planners of the national Bicentennial celebration originally conceived of it as an opportunity to reinvigorate Americans' appreciation of the nation's founding principles, they also developed at least a superficial commitment over time to the idea that diversity was a key American value worthy of lauding on a grand scale. Despite this acknowledgment, the relationship of various racial and ethnic groups to Bicentennial observances was complex, if not strained. Amidst the array of festivals, performances, workshops, and exhibits, certain ethnic and racial minorities found a niche. Many, though, questioned the relevance of the Bicentennial to their lives and doubted its potential to positively

influence their struggles to achieve equality in labor, housing, the law, education, healthcare, and other areas. The harsh and divisive realities of America's racial dynamics complicated efforts to make pluralism one of the hallmarks of the Bicentennial.

The Smithsonian's exhibits were only some of the many proposals for Bicentennial activities put forth in this era. As early as the late fifties and early sixties, Philadelphia and Boston began planning for their observances, and in 1966, the federal government began its planning process. In July of that year, Congress created the American Revolution Bicentennial Commission (ARBC).[11] Comprised of cabinet officials, members of Congress, other government bureaucrats, and private individuals, the commission took on the difficult task of figuring out a way to fashion a national celebration in a country that at the time lacked both a strong sense of unity and an overwhelming pride in its history.[12]

One of the ARBC's early proposals was for a Bicentennial world's fair to be held in Philadelphia. Because it had hosted the nation's centennial festivities in 1876, Philadelphia seemed to be the logical choice for a large-scale bicentennial celebration. Like so many of the commission's proposals, however, this idea ultimately sank under the weight of social and political tensions and bureaucratic squabbling. The complex realities of urban society and politics in the 1970s undermined any possibility of repeating the successes of the Philadelphia Centennial Exhibition. Even finding a site for the fair proved impossible, as various constituencies vigorously defended their turf from encroachment. Blacks opposed holding the fair at Thirtieth Street Station in Philadelphia's center city because they feared that it might lead to the destruction of their neighborhood—a legitimate concern considering the devastation other urban renewal projects had wrought on inner city communities. Similarly, white residents rejected an alternate proposal to hold the fair in the Byberry neighborhood, a predominantly Jewish and Irish section of the city, because they thought it might bring blacks into their enclave. Additionally, a Polish neighborhood near the Delaware River turned away fair planners. Amidst the divided racial and ethnic space of the city, a pluralistic celebration of American history, ideals, and traditions could find no home. Government officials also balked at the cost of the proposed celebration—$1.2 billion in funds, half of which would go to urban renewal—as being excessive during an age of fiscal crisis. Facing racial tensions, community objections, and economic concerns, the ARBC eventually abandoned the idea altogether, turning their attention to other things.[13]

Boston similarly struggled as racial tensions intruded on its early attempts at observing the Bicentennial. In 1974, federal judge W. Arthur

Garrity Jr. issued a ruling declaring that although Boston's schools were not legally segregated they evidenced a pattern of de facto segregation that was unconstitutional and needed to be remedied. The solution—busing of children from one part of the city to another—led to a vigorous and sometimes violent backlash from white residents. Using the commemoration of the American Revolution as an opportunity to argue that a tyrannical government was violating their rights, four hundred anti-busing protesters showed up at the 1975 Boston Massacre reenactment with a coffin marked "R.I.P. Liberty, Born 1770—Died 1974." Three months later at the anniversary of the Battle of Bunker Hill, an anti-busing banner was displayed that read "We're right back where we began 200 years ago."[14] With Boston's and Philadelphia's racialized conflicts on full display, hopes of generating feelings of unity by celebrating diversity must have seemed a fantasy at best.

Although the national Bicentennial planners struggled for many years with resistance to their efforts, bureaucratic setbacks, and administrative ineptitude, tens of thousands of separate events did take place across the country on July 4, 1976. The largest and most popular was in New York City where Operation Sail '76 brought historic ships (the so-called Tall Ships) to New York Harbor. Boston, Philadelphia, and Washington also held large-scale Fourth of July observances.[15] The heart of America's bicentennial observances, however, was at the local level. In towns across the country, many Americans observed the Bicentennial, with over 12,000 communities holding "grassroots" observances.[16] In Westport, Connecticut, for example, residents hosted "colonial balls, musicals on the town green, churchyard pageantry, tree plantings, balloon lifts, . . . art exhibits, minibus tours of historic sites, [and] assorted prize-winning quilting bees." Countless Americans also engaged in historical research in their attics, basements, and garages and assembled oral histories from grandparents and town elders. In addition, communities dedicated monuments, opened libraries, historic sites, and other civic institutions, and organized beautification projects.[17]

Public attitudes toward the Bicentennial ranged from outright disgust to wholesale embrace, and observances encompassed everything from pure kitsch to genuine expressions of patriotism. In a documentary film produced by the National Park Service, titled *The Birthday Party*, which recorded man-on-the-street views, people offered comments such as: "Right now we don't have a great deal to celebrate" and "This country is faced with so many problems, I just can't stand aside and say hip hip hooray for the Bicentennial."[18] Though the film's producers were careful to include some positive comments, the film presented mostly ambivalent opinions. Only a handful of people interviewed expressed clear enthusiasm for the

celebrations while the rest discussed reservations of various kinds. Some objected to artificiality and commercialism. "I feel that it's like a big fad," said one man, suggesting that the Bicentennial was no more than a passing fashion like bell bottoms or the hula hoop. Some observers took a more philosophical approach and saw the anniversary as an opportunity to refocus the energies of the American people in a more positive direction. "[We should] rededicate ourselves to making things a little bit better," a young man maintained. Others, however, were downright negative: "I really don't see any advantage in the Bicentennial," said one man. A Park Service ranger offered this opinion: "The Bicentennial ought to be a celebration, a very personal kind of thing for everyone involved. . . . No one has the right answer about what the Bicentennial means in this country, it's what everybody feels inside of themselves." Stressing individual, rather than collective, significance demonstrated the inability of many Americans to agree on the meaning of the Bicentennial and reinforced Tom Wolfe's characterization of the 1970s as the "me decade."[19]

Many people of color had a different perspective.[20] In the Park Service film, a young African American man said of the Bicentennial, "I feel that it might leave a lot of people out."[21] The issue of omission or silencing was of great concern to people who traditionally did not appear in popular narratives of the nation's history. Because of the social and political movements of the 1960s and early 1970s, blacks, Hispanics, women, American Indians, and gays and lesbians had gained a stronger voice in the public sphere. Moreover, within the historical profession, the new social history was just beginning to recover the long-ignored stories of ordinary people (both white and non-white) in the American past. As a result, more inclusive and plural narratives of the past and present of the United States emerged in this period. Yet, simplistic patriotic celebrations of the Bicentennial raised the possibility that such narratives, which often dealt with the negative aspects of American history, would be excluded or minimized. Because they feared this eventuality, black activists formed an Afro-American Bicentennial Corporation (ABC) in December 1970. Speaking before a congressional subcommittee, Vincent DeForrest, president of the ABC, explained the rationale behind creating this organization:

> We at ABC are greatly concerned that the bicentennial not be reduced to a meaningless charade acted out by modern-day George III's. Perhaps, as black Americans, we have a special sensitivity for recognizing "oppression" in any guise. And perhaps this makes us natural heirs to the tradition of providing counterpoint to major forces at work, often unwittingly, at any given time in American society.

Whatever the reasons, we are committed to doing all in our power to insure that the bicentennial commemoration is a movement which further liberates the people and sets them in motion to solve their own problems of social and political life . . . the problems won't just fade away. For the questioning generation and the acting generations, the young of all colors and the minorities schooled to recognize opportunities and also evasions in social affairs, won't let the American Revolution die out or allow its bicentennial to be camouflaged behind a display of fireworks.[22]

Around the same time, antiwar activist Jeremy Rifkin established a Peoples Bicentennial Commission with a similar aim—to challenge official commemorations sponsored by the "White House and Corporate America."[23] Both groups saw the Bicentennial as an opportunity to address contemporary issues of race, class, and state power. Their public statements were deliberately not therapeutic or conciliatory; rather, they were confrontational and critical of the present state of American democracy.

Perhaps in response to these rival organizations, in the early seventies the ARBC and its successor, the American Revolution Bicentennial Administration (ARBA), began to make a more concerted effort to emphasize the range of racial, ethnic, and cultural groups present in the United States.[24] This effort was belated and only partially successful, reflecting an uncertainty about how to address issues that had been, and continued to be, quite controversial and divisive. In 1972, the commission added members, according to ARBC chairman David Mahoney, in order to "permit wider representation of minority and ethnic groups, youth, women, et cetera."[25] They joined a handful of other women and people of color previously appointed to the ARBC.[26] Although the commission hoped to move toward inclusiveness with this gesture, it did little to shift the racial and gender composition of the group, which was predominantly white, male, and middle-aged. One of the new members was a twenty-four-year-old woman named Thomasine Ruth Hill, a student at the University of Arizona who had been crowned Miss Indian America in 1968. Hill (Crow-Pawnee) was the sole Native representative at the time on the commission. Although Hill and other people of color on the ARBC worked hard to advance the ideas and interests of the particular groups they represented, they had little chance of fundamentally redirecting the Bicentennial planning process.[27]

In June 1974, ARBA took another, more significant step in the direction of inclusiveness, convening a conference which brought together representatives from a variety of ethnic and racial groups. The eighty attendees subsequently formed a Bicentennial Ethnic/Racial Coalition, and later,

in 1975, ARBA created a Racial, Ethnic and Native American Advisory Committee.[28] The committee oversaw a host of events—"approximately 5,000 ethnic racial projects," which received nearly $18 million in federal grants—designed to showcase American pluralism.[29] Despite this apparent success, however, the Bicentennial commission's relationship to racial and ethnic minorities was strained.

ARBA offered an optimistic spin on the participation of diverse groups. "The Bicentennial," according to an ARBA publication, "made it possible for Blacks, Hispanics, Native Americans and other ethnic groups and minorities to tell their story and take pride in their contributions, showing how they had enriched the lives of all Americans while preserving their own cultures."[30] Clearly, though, blacks, Native peoples, and other people of color had far more ambivalent feelings about celebrating the anniversary of the nation than other, predominantly white, ethnic groups. Writing in July 1976 in Portland, Oregon's African American newspaper, *The Skanner*, Howard R. Jerry III posed the question: "How can we [African Americans] or should we take part in this event? Is the Bi-centennial celebration relevant to me?" Listing statistics that reflected the continuing challenges faced by blacks in American society, Jerry offered a convincing argument that racial inequality persisted in employment, housing, education, and healthcare. He also pointed to historical injustices: "As we recall the institution of slavery followed by Jim Crow laws, the Civil Rights Movement, and look at the results . . . the thought of a Bi-centennial celebration turns into a mockery."[31] Reflecting on the bicentennial year in January 1977 in the *Sun Reporter*, San Francisco's oldest black newspaper, Clarence Johnson evaluated the place of racial minorities in its celebrations: 1976 had been a "pale year of frustration and confusion—pale because it was painted white from the outset. . . . There were 366 days of color blindness, in which red people, brown people, yellow people, Black people became invisible people."[32]

Many Native peoples also felt strong ambivalence about embracing the Bicentennial. At an important meeting convened at the Smithsonian on July 30 and 31, 1972, Native leaders voiced their grievances regarding the role of American Indians in the Bicentennial planning process and discussed with government officials the place of Native peoples in the Bicentennial celebration. Hosting was Clydia Nahwooksy, head of the Smithsonian's American Indian Awareness Program, and attending were Smithsonian staff members, government officials, and Native American tribal leaders and social and political activists, including prominent figures Russell and Ted Means of the American Indian Movement (AIM), Ada Deer, and LaDonna Harris. The meeting began with statements by representatives

from the Smithsonian, ARBC, and the National Park Service, each of whom professed attention to the needs and desires of American Indian peoples in their agencies' Bicentennial planning.

Understandably, the Native leaders in attendance were skeptical, voicing concerns that too few Indians were being included in these projects and maintaining that those who were included were not involved in the initial stages. Perhaps the most obvious deficiency in national Bicentennial planners' attention to Native culture, they pointed out, was the fact that at the time only one member of the ARBC was an American Indian. Thomasine Hill, who also attended the session, was charged with representing the interests and demands of hundreds of Native communities—a task that would have been virtually impossible for even the most seasoned leader. For Nahwooksy and others, such token representation combined with limited Native consultation was unacceptable and constituted a whitewashing of American history. Given the poor track record of Bicentennial planners, the more radical attendees argued that Native peoples should not participate in the Bicentennial festivities unless they were given the central role. Although not all of the Native attendees agreed with this idea, all of them favored a greatly expanded recognition of Native peoples and more Indian control over the content of the celebrations.[33]

Following the meeting, Nahwooksy and Russell Means took the recommendations of the group to Congress where on August 2 they offered testimony before the Senate subcommittee that was overseeing the Bicentennial planning process. Making the case for Native peoples during a session that also included individuals advocating for the increased visibility of African Americans and women in Bicentennial celebrations, Nahwooksy maintained that "as the first inhabitants of this land, the American Indians must be given a featured role" in all Bicentennial observances. Means took this a step further, stating "we are damned mad that we were not invited to your birthday party after we provided all the presents. The American Indian Movement has instructed me to state . . . that we will not allow white America to have a happy birthday celebration in 1976 unless the American Indian is given the featured role in the Bicentennial Commission's endeavors, in all aspects."[34] Although not as blunt as Means, Nahwooksy laid out a strong case for American Indians' concerns and expectations for the Bicentennial:

> We feel that participation of native Americans in America's Bicentennial should not be a celebration of the past, for no American can truly celebrate in speeches or fireworks the events of Sand Creek, Washita or Wounded Knee.

Neither should this be a celebration of the present . . . For who can celebrate the unemployment, the bad health and the poor housing which characterize the lives of so many American Indians, Eskimo, and Aleut people.

This must be the celebration of a new beginning . . . A new beginning in which pluralism is recognized as the hallmark of the American experiment, and pride in difference its unique strength. A time when none of us seeks either to overcome or to become the other, but when each of us can give strength and draw strength from the other . . . We are still today, after many years of suffering on the part of many of us, 200 nations within this one Nation.[35]

Nahwooksy's incisive statement pointed the way toward a Bicentennial observance that would be more than a simplistic affirmation of cultural diversity as a source of pride for all Americans. Complicating the classic formulation of the United States as "a nation of nations," Nahwooksy invoked the sovereignty of American Indian nations—sovereignty which carried with it the right of self-determination and the capacity for making histories. America's pluralistic history evoked both pride and pain. By openly discussing past and present injustices and racial inequalities, she challenged a therapeutic portrait of cultural diversity while pressuring Congress and the American people to acknowledge both the positive and negative aspects of their history.

Beyond the halls of the Smithsonian and Congress, Native communities all over the country also debated whether to participate in Bicentennial observances. For many, celebrating the United States' 200th birthday amounted to tacit approval of conquest. Others, however, thought they might use the Bicentennial as a platform to discuss Native issues and to celebrate American Indian culture.[36] Some American Indian activists used the Bicentennial celebrations to call attention to the plight of Native peoples in the United States. Members of the Stillaguamish tribe of Washington State, for example, stopped the Bicentennial Wagon Train, which was heading from the Pacific coast to Valley Forge, to protest the fact that their tribe had been unable to obtain federally recognized status for over fifty years.[37] Another group of activists also used the wagon train as a backdrop to voice their grievances with the federal government. The group, which called itself the Trail of Self-Determination, a successor to the 1972 Trail of Broken Treaties, followed behind the wagon train as they headed to Washington to check on the status of the list of "Twenty Points," which participants in the earlier "Trail" had delivered to President Nixon.[38] These direct action protests presented a strong counterpoint to the Indian "attacks," which the wagon train had hoped to simulate along its route.[39]

Overall, African American and Native American responses to the Bi-centennial highlighted the disparity between official representations of pluralism and the contested realities of America's racial history. They demonstrated that the Bicentennial could not be a simple celebration of the country's history but needed to be an event that probed both the posi-tive and negative aspects of American society, past and present. As the Smithsonian formulated its Bicentennial exhibits, it had to confront these competing narratives.

A *Nation of Nations* was originally conceived by Daniel Boorstin, the historian who became director of the Museum of History and Technology in 1969, leaving the University of Chicago.[40] A popular writer, public intel-lectual, and member of the ARBC, he seemed to be the ideal person to de-velop a large-scale exhibit for the Bicentennial. By the time he joined the Smithsonian staff, he had already published two volumes of his grand syn-thesis of American history, *The Americans,* as well as a number of other his-torical works. He had also weighed in on contemporary issues, position-ing himself as a vocal critic of the New Left and Black Power. The year he came to the Smithsonian, Boorstin issued a collection of essays titled *The Decline of Radicalism: Reflections on America Today* in which he argued that the radicals of the sixties represented a fundamental threat to community and cohesion in American life. "The most vocal and most violent disrupt-ers of American society today are not radicals at all," Boorstin wrote, "but a new species of barbarian." The "new barbarians," he maintained, were not invaders; they came from within. Like the ancient barbarians, how-ever, they aimed not to "reform or reshape the society" but "to destroy it."[41] Rejecting the kind of constructive critiques of society rooted in the quest for a "just community" offered by earlier radical groups, including communists, the sixties radicals were, according to Boorstin, "egolitar-ians, preening the egoism of the isolationist self." "Theirs is a mindless, obsessive quest for power," he wrote.[42] A consensus historian in the truest sense of the term, Boorstin stood as a bulwark against protesters and in-tellectuals who wanted to focus national attention on persistent conflicts, especially along racial lines, in American life.

Boorstin's conceptualization of *A Nation of Nations* was a response to the threat posed by the "new barbarians," and it accorded with his larger goals as director of the Museum of History and Technology. "In our country today," he said after assuming the directorship, "this is an age of apology, of self-denigration, and even of self-flagellation. We have come to believe, to advertise, and even to act upon the most uncharitable judgments of our country and our civilization." In response, he argued that the museum

would "emphasize the positive. Without denying our failures, we under-line and dramatize our successes."[43] For Boorstin, the museum should be:

> A place of pride and patriotism. Here we celebrate and demonstrate what Americans—all Americans—have accomplished. What we have accomplished individually, but especially what we have accomplished together. . . .
>
> Here we help build the nation, we oppose chaos and dissolve hatreds by a shared pride—a pride in what each and all of us have done toward a richer better life for each and all of us.[44]

Accordingly, Boorstin explicitly rejected an approach for *A Nation of Nations* that called attention to divisive particularities and persistent inequalities in American society. A fundamentally positive exhibit was needed, he argued, because the nation was "preoccupied with its internal divisions." It would counteract the tendency "to identify 'minority' status with underprivilege, poverty, and inequality" and instead foster "a broad humanistic pride." "We will remind all Americans," he wrote, "that our 'minorities' are the symbols of our peculiar strength and of our ties to all mankind."[45] Pluralism became a matter of pride and a symbol of the United States' great impor-tance for all the world's peoples. Persistent racial and economic inequality was irrelevant to this narrative—a distraction from the larger story of the ascendance of American civilization.

Boorstin's plan for *A Nation of Nations* envisioned two outdoor pavilions, which would have augmented the space of the Museum of History and Technology and provided a highly visible setting for the exhibit. The first pavilion was to show "the varied contributions of . . . different peoples to our nation." In three main units, it was to illustrate when, why, and how people came to North America, where they came from and how their cultures "affected their coming and what they brought," and what they contributed to "American civilization." The second pavilion was to focus on "where Americans have gone, and the shaping influence of American ideas, techniques, attitudes, and products on life all over the globe"—i.e., the United States as a world power.[46] Overall, the intended message of the pavilions was that the United States had witnessed an unprecedented influx of peoples from many countries who had come together to form a single nation and that this nation had exported a remarkable array of ideas and products that had transformed the world.

In the early seventies, the museum contracted with a private firm—Chermayeff, Geismar & Associates—to design the exhibit. At the behest of Boorstin, the sociologist Nathan Glazer, a well-known public intellectual,

authored the firm's proposal, with strong input from Ivan Chermayeff.[47] In 1963, Glazer had issued (along with co-author Daniel Patrick Moynihan) the influential study *Beyond the Melting Pot*. Examining the social and cultural life of blacks, Puerto Ricans, Jews, Italians, and Irish in New York City, it argued that race and ethnicity belonged at the center of sociological and political analyses of contemporary American life.[48] One of the most important, if controversial thinkers on the subject of cultural pluralism, Glazer was one of the "New York Intellectuals," a group of predominantly Jewish thinkers who moved from liberalism to neo-conservatism in the decades following World War II. Originally part of the anti-Stalinist Left during the 1930s and early 1940s, these writers and scholars played key roles in shaping the policies and programs of LBJ's Great Society in the early sixties. By the late sixties and early seventies, however, they were becoming increasingly disillusioned with the ideas and actions of the Left and began defecting to the conservative side of many of the public debates of the era.[49] Glazer, for example, became a strong critic of affirmative action. Although supportive of the active recruitment of minority candidates, he opposed the "setting of statistical requirements based on race, color, and national origin for employers and educational institutions."[50]

In his 1975 book, *Affirmative Discrimination,* Glazer argued that such requirements violated the Constitution, fostered resentment among whites, and were simply unfair. "Racial and ethnic groups," he wrote, "make poor categories for the design of public policy." Affirmative action as it was construed at the time was, in Glazer's estimation, inconsistent with a "harmonious multigroup society."[51] Such a criticism was motivated not only by Glazer's sense of fairness and his reading of the history of race and ethnicity in the United States, but also by the realities of 1970s American society. Affirmative action policies sparked a major backlash from white men in the early to mid 1970s. In Detroit, for example, white police officers protested angrily when the city attempted to circumvent seniority rules in order to retain and promote black officers during a period of budget cutbacks. During the first six months of 1974, the Equal Employment Opportunity Commission recorded 335 complaints of "reverse discrimination"—that is, discrimination against individuals who were members of groups that had historically been the oppressors, not the oppressed.[52] In such a charged atmosphere, it is no wonder that Glazer worried about the possibility of fostering harmony in a diverse society.

In Glazer's view, the hallmark of American history was a "distinctive American orientation to ethnic difference and diversity." "The major

tendencies of American thought and political action," he wrote, pointed toward three "decisions" regarding pluralism:

> First, the entire world would be allowed to enter the United States. The claim that some nations or races were to be favored in entry over others was, for a while, accepted, but it was eventually rejected. And once having entered into the United States—and whether that entry was by means of forced enslavement, free immigration, or conquest— all citizens would have equal rights. No group would be considered subordinate to another.
>
> Second, no separate ethnic group was to be allowed to establish an independent polity in the United States. This was to be a union of states and a nation of free individuals, not a nation of politically defined ethnic groups.
>
> Third, no group, however, would be required to give up its group character and distinctiveness as the price of full entry into the American society and polity.[53]

This interpretation of American social, cultural, and political history undergirded Glazer's vision for A Nation of Nations. The United States, he contended, welcomed individuals from many backgrounds without demanding that they assimilate. It did not, however, favor any group establishing an independent political bloc distinct from the larger polity. By the mid 1960s, Americans and their government, Glazer contended, had "reached a national consensus as to how we should respond to the reality of racial and ethnic-group difference."[54] In the 1970s, however, this consensus was under siege. To Glazer's mind, affirmative action, or more precisely "statistical goals or quotas by race for employment or promotion," violated the consensus that reached full equilibrium with the liberal reforms of the mid 1960s, specifically the Civil Rights Act, Voting Rights Act, and Immigration Act of 1965.[55] He feared that the widespread adoption of policies based on racial quotas meant that the United States would "be permanently sectioned on the basis of group membership and identification."[56] Counteracting this tendency became an important goal of Glazer's public work.

Glazer and Chermayeff's proposal for A Nation of Nations, then, balanced pluralism with a narrative of convergence into nationhood. "The theme of the exhibit," the proposal read, "is the contribution of varied streams of people to the making of the American people." The exhibit "concentrates on the formation of a new people, one that incorporated in many complex ways the different cultures and experiences and attitudes brought by so many people from all over the world." Pluralism, in this sense, created a kind of variegated unity. The exhibit "expresses the reality," according to

the proposal, "that each of these people have woven their own evolving uniqueness into the fabric of a common nation—'e pluribus unum.'"[57]

Glazer and Chermayeff's proposal clearly identified immigration as the central experience of American life. Physically, it altered Boorstin's plan for pavilions, combining an outdoor exhibit with exhibits inside the museum; however, ideologically, it accorded with Boorstin's desires. Beginning with an outdoor section called "The Gathering of the Peoples" that funneled people into the museum, it encouraged visitors to imagine themselves as immigrants.[58] "On the walls are to be seen," the proposal read, "life-size . . . photographs of settlers and immigrants of every time and place, and on the remaining parts of the mirror-surfaced walls are to be seen the reflections of the people waiting to see the exhibit."[59] This less-than-subtle visual trick made it clear how Glazer and Chermayeff expected visitors to see themselves in the exhibit. Moving into the museum building, visitors were to progress into "The Passage," which recreated the vessels in which migrants traveled to North America. A "colonial ship," "a 19th century immigrant sailing ship," "a slave ship," "the steerage of a great early 20th century transatlantic ship," and "a cross-section of a jet airplane" were proposed for this segment.

From here, visitors were to move into "The Arrival," which was to be a replica of the "entry hall at Ellis Island." Then on to "The Composition of the Nation" where visitors would view a film that illustrated "the changing stream of immigration over time by source"—"from the English and the Blacks," the proposal read, "to the Northwest Europeans, to Eastern and Southern European, to—today—the prominence of Asians—Filipinos, Chinese, Indians."[60] The proposed montage would suggest the gradual diminishing of group differences over time: "The film shows the current composition of the American people by ethnic background and race, with appropriately hazy borders to suggest that groups have merged and that ethnic background has become distant and unknown to many Americans."[61] From the "Composition of the Nation," visitors were to proceed through at least seven more display areas, each of which would trace the amalgamation of varied immigrant peoples into a coherent national whole.

With this plan, Glazer and Chermayeff attempted to strike a balance between national unity and respect for cultural difference. A Nation of Nations did not promote full assimilationism nor did it embrace wholesale particularism. Instead, it used Glazer's idea of a "national consensus" regarding racial and ethnic difference to undergird an exhibit scheme that depicted a nation that had worked out a compromise position toward cultural pluralism. It was a position rooted in Glazer's interpretation of American history

and his reading of the Immigration Act of 1965, which opened the door to many previously excluded racial, ethnic, and national groups, and the Civil Rights movement, which argued for equal rights for all peoples regardless of race.

The museum's staff did not embrace Glazer and Chermayeff's proposal wholeheartedly—indeed, at least one curator strongly resented not being consulted in its creation—and it would undergo significant modification before the final exhibit debuted in 1976.[62] The use of an outside consultant rather than reliance on in-house curators and designers to develop the exhibit was emblematic of a broader shift in museums. The process of creating exhibitions was changing in this period. Whereas over the past century individual curators had exercised authoritative control over their content, the process of exhibit making was now becoming more collaborative and authority was more dispersed. Because of the incredible expense and complexity of designing and building exhibits, teams of content experts, designers, and curators were needed to create exhibitions. No longer the brainchildren of single curators, exhibits became products of long, complicated negotiations involving multiple viewpoints and stakeholders. This new mode of exhibition development was clearly evident in the multi-year process of creating *A Nation of Nations*.

From early on, some staff members questioned Boorstin's concept. In a February 1971 memo to the Museum of History and Technology's deputy director Silvio Bedini, Carl H. Scheele, curator of postal history and chairman of the exhibit committee for *A Nation of Nations*, expressed the "frustrations and misgivings" of several curators. The idea of input (of peoples from all over the world) and output (of ideas and products from the United States) was, for some curators, apparently not a workable frame for an exhibit based on objects. Moreover, "a concept of history based on compartmentalization according to national origins," Scheele wrote, "was a concept not readily embraced."[63] Although he did not elaborate on this statement, Scheele was likely drawing on the criticisms of Malcolm Watkins, who in a similar memo to Bedini in September 1971 wrote that regional variation was more evident in the material record than ethnic variation. Without denying the existence of ethnic differentiation, he argued that it would be difficult to represent strict ethnic lines in a museum exhibit. Moreover, he pointed to the complications that might arise when attempting to address ethnic cultures that had been modified or adapted in an American context, suggesting the importance of acculturation and assimilation. Being a scholar of the colonial period, Watkins recommended that the exhibit focus considerable attention on the era of settlement, as this period offered the

clearest delineations among ethnic and racial groups. He suggested that the exhibit include sections on English, German, Dutch, French, Scandinavian, and Hispanic settlers, as well as "a fine exhibit on the African—his art, his housing, his music—and the American Indian, who was here and became in spite of himself a part of us."[64] Beyond giving voice to criticisms such as those of Watkins, Scheele's report added his own concerns regarding the output section of the exhibit. He found little to support Boorstin's assertion that American ideas had had a profound influence on other countries. "I remain very uncertain," he wrote, "as to the extent to which America has reshaped the lives of people the world over." He also recommended taking a more balanced perspective on the positive and negative aspects of American society, suggesting that the exhibit might examine "the poor," "penitentiaries," and "the superhighways of America."[65] Such criticisms demonstrated that not all of the museum staff embraced Boorstin's overwhelmingly positive assessment of the history of the United States.

In response to a "conceptual framework" for the exhibit approved by Boorstin and other staff members from the museum as well as representatives of Chermayeff, Geismar & Associates in March 1973, Scheele solicited comments from curators and other staff members who, in turn, offered some pointed criticisms. On the opening section, which was now titled "A Great Migration," the curators said, "This must include peoples who came before the Europeans. Correct the present lack of reference to Indians and Orientals." Perhaps challenging Boorstin's focus on the positive, they said, "The complexity and excitement of our history should be apparent. Our history is not neat—not simple." Questioning the unity of the immigrant experience, they added, "'Migration' in heading above should be changed to plural form—there was a complex of migrations." This brief comment suggests that the curators were attempting to account for migrations that occurred outside the traditional European immigrant story, such as the experiences of African slaves or Chinese immigrants. Another comment reinforces this perception: "Numerous points of arrival are now lacking. Include reference to arrivals at both coasts and both borders."[66] The exhibit's exclusive focus on Ellis Island was a problem for the curators. Recently, such a narrow focus in popular narratives of American immigration history has attracted criticism from scholars. As the historian Matthew Jacobson has observed, "Ellis Island *was* the point of entry for migrants who were overwhelmingly admitted as the 'free white persons' of U.S. naturalization law; and so the iconic figure of the white immigrant has dominated all others."[67] Malcolm Watkins voiced a similar concern decades earlier than Jacobson when he wrote of the exhibit proposal in a February

1973 memo, "I am a little bothered that the only arrival experience shown is that of Ellis Island. Droves of Chinese landed in San Francisco in the Gold Rush, and of course there were many individuals, not representing the poor European masses, who came to other places and by other types of entry."[68]

Fairly rapidly, criticisms such as Watkins's and Scheele's gained traction, especially after Boorstin stepped down as director in October 1973 to become Senior Historian at the museum. (He subsequently left the Smithsonian entirely in 1975 to become Librarian of Congress.)[69] He was replaced temporarily by acting director Silvio Bedini and then permanently by Brooke Hindle, a historian of science and technology from New York University, in February 1974.[70] Subsequently, an exhibits committee led by Scheele, which included Malcolm Watkins, Grace Rogers Cooper (curator of textiles), Richard E. Ahlborn (curator of ethnic and Western cultural history), Otto Mayr (curator of mechanical engineering and mechanisms), John H. White Jr. (curator of transportation), Harold D. Langley (curator of naval history), and Peter C. Marzio (curator of graphic arts), assumed control of the herculean effort of bringing the exhibit to completion.[71] In this period, the exhibit concept changed significantly, although the basic idea that the United States was a nation of immigrants remained intact.

The committee's priorities were both interpretive and logistical. "The complete lack of a detailed [exhibit] script" was a major concern.[72] Furthermore, issues with the design of the exhibit needed to be resolved. At a meeting with Chermayeff, Geismar & Associates in early February 1974, Scheele informed the designers of various changes to the original plan.[73] About a week later, Director Hindle sent a memo to "All NMHT Staff" outlining work responsibilities for the development of content and scripts, design, acquisition and preparation of objects, and management. As chairman of the curatorial committee, Scheele acted as coordinator of all museum staff and liaison between the curatorial committee and the designer. Other curators took charge of the specific sections of the exhibit. By March, they had circulated revised preliminary scripts to museum staff and solicited suggestions from them, and, by October, the curators had an outline for the entire exhibit.[74]

The outline included several subsections under each of the four main headings. The first section, titled "People for a New Nation," included three subsections: a map indicating "Where They Came From," a section on the American Revolution, and another called "A Nation of Differences," which included both "The English: The Dominant Minority" and "The Others: A Diverse Majority." Section two—"Old Ways in a New Nation"— included sections on "Arriving," "Traveling," and "Working" with proposed

objects such as trunks, an ox cart, shoes, saddles, and work benches. It also contained a section titled "Ways of Thinking," in which the curators planned to address status, prejudice, faith, and group identity. The last two subsections in "Old Ways in the New Nation" were "Enjoying Life," which would feature arts and pastimes, and "Immigration Patterns," which would contain a map illustrating how the sources of immigrants to the United States changed from 1850 and 1910 to 1970. Section three—"Shared Experiences"—covered education, citizenship, politics, labor, the military, sports and entertainment, and housing. Finally, section four—"A Nation Among Nations"—included subsections on mass production, foreign goods in the United States, world travelers, and an area titled "Everywhere is Now," which was not explained.[75] Nearly every section of the outline included suggestions for specific objects or types of objects that could be displayed and that correlated with the themes. Although still a work-in-progress, the exhibit was starting to take definite shape as curators and other staff did the hard work of connecting objects with ideas, revising exhibit scripts as the opening date drew closer.

One of the challenging problems the curators had to address in this phase was how to represent the many different origins of people living in the United States. Since their goal was that "virtually all peoples be recognized" in the exhibit, they understandably struggled with the breadth of this task. For the planned maps, the curators recommended that the designers consult Wilbur Zelinsky, author of the 1973 book *The Cultural Geography of the United States*.[76] Zelinsky provided data about the ethnic makeup of the United States in 1780, as well as a listing of ethnic groups and countries of origin for the American population in the present day. For the earlier period, he elected to provide only ethnic groups, and not countries of origin, because he said that he was unable to identify with any precision the specific origins of the "American Black population." "The territory involved is so vast, the identification of tribes so tenuous in so many cases, the number of tribes so great, and their relatively quantitative contribution so very speculative," he wrote, that more detailed conclusions were impossible.[77] As a result, his compromise was to write, "The African population of the future United States was drawn in part from the West Indies but predominantly from more than a score of ethnic groups living along or near the Atlantic Coast of Africa from presentday [sic] Senegal to Angola." For the present-day map, Zelinsky was able to provide a much more detailed list, which included eighty-three countries and more than one hundred ethnic groups.[78]

Beyond the maps, the exhibit's curators and other staff meticulously documented the ethnic origins of each of the over five thousand objects

that were to be displayed. A section of the exhibit containing musical instruments, for example, contained a Ute flute "used for courting," a concertina "made in London about 1850," a mandolin made by "Gene Trusiewicz [Polish] of New York, about 1900," an African American "rasp made of mule's jawbone," a dulcimer of German origin "made in North Carolina" in 1934, a ram's horn, or shofar, "used ceremonially in a synagogue," and a harp zither "made by Franz Schwarzer" around 1880. The diversity of ethnic materials was dizzying, and the internal coding system for the objects included abbreviations for "Asians," "Blacks," "Eastern Europe & Russia," "Germanic & Swiss," "Indian" [i.e., Native American], "Latin American," "Mediterranean & S. Eur.," "Northwest Europe," and "Scandinavian." A section on religion included a painting of Saint Anthony of Padua, several objects from a Roman Catholic church in Connecticut, Eastern Orthodox icons, Protestant revival objects including a roadside cross from Kentucky, an 1870 Bible, a Decalogue Plaque from a Philadelphia synagogue, a Jewish wedding certificate from 1890, a prayer rug from Saudi Arabia, the Qur'an, and phrenology and palmistry charts "said to have traveled from Kansas to Washington in Gold Rush days with a family of Romanian Gypsies." The section also included lion masks from a Chinese New Year celebration in Philadelphia about 1890, as well as several American Indian religious objects, including an Apache headdress used in the Ghost Dance, a Kiowa painted deer hide that showed an aspect of the Sun Dance, and a Tlingit dance mask.[79] To help visitors keep all of these objects straight in the final exhibit, the curators created a pamphlet with a color-coding system that enabled the correlation of specific objects with particular ethnic groups.[80] Despite such herculean efforts to be inclusive, the exhibit did not please everyone. The Polish American Press Council complained even before the opening that *A Nation of Nations* did not include famous Poles. Later, an individual complained about the lack of Portuguese representation.[81] It is hard to imagine, however, how the curators could have been more conscientious or inclusive in the selection and displaying of objects.

Because the exhibit strove to include such an extensive range of materials, its curators could not rely solely on the existing collections of the museum; they had to do additional collecting and borrow items from other non-Smithsonian museums to secure the objects they needed. Staff member Ellen Roney Hughes who served as coordinator of *A Nation of Nations,* for example, collected numerous objects, including a golf club from Lee Elder, Muhammad Ali's boxing gloves, and an early electrical voting machine and ballot boxes. Another staff member secured a surplus barracks from the Army, as well as other objects for the military displays,

and still another staff person made local collecting trips to gather materials for displays on the home and labor.[82] Because the exhibit contained such a remarkable array of material culture, many staff members contributed to the process of collecting objects and preparing them for display. Overall, they made more than three thousand new acquisitions.[83]

Other objects came from the museum's existing collections. *A Nation of Nations* drew heavily from the costume and textile collections, and curators also included in the exhibit previously accessioned colonial and early national Euro-American materials as well as objects associated with the American Revolution. Part of the problem in drawing on the existing collections, however, was their limited scope. The museum's overwhelming focus on Euro-American history and culture meant that materials associated with African American, Asian, and other non-white cultures were in short supply. Malcolm Watkins alluded to the concerns this gap raised when he wrote in a 1974 memo: "I am especially anxious that the black contributions shall be well stated in terms of objects."[84]

Outside collecting was one way *A Nation of Nations* curators overcame this obstacle; reaching out to departments in the Smithsonian's other museums was another. Fortunately, they were able to secure the cooperation of the Department of Anthropology, which loaned many American Indian objects. William Sturtevant acted as primary liaison in anthropology, facilitating the loan of objects and offering input on texts and labels in the exhibit. According to curator Richard Ahlborn, the reason for this successful collaboration reached back to the days before the Euro-American collections were separated from the Department of Anthropology: "Our successful contacts with Anthropology derive from a long and mutually respectful relationship, due largely to Malcolm Watkins who imbues cultural history at MHT with an anthropological approach."[85] The presence of Watkins bridged the divide between anthropology and history that had been solidified by the separation of these disciplines into two different museums. He and Sturtevant, with the assistance of Wilcomb Washburn, facilitated cross-disciplinary cooperation between museums.

All three men worked at the intersection of history and anthropology. Like Jack Ewers, Sturtevant was a pioneer in the field of ethnohistory who had studied anthropology at Yale, graduating with a doctorate in 1955. A well-respected expert in the history and culture of the Seminole, he came to the Smithsonian's Bureau of American Ethnology in 1956 and later became curator of North American ethnology in the Department of Anthropology. He is best remembered as the general editor of the *Handbook of North American Indians*, a major multi-volume reference source that

was originally intended to be published in its entirety for the Bicentennial. Sturtevant presided over several major professional organizations during his career, including the American Anthropological Association and the Council for Museum Anthropology. In 1965–1966, he served as president of the American Society for Ethnohistory.[86] Seven years earlier, his colleague Wilcomb Washburn had presided over the American Indian Ethnohistoric Conference, the organization that would become the American Society for Ethnohistory. Joining the Smithsonian's staff in 1958, Washburn was a political historian who dedicated much of his career to writing about American Indian society and culture. His first book explored the role of racial animosity toward Indians in stoking Bacon's Rebellion. Refuting consensus interpretations of history, which argued that the rebellion was a harbinger of the American Revolution's revolt against aristocracy, Washburn demonstrated convincingly that Bacon stoked racial hatred in order to galvanize a movement to secure power. Later in his career, he served as editor of volume four of *The Handbook of North American Indians* and produced a sweeping book titled *The Indian in America,* which synthesized the work of both historians and anthropologists to construct a narrative of Native society, culture, and politics from pre-contact to the present.[87] Because of the nature of their scholarship as well as their personal connections, Watkins, Sturtevant, and Washburn allowed *A Nation of Nations* temporarily to breach bureaucratic divisions that were reinforced by the Smithsonian's physical geography. It demonstrated the broad scope Smithsonian exhibits could have when curators were permitted to work on an institution-wide, rather than museum-centric, basis.

Working feverishly and putting in long hours, a small army of museum staff members and volunteers readied the exhibit for its opening. More than eighty people prepared the objects, installed the displays, handled administrative duties, cleaned, wrote label texts, built models, constructed walls, and performed many other essential tasks.[88] Finally, on June 9, 1976, the 35,000-square-foot exhibit, which cost $2.7 million to construct and occupied half of the National Museum of History and Technology's second floor, opened to the public. It had been a monumental undertaking and represented a landmark achievement for the institution. According to the fact sheet that was released to the press, *A Nation of Nations* explained "how people from literally every part of the world came to America, from prehistoric times to the present, what they brought with them and how experiences in the new land changed them." The exhibit illustrated the "ethnic diversity of this country's origins" as well as the "melding together of immigrants from many nations to form one new American nation." In

A Nation of Nations, 1976. Smithsonian Institution Archives, neg. #76.14329.3A.

addition, it demonstrated "how America interacts with the rest of the world today."[89] Secretary Ripley said of the exhibit that it was "the Smithsonian's most important Bicentennial show—a climax to what the Smithsonian is all about."[90]

Entering the exhibit, visitors would have immediately sensed a change from the rest of the museum. A linear "tube," with a raised floor and dropped ceiling, defined the visitor's path through the four sections, and lighting, sound, and video increased the exhibit's dramatic effect. In the first section, "People for a New Nation," visitors immediately encountered a display of objects from the pre-Columbian era.[91] Based on the premise that the peoples who crossed the Bering land bridge from Asia around 20,000 years ago were in fact early immigrants, this opening area set the theme for the entire exhibit—that all Americans were immigrants. As visitors continued beyond the initial display case of pre-Columbian objects, they would have found materials from the diverse European settlers and enslaved Africans who came to North America in the seventeenth and eighteenth centuries. A long glass case contained many of the typical items, such as chairs and cooking utensils, one would have encountered in English settlers' homes. Complementing this case was an entire colonial kitchen, c. 1695, both interior and exterior, which came from Malden, Massachusetts. As they approached it, visitors saw a cutaway section of the front wall

with a window, door, clapboards, studs, and mortise-and-tenon construction. When they got closer, visitors could peer inside to see a somewhat cluttered array of period furnishings. Another display, titled "A Plantation of Differences," discussed the non-English peoples—Spanish, Dutch, Swedish, German, African, French, Jewish, Scots-Irish, Swiss, and Russian—who came to North America in this period. One of the most intriguing objects in this area, on loan from the British Museum, was an eighteenth-century Akan drum made in West Africa and transported by an enslaved African to Virginia.[92] Visitors would also have seen a statue of the Archangel Michael from a Franciscan mission church at Zuni pueblo dating to about 1770, a Dutch carved oak footwarmer, and silver bells that decorated Torah scrolls from New York around 1765. Making the point that this exhibit was about the formation of a nation, not simply an accumulation of objects from different peoples and cultures, a key display in this section was that of materials associated with the American Revolution, including the portable writing desk on which Thomas Jefferson drafted the Declaration of Independence and George Washington's uniform and mess chest. Finally, at the end of the opening section, was a display titled "Cultures in Contact," which addressed the ways in which Native and European peoples mixed and adapted to one another. Featured prominently here was an 1855 statement from Chief Seattle of the Duwamish Tribe, imagining what it would be like "When the last Red Man shall have perished, and the memory of my tribe shall have become a myth among the white men." Although voiced by a Native leader, in this context the quotation likely reinforced visitors' preexisting notions of the "Vanishing Indian." The next section, which started with the arrival of millions of immigrants to the country primarily from Europe in the nineteenth and the early twentieth centuries, would only have served to reinforce this perception.

Progressing into the second section of the exhibit—"Old Ways in a New Nation"—visitors immediately came upon various modes of transportation. A model of a nineteenth-century ship that carried immigrants from Hamburg, Germany, to New York represented the means by which late nineteenth-century and early twentieth-century immigrants traveled to the United States. The same case also included images of slave ships and shackles, illustrating how the vast majority of Africans had come to North America. Adjacent to this case was a passenger wagon from the 1880s loaded with baggage and a New England peddler's cart filled with supplies. Across from them were a Native canoe and kayak, a nineteenth-century Mexican ox cart, and an array of saddles and snowshoes. The purpose of these items was to illustrate the many different ways in which people had

traveled across land and sea. From here, the displays shifted to an examination of work. A grist mill from New Mexico and Samuel Slater's spinning and carding machines from New England shared space with farm equipment, tailor's tools, various other hand tools, spinning wheels, and baskets from San Francisco's Chinatown. One of the most significant objects in the exhibit could also be found in this section—the "Bible Quilt" made by African American quilter Harriet Powers around 1886.

Continuing in the second section of the exhibit, visitors would have encountered a tightly packed mass of eye-catching objects that illustrated the themes of artistic traditions, prejudice, religion, and status. An inlaid table made in 1864 by a German immigrant; Slovene, Ukrainian, and Croatian decorated eggs; a glazed earthenware jar made by an African American potter in South Carolina or Georgia; a large loafdish from Pennsylvania; a Pueblo jar—together, these objects and others made the point that ethnic traditions often survived in the creation of art. Next, visitors moved jarringly to a cluttered nook of objects associated with segregation and discrimination. Two doorframes, which read "Men White Only" and "Ladies White Only" stood in front of a Ku Klux Klan robe which was positioned underneath a charred cross. A sign reading "Japs Keep Out You Rats" hung

"A Plantation of Differences" from *A Nation of Nations*, 1976. Smithsonian Institution Archives, neg. #76.14319.29.

Display of objects associated with artistic traditions, prejudice, religion, and status, *A Nation of Nations*, 1976. Smithsonian Institution Archives, neg. #76.14331.23.

next to signs for a "Colored Entrance" and "Colored Café." Without a pause to catch their breath, visitors then moved immediately into a polyglot display of religious objects, including an imposing roadside cross reading "Get Right With God" and a Jewish Decalogue. Finally, visitors could ponder the significance of status in America by gazing on a diamond tiara set with 495 diamonds in white gold and platinum.

Next stop was "Shared Experiences." Here, attentive visitors would have seen American culture beginning to coalesce around certain shared attitudes and experiences. A reconstructed schoolroom from Dunham Elementary School in Cleveland, Ohio, made the point that education served as an instrument of Americanization. Closed in 1975 after ninety-two years of operation, the school educated a population of students that mirrored the changing demographics of the city that surrounded it. Another key piece of the Americanization process was naturalization. A bench from Ellis Island invited visitors to sit and imagine themselves as immigrants on their way, presumably, to naturalized citizenship. "The one thing 42 million immigrants had in common," the text for this display read, "was the simple and profound moment of becoming a citizen. But once you could say 'I am an American,' would you be accepted? How much of the old identity remained?" Fittingly, given the privileges that came with citizen-

ship, visitors also encountered objects associated with the political process, including an assemblage of 1,603 campaign buttons dating from about 1880 to 1976. After this display, they saw items relating to work, such as postal uniforms, a railroad car from the Atcheson, Topeka, and Santa Fe Railway Company, and a 1935 strike poster from the Model Blouse Company in New Jersey. In addition, the military experience was dramatized through part of a U.S. Army barracks from Fort Belvoir, Virginia, decorated for the World War II period. Carrying the Americanization theme forward, the text for this display posed the question: "How separate could the immigrant feel when everybody was wearing the same uniform?" This section also contained sports and entertainment memorabilia, such as Irving Berlin's piano and Muhammad Ali's boxing gloves from the "Rumble in the Jungle," accompanied by multimedia presentations. Through these leisure activities, the exhibit seemed to argue, Americans developed a common frame of reference despite their backgrounds. Tempering this theme of assimilation through the consumption of popular culture, however, was a 1925 Italian American kitchen and living room, which represented the balance between Americanization and the continuity of ethnic traditions in the home.

The fourth and final section of the exhibit—"A Nation Among Nations"— used mass production, mass consumption, and mass communication to situate the United States in a global context. The displays on mass production connected American-made products, such as an early automobile made in Springfield, Massachusetts, in 1894 and a Ford Model T, to contemporary products that were manufactured abroad. To illustrate mass consumption, both at home and abroad, the exhibit displayed a wall of neon signs from ethnic restaurants as well as a collection of American trademarks used in foreign countries—e.g., a Kentucky Fried Chicken sign in Spanish and a MacDonald's sign in Japanese. Finally, in the area on mass communication, visitors could play with an operating ham radio station, view a sample of the 1858 trans-Atlantic telegraph cable, listen to live short-wave radio transmissions from countries around the world and samples of historic messages, and view programs on a bank of television screens.

From the pre-Columbian era to the age of television, the reach of *A Nation of Nations* was sweeping. Such a broad scope was fitting for the Smithsonian, given its nineteenth-century ambition to be a truly comprehensive museum. The challenge in exhibiting such a broad range of materials was, of course, to find a theme or narrative that would connect everything. Here, Boorstin's original concept remained the guiding force. Despite numerous revisions and input from many staff members over the years, the basic idea of an exhibit that would depict a diverse mass of

peoples from all over the world coming to America to form a single, unified nation remained essentially unchanged. A press release announcing the opening of the exhibit stated this clearly:

> Perhaps our most significant achievement as a nation is the very fact that we are *one* people. So many ancient and modern states composed of conflicting tribes, languages, and religious factions have failed to unite and remain whole. This country, on the other hand, peopled solely by immigrants from foreign shores and different traditions, is now to celebrate 200 years as a single nation. How is it that people representing cultures and traditions of literally every part of the world could come to think of themselves as one nation of Americans?[93]

Section three—"Shared Experiences"—made this point vividly through the use of powerful symbols such as a schoolroom, bench from Ellis Island, and voting booth. Here in the United States, *A Nation of Nations* told visitors, one could find an essentially unified polity and a common culture. But, what of the balance between a therapeutic depiction of pluralism and the divisive realities of present-day American society? The display on prejudice was only a small, albeit powerful part of the overall exhibit. Was it enough to convey the conflicts and tensions endemic to a pluralistic society? For at least two visitors, *A Nation of Nations* did effectively balance positive and negative aspects of the American story. Robert L. Tripp of Reston, Virginia, visited the exhibit with his family and wrote in a letter to Director Hindle that they:

> found the exhibit not only exceptionally fascinating but absorbing and enlightening. We especially appreciate that the exhibit really does demonstrate that this indeed is a multi-ethnic, multi-racial society, and it demonstrates it in a forthright, open, honest way—showing positive as well as negative aspects of our past and present. This degree of honesty combined with a very interesting display is not as common as one would like. So for us the NATION OF NATIONS exhibit stands out especially.[94]

Similarly, for Arabella Sparnon, the exhibit had "the effect of making us *think*—about what went into the making of our country—not just the things we've done right—but the things we've done wrong. It should inspire all who see it to continue the 'building of our country' and to strive to correct our mistakes of the past."[95] Judging by these responses, which admittedly come from a very small sampling pool of letters preserved by the Smithsonian, perhaps the curators of *A Nation of Nations* were able to find just the right middle ground between positive and negative. I suspect, however, that many American Indian, African American, and other non-

white visitors may have had more critical reactions, which were similar to their responses to the Bicentennial celebration as a whole.

The great achievement of A Nation of Nations was its remarkable inclusiveness. The range of objects was staggering, and, if visitors looked closely, they could find representation of nearly every cultural group imaginable. The problem came with the interpretation, which relied so heavily on a European immigration narrative. Putting images of slave ships in a case with a German steamer that carried immigrants to the United States in the nineteenth century, for example, was problematic because it may have led visitors to conflate these experiences. By extension, a visitor could easily ignore key differences between European immigrants and their descendants and African Americans in contemporary society. Similarly, casting Native peoples as immigrants might also have led to harmful conclusions about the place of American Indians in the present-day United States. The notion that Native peoples had come from somewhere else and therefore were not truly Native Americans has been strongly criticized by many contemporary indigenous groups. Questioning Native claims to indigeneity, some have argued, undermines claims of illegal dispossession of the land and runs counter to Native histories and religious traditions. Although beautiful and culturally significant objects from Native peoples, African Americans, Asians, and others were prominently displayed in the exhibit, contemporary members of these groups lacked a significant voice in how these objects were interpreted. For that, the Smithsonian would have to invite real people to tell their own stories.

Where A Nation of Nations represented American diversity through the display of over five thousand objects, the Bicentennial Festival of American Folklife did it by bringing over five thousand people to the National Mall to present their cultural traditions to the public. Although the Bicentennial festival followed the same basic model as the festivals that had preceded it, it was much larger and more ambitious than any of the earlier ones. Spanning twelve weeks and attracting approximately 4.5 million visitors, it was an event of unprecedented size and scope.

In 1969, the same year Daniel Boorstin came to the Smithsonian, festival director Ralph Rinzler and Division of Performing Arts director James Morris began discussing the development of special presentations to mark the Bicentennial.[96] Over the next two years, in addition to organizing the summer festivals, they continued long-term planning and reached out to other organizations to recruit partners. In early 1971, they forged an important partnership with the AFL-CIO to develop programs showcasing

American workers beginning with the festival that summer and culminating in 1976.[97] This type of large-scale institutional support was vital, because of the ambitious scope of the endeavor they were planning. In 1972, the Division of Performing Arts drew up a plan for a four-month festival, which would be six times longer than the earlier festivals. Such a massive undertaking became a realistic possibility when, in 1973, the National Park Service joined the Smithsonian as a co-sponsor of the festival, and the ARBC added its endorsement.[98] In a preliminary proposal to the commission in April 1973, the Division wrote, "The purpose of the Festival is to deepen and broaden public appreciation of the richness and vitality of American creativity. The festival stresses the fact that just as each of us is a citizen in many communities—regional, ethnic, occupational—so the entire population is wondrously diverse."[99] Over the course of the next three years, Rinzler and other staff members would try to capture as much of that diversity as possible and bring it to the festival.

Each year leading up to the Bicentennial, the festival's organizers used the annual summer festival to develop new ideas and to refine their programs. Through this process, they ultimately devised seven program areas: "Old Ways in the New World," "African Diaspora," "Working Americans," "Regional America," "Native Americans," "Family Folklore," and "Children's Folklore."[100] The primary aim of "Old Ways in the New World" was to show "traditions immigrants brought to the New World and explore how these traditions have survived or changed in the process of acculturation."[101] "African Diaspora" took a similar approach, documenting continuities in traditions among peoples spread across the African continent and the Western Hemisphere.[102] Where "African Diaspora" traced cultural bonds among people who shared at least a perceived common ancestry, "Working Americans" emphasized the cultural ways developed by workers who shared a common occupation.[103] Designed to emphasize the worker, not the machine, "Working Americans" brought meat cutters, taxi drivers, truckers, machinists, bricklayers, electricians, joiners, and many other types of workers to the festival.[104] "Regional America" offered the most flexibility and diversity of the program areas because its participants needed only to share a common geographical origin. "The objective of Regional America," read a festival planning document, was "to show the special color of . . . regions by presenting the forms of expressive culture that people living in them have developed over the years."[105] Complementing the presentations in "Regional America" were programs in "Family Folklore," which collected information about family-centered traditions from festival visitors, and "Children's Folklore," which brought schoolchildren

from Washington, D.C., and the surrounding areas to the Mall to share their games and stories. Finally, "Native Americans" brought American Indian singers, dancers, craftspeople, tribal leaders, and activists together to present not only a portrait of Native traditions but also an overview of contemporary American Indian life. Each of these programs had its own rationale and its own staff, and each developed relatively independently of the others.

To bring these programs together, the festival needed a larger staff and more money. Augmenting the staff happened rapidly, as fieldworkers, program coordinators, and other administrators were hired to meet the increasing pressures of logistics, management, and, most important, locating festival participants. Ultimately, around three hundred people would contribute in some capacity to the making of the festival. Financially, having the support of the Smithsonian, AFL-CIO, Park Service, and ARBC provided a major boost, but, if they were to pull off an event of this size, they also needed corporate support. At a February 1975 meeting, staff members learned that American Airlines would be announcing its sponsorship of the festival shortly and that General Foods was close to making a commitment as well. Caution was urged, however, as staff members were warned not to "refer to any arrangements the [Smithsonian] has made with any other agencies or corporations."[106] This caveat may have been motivated by festival staff members' inexperience with the corporate world. Generally the type of people who eschewed contact with the world of business—and perhaps even secretly wished for the overthrow of the capitalist system—the folklorists who put together the festival were lucky to attract any corporate support. Their early attempts at fundraising had been unsuccessful, because they did not know what to say to corporations to get them to open their wallets. Fortunately for them, American Airlines asked the right questions, and, in response, they were able to adjust their approach. Corporations, they found, wanted hard data proving that the festival reached a wide audience. They also wanted to know that the event would generate goodwill toward them and visibility for the corporation; moreover, that it would offer opportunities for employee involvement and the generation of revenue. With this knowledge in hand, Ruth Jordan, special assistant to Morris, recommended that each of the program areas meet and "design an approach to the groups you want to interest in the Festival."[107] A harbinger of what was to come for Smithsonian curators as the institution's government funding was reduced in the 1980s and '90s, this early foray into the realm of corporate support was a trial by fire for people who had not been trained to think as businessmen did.

During the first half of 1975, festival staff concentrated on completing fieldwork and coordinating arrangements for that summer's festival. Since the '76 festival was so all-encompassing, however, much of this research could be reused the following year. For "Working Americans," for example, the '75 festival was essentially a trial run for the transportation section of the Bicentennial festival. Fieldwork administrator Bob McCarl was with towboat operators in St. Louis in mid-February, truckers in Maryland, Pennsylvania, Ohio, and Virginia in mid-March, and employees of Cessna and TWA in Kansas and Missouri in late March.[108] At the same time, fieldworker Miiko Toelken was in Japan and Ralph Rinzler was in Italy and Lebanon conducting fieldwork for "Old Ways in the New World." In upstate New York, Tom Kavanagh, assistant program coordinator for Native Americans, was meeting with Iroquois leaders, and in California, "Regional America" fieldwork was underway.[109] If all of this work was required for a typical two-week festival, the Bicentennial must have felt like a looming behemoth.

After feverish preparations, the festival grounds vibrated with activity from June 25 through July 6—at times, it quite literally vibrated as when Washington truckers held their "roadeo," a driving competition that took place on Bacon Drive adjacent to the Lincoln Memorial, or when a four-car train was set on 228 feet of track south of the Reflecting Pool so the railroad workers could demonstrate their skills.[110] The air traffic controllers also inadvertently added to the din, as jets passed overhead every few minutes on their way to and from National Airport. Beyond the transportation demonstrations in the "Working Americans" area, festival visitors could check out livestock handlers, as well as musicians, dancers, and craftspeople from California and the Northern Plains in "Regional America." In "Native Americans," they could watch demonstrations with Iroquois lacrosse players, craftspeople, dancers, cooks, and singers. They could also sit in on discussions in the Learning Center with tribal leaders and learn about other tribes in the Eastern United States from representatives of the Coalition of Eastern Native Americans (CENA). In the first week of the festival, visitors to "Old Ways in the New World" could experience German and Lebanese traditions, and, during the second week, they could view a showcase of Japanese, Mexican, and Italian traditions.[111] In the "African Diaspora" area, they could explore African music, dance, and crafts in three different settings—porch, market, and church—from the United States, the Caribbean, and West Africa. In the market area, for example, they could choose to attend a daily "Street Sounds" workshop, which, at various points, featured Salisu Mahama with an ensemble of Ghanaian gonje players, American

blues harmonica player Charlie Sayles, the Rising Star Fife and Drum Band from Mississippi, and a Rara group from Haiti.[112] Finally, visitors could stop by "Family Folklore" before heading home to record their own traditions.

In the July 1975 issue of *Redbook* magazine, the famed anthropologist Margaret Mead praised the folklife festival, calling it "a people-to-people celebration in which all of us are participants—now as organizers, now as celebrators, now as audience, as hosts and as guests, as friends and neighbors or as strangers finding that we can speak the same language of mutual enjoyment."[113] A member of a special advisory panel of ARBA, Mead identified the festival as an excellent way to mark the Bicentennial.[114] "A festival that celebrates people in their extraordinary diversity," she wrote, "needs no justification." For Mead, however, the idea behind the festival was not simply "to provide a framework for self-praise, but instead to heighten our own awareness of our internal diversity and to say, in a way that everyone can understand, that we realize we have links—through people—to the whole world."[115] In this statement, Mead addressed the major issue at the heart of the Smithsonian's Bicentennial tributes to American pluralism. To what degree could they be simply celebrations of diversity? Mead saw celebration and enjoyment as pathways to a greater capacity to face problems "that are unsolved and otherwise may seem insoluble." The festival helped to "extend and expand our capacity to enjoy one another and to live responsibly with one another." It was a way for Americans not only to improve their relations with one another but to become more responsible citizens of the world.

Rinzler agreed wholeheartedly with this assessment of the festival's role in society. However, he and his staff did not have much time to be philosophical after the '75 festival. They had to dive headlong into planning and fieldwork for next year. Adding to their burden was the fact that they had to coordinate national tours for the "Old Ways in the New World" groups that had performed at the festival. Starting in 1973, "Old Ways" participants had traveled to communities across the country to perform for several weeks after the festival. Extremely popular with the public, in 1975 these tours brought Lebanese, Ghanaian, Mexican, Japanese, Italian, German, Jamaican, and Haitian performers to thirty-eight cities including Atlanta, Baltimore, Cleveland, El Paso, Milwaukee, and Philadelphia.[116] While these groups toured, Bess Lomax Hawes, who was serving as a research coordinator for the 1975 "Regional America" program and would be a deputy director of the '76 festival, circulated a memo to festival staff pondering which countries to invite next year. She created three lists: countries that were "possibly to be included," those that were "up in the air but under

consideration," and countries that would "probably *not* be included." The third list included China, Cuba, all Latin American countries except for Mexico and Panama, the Virgin Islands, Puerto Rico, Samoa, all countries in Southeast Asia, and the Soviet Union. The exclusion of some of these countries raised concerns, however, as they were the countries of origin for "significant blocks within the general population—e.g. Puerto Ricans, Chinese, Armenians, Lithuanians." Members of these groups, Hawes noted, were "deeply and legitimately concerned that their importance be recognized during the 1976 celebration." As a result, she suggested asking fieldworkers about locating "potential participants from the third list."[117]

Festival staff engaged in much hand-wringing over which countries and ethnic groups to include. In November, a supervisory group of staff agreed on their "priority countries." "The basic criteria for selecting these countries," they wrote, "were percentage of contribution to the American population (based on a comparison of the cumulative immigration statistics since 1820 and the 1970 census) and the evidence of cultural continuity." On the list were Israel and Egypt, which staff members acknowledged did not meet these criteria strictly, but argued that they did so symbolically. Israel stood in for the "Jews of Eastern Europe and other countries around the world from which the significant Jewish immigration to the United States came." Similarly, Egypt served as a "symbol of Pan-Arab culture." The group also discussed that "some provision must be made for ethnic groups which for political or financial reasons will not have a foreign counterpart on the Mall."[118]

In early December, Hawes offered her assessment of "the problem of ethnic group inclusion" in the Bicentennial festival. She pointed to the difficulty of obtaining an accurate count of immigrants' countries of origin as well as Americans' ethnic identities from census and other records. Since November, she reported, the supervisory group had further refined their list, agreeing on a "top sixteen": Canada, Egypt, France, Germany, Great Britain, Greece, Ireland, Israel, Italy, Japan, Mexico, Poland, Scandinavia, Spain, and Yugoslavia. "Political considerations," Hawes admitted, had "strongly affected this list." Evidently, the State Department had requested that they eliminate China, and the Soviet Union had not accepted the Smithsonian's invitation. In addition, the group had added Canada, which it had originally rejected because it was not an "old world" country, since it is "our close neighbor and we share so many cultural features it would be unthinkable not to have Canada present on the mall." The main justifications for inclusion should not be statistical representation, Hawes argued, but rather two other factors. The first was cultural continuity, which, for

Hawes, was an "umbrella phrase" that included "such factors as retention of original language, tendency to clump rather than scatter in settlement pattern," a cultural disposition against assimilation, and "perceptible impact on national culture." The second rationale for inclusion of particular countries was "as a recognition of the multiple sections of the world from which Americans have come." Along these lines, the group determined that Egypt would stand for "the Arab world and Japan for the orient."[119] Despite the identification of a "top sixteen," however, the list was still a work-in-progress as the New Year loomed. Over the next few months, it was expanded and, eventually, twenty-six countries were represented in the "Old Ways" program: Israel, Romania, Denmark, Norway, Iceland, Sweden, Finland, France, Canada (French- and English-speaking), Poland, Great Britain, Portugal, Yugoslavia, Ireland, Belgium, Egypt, Germany, Pakistan, Spain (participants came from the United States only), Mexico, Japan, Greece, Austria, India, Switzerland, and Hungary.[120]

Beyond settling on a list of countries, another concern was the lack of a "Festival-wide proposal vis a vis ethnicity." Other program areas, Hawes suggested, needed to pick up the slack in representing important groups such as Virgin Islanders, American Samoans, Chinese, and Ukrainians that "Old Ways" could not cover. To facilitate this process, she recommended that she and Susan Kalcik, folklorist for "Old Ways," "undertake serious discussions on the ethnic representation problem" with the other program areas. She knew that the festival could not hope to represent all aspects of ethnic culture in the United States and around the world. "We are dipping buckets," she wrote, "into a cultural sea." Festival-wide policies or discussions that transcended program boundaries, she hoped, might ameliorate some of the more obvious gaps.[121] In the end, this is exactly what happened, as both "Regional America" and "African Diaspora" expanded the number of countries and ethnic groups included in the festival, increasing the final tally of countries to thirty-five.[122] Nevertheless, many countries and ethnic groups still lacked representation.

To even begin to navigate the "cultural sea" of American and world cultures, the organizers of "Old Ways" and the other program areas needed to assemble an army of fieldworkers. For "Old Ways" this brought the added complication of identifying folklorists and other scholars with experience working in foreign countries. To assist in this task, the staff convened a meeting of the "Old Ways in the New World Advisory Committee," which was similar to advisory groups for "Native Americans" and "African Diaspora" that had been organized previously to provide scholarly direction and basic oversight for staff. Meeting attendees included Alan Lomax, Bess

Lomax Hawes, and program coordinator Shirley Cherkasky, as well as anthropologist Conrad Arensberg who was best known for his landmark study *The Irish Countryman,* folklorist Svatava Jakobson who was an expert in Czech language and culture, and anthropologist David McAllester who was one of the founders of the field of ethnomusicology in the United States. This distinguished group tapped their wide-ranging network of professional contacts to recommend fieldworkers in a long list of countries in Europe, the Middle East, and Asia. For example, they recommended a young folklorist named Barbara Kirshenblatt-Gimblett to conduct research in Israel.[123]

Fieldwork was an essential part of the process of creating the festival. It was the only way to identify the people who would bring the diversity of American and world cultures to life on the festival grounds. Consequently, each program area developed guidelines for its fieldworkers to ensure that those people who were invited to the festival were suitable participants. The "Old Ways" guidelines instructed fieldworkers to find the "most genuinely traditional performers." The festival's organizers were not interested in presenting "professional interpreters of traditional art or those who revive it." Appropriate "traditional artists," the guidelines suggested, were "found mostly among working people—farmers, miners, housewives, people who work with their hands." Their music, dance, or craft "springs directly from a particular community" and is transmitted through "face-to-face communication." Canned, or rehearsed, presentations by ethnic or national troupes were anathema to the festival organizers' concept of authenticity. To reinforce this point, the guidelines stipulated that "Clothing or costume worn by Festival participants must be the same as that customarily worn for esoteric performances and celebrations in the home community." For everyday activities, such as cooking or craft demonstrations, "ordinary clothes" were appropriate. "National costume or other traditional dress may be worn for Festival events representing feast days, holidays, or other celebrations," the guidelines read, "only if it is customarily worn on those occasions in the community."[124] The goal of these restrictions was to caution fieldworkers from selecting well-rehearsed, professional ethnic troupes that did not accurately represent the contemporary traditions of real people in either the United States or other countries.

This caveat could be a tall order for some fieldworkers, particularly those working in foreign countries. Ethnic or national troupes often bore the government's official stamp of approval and were an accepted part of diplomatic exchanges. The "Old Ways" guidelines reminded fieldworkers that the program was "based on a government-to-government relation-

ship." It was important, therefore, that "the fieldworker be concerned with the political implications of his/her activities." However, a commitment to securing "genuinely traditional performers" took precedence over appeasing foreign governments. Indeed, sometimes it was necessary for the fieldworker to do a bit of convincing to get foreign officials to sign off on a particular group. In India, for example, the fieldworkers (Usha Bhagat and Swatantra Prakash) had to fight with the cultural ministry to bring folk artists, craftspeople, and musicians rather than the classical artists the ministry preferred. In this instance, they were successful because Usha Bhagat had been an aide to Indira Gandhi for many years and therefore had influence within the government.[125]

In addition to finding the right participants, fieldworkers were expected to document the cultural context of the traditions they observed. In "Old Ways," festival organizers often used this information to develop presentations that allowed visitors to experience cultures as people at home might. Celebratory events such as parades, processions, picnics, festivals, religious ceremonies, and wedding festivities were seen as being particularly useful lenses through which to view contextualized performances of tradition. The ultimate task of fieldworkers was to visualize how traditions might be presented in the festival setting. Their research, according to the guidelines, was *presentation, not publication, oriented.*" Fieldworkers were not only the people who selected the participants; in many cases, they also bore the responsibility of explaining and contextualizing the traditions and tradition bearers who presented at the festival. They were the intermediaries between the participants and the festival audience, serving as facilitators of cultural exchange. "A keynote" of the festival, according to the fieldwork guidelines, was "visitors' participation." Visitors should have the opportunity to "directly experience traditional culture." At the same time, fieldworkers and other festival staff had a responsibility to the participants: "We want to encourage their traditions, support their community efforts, and establish a climate at the Festival which will allow them to perform at their very best."[126] Balancing the needs of participants with the education of visitors was perhaps the most challenging task for the festival's organizers.

As the summer began to loom larger on the horizon, fieldwork accelerated for all of the program areas. In "Regional America," approximately 140 fieldworkers fanned out across the country to gather information on potential participants. On December 11, for example, Tim Lloyd met with Lorence Le Roy Smith, "proprietor of Colorado's only bootmaking shop," and on December 18, Nick Spitzer visited with Sidney and Nola Guidry who ran a crawfish business in Louisiana. Of Nola, Spitzer reported: "She

peels crawfish in her husband[']s store. She can peel very fast (which is revered locally). She can show people how to do it and very talkative—good participant. She and her husband are a quintessential Cajun couple." Envisioning how she would present at the festival, he added, "She should sit at a high table with a sink in it for water to rinse off her hands and the crawfish."[127] Not all the field reports were as detailed as this one; still, it is possible to recover some of the breadth of research that was conducted by examining them. It is also possible to see how closely fieldworkers followed research guidelines, which recommended that they gather "vital statistics" about the potential participants, as well as background information on the acquisition of skills, performance context, and community.[128] On January 28, Peggy Yocom recorded her meeting in Pennsylvania with Robert C. Gelnet, the publicity chairman for the local "Applebutter Boil." About a month later, Suzi Jones was in Oregon with Duane Coop, the main organizer of the Northwest Logging Sports Festival, and then on St. Patrick's Day, she was in Utah with a Mormon family of quilters. Of them, she wrote, "Recommend strongly–Exceptionally suitable–They are a whole family–3 generations of quilters." Like Spitzer, she also made recommendations for how they might present their craft at the festival: "All 7 will quilt together on a pieced quilt—each square will be a different traditional pattern."[129]

The same day that Jones was in Utah, Bob McCarl was meeting with fur manufacturers to discuss their participation in the "Workers Who Clothe Us" section of "Working Americans" scheduled for July 14–25.[130] Fieldwork for "Working Americans" proceeded somewhat differently from the research in "Regional America" and "Old Ways." Because of the festival's partnership with the AFL-CIO, all fieldwork was done in cooperation with unions. After electing to participate, unions selected a coordinator to work with the field researcher to choose participants for the festival. For unions, the main benefit of participation was good public relations and the opportunity for the rank-and-file to show off their skills. For the festival, the partnership with the AFL-CIO made possible access to an incredibly wide range of workers. From the Glass Bottle Blowers Association of the U.S. and Canada and the International Union of Journeymen Horse Shoers to the United Brick and Clay Workers of America and the Laborers' International Union of North America, festival staff worked with union representatives to construct a sweeping, yet detailed overview of the world of unionized labor in the United States.[131]

Another major advantage of working through the unions was that "Working Americans" staff did not have to deal with letters from aspiring

participants. "Regional America," on the other hand, was flooded with such applications. A saddlemaker from Maryland, for example, wrote to festival staff members in January inquiring about participation. In response, Alan Lester, program coordinator for "Regional America," responded: "I must tell you that we select participants only on the basis of interviews. . . . Only those people located and interviewed by these fieldworkers are even considered as potential participants." Lester added, "we look for people who have learned their skill in an informal, traditional way rather than those who have their knowledge from formal study." Unsatisfied with this answer, the saddlemaker responded that his training was more of an apprenticeship than a formal education and that it was a shame that saddlemaking would not be included in the festival. Responding again, Lester wrote that they did expect to have "master craftsmen in saddlemaking" at the festival; however, they would be coming from the Western United States. "Urban and ethnic folk arts and crafts along with more rural forms," he wrote rather vaguely, "will make up our Eastern program."[132] This exchange illuminated the essential biases of festival staff and the challenges they faced in selecting participants. In rebuffing this aspiring participant, Lester remained committed to a concept of the authentic, or "genuinely traditional" folk, rejecting someone he deemed to be a revivalist. Like the costumed ethnic troupes that were anathema to "Old Ways," the saddlemaker was not the right fit for this particular festival. The only way to determine the difference between the "genuinely traditional" and the inauthentic was to have a fieldworker on the ground who made this determination. Given the number of fieldworkers involved in gathering participants, however, differences of opinion were inevitable and mistakes were made. Moreover, the line between "genuinely traditional" and not was sometimes unclear. Nevertheless, this ideal remained at the heart of fieldworkers' research.

Contemporary scholars have deconstructed, and even mocked, this idea of an "authentic" folk. The mission of the festival, however, was not so much to find the "authentic" folk as to display the diversity of American life. In this context, rejecting applicants such as the saddlemaker was necessary in that it allowed fieldworkers to identify and invite people who might otherwise have gone unnoticed. Thus understood, the undemocratic process of selection by fieldworkers and festival staff facilitated the creation of a much more democratic exhibit.

Detailing every program and event of the festival's twelve weeks would be impossible. A close examination of one week is sufficient, however, to illustrate its remarkable breadth. For those visitors who chose to spend the week of the Fourth of July in Washington, the festival offered a cornucopia

of options.[133] Walking the grounds, a family might have gone first to "Regional America" to chat with fifty-two-year-old Mary Jane Bennett, an African American sweet-grass basket maker from South Carolina who started making baskets as a child, selling them at a roadside stand outside Charleston.[134] Nearby, they would also have found Nola and Sidney Guidry, the white Cajun couple from Louisiana that fieldworker Nick Spitzer had identified. Moving on to the adjacent "Native Americans" area, they could have seen Seminole artist and political leader Kelly Haney showing examples of his artwork and playing tapes from his Shawnee, Oklahoma, television show in the Learning Center. If he piqued their interest, they might have stayed for a panel discussion about the Seminole, Muscogee, and Miccosukee peoples of Oklahoma, during which Haney spoke openly about the painful history of dispossession that had occurred: "My grandmother lost 160 acres of land. She thought she was signing a lease for 50 dollars and a pair of mules for 160 acres. On that piece of property today is many oil wells." For those audience members who thought that these practices had ended, Haney added, "many people today think, well, that's in the past, but it's not because working in tribal government as I have, I saw 40 acres of land go for a little over 400 dollars. And that's being permitted by the government . . . And so we still have [to] fight to some degree with the system that we have to live within." Clearly an effective public speaker, Haney would go on to serve for a decade in the Oklahoma state legislature and later as Principal Chief of the Seminole Nation of Oklahoma.[135]

After listening to Haney's sobering words, the family might have wanted to hear some music to brighten their mood. A performance by Dewey Balfa and other Cajun musicians in "Old Ways in the New World" would have fitted the bill perfectly. "I get the feeling that I'm on the Bayou back home," Balfa said, "seeing all these people dancing and having a good time." He marveled at the fact that his music, which was "isolated" in "southwestern Louisiana," had gained such a broad audience and that "thirty Cajuns from Louisiana" were in Washington playing their tunes. Here, Balfa acted as both performer and presenter. Playing the role of cultural intermediary, he explained to the audience how he and his fellow musicians had ended up at the festival and offered background information on Cajun music, culture, and history. Before hearing "Pine Grove Blues," for example, the family would have learned that it was popularized in the 1950s by the accordion player and festival participant Nathan Abshire. In addition, they would have heard that Abshire was reuniting at the festival with the fiddler Lionel LeLeux with whom he had played at dance halls and dance parties in the early 1930s. Amazingly, they had not played together since 1932.[136]

After witnessing this thrilling reunion, the family might have chosen to stick around to hear the next performance, which featured traditional French ballads from the old and new worlds. Here, Cajun singer Lula Landry sang "La Chanson de la Mariée," which she had learned from her aunt when she was ten years old. Her performance sparked another participant, Louise Reichert, from Auvergne, France, to sing a version of the same song. Hearing these ballads also inspired Balfa, who joined in with another song. This type of interaction was unplanned; it was the dynamic nature of the festival that motivated it.[137] Finally, if they still had any energy, the visitors might have observed a bricklaying demonstration in "Working Americans" or headed to "African Diaspora" to attend an early evening performance of "Sweet Honey in the Rock," the African American women's singing group founded by festival staff member Bernice Johnson Reagon.

Another participant the family might have encountered in the "African Diaspora" area was Mary Carter Smith, a griot from Baltimore. Smith had been a teacher in the Baltimore City public schools since 1943 and had turned to full-time storytelling in the 1970s. She was a co-founder of the National Association of Black Storytellers and hosted a show called "Black Is" on Maryland Public Television. Summing up what the festival meant to her and many other participants, she wrote: "You meet so many different people from so many places, and people smile at each other, and you have good feelings toward each other. It is like a miniature United Nations. And the beauty, the richness, the joyous celebration of life I experienced will be with me always."[138] Festival staff could have had no clearer proof that they had achieved their stated goals.

Public reactions to the festival were similarly positive. Diversity, in the festival context, was a source of pride and a refreshing alternative to divisive politics and soulless commercialism.[139] In a letter to Rinzler, "Wendell V. Cohen and friends and family" wrote, "I would like to express my appreciation and thanks to you and your staff for the 1976 Folklife Festival. It has been a constant source of intellectual stimulation for me and my friends! We have tried to return at least two or three times a week (!!) to enjoy the marvelous assortment of entertainment, culture, crafts and people." Effusively, Cohen added, "Everyone there seems to be on the same, 'Let's celebrate' wavelength. I'm sure this is partly a result of the design of the festival."[140] Another enthusiastic visitor, Julie Du Bois, wrote to Secretary Ripley, "For ten weekends during the summer, I had the best time of my whole entire life, and it was all due to the Festival. . . . Each week, I came away with the feeling that I had come to know myself a bit better, the participants a bit better, their country and my country a bit better."[141] John

and Regina Tauke of Pennsylvania added their praise, "Learning [about traditions] certainly gives one a better understanding of the attitudes and feelings of other people and eliminates many of the barriers which separate people of varying backgrounds and occupations."[142] The visitors' letters emphasized the healing powers of the festival as well as the enriching qualities of cultural diversity. "The festival," wrote Peter Harnick of Washington, D.C., "is a special treat at this time when most of our society is trying to become more homogenized and 'plastic' instead of cultivating the special values and diversity that make America great."[143]

Stimulating good feelings about American society and culture was, of course, an important aim of the festival's organizers. Rinzler wrote in the festival's program, "As we face the serious world problems of energy, the environment, economic and international tensions, it is the more crucial that we reaffirm our pluralism and cherish our differences while singing each others' songs."[144] Casting the celebration of pluralism as an important binding agent for a country facing a range of challenges, Rinzler overlooked the tensions that diversity often entailed. He clearly understood the persistence of inequalities in American society; nevertheless, he glossed over these kinds of social problems in his description of the festival in order to cast the event in a noncontroversial and celebratory light. The primary goal of the festival then became not to understand American society in all of its complexities, but to offer a therapeutic portrait of American cultural pluralism that fostered cross-cultural understanding.

The fact that the festival's organizers embraced such an objective should not be interpreted as a lack of commitment on their part to social justice. Indeed, the majority of them held deeply critical opinions of American society and sought to change it. Many were inspired by the Civil Rights movement and other social and political movements of the 1960s, and some had even taken part in activism during this period. Perhaps the best example of this was Bernice Johnson Reagon. As a member of the Freedom Singers, Reagon inspired countless audiences during the peak of the black freedom struggle in the early to mid 1960s. Through the NAACP and SNCC, she challenged segregation and discrimination in American society, and, as a performer, she galvanized movement activists to resist violence and oppression.[145] Later, as a scholar and musician she did not abandon her efforts to promote racial equality and social justice. Her entire career was suffused with politically conscious work. Still, the main thrust of the programs she helped to create for the festival's "African Diaspora" section did not overtly tackle social or political issues. Rather, they focused on the richness and beauty of African, African American, and Afro-Caribbean cultures. The

goal of the exhibit was not angry confrontation, but rather gentle healing through immersion in cultures different from one's own. Reflecting on what the festival attempted to do, Reagon said: "If a museum is trying to look at what a country in as much trouble as we are in actually needs, that museum ought to be finding hundreds of different ways for Americans to walk into a space and go through the exercise of visiting another piece of America that's not them."[146]

The minimization of conflict and the avoidance of divisive issues characterized a number of the festival's presentations. Because it was affiliated with the AFL-CIO, "Working Americans," for example, tended to offer the union establishment's perspective on labor politics. Reacting to this program area, Bernice Reagon wrote: "The unions are powerful. They are as powerful as the companies they call management. . . . The exhibits told this story. It was in the air, the heavy concentration of Blacks in the laborers union told a truth that everyone could see."[147] Other forms of labor not represented by AFL-CIO unions were not displayed at the festival, and labor radicals' ideas were given only fleeting mentions—usually by singers of labor songs, not the workers themselves.[148] "Old Ways in the New World" and "Regional America" also steered clear of controversial issues, preferring instead to showcase the skills and talents of the tradition bearers.[149] The only festival program area that directly and systematically addressed controversial issues of race and inequality was "Native Americans."

Nevertheless, the festival was perhaps the closest thing to a realistic and unromanticized celebration of pluralism in the Bicentennial year. It was an unprecedented event that brought a remarkable array of real people together to share their cultural traditions. Such an event would never be repeated in large part because of the logistical challenges involved. Still, for one summer, something approximating the actual diversity of American life was on display for all to see.

6

A Family of Humankind

The Making and Unmaking of a Museum of Man at the Smithsonian

As the Bicentennial festival reached its peak in the summer of 1976, Smithsonian officials debated its future. After such a blockbuster, what could they possibly do next? They knew the Bicentennial festival would be a hard act to follow, and no one favored mounting a festival of similar scale the following year. Various proposals were floated for reducing its size and scope. Some argued, for example, for "mini-festivals," which would focus more intensely on a specific folk group.[1] A bolder suggestion was for the folklife festival to become part of a proposed Museum of Man.[2] A Smithsonian Museum of Man had been a key goal of Ripley's since at least 1967, but he had not been able to outline a definite plan for it or secure funding from Congress. Ripley conceived of the museum in universalist terms and hoped that it would nourish the idea that "[all human beings] are one family in one world." Writing in *Smithsonian* magazine in 1974, he had called it "a museum of the Family of Man"—one that would emphasize the "interdependence" of all of humanity. Beyond this general theme, Ripley envisioned the museum addressing two main currents: first, the creativity of humans "in art, science, [and] invention . . . which occurs in our species no matter how diverse our environment," and second, the relationship of humans to their natural environment. "We have continually raided the savings bank of nature without letup," he wrote. The Museum of Man, he hoped, would stress the urgency of environmental problems and suggest solutions to them. Overall, Ripley believed that the museum would "link the chains of mankind over the generations" and provide a site where the Smithsonian could surmount barriers of race, ethnicity, and nationality and offer universal solutions to problems of the environment.[3]

A Museum of Man was not the only new museum envisioned for the Smithsonian in these years. The institution was in the midst of an expan-

196

sionist period, adding museums at an unprecedented rate. After the found-
ing of the Anacostia Neighborhood Museum in 1967, Smithsonian officials
had relocated the National Collection of Fine Arts (NCFA) to the Old Patent
Office Building in 1968, placing it there alongside the National Portrait
Gallery, which had been established by Congress in 1962.[4] Also in 1968, the
Smithsonian took control of New York City's Cooper-Hewitt Museum.[5]
Four years later, the Renwick Gallery opened as a branch of the NCFA that
specialized in displaying crafts, and, in 1974, the Smithsonian unveiled the
controversial, modernist structure on the Mall that housed the Hirshhorn
Museum.[6] Finally, in 1976, the long-awaited National Air and Space Mu-
seum made its popular debut. Over the coming decade, several additional
museums would appear. In 1979, the Smithsonian acquired the Museum
of African Art, located in Washington's Capitol Hill neighborhood, and
in 1987 this museum was moved to a location on the Mall adjacent to the
Castle. It was joined there by the new Sackler Gallery for Asian and Near
Eastern Art. Perhaps most important, it was in this period that Smithsonian
officials began discussing the creation of a Museum of the American Indian.

A Museum of Man, then, was only one project among many during this
period of growth. Unlike the others, however, it did not come to fruition,
despite strong support from Secretary Ripley and others at the institution.[7]
The construction of the museum was an important goal of the Department
of Anthropology; however, in internal planning discussions, its scope was
not limited strictly to this discipline. At various points, Smithsonian officials
envisioned folklife, cultural history, African American history and culture,
African and Asian art, and various sciences being part of the museum. No
consensus was ever reached, however, about the exact scope and mission
of the museum. Although Congress authorized a space for the museum on
the National Mall, it never received the necessary support from Congress
or the public to become a reality.

Why was this new museum proposed, and why did it fail when so many
others succeeded at the Smithsonian in this period? And, what implications,
if any, did the failure to develop a Museum of Man have for the institution's
existing museums? The answers to these questions lie in both internal and
external factors that shaped the Smithsonian in the late 1960s, '70s, and
'80s. The Smithsonian entered a fourth great era of museum building in
this period: the first was in the 1870s and 1880s when the institution created
the United States National Museum, the second in the first decade of the
twentieth century when the Natural History Building was constructed,
and the third in the '50s and early '60s when the Museum of History of
Technology was designed and built. This new phase differed from the

earlier ones, because it did not center on the creation of a single, omnibus museum. Instead, it witnessed the creation of several distinct museums, each with a narrower focus. The idea for a Museum of Man did not fit this new model of museum growth. It was, rather, a throwback to those earlier epochs when the Smithsonian had received congressional funding for sweeping, comprehensive museums that encompassed multiple divisions within the larger institutional structure. Rallying external support for such a project and building internal consensus on its focus and mission proved impossible in years that saw broader American society become increasingly fragmented and the Smithsonian's physical space more dispersed.

Dillon Ripley's interest in "man's place in the world" pre-dated his ascension to Secretary of the Smithsonian in 1964.[8] A number of trips abroad in his youth and adulthood had an important influence on the way he viewed the world. Ripley's first major expedition was a trip of several months to India and Tibet when he was thirteen years old. Then in 1936, after graduating from Yale, he joined a zoological expedition to the Pacific Islands sponsored by the Philadelphia Academy of Natural Sciences in which he served as ornithologist. Sailing almost 30,000 miles, Ripley was gone for a year and a half on the expedition.[9] When he returned, he went to Harvard to pursue a Ph.D. in zoology, earning the degree in 1943. That same year, he joined the Office of Strategic Services (OSS), the predecessor to the CIA, and became chief of its counter-intelligence branch for Southeast Asia.[10] Stationed in Ceylon, he combined military duties with scientific exploration, recalling that he drove "out into the . . . bush in a jeep with native helpers" in order to trap and shoot "several hundred birds."[11] As an officer of the U.S. military, a student, and a scientist, Ripley had numerous encounters with the local peoples of India, Southeast Asia, and the Pacific Islands. These experiences exposed him to a wide range of traditional cultures; as a result, although he was not an anthropologist, he developed a deep interest in non-Western societies.

After the war, Ripley became a professor in the biology department at Yale—specializing in ornithology—and then in 1960 took the position of director of the university's Peabody Museum of Natural History. That year he also spent a month during the summer with his wife, Mary Livingston Ripley, in the central mountains of New Guinea. Though not trained as an ethnographer, Ripley tried his hand at a bit of ethnographic observation during this trip.[12] Throughout this period, he continued to visit numerous sites in Asia on scientific missions. His 1964 book *The Land and Wildlife of Tropical Asia*, a popular scientific volume published by Time-Life, suggested

the broad scope of his interests in the wildlife and human populations of the region. From the trees of Borneo to the tigers of India, Ripley offered a general scientific introduction to the flora and fauna of tropical Asian habitats. Moreover, he surveyed the archeological and historical evidence of human populations in the region from the time of its earliest inhabitants, using recent excavations to show that its native peoples had a long and complex history even before the arrival of invading populations such as the Malays.[13]

Ripley witnessed first-hand the dramatic transformations in South and Southeast Asia during these years. The war had unleashed nationalist forces in countries such as India, Burma, and Vietnam, which rapidly became the leading edge of anticolonial, independence movements. Moreover, it had transformed the ethnic minorities of the region. Postwar independence movements combined with the awakening of ethnic identity among the peoples of the region fundamentally remade the societies and cultures that

S. Dillon Ripley and Mary Livingston Ripley in India, 1976. Seated to the left of Mary Ripley is Salim Ali, with whom Dillon Ripley authored *Handbook of the Birds of India and Pakistan*. Also pictured are P. B. Shekar (*back row, right*) of the Bombay Natural History Society and unidentified individuals. Smithsonian Institution Archives, neg. #2005-7933 and SIA2007-0155.

Ripley had first encountered as a thirteen-year-old boy.[14] Perhaps it was these experiences that inspired him to write in the Smithsonian's 1967 annual report that "The emergence of new nations . . . signals the end of the era when there was 'civilized man' who ruled another kind of man called 'natural man,' and often displayed him in a museum along with precious jewels, rocks, and dinosaurs. All cultures and all humans should be accorded equal dignity and respect, and for this they deserve a museum of their own."[15] Embracing the decolonizing spirit of the post–World War II era, Ripley made a powerful case for removing research and exhibition on human cultures from the natural history museum, arguing that this organizational structure was a relic of an earlier era of cultural hierarchies. His rejection of the dichotomy of "civilized" versus "natural" man was a direct repudiation of the nineteenth-century museum anthropology on which the Smithsonian's original ethnological exhibitions had been based. It was also an acknowledgment that his predecessors had erred in their decisions regarding the structure and content of the Smithsonian's museums. "I have always been unhappy that the museums on the Mall divide up along racial and ethnic lines," he wrote in a 1969 draft letter to Representative Julia Butler Hansen, a member of the House Appropriations Committee, which was circulated to his assistant secretaries. "The Museum of History and Technology, by traditional design," he continued, "concentrates on the history and technology and the decorative arts of white westerners. The Museum of Natural History, besides dinosaurs and other subjects of natural history, offers exhibits involving negroes in Africa, Indians in India, the Chinese, and so on."[16] To rectify this problem, he proposed that Smithsonian officials explore the creation of a "modern Museum of Man."[17]

In response to Ripley's charge, members of the anthropology department began preliminary discussions regarding the museum in 1968. The department was already in the midst of administrative change. In 1965, the Bureau of American Ethnology had been merged with the Department of Anthropology to create the Smithsonian Office of Anthropology (SOA). Since the late nineteenth century, the BAE, which was the Smithsonian's storied Americanist research arm, had been independent of the Department of Anthropology.[18] The merging of these two historic units was not without its tensions, and factions emerged within the SOA that became firmly entrenched over the next decade. The turmoil this caused made it difficult to forge a consensus over the future of anthropology at the Smithsonian.[19]

Further complicating matters was the fact that in 1968 Ripley had created a Center for the Study of Man. An independent bureau of the Smithsonian, the center undertook activities that overlapped with the concerns of the

curators in the Office of Anthropology, but went beyond their traditional objectivist approach to scientific research. The center's director was the University of Chicago anthropologist Sol Tax, a former president of the American Anthropological Association and founder of the journal *Current Anthropology*. Tax was best known for his efforts to use anthropological research to help solve social problems—an approach dubbed "action anthropology." He had put these principles into practice in 1961 when he had coordinated the American Indian Chicago Conference, a landmark meeting that spawned the National Indian Youth Council and drew attention to contemporary American Indian issues.[20] The center continued this work, maintaining active correspondence with American Indian activists during the critical years of the Alcatraz occupation and "Red Power."[21] It also assumed oversight of the compilation of the *Handbook of North American Indians*. Ultimately, the center was an experimental unit that never fully realized its promise before being phased out in the early 1980s. Its short existence, however, demonstrated Ripley's restlessness with the status quo in anthropology and his desire to press the discipline to adapt to the transformations of the late sixties and seventies in public attitudes toward the study of culture, particularly the cultures of racial and ethnic minorities. For a time, it seemed as if a Museum of Man would be the place such a shift would occur at the Smithsonian.

In early 1968, the chairman of the Office of Anthropology, Saul Riesenberg, asked Jack Ewers to formulate a preliminary plan for "the organization and functions" of a Museum of Man and solicited input from the staff.[22] Reacting to institution-wide discussions of the museum, he thought it prudent that the anthropologists take some initiative in defining what they would like to see in the new building. Although the response was tepid at first, by the fall of 1969 several anthropologists had become active in an Ad Hoc Steering Committee on the Museum of Man, which was formed at Ripley's request. T. Dale Stewart, a physical anthropologist and former director of the Natural History Museum who was serving as the committee's chairman, reported that the group had been "concentrating initially on a new image of anthropology. To this end we have been 'brain storming' in an effort to break out of the traditional way of looking at the science."[23] Thinking about a Museum of Man encouraged the anthropologists to examine the various divisions of the Smithsonian that dealt with "man's environment" and the ways in which the activities of these divisions might be connected. Although they envisioned the new museum as a home primarily for anthropology, they were not opposed to the inclusion of other disciplines.

Following on the heels of these discussions, Ripley was able to secure a statement from the Board of Regents requesting that Congress "appropriate a site for a museum of man for the Smithsonian Institution."[24] Consequently, in early December, Senator J. William Fulbright, a member of the Board of Regents, introduced legislation in the Senate doing just that, and later in the month, Representative Frank Bow, also a Regent, did the same in the House.[25] Bow succinctly stated the rationale for the new museum to his colleagues. It would, he said, "permit removal of the sciences of man from the Museum of Natural History and for the first time put in a single worldwide context all studies and exhibits of cultures and peoples from the earliest time to the present."[26] Despite support from members of Congress and the Board of Regents, however, neither bill was passed during this session.

Undeterred, Ripley persisted in advocating for the museum both internally and to influential individuals outside the institution. He continued to see the museum as vital to the growth and transformation of the field of anthropology and the Smithsonian as a whole. In January 1970, he wrote to the Harvard anthropologist Irven DeVore, "anthropology has a real chance to come into its own by maintaining itself as a sort of bridge between the humanistic sciences such as biology and the new humanism which will have to emerge." His hope was that anthropology would ally itself with "environmental biology" and tackle questions related to "man's effect on the environment." As a naturalist, Ripley had always been concerned with the environment, and he was not afraid to make practical recommendations for improving international environmental and development policies. In an address to the American Anthropological Association in 1965, he had asked, "Should not teams of anthropologists and biologists accompany large economic aid projects that eliminate natural environments and disrupt cultural patterns, at least to record them and perhaps to [influence] these massive projects in more auspicious directions?"[27] The following year, he had again asserted in a speech that "the future of environmental improvement depends . . . [on] achieving a rational, self-sustaining homeostasis of human populations within the ecosystems of the earth."[28] A Museum of Man, he believed, could serve as a center for this kind of research.

Following Ripley's lead, in mid-February 1970, Tax convened a special planning committee meeting to tackle the question of "How Anthropology in the Context of a Great, New Museum of Man Can Educate the Public to the Complex Nature of Some of the Major Problems Facing the Survival of Our Species." The meeting's attendees were a small group of influential anthropologists. Attending from the Smithsonian were Tax and Bill

Sturtevant. Joining them were DeVore, who served as acting chairman; Douglas W. Schwartz, president and CEO of the School for Advanced Research in Santa Fe, New Mexico; M. N. Srinivas, a distinguished social anthropologist from India; and Sherwood Washburn, a primatologist who was a pioneer in the study of the evolution of human behavior.[29] According to DeVore, despite the fact that the members were all anthropologists, one of the committee's primary conclusions was that the Museum of Man should not be only a Museum of Anthropology. They did not wish to "de-emphasize anthropology's crucial role" in the museum, but they clearly valued an interdisciplinary approach. "Anthropologists . . . today," they noted, "[are] reaching out to neighboring areas of inquiry, ranging from biology and genetics through linguistics and psychology to art, law, economics, and history." Perspectives from all of these fields were necessary, the committee believed, if the museum was going to tackle "the broad relationships of man and environment." Beyond emphasizing the importance of inter-disciplinarity, the committee discussed themes for the museum. Schwartz suggested that the museum might examine the dynamics of continuity and change in social and cultural systems and explore "universal concepts and processes" as well as cultural traditions specific to particular communities. It should also be a site, he suggested, for probing "what is the growing edge of anthropology today"—i.e., it should be a leader in the field. The museum should be flexible, Sturtevant contended, and do "what universities cannot do, or cannot do as well." It should also, Srinivas argued, "provide leadership to museums in other parts of the world, especially museums in the 'new nations.'" This, he continued, might be part of a larger effort to "put on a new face" for anthropology "in the non-Western world."[30]

These inspiring sentiments were meaningless, however, without practical support from Congress to construct a museum. In March 1970, Tax floated an idea to Ripley that the museum might be housed in the old San Francisco Mint at least temporarily until a building could be obtained in Washington. This went nowhere. The following month, however, Ripley had a productive conversation with Senator Hiram Fong, a member of the appropriations subcommittee that oversaw the Smithsonian, about "developing Congressional support for a possible Museum of Man." Fong believed that Ripley could generate "popular support" in Congress for a museum that would "illustrate the history of ethnic diversity of the present American nation."[31] Despite Fong's encouragement, however, progress on the museum stalled, perhaps because in the summer of 1970 Ripley's relationship with a powerful member of Congress soured. In July and August, Arizona Republican Senator Barry Goldwater called Ripley's leadership

of the institution into question on the floor of the Senate, bemoaning the poor treatment of science under Ripley's watch. Asserting that Ripley had neglected both the National Museum of Natural History and the National Air and Space Museum in favor of projects that featured the arts, such as the folklife festival, Goldwater argued that the Smithsonian had strayed from its roots as a scientific institution.[32]

The motivation behind this attack was Goldwater's desire to see the stalled Air and Space Museum project move forward. Congress had created a National Air Museum at the Smithsonian in 1946, but it was not until 1958 that the institution was able to secure a spot on the Mall for it. Even then, it would take another eighteen years before the museum was completed. In the interim, most of its collections were stored in a facility in Maryland, while some were displayed in and around the Arts and Industries Building. The museum might never have secured its own home without the relentless advocacy of Goldwater, who took the Smithsonian, and Ripley, to task for neglecting it. Goldwater, who had served in the U.S. Army Air Forces during World War II and continued to be a reserve officer in the Air Force, called on Ripley to make the NASM a priority. Although Ripley was able to refute Goldwater's criticisms regarding the neglect of science, he acknowledged that it had been difficult to secure funding for planning and construction as the Vietnam War drew resources away from domestic projects. Without Goldwater's intervention this situation might have continued. In 1971, however, the senator was able to shepherd a $40 million appropriation through Congress and, with that, the NASM was finally guaranteed a permanent home.[33]

The Museum of Man had no such champion in Congress, so it languished. The best Ripley could do was to add the name "Museum of Man" to the existing National Museum of Natural History. The name change was largely symbolic, however, as it did not represent any shift in the administrative structure or scientific focus of the museum.[34]

If anyone at the Smithsonian knew how to get Congress to support a new museum, it was Frank Taylor. In November 1971, he offered his ideas for what he called the "Museum of Man and the environment." "The new museum is required," he wrote in a paper circulated for discussion among staff, "to inform 6 to 7 million annual visitors . . . on the relationship between the protection of the environment and the rational use of the earth's limited resources in the service of man and the other living things with which he shares the biosphere." Connecting the Smithsonian's research and collections in biology, environmental science, and human cultures, the new museum would advance the type of work Smithsonian scientists had been

engaged in for over a century. More important, however, was the fact that a major theme of the museum would be the "losses inherent in irreversible deterioration of the environment." Here was a crisis that required immediate attention and might spur Congress to action. Recognizing the growing environmental concerns of the early seventies, Taylor saw in Ripley's vision a way both to use the new museum to serve the institution's mission and to touch a nerve with Congress and the American public.[35]

Internal consensus on this or any other overarching theme for the museum, however, was difficult to achieve. Over the next several years, Smithsonian officials floated numerous ideas, none of which gained much traction. At the same time, the bills in Congress did not move forward—although in April 1972 a significant hurdle was surmounted when the National Capital Planning Commission endorsed legislation to set aside the area between Third and Fourth Streets and Jefferson Drive and Maryland Avenue for a "proposed Museum of Man."[36] Despite this endorsement, Smithsonian officials could not agree on what belonged in the museum. Some argued that the entire Smithsonian was a Museum of Man and, therefore, an additional museum might not be necessary.[37] In a March 1973 memo, the deputy director of the National Zoo, Edward Kohn, asked of Ripley: "May not the Smithsonian, in its entirety, be mobilized as the Museums of Man?" Kohn laid out a plan whereby each already existing museum would focus on a particular aspect of human existence: the Museum of History and Technology would emphasize "Man and Institutions"; Natural History would take "Man, Land and Ethos" as its theme; the art galleries would probe "Man and Creativity"; and Air and Space would, of course, examine "Man and Space." This, he suggested, would leave the new mall site for a museum of "Man and the Sea."[38] The Director of Exhibits Central, James A. Mahoney, liked Kohn's idea for the new museum, but he suggested that it be modified to a museum of "Man and His World" that would include subsections on "man and the sea, man and the land, and man and the atmosphere." Similar to Taylor, Mahoney saw the main theme of the museum as "the use and abuse of the environment."[39]

At the same time, a wholly different idea made its first appearance. In an April 1973 memo to Assistant Secretary Robert Brooks, National Portrait Gallery director Marvin Sadik wrote: "It seems to me that the one remaining spot on the Mall might well be devoted to a National Museum of the American Indian."[40] In the same memo, Sadik suggested as another possibility a National Museum of American Folk Art. It was his idea for an American Indian museum, however, that would spark considerable debate among Smithsonian officials and, ultimately, change the course of

the institution's history. The idea was inspired by a visit to Mexico's Museo Nacional de Antropología. In September 1964, Mexican president Adolfo Lopez Mateos had inaugurated the new museum in Mexico City. It was a stunning achievement, and anthropologists, curators, and government officials in the United States and elsewhere hailed it as one of the world's great museums. Exhibiting archeological and ethnographic collections from Mexico's indigenous populations, the museum was a beautifully designed monument to the central place of Native peoples and cultures in Mexican national identity. Dedicated to presenting not only the remnants of pre-Columbian societies but also the contemporary indigenous cultures of Mexico, the museum offered a panorama of Native societies and cultures from their early history to the present in a way that no other ethnographic museum did successfully in this period.[41]

In a follow-up memo to Ripley clarifying his idea, Sadik wrote:

> As I see the possibility of a National Museum of the American Indian, or a National Museum of the Native American, it would deal with the subject in an absolute way—the unique achievements of each tribe on its own terms, and only secondarily in relationship to the coming of the white man. This is hard to express, but I was overwhelmed by the Museo Anthropologia [sic] in Mexico City, which brilliantly accomplishes what I am trying to suggest. While I had always known a certain amount about Pre-Columbian Art, I never before had been fully cognizant of the values of these various cultures per se.[42]

Sadik contended that the new museum should provide an opportunity for "the American Indian" to be seen "primarily on his own terms, rather than solely through the eyes of ethnologists, sociologists, historians, art historians, etc." Perhaps influenced by Vine Deloria Jr.'s powerful critique of anthropologists in his landmark 1970 work Custer Died for Your Sins, Sadik constructed a nascent vision of a museum paradigm in which the authority of the expert might be challenged or even supplanted. He stopped short, however, of suggesting that Native peoples should be in charge of the museum: "I don't mean by this . . . that Indians need do the museum." Still, he did hope that some Native peoples "might be involved."[43]

The response to Sadik's proposal from Smithsonian officials was mostly negative. Richard Ault, who was director of support activities in the secretary's office, wrote to Ripley's executive assistant Dorothy Rosenberg: "I can't see the justification for a museum of the size we're considering devoted solely to the American Indian . . . any more than to any other ethnic group." Instead, he preferred Taylor's suggestion of a "Museum of Man and His Environment." He did suggest, though, that there might be

"an entire hall in the new museum as a tribute to our American Indians."[44] Special assistant to the secretary Margaret Gaynor similarly argued that "The concept of a Museum of the American Indian seems too narrow for the capstone of the Mall's development. However, the Indian would be appropriate for inclusion in a Museum of Man or a Museum of the American People which might display the history and artifacts of all ethnic groups who aided in the development of the Nation." Furthermore, Gaynor raised two major concerns about developing a museum devoted to American Indians. First, she argued that the creation of such a museum would force the Smithsonian to engage in "continued negotiations with elected tribal governments and the usurpers [by which she presumably meant American Indian activists who challenged tribal leadership] over exhibits, employment, and scholarship." The complexities of American Indian politics, she warned, would lead to numerous internecine squabbles. "I can foresee the Navajos demanding the largest amount of space, being the largest tribe," she wrote, "the smaller southeastern tribes feeling slighted [and] the Agua Caliente making demands based on their wealth." Second, she felt that it was "somewhat anachronistic to establish an Indian museum at the capital of his antagonist." Regional museums would be preferable, she contended, because Washington stood as a symbol of negative government policies toward American Indians. Erecting a museum in the city would be to ignore the contentious, and often bloody, history of relations between American Indians and the federal government.[45]

Under Secretary James Bradley added a third concern to this list of reservations regarding the ways in which history and politics might disrupt a Museum of the American Indian. "We should be aware," he wrote to Ripley, "that there are militants who are actively protesting the display of Indian icons and skeletal remains as evidence of an act of plunder or degradation."[46] Here was the first suggestion of how the issue of repatriation might affect the Smithsonian.

Assistant Secretary Paul Perrot added his contribution to the barrage of criticism directed toward Sadik's idea. "I must say I am extremely cool to the idea of developing a Museum of the American Indian," he wrote. "Haven't they been on the reservation long enough?" Opposing a museum that would "underline their separateness," he wrote that he would "much rather have their inclusion within a broader scheme." Like Ault and Gaynor, he thought Native societies and cultures should be exhibited in a broader Museum of Man. Taking his critique a step further, he added, "I would also question the singling out of *any* specific ethnic group. This would create demands for other specialized museums." Specifically, he anticipated calls

for a museum of "The Black Man in America." His preference was for a museum that would interpret "the cultures and the races of the world . . . as the different branches of one large family."[47] Ripley seemed to share Perrot's concerns about the complications arising from the profusion of ethnically specific museums at the Smithsonian. In a handwritten note on a memo from another of his assistant secretaries, he wrote, "The concept of dedicating a whole museum on the Mall to *one* ethnic minority implies many things . . . the question of why *one*, without others, even though we are [focusing on] the original one, the emotions roused (and to be roused in the future) over Wounded Knee with attendant backlashes, the question of reverse prejudice etc etc."[48] Although he did not oppose the idea out of hand, his preference was clearly for a Museum of Man.

Evidently, only one official, the assistant secretary for history and art Charles Blitzer, supported "Sadik's proposal for an American Indian Museum" wholeheartedly. He offered several reasons why such a museum was a good idea. First, it involved one of the central research fields of the Smithsonian, and the institution already had extensive collections and staff in this area. Second, "the idea would almost certainly have great appeal on the Hill." In other words, this was a museum concept that Congress would undoubtedly be willing to fund. And, finally, Blitzer believed that the subject was "one that would lend itself to the creation of a truly great museum."[49] Despite Blitzer's ringing endorsement, however, a Museum of the American Indian would have to wait for its day. Institutional support remained strongest in this period for a Museum of Man.

In early 1973, bills had again been introduced in the House and Senate reserving the Mall site for a new museum, and, once again, neither one had been passed.[50] Still, internal discussions about the museum continued; indeed, over the next two years, they intensified as Ripley and his assistants strove to develop a workable concept that would be accepted by both the interested parties within the institution and a majority of members of Congress. In June, Robert Farrell, who had the title "agenda office director," wrote up a document titled the "Purposes of a Museum of Man" in which he argued that the museum should be devoted to "the history and achievements of various groups of people" and "the influence of selected scientific and cultural ideas on man's development." In his view, the ideal museum would be interdisciplinary and "require a marriage of culture and science."[51] Almost immediately, Frank Taylor responded that Farrell's plan was unfeasible for practical reasons. He contended that the various Smithsonian museum directors would not endorse a "new museum with institution-wide scope," because it would "require aid from their resources

while competing for appropriations." Here was the rub—at least internally to the Smithsonian. A new interdisciplinary museum sounded like a great idea until Smithsonian officials had to sort out issues of funding and resources. The multiplication of museums, not to mention divisions and departments, at the Smithsonian inevitably led to competition for scarce resources and created significant barriers to unifying the Smithsonian's scientific, technological, cultural, and historical activities under one roof. Over the course of many decades, the Smithsonian had become fragmented in such a way that new configurations that attempted to cross established barriers were stymied. Taylor presented the options in clear terms: "Before more time is spent on this, I recommend that we obtain from Mr. Ripley an expression of his interest in one of the two general kinds of museums. One is the museum with the broad, interdisciplinary, institution-wide character. The other is the museum based upon one subject or discipline."[52] He obviously had serious doubts that the former option was feasible, but he left the final decision to Ripley.

Despite Taylor's reservations, Ripley did indeed choose the former option. Having taken what was the more difficult path, he and his assistants now needed to come up with a concept that Congress and Smithsonian staff alike would accept. After much deliberation, they proposed that the museum be organized around the theme of human creativity—not simply in the arts, but in science, technology, ideas, and social institutions as well. The museum, to use a phrase from Ripley, would explore the "questing spirit" from humanity's earliest days to the present.[53] Although the concept was rather vague, its appeal for Ripley was that it would allow the Smithsonian to "express [humanity's] diversity" and "celebrate our kinship." In other words, it would enable the enumeration of both similarities and differences in the "family of man."[54] Creating exhibitions for such a museum would require drawing on the work of many different disciplines, including anthropology, history, and the sciences. It would also require objects. To circumvent the objections of Smithsonian museums and divisions that presumably would be asked to contribute materials and resources, Brooks wrote that the new museum would have no permanent collections and would be "a borrower, both from the Smithsonian museums and from other museums of the world." Its exhibits would be temporary and change on a regular basis. Moreover, it would have only a small staff.[55]

Despite these caveats, the new museum's infringement on other units remained an active concern, especially for staff members in anthropology. In a September 1974 memo, Porter Kier, director of the National Museum of Natural History, wrote to Ripley of his concern over the possibility that

anthropology might be "separated from the other disciplines comprising the Museum of Natural History." Kier discussed the effect both the proposed Museum of Man and a "Museum of Native Americans" might have on anthropology at the Smithsonian. He opposed the latter museum for reasons similar to those expressed earlier by others at the institution: "I do not like the idea of a separate Museum of the Native Americans. It runs counter to our efforts at the S.I. to 'bring things together'. Furthermore, I suspect that our native Americans would take offense at this 'segregation'." At the same time, although he did not oppose the "Museum of the Family of Man," he did express his "strong conviction that it would be a serious blow to natural science in this Institution for an anthropological research function to become part of either of the two museums now being considered."[56] For Kier, it was vital to keep anthropology in Natural History because of the increasingly interdisciplinary character of research and exhibitions in the museum. An example of this new approach could be found in the new permanent exhibit *Ice Age Mammals and the Emergence of Man,* which opened in 1974. Combining paleontology, geology, and anthropology, the hall was the "first real interdisciplinary" exhibition in the museum and suggested the promise of combining "environmental studies with culture and paleontology."[57] Interestingly, it would have fitted nicely in the Museum of Man as conceived by Ripley.

At the same time Kier penned his memo, Sturtevant assembled some "Notes Toward a New National Museum of Cultures," which suggested that the anthropologists were attempting to regain control of the museum concept. Disagreeing with Kier, Sturtevant argued that anthropology should be "charged with the organizing, support, staffing, and direction of the museum." Despite the possible benefits of interdisciplinary work within Natural History, Sturtevant maintained that it was "anachronistic to keep anthropological research and exhibits under the natural history roof." Echoing the criticisms of many American Indian activists, Sturtevant wrote unequivocally that "It is wrong to classify the study of cultures with the study of animals and minerals, especially when, as with us, the cultures exhibited turn out to be carried by non-European peoples, implying that the S.I. and anthropology treats of 'lesser breeds' as like animals, and of Whites as having history and technology and art, but not cultures." Here, from a longtime Smithsonian staff member, was a trenchant critique not only of Smithsonian anthropology but of the institution's entire organizational structure. A Museum of Cultures, he argued, would rectify this glaring institutional problem. At the same time, it would refrain from impinging too directly on the activities of the other museums. Natural History would

continue to examine "human biology and the human component of ecology," History and Technology would focus on "the history of the American nation and its technology," and the art museums would "retain their own domains." "The Museum of Cultures," he added, "should be a celebration of ethnicity—for the United States, where it can mark the rise of the ethic of cultural pluralism, the demise of the melting pot ideal . . . and for the world, where it can emphasize the past and present persistence of cultural diversity." In this, Sturtevant's vision was very similar to the concept behind *A Nation of Nations*. It differed from that exhibit in one important way, however—its foundation would be in anthropology rather than history. This was not to say that its exhibits would be limited entirely to the work of this discipline. "Linguistics, folklore, (culture) history, art history, musicology, and sociology," Sturtevant noted, would all be included in the museum. Like Marvin Sadik, Sturtevant drew inspiration for his museum concept from Mexico's Museo Nacional de Antropología, which he called the "best anthropology museum in the world." However, he came to a very different conclusion from Sadik's, arguing strongly against a "New Museum of American Indians." Since his preference was for a museum celebrating cultural pluralism, he maintained that it was "wrong and not justifiable to focus on only one element of the American population." Like some of his colleagues, he also anticipated that the museum would face "opposition among many Indians" who, he contended, "would see this as exploitation of their cultures by the non-Indian majority and the non-Indian power structure." In addition, he raised a more bureaucratic objection—an American Indian museum would "unreasonably split the anthropological collections and staff, along lines that do not agree with academic training and specialization." It would fracture the anthropology department in ways that would make management of collections difficult. The new museum he envisioned would allow all of the branches of anthropology to remain unified.[58]

Ultimately, all of these proposals went for naught, as Ripley was unable to muster the congressional support needed for the project to move forward. The flurry of internal discussions over several years had not resulted in a coherent museum plan able to win support during a difficult fiscal period for the nation. In May 1975, Ripley reported that "the present climate in the Congress was against further invasion of the Mall by permanent structures" and that "over the last few months he had come to the same conclusion."[59] Despite this apparent death knell for the museum, only a few months later Ripley was able to secure legislation reserving the Mall location for Smithsonian purposes. This was not the authorization for a

new museum he had originally hoped for; however, it was an acknowledgment that the Smithsonian could, in the future, utilize the space for some unspecified purpose. (Having this space set aside for the Smithsonian would be crucial in the development of the National Museum of the American Indian.) For the time being, Ripley suggested using the location for outdoor demonstrations that would expose visitors to "the major problems facing the planet and project solutions that might be reasonably arrived at on the basis of present advanced research."[60] Returning in a sense to the idea for a Museum of Man and the Environment, Ripley suggested that a new building might not be necessary to accomplish at least some of the purposes envisioned for the proposed museum.

Why had this project failed while several other museums succeeded during this period? Creating a new museum is never an easy proposition—especially when doing so requires congressional approval. Most of the Smithsonian's post–World War II museum projects traveled long, hard roads to authorization and, more important, funding and construction—none more so than the National Air and Space Museum. Strong congressional backing was clearly essential to the success of any museum project. Several other factors, however, also influenced the outcome. Perhaps most important to the internal dynamics of the Smithsonian was the fact that none of the new museums impinged on the research or collections of existing museums or units. NASM had long existed within the institutional structure and had its own collections, which Smithsonian staff had been accumulating for decades. The collection of the Hirshhorn was also free of competing claims from within the institution, because it came from private collector Joseph Hirshhorn. The Anacostia Museum had minimal collections, so it was not viewed as a threat. Moreover, its focus on African American history and culture was not a major concern of the other museums—although the Museum of History and Technology was beginning to see the necessity of improving its collections and exhibitions in this area. Beyond the Hirshhorn, the other art museums also faced little opposition, because, other than the Freer, the Smithsonian had no separate art galleries. Moreover, they did not require the construction of new buildings. The NCFA had been located, awkwardly, in the Natural History Building for years, so its relocation, along with the newly established National Portrait Gallery, into the Old Patent Office building was not an issue. The addition of the Renwick was also a welcome bit of expansion into a preexisting building. Similarly, the addition of the Cooper-Hewitt entailed the acquisition of an already extant institution, which had its own

structure and collections. Moreover, it was in faraway New York City, so it had little impact on the Washington-based museums.[61]

The Museum of Man was the outlier in this boom era of new museums for the Smithsonian. Rather than adding around the edges, the museum would have cut to the heart of the Smithsonian's existing functions, entailing a major reorganization not only of the institution's administrative structure, but also of its physical geography. It promised to touch many of the museum's core disciplines, especially anthropology, and promote interdisciplinarity. Moreover, it had no collections of its own, so it would need to borrow or take from the Smithsonian's existing units. Why did the museum proposal fail? By the 1970s, the Smithsonian had become too fragmented to put all of its constituent parts together in one place. Institutional lines had been drawn, not only bureaucratically but in concrete and marble. Creating a space where everything, or nearly everything, might be drawn together in new configurations had become impossible. In a sense, the original National Museum had become irreproducible.

Yet, the Museum of Man idea did not die at this point. After the Bicentennial, it lay dormant for several years before resurfacing in the early eighties. By that time, however, the institution was clearly headed in a different direction, and creating a separate Smithsonian Museum of Man became increasingly unlikely. Nonetheless, a Museum of Man Planning Group was formed in 1980, which facilitated extensive discussions among staff members about the museum. Curators, anthropologists, and administrators weighed in on everything from the museum's name to its philosophy and collections. The sheer range of opinions offered by Smithsonian officials clearly demonstrated how difficult it was to build consensus around a single museum concept, and the proposal again failed to move forward.[62] The institution did, however, continue to add museums. In the summer of 1979, the Museum of African Art became part of the Smithsonian after Congress approved funding for it. Founded as an independent entity in 1964, it had a collection of over eight thousand objects and one hundred thousand images, documenting nearly every region of Africa.[63] For the time being, the museum stayed in its original home on Capitol Hill. Later, however, it would be moved to a new structure on the Mall. The incorporation of this museum symbolized a burgeoning interest among Smithsonian officials in directing research and exhibitions toward the cultures and histories of people of color in places outside the Museum of Natural History. Perhaps, the introduction of this museum seemed

to suggest, the goal of reorienting the institution's treatment of African Americans, Native Americans, and other people of color in exhibitions could be done without constructing a Museum of Man.

Shortly after the acquisition of African Art, the Museum of History and Technology hosted a temporary exhibition titled "The Afro-American Tradition in Decorative Arts," which was a harbinger of things to come.[64] It ran from October to December 1979, and its opening corresponded with the arrival of a new director for the museum, Roger Kennedy, who would press hard for more exhibits on the history and culture of African Americans and other people of color.

Kennedy had had a varied career before coming to the Smithsonian. After serving in the Navy during World War II, he had graduated from Yale and the University of Minnesota Law School. In 1953, he had become a special assistant to the U.S. Attorney General before moving on to a career in media as a correspondent, producer, and public affairs broadcaster with NBC. He had subsequently held additional positions with the government, worked in banking and finance, and then had become vice president for the arts at the Ford Foundation. In addition, he had published two books and numerous articles on architectural history. Kennedy was just the kind of renaissance man that fitted in well at the Smithsonian. He was also an old-fashioned midwestern progressive in the vein of Henry Demarest Lloyd.[65] In short, he had the right combination of management know-how, scholarly credentials, and willingness to challenge the status quo needed to move History and Technology into a new epoch. Fittingly, as Kennedy entered, one of the founding curators of the museum took his leave. Malcolm Watkins retired in October 1979 after thirty-one years at the Smithsonian.[66] A pathbreaking cultural historian and museum professional, Watkins had been ahead of most of his colleagues in pushing for more diversity in the museum. Ironically, he departed just as this wish was beginning to be fulfilled.

A program in early 1980 encapsulated the spirit of the museum after Kennedy's arrival. "Voices of the Civil Rights Movement: A National Working Conference on Civil Rights Movement Culture" was co-sponsored by Howard University and the Smithsonian and included presentations on the past, present, and future of the movement from such leading figures as Ella Baker, Diane Nash, Fred Shuttlesworth, E. D. Nixon, Bob Moses, Dave Dennis, Amzie Moore, and James Forman. Accompanying the presentations was a photo exhibit titled "We'll Never Turn Back: An Exhibit of Movement Photographers." At the conclusion of the conference, Bernice Johnson Reagon led a forum on "National Dissemination" of the ideas that

had been discussed, followed by a "Songleaders' Workshop Concert."[67] Reagon, who had begun her career at the Smithsonian with the folklife festival, was now a staff member at the Museum of History and Technology in charge of the "Program of Black American Culture."[68] Around this time, African American historians Fath Davis Ruffins, Spencer R. Crew, and James O. Horton also joined the staff. In the coming years, they would play key roles in developing exhibitions and doing research on African American history in the museum.[69]

On top of these important developments, Kennedy also oversaw a cosmetic transformation that had deep repercussions for the museum's future direction. In October 1980, Congress passed and President Carter signed legislation changing the name of the museum to the National Museum of American History. The same legislation made the National Collection of Fine Arts into the National Museum of American Art. In one fell swoop, the Smithsonian now had two museums dedicated to "American" things. Ironically, just as Kennedy was expanding the scope of the history museum to include more cultural diversity, this legislation, which Smithsonian officials requested, restricted its scope to the American nation. "History" and "Technology"—two concepts not bounded by any national, racial, or ethnic qualifiers—had given way to "American history," which of course meant United States history. Although the museum had from its founding focused largely on the history and technology of Euro-Americans, its universalist scope remained present as long as it retained its original name. Changing the name condemned the museum to a particularist focus on the history of the United States. Kennedy, the cool-headed administrator, took the change in stride, stating that the "new name clarifies rather than changes what has always been the museum's basic mission—to illuminate . . . the entire history of the United States, including the external influences that have helped shape our national character." This, of course, had not always been the "basic mission" of the museum. Although in practice its scope had often been limited, the original idea behind the museum was not so narrowly defined.[70]

At least one staff member expressed his extreme disappointment with the change. Robert Vogel, who was a curator of civil and mechanical engineering, wrote an extensive memo to Kennedy just before the name change became official in which he offered carefully reasoned arguments against calling the museum the National Museum of American History. First, he pointed out that "American" does not refer strictly to the United States, but could in fact refer to the Americas as a whole. Other Smithsonian museums, he noted, had scrupulously, and correctly, avoided this

adjective. Second, and more important, the new name, according to Vogel, would not accurately reflect the mission of the museum. "In the minds of the great majority of the American public, 'American History' certainly means little beyond presidents and battles and political history. [This is] not the image we ought to project." Understandably, Vogel feared that science and technology would completely disappear, at least in the public's understanding of the museum. He also suggested that social and cultural history might be ignored. As an alternative, he proffered the "very name we proudly bore for decades: THE UNITED STATES NATIONAL MUSEUM." He felt that this moniker was most appropriate because it was clear and would not mislead the public in any way. Moreover, it suited the Museum of History and Technology because it was "the sole Smithsonian museum that is not a specialist museum; only we cover a nearly infinite gamut of subject areas rather than a very narrow one."[71]

A similar transformation occurred with the National Collection of Fine Arts. Over its more than a century of existence, the collection had included both European and American art, along with some non-western pieces. Indeed, the presence of the NCFA in the Natural History Building for many years was in some ways fitting given its broad, international sweep. In the 1960s, however, the NCFA's leaders had turned increasingly to the "study, collecting, and exhibiting of American art," and the name change solidified this focus. Indeed, the museum even sold European paintings to fund acquisitions of works by American artists.[72] Ironically, at the same time that the NCFA was limiting its scope, the Renwick, its branch museum dedicated to crafts, was organizing a major cross-cultural show. Intended as an extension of the folklife festival's multicultural exhibition programs, "Celebration," which opened in 1982, brought together objects from the Smithsonian's collections that were related to the act of celebrating. A kind of mini–Museum of Man, this exhibit allowed visitors to view pieces from a dizzying array of cultures.[73]

While the National Museums of American History and American Art narrowed their purview, Smithsonian officials revisited an older proposal to expand the institution's physical geography. In mid-1980, Charles Blitzer reported to Secretary Ripley that the Museum of the American Indian, which operated under the auspices of the Heye Foundation in New York City, had agreed to transfer its extensive collections of Native American cultural artifacts to the Smithsonian. The collections could reside in the Smithsonian's new Museum Support Center in Suitland, Maryland, which the institution planned to open in order to properly store and conserve artifacts from its museums.[74] Echoing his earlier recommendations, Blitzer contended

that the acquisition of this collection should "lead to the creation . . . of a full-fledged Museum . . . [that] would concentrate on Native Americans." Blitzer also hoped that the collection would enable the Smithsonian to mount a major exhibit in the Museum of History and Technology "devoted to Native Americans as part of American history."[75]

Although the transfer did not occur at this time, it would resurface with much greater support within several years. In the meantime, the leaders of the Museums of American History and Natural History made an effort to develop new exhibitions and programs that included American Indian peoples and cultures. At American History, Kennedy worked on a proposal to expand collecting, research, and exhibition on Native American and Hispanic cultures and encouraged his staff to "put American Indians back in American history."[76] In response, as part of a new permanent exhibit on the eighteenth century that would replace Malcolm Watkins's *Hall of Everyday Life in the American Past,* curators developed a section on "The Seneca Nation of the Iroquois Confederacy." Tentatively dubbed "Life in America" at this point, the overall exhibit would eventually become *After the Revolution: Everyday Life in America, 1780–1800.* A landmark exhibit because it represented the museum's first attempt to depict a richly diverse narrative of American social history, it included sections not only on the Seneca but also African Americans in the Chesapeake, as well as Euro-American families in Delaware, Virginia, and Massachusetts.[77] In an August 1981 planning memo, curator Fath Ruffins wrote that the objectives of the Seneca section were fourfold: 1) to provide a detailed portrait of a particular tribe "rather than making a generalized statement about 'Indian life,'" 2) to make American Indians part of the "overall conceptual scheme of the exhibit, not tacked on as a token afterthought," 3) to avoid using sacred objects the display of which would offend some Native peoples, and 4) to make a "concerted attempt to depict diversity, rather than a homogenized version of Indians which assumes a similarity that does not exist."[78] To guide their thinking, the curators consulted Rick Hill (Tuscarora), who had been an advisor on the folklife festival's Iroquois presentations. Hill offered strong criticisms on a preliminary research report, pointing to "several instances of major errors in fact or interpretation." Beyond these concerns, he made a key suggestion:

> It will be important for the viewing public to be informed at some point in the exhibit that the various Iroquois tribes are still in existence, have retained a "traditional" culture, and have reservations and communities in New York State, Pennsylvania, Wisconsin, Oklahoma, Ontario, Quebec, and Alberta. All too often, exhibits are created which provide

only a picture of what life was like for the Iroquois in the period of a hundred or more years ago. The impression that is left in the public mind reinforces the idea that the Iroquois are no longer in existence.[79]

Echoing the message of many Native participants at the folklife festival and anticipating the central theme of the National Museum of the American Indian, Hill emphasized the importance of connecting historical and contemporary narratives of Native life.

In June 1984, while *After the Revolution* was still in development, the Museum of American History convened a large meeting to discuss "the role of American Indians in American history." Attendees included a wide range of curators and other museum personnel from the Smithsonian, as well as several outside consultants. Chaired by deputy director Douglas Evelyn and attended by Roger Kennedy, the meeting offered a lively forum for discussing how better to represent Native peoples in the museum. Recommendations from the group included consulting with "American Indian scholars, museum professionals and community activists," taking "responsibility for showing the diversity of Native peoples in America," and not separating "American Indian history from American History." Acknowledging the broad audience of the museum as well as widespread ignorance about Native peoples, they also suggested approaching "Indian subjects with a sensitivity to the Native American perspective" but pitching "the approach to a wider America which badly needs education." Making a point similar to Hill's recommendation for *After the Revolution*, the group stated that the museum should "affirm the continuing presence of Native peoples [and] show Indian life now as well as then." To accomplish this objective, they recommended presenting "modern Indians with modern devices for presentation . . . rather than confining Indians to the traditional anthropological museum form of display." Finally, the group recommended that the museum, and the Smithsonian as a whole, "develop a continuing dialogue" about these issues.[80] Following the meeting, Kennedy brought museum consultant Rayna Green on full time to head a Native American Initiative that would develop programs on Native histories and cultures and train Native American interns.[81]

Although they were not as formal, similar discussions occurred among the museum's staff regarding African American history and culture in these years. With Roger Kennedy's encouragement, the museum's staff placed an increased emphasis on black history in exhibitions. When *After the Revolution* opened in November 1985, it contained objects and labels illuminating the lives of African Americans in the Chesapeake region and free blacks in

Philadelphia. These materials were central, rather than peripheral, to the history of the Revolution and Early Republic the exhibit presented. A year and a half later, in February 1987, the museum opened a major exhibition focused exclusively on African American history. Curated by Spencer Crew, *Field to Factory: Afro-American Migration, 1915–1940* narrated the history of the Great Migration of blacks from the rural South to the urban North in the first half of the twentieth century. In three main sections—"Life in the South," "The Journey North," and "Life in the Urban World"—the exhibit dramatized the hardships blacks faced as they fled the entrenched racism and exploitative economic systems of the South in the hope of finding expanded freedoms and opportunities in northern cities.[82]

Because of the paucity of material culture associated with African Americans in the museum's collection, Crew traveled the country making presentations and asking people to donate items while assembling the exhibit. He was able to do this through a National Endowment for the Humanities grant that he had received in partnership with the African American Museums Association. In presentations at a family reunion in Mississippi, the National Afro-American Museum and Cultural Center in Ohio, and many other places, Crew discussed the exhibit and made his pitch. He even asked his African American interns to inquire with their families about possible objects or stories they had from this period. Despite his strenuous efforts, however, in the end Crew had to make compromises in order to accomplish his goal of presenting the story of the Great Migration. The final exhibit contained original objects with direct connections to African American individuals and families who were part of the Great Migration, contemporary reproductions of period items, and objects that were similar to those that might have been used by African Americans during the period. The use of the latter type of object provoked some criticism from members of the museum profession who contended that only objects with a clear provenance connecting them to black individuals or families should have been used. This criticism pointed to a larger challenge that the curators of both *After the Revolution* and *Field to Factory* confronted: how to present social history narratives in a museum setting when so few objects associated with ordinary, non-elite individuals have survived. For the curators, however, the significance of presenting such long-neglected histories at the Smithsonian far outweighed the potential pitfalls of working with limited numbers of objects.[83]

Another major exhibition mounted in 1987 solidified Kennedy's commitment to diversifying the museum's exhibitions and addressing neglected areas of history. Created to mark the bicentennial of the Constitution,

A More Perfect Union: Japanese Americans and the United States Constitution told the story of Japanese internment during World War II. Not a simple exposition of the facts, the exhibition attempted to illuminate the experiences of the individuals and families who were sent to the camps. As with *Field to Factory,* the exhibit's curators struggled to present a complex history with few objects. Here, however, they were able to use video clips from former internees to narrate their own stories. The exhibition provided interactive displays that allowed visitors to ask questions (from a pre-determined list) of former internees and thereby learn first-hand what the experience was like. Complementing the videos were photographs, objects, and a reconstructed Los Angeles grocery store and barracks from one of the camps.

Tackling such a dark chapter in U.S. history was not without its challenges, and Kennedy received a fair number of complaints about the exhibit. The complaints fell into two basic categories: those people who continued to confuse Americans of Japanese ancestry with the Japanese enemy and those who argued that focusing on such a negative story was an inappropriate way to mark the bicentennial of the Constitution. Kennedy was adamant, however, that the exhibit was patriotic because it demonstrated that the United States had a long tradition of correcting injustices. This argument was especially appropriate because Congress was at the time voting to approve reparations for the former internees. For Kennedy, a good exhibition had to serve a moral as well as an educational purpose; otherwise, it was not worth doing. *A More Perfect Union,* in his estimation, accomplished this goal by encouraging Americans to better live up to the ideals of their democracy.[84]

While American History moved successfully under Kennedy to recruit staff members of color and develop exhibitions on topics involving racial and ethnic minorities, Natural History made its own efforts in these areas. In December 1980, a group of anthropologists, including Douglas Ubelaker, Bill Sturtevant, and Herman Viola, recommended the creation of an "Indian Outreach Program," which was designed "to improve the quality of care for museum specimens of American Indian origin, to improve museum exhibitions dealing with subject matter relating to American Indians, and to provide museum services directly to the Indian community." The proposal called for an extensive program that would include consultation with Native peoples about "proper storage, handling and exhibition" of artifacts, "workshops and internships for Native American museum personnel," "technical assistance to American Indian museums," support for Native American historians and museum curators to visit the institution's collections and to help with the documentation of artifacts, "photography

and photocopying of artifacts and documents for Native American scholars and museums," and the creation of traveling exhibits.[85] In 1982, Ubelaker noted that "considerable discussion" had "centered on the critical need for a program focusing on the study and preservation of contemporary American Indian culture." He suggested hiring a Native American curator who could organize such a program as well as serve as a "liaison with American Indian communities."[86] These efforts were bolstered by the recently created Native American Museums Program, which provided "special opportunities and information services to the staff of Native American museums and cultural centers." Its objective was to "create a pool of Native Americans who are qualified for employment in museums and related cultural institutions."[87]

In 1986, JoAllyn Archambault (Standing Rock Sioux) was hired to coordinate Native American programs. After arriving, she also became involved in an effort to redo the museum's permanent American Indian Halls, which had remained essentially unchanged since the 1950s. Fairly rapidly, she was able to make small, but significant changes. She immediately closed the Snake Dance display because it was offensive to the Hopi and also removed some other offensive material. In addition, she was able to develop several displays, including ones on Iroquois beadwork, basketry, and Seminole art. She also did a display case on twentieth-century paintings with pieces borrowed from Suzan Harjo.[88] If the halls were truly to be made acceptable and appealing to late twentieth-century Native and non-Native audiences, however, major renovations were necessary. Archambault needed the funds for a total overhaul. These could be obtained only with strong support for the project from the institution's leadership and Congress, as a major renovation of the permanent halls would have cost at least several million dollars. An internal report discussed plans for the redesigned halls and provided a rationale for why such a large-scale project was necessary at this time. "The ethnology halls are replete with inaccuracies," the report read, "and tend to portray American Indians as 'frozen in time.'" To correct this problem, it was proposed that the "general framework" of the exhibits be "historical, in contrast to the static 'culture areas' organization of the current ethnology halls." Echoing Jack Ewers's criticism of his own work, the report emphasized the importance of connecting archeology, ethnology, and history and demonstrating change over time among Native communities from "the time of their arrival in the New World to today." The report also stated that, like the folklife festival's Native American programs, the exhibit would counter "pervasive stereotypes of American Indians: that they are (or were) homogeneous in language and culture, the 'first

ecologists,' nomadic, egalitarian, warlike, lazy, powerless in the face of European conquest, and so on." Finally, the exhibit would include "space for performances and demonstrations by Indian people and an area for temporary exhibits that will allow the halls to be updated over the years." When the work was completed, Archambault and her colleagues at Natural History hoped that the exhibit would form the centerpiece of a "major effort . . . to transform the relationship between American Indians and the Museum of Natural History."[89]

In 1987, the museum secured a grant of $20,000 from the institution to proceed with planning for the new halls. With these funds, the "Hall Planning Team," which was headed by Archambault, traveled to the Northwest Coast to "meet with . . . representatives of Indian tribal, political and cultural organizations, to solicit Native American input in the planning process, and to review existing native [sic] American exhibits, museums, and cultural centers."[90] Additional trips were also planned to visit Native groups in the Southwest and other regions. Under Archambault's leadership, "close consultation with Native people from across the continent" was an essential part of the exhibit development process. In fact, her plan was for sections of the exhibit to be co-curated with Native scholars. The ideas and opinions of Native peoples would be combined with "solid scholarship," highlighting "recent advances in knowledge."[91] In a sense, the hall might have laid the groundwork for a rapprochement between anthropologists and Native peoples. Ultimately, the hope was that this material would become a showcase for the museum's extensive Native American collections, occupying a central location on the museum's second floor. The famed designer Ralph Applebaum was contracted to draw up preliminary plans, and Archambault and the hall's other planners made a series of presentations to Smithsonian officials and the Board of Regents in the late eighties.[92]

The project would not advance beyond this stage, however, because at the very same time Archambault was developing her plans, the Smithsonian was finally moving forward in a serious way with creating a National Museum of the American Indian. In 1987, Senator Daniel Inouye, chairman of the Senate Select Committee on Indian Affairs, introduced legislation to transfer the collection of New York's Museum of the American Indian/ Heye Foundation to the Smithsonian. At the same time, Senator John Melcher of Montana introduced another bill concerning the repatriation of human remains to Native groups.[93] Responding to years of pressure from Native activists, both of these bills would have major repercussions for the Smithsonian.[94] The anthropology department reacted to the proposed legislation with grave concerns regarding both the future of the study of

Native cultures at the institution and their (fading) hopes for a separate Museum of Man. Their main fears were that the department would lose its skeletal collections and that an American Indian museum would be established that was not associated with the department. They continued to hope that a Museum of Man (or Mankind) would be built and suggested that perhaps the Museum of the American Indian could be one component of this museum.[95] In February 1988, Assistant Secretary for Museums Tom L. Freudenheim wrote to James Tyler, acting director of NMNH, that "The unresolved issues surrounding the Museum of the American Indian must be understood as having a potential impact on NMNH. We can't plan on this scale with projects in isolation one from the other."[96] The Department of Anthropology hoped that this meant that a complementary relationship could be developed with the new museum and that its genesis would not have a detrimental effect on Native American–related projects at Natural History.[97]

Anthropology was out of step, however, with the Smithsonian's leadership. In 1984, Dillon Ripley's twenty-year tenure as secretary ended, and Robert McCormick Adams ascended to the position. Adams, who was a University of Chicago–trained anthropologist and archeologist, did not share the anthropology department's desire for a Museum of Man, and soon after arriving dedicated himself to repairing the Smithsonian's relationship with Native communities. In April 1987, he toured New York's Museum of the American Indian with Senator Inouye and discussed the possibility of transferring its collection to the Smithsonian.[98] Then, in August, he organized an important meeting at Santa Clara Pueblo with Suzan Harjo, executive director of the National Congress of American Indians, Alan Parker, staff director of the Senate's Indian Affairs committee, and various tribal representatives. There he discussed the Smithsonian's American Indian program initiatives and, more important, indicated that the institution would look favorably on requests for the return of human remains and sacred objects.[99] By October 1987, the anthropology department reported that it had received fourteen inquiries regarding Native skeletal remains, ten of which were official inquiries from tribes and two from the Senate on behalf of "tribal concerns."[100] It was clear that the groundwork was being built for a new relationship between the Smithsonian and Native peoples and momentum was gaining for an American Indian museum.

Within the Museum of Natural History, this continued to provoke anxiety. In October 1988, Frank Talbot, director of the museum, commented on a recent draft of Inouye's bill, remarking that it needed revision. Wisely, he started by acknowledging the "understandable and laudable drive for

recognition of the first Americans." "A Museum of the American Indian," he continued, "is seen as a much needed public statement and a focus for Indian and national pride in the rich and diverse culture and long history of the first Americans on the continent." Acknowledging the likelihood of the bill's passage, he attempted to defend anthropology and protect Natural History's interests. He hoped that the museum's "superb collections," "vigorous community of scholars and good research programs" could complement the new museum rather than compete with it. His fears, however, were that the legislation would "threaten the integrity of the Smithsonian's present collections" and "create competition" between two bureaus with overlapping concerns.[101]

The first of these fears turned out to be partially unfounded. In 1989, when President George H. W. Bush signed Inouye's legislation establishing the National Museum of the American Indian, its collections came, as planned, from the Heye Foundation.[102] The new museum's staff did not gain control of the Museum of Natural History's collections of American Indian materials. Indeed, the collections of the two museums remained entirely separate. The Natural History museum did, however, have to comply with requests for the return of human remains and sacred objects. Native groups insisted that the Smithsonian devise new standards for the repatriation of human remains and other objects. They wanted to make it easier for individuals and tribes to bring these items back to their families and communities. Although Adams had signaled an openness to repatriation, the institution's established policies required that individuals prove that they were direct descendants before gaining access to the remains, and the Smithsonian reviewed each claim on a case-by-case basis. Thus, the process could be quite lengthy and was often unsuccessful as it was difficult to prove ancestry because of the institution's poor documentation procedures. Because the Smithsonian possessed the largest collection of human remains in the world—over 18,600 objects—Native leaders maintained that a revision of its procedures was a crucial step in rectifying the institution's history of collecting Native remains and cultural artifacts, in some cases without permission or proper documentation.[103]

The latter fear was more fully realized. The Museum of Natural History and the National Museum of the American Indian experienced very little, if any, cross-pollination—sharing neither staff nor collections—and undoubtedly competed with each other for funding from Congress. The Department of Anthropology, for example, was never able to secure funding for revised American Indian halls and consequently closed most of the older exhibits. As a result, the museum that possesses what is widely regarded as

the world's greatest collection of Native American materials has very few of these objects on display. The legislation authorizing NMAI also certainly signaled the final end to any hope of creating a separate Museum of Man. The new museum would be constructed on the Mall next to the Air and Space Museum—the location on which Ripley had originally hoped to construct a Museum of Man.

For anthropology and the Museum of Natural History, then, the creation of NMAI had several negative repercussions. For many Native communities and their non-Native supporters, however, the museum was a landmark achievement and represented an unprecedented opportunity to fundamentally reorient representations of Native peoples in museums and American culture. Tired of waiting for museums to revise long-outdated exhibits, Native peoples took the reins, crafting new modes of exhibition that attempted to correct entrenched stereotypes. The museum's new director, W. Richard ("Rick") West, summed up NMAI's approach this way: "What we want to do is give the American public a picture of Indian life past and present that is more accurate and more complete than any museum has done before. And for the museum to reach out and to engage the Indian community as no museum has ever done before."[104] His stated goals—accuracy and outreach—were both impossible without the other. Clearly, the project resonated with Native leaders, and despite some qualms, the majority came to support it. "Usually we're found in natural history museums and the Bureau of Indian Affairs—with animals and plants and trees and fish," said the Native American scholar/activist and NMAI curator George Horse Capture. "This will be the first time we are recognized as official human beings. It is long, long overdue."[105]

This moment of triumph signaled a broader transformation at the Smithsonian. The momentum began to shift away from cultivating polyglot spaces such as a Museum of Man or revised Museums of American History and Natural History and toward creating new culturally specific museums. Even as NMAI was becoming a reality, members of another neglected group made a case for similar recognition on the Mall. As the NMAI Act worked its way through Congress, discussions took place on Capitol Hill and at the Smithsonian regarding a museum of African American history and culture.

The driving force behind many of these conversations was an African American entrepreneur, Tom Mack, who owned and operated the Tourmobile sightseeing company in Washington, D.C. Bemoaning the absence of a black presence on the Mall, Mack courted members of Congress and built an organization to raise funds for a museum. Through his efforts, the

House passed a non-binding resolution in 1986 in support of the idea of an African American museum on the Mall. Mack's lobbying efforts prompted intense debate within the African American Museums Association over the desirability of a Mall museum with many in the organization opposing it on the grounds that it would draw support away from existing black museums. Mack's work also catalyzed discussions within the Smithsonian, leading to the creation of an Institutional Study Project in 1989, which was charged with investigating the museum concept for the Board of Regents. The bridge between the AAMA and the Smithsonian was John Kinard, who was a key player in both organizations. Kinard initially opposed a Mall museum, but changed his mind before his death in 1989. His primary concern was defending the independence and integrity of the Anacostia Museum, which he did not wish to see submerged in a larger museum on the Mall. Kinard's legacy hovered over the Study Project's advisory committee, which explored various institutional challenges, including the future of the Anacostia Museum, to the feasibility of such a museum. According to Fath Ruffins, the key questions the advisory committee tackled were: "Who would control the museum? Who would pay for the museum? Was a free-standing museum necessary? If so, why?" The committee did not resolve these thorny issues. Eventually in the early 2000s, however, Congress, the Smithsonian, and proponents of the museum were able to devise a workable solution.[106]

A Smithsonian African American museum on the Mall was certainly not inevitable—far from it. Many years of negotiations, lobbying, and debate, not to mention several setbacks, would occur before it became a reality. Nevertheless, proponents of the museum chose the right time to advocate for it. The failure of the Museum of Man concept and the success of the National Museum of the American Indian suggested that a new culturally specific museum was more feasible than a culturally pluralist museum at this point in the institution's history.

Epilogue
Is It Possible to See It All?

After 1989, the Smithsonian entered one of the most tumultuous periods in its history. The early 1990s saw the institution become one of the primary battlegrounds in the "culture wars." This is an oft-told tale, and interested readers may consult any number of books and articles to learn about the controversies of this period. The existing accounts, many of which were written by actual participants, stand as a detailed record of what occurred.[1] The twists and turns of "The West as America," "Science in American Life," and the failed Enola Gay exhibition serve as important lessons about handling controversial exhibitions. Studying these events is an essential part of any museum professional's training. I have chosen to focus this book, however, on a different story—one that I argue is more central to the total history of the Smithsonian.

Although exhibition controversies continue to crop up from time to time, the main constant of the Smithsonian's history continues to be the expansion of physical space and the resulting organizational and epistemological decisions that emanate from these spatial considerations. The opening of the National Museum of the American Indian on the Mall in September 2004 was preceded in December 2003 by President George W. Bush's signing of legislation creating the National Museum of African American History and Culture. (Ground was broken for the construction of this museum in February 2012.) Moreover, in 2008, Congress authorized a commission to study a National Museum of the American Latino, and discussions are ongoing about creating museums dedicated to women and Asian Pacific Americans.[2] Although it is not clear where these proposed museums will be located, the Smithsonian will almost certainly continue to grow for the foreseeable future.

As I hope this book has shown, physical expansion has been the Smithsonian's fate ever since Joseph Henry lost his battle against developing a

227

museum and large collections in the mid-nineteenth century. Expansion has created tremendous opportunities and caused immense complications—of course there is never enough of it, and people always want more. The desire to create new spaces is understandable as the hope springs eternal that what cannot be accomplished in existing spaces can be realized in new ones. A new museum means, above all, money—money to build a staff, develop collections, and create exhibitions. Older museums rarely receive the level of support that new museums attract. A new museum is also a blank canvas. Existing museums suffer under the burdens of what previous generations of curators and administrators have created. Permanent exhibitions, for example, routinely stay in place for decades and raising money to renovate them is extremely difficult, if not impossible. As the Smithsonian has endured cuts to its funding and reductions in staffing in recent decades, the challenges the older museums face have only multiplied. Small wonder that groups seeking recognition put little stock in seeing their stories represented adequately in these spaces. A new museum with fresh funding, from Congress or private donors, is their best hope to construct the kind of exhibitions they desire.

The creation of these new museums, however, raises the question: As the Smithsonian splits subject matter and collections into more and more different spaces, how can it also continue to lump things together? The great promise of the Smithsonian is that it will offer us a portrait of "human activity in every direction." This means, of course, that it will examine areas of convergence as well as divergence. Human populations have migrated, mixed, and shared for millions of years, creating a remarkable array of social and cultural formations that are constantly shifting. The Smithsonian is uniquely positioned to survey the entire sweep of human history. Understanding the story of humanity requires a deep focus on the particulars, but also a grand vision that transcends contemporary boundaries. Perhaps unique among global institutions of culture, the Smithsonian has the opportunity to have both simultaneously. The universal and the particular coexist within the Smithsonian's sprawling complex. Nonetheless, they could coexist more productively. Internecine squabbles and competition among museums have served to undermine the Smithsonian's true promise as an institution that balances the universal and the particular and probes the creative tension between these ways of conceptualizing human society. Each individual museum at the Smithsonian cherishes its autonomy even as it remains part of the larger complex. Collaboration among museums— the sharing of collections, resources, and expertise—is rare and, as a result, many opportunities to develop exhibitions using the Smithsonian's incred-

ibly rich collective resources are missed or not pursued. Removing the in-
stitutional obstacles to collaboration would be a key step toward unlocking
the Smithsonian's full potential as an institution that presents both universal
and particular narratives of human history and culture.

In April 2011, the Smithsonian's *Around the Mall* blog featured a story
about the New Year's resolution of a man from Alexandria, Virginia,
who had pledged to visit all of the Smithsonian museums within a year.
Remarkably, he was able to visit each of the twenty sites—including the
National Zoo—by the end of April.[3] Still, four months to see every one of
the institution's exhibition spaces is a far cry from the few hours it would
have taken in the 1880s to tour the entire United States National Museum.
Whereas in the late nineteenth century many people could have reasonably
expected to see all of the Smithsonian's exhibits in a visit or two, nowadays
it is so rare that when a person accomplishes it, it is worthy of note. The
original National Museum was incredibly compressed—so many things
were housed inside that it was literally overflowing with stuff. Conversely,
today the institution's collections and exhibitions are so dispersed it is im-
possible to imagine bringing them all back together into a single building.
A day in Washington offers barely enough time to see two museums, let
alone all of the Smithsonian sites in the city.

The dispersal of collections has had obvious benefits as well some draw-
backs. As the Smithsonian expanded, its all-encompassing ambitions were
simultaneously fulfilled and undermined. With more space, the institution
could collect and exhibit more material; however, by creating separate
spaces, rather than one large building, the Smithsonian divided its collec-
tions and exhibitions, in the process constructing boundaries that discour-
aged universalizing, comparison, and creative mixing. The challenge the
Smithsonian faces in the twenty-first century is to create spaces—both
physical and virtual—that allow visitors to continue to see interconnections
among the collections and exhibitions of the entire institution. Something
of the original National Museum should survive alongside the more dis-
persed and compartmentalized spaces of the contemporary Smithsonian.
Because visitors are unlikely to see more than one or two museums in
a day, Smithsonian officials must be creative in devising ways to ensure
that visitors get a sense of the true breadth of the institution's collections.
One way they are beginning to make this happen is through online collec-
tions and exhibitions where visitors can scroll through thousands of pages
of materials without visiting a single museum. It is vital, however, that
this also occur in physical space. One simple way to accomplish this goal
may be to encourage unexpected juxtapositions of materials—for example,

an exhibition of Asian art in the National Air and Space Museum. This does occasionally occur, as when the Museum of Natural History hosted a popular exhibit on baseball, but it could become a regular part of museums' exhibition planning processes.[4] More ambitious efforts to connect the Smithsonian's many constituent parts require visionary leadership and the willingness to break down entrenched boundaries. In 2010, to encourage movement in this direction, the institution adopted a new strategic plan that emphasized interaction among Smithsonian units and proposed the creation of interdisciplinary centers to promote collaboration. In addition, it offered four "grand challenges" for the institution to address collectively: "Unlocking the Mysteries of the Universe," "Understanding and Sustaining a Biodiverse Planet," "Valuing World Cultures," and "Understanding the American Experience."[5] Such an approach may prove to be the way for the Smithsonian to bring its disparate pieces back together.

Encouraging individuals to make discoveries and have unanticipated encounters is one of the great virtues of universal museums. For all their flaws, such museums remain one of the most accessible ways to experience the diversity of human society and culture. By maintaining a balance between the universal and the particular, the Smithsonian will continue to both broaden and deepen our understanding of the world in which we live.

Notes

Introduction: The Changing Universal Museum

1. For background on the creation of the National Museum of the American Indian, see Amy Lonetree and Amanda J. Cobb, eds., *The National Museum of the American Indian: Critical Conversations* (Lincoln: University of Nebraska Press, 2008). On the ways in which NMAI and other indigenous efforts to transform museums have had a profound influence on the field, see Susan Sleeper Smith, ed., *Contesting Knowledge: Museums and Indigenous Perspectives* (Lincoln: University of Nebraska Press, 2009); and W. Richard West Jr. et al., *The Changing Presentation of the American Indian: Museums and Native Cultures* (Seattle: National Museum of the American Indian in association with University of Washington Press, 2000). For a fascinating exploration of revolutionary change in museums see Simon J. Knell, Suzanne MacLeod, and Sheila Watson, eds., *Museum Revolutions: How Museums Change and Are Changed* (New York: Routledge, 2007). For an interesting critique of the National Museum of the American Indian and a counterpoint to prevailing attitudes toward cultural exhibition and museum anthropology, see Steven Conn, *Do Museums Still Need Objects?* (Philadelphia: University of Pennsylvania Press, 2009), 38–45.

2. See, for example, "Room for Debate: Should We Have a National Latino Museum?" *New York Times,* April 26, 2011, www.nytimes.com/roomfordebate /2011/04/26/should-we-have-a-national-latino-museum; and Steven Pearlstein, "Why Not a Museum for American Ingenuity?" *Washington Post,* Feb. 20, 2012, www .washingtonpost.com/blogs/ezra-klein/post/why-not-a-museum-for-american -ingenuity/2012/02/20/gIQAXDsiPR_print.html. See also Fath Davis Ruffins, "Culture Wars Won and Lost: Ethnic Museums on the Mall," *Radical History Review* 68, 70 (Spring 1997, Winter 1998), two-part article.

3. Universal museums faced such intense criticism from various quarters that the directors of the Louvre; the Metropolitan Museum of Art; the Museum of Fine Arts, Boston; the Museum of Modern Art; the Prado; the State Hermitage Museum, St. Petersburg; the Whitney; and several others issued a "Declaration on the Importance and Value of Universal Museums: 'Museums Serve Every Nation,'" in the *Wall Street Journal* on Dec. 12, 2002. Reprinted in Ivan Karp, Corrine A. Kratz, Lynn Szwaja, and Tomas Ybarra-Frausto, eds., *Museum Frictions: Public Cultures/Global*

Transformations (Durham and London: Duke University Press, 2002), 247–49. For another vigorous defense of universal museums, see James Cuno, *Whose Culture?: The Promise of Museums and the Debate over Antiquities* (Princeton: Princeton University Press, 2009), 17, 27–28.

4. For a thoughtful exploration of this debate, see Kanishk Tharoor, "Will the Museum of the Future Be Universal or Defined by Its Borders?" *The National*, May 12, 2002, www.thenational.ae/arts-culture/art/will-the-museum-of-the-future-be -universal-or-defined-by-its-borders. For a comparative international perspective on national museums, see Darryl McIntyre and Kirsten Wehner, eds., *National Museums: Negotiating Histories* (Canberra: National Museum of Australia, 2001).

5. For a brief, but insightful history of public museums, see Jeffrey Abt, "The Origins of the Public Museum," in *A Companion to Museum Studies*, ed. Sharon Macdonald (Malden, Mass.: Blackwell, 2006), 115–34.

6. Eilean Hooper-Greenhill, *Museums and the Shaping of Knowledge* (New York: Routledge, 1992), 5–6.

7. Tony Bennett, "The Exhibitionary Complex," in *Culture/Power/History: A Reader in Contemporary Social Theory*, ed. Nicholas B. Dirks, Geoff Eley, and Sherry B. Ortner (Princeton: Princeton University Press, 1993), 123–54. See also Tony Bennett, *The Birth of the Museum: History, Theory, Politics* (New York: Routledge, 1995).

8. Curtis M. Hinsley Jr., *The Smithsonian and the American Indian: Making a Moral Anthropology in Victorian America* (Washington, D.C.: Smithsonian Institution Press, 1994). Originally published as *Savages and Scientists: The Smithsonian Institution and the Development of American Anthropology, 1846–1910* (Washington, D.C.: Smithsonian Institution Press, 1981). Steven Conn, *Museums and American Intellectual Life, 1876–1926* (Chicago: University of Chicago Press, 1998).

9. H. Glenn Penny, *Objects of Culture: Ethnology and Ethnographic Museums in Imperial Germany* (Chapel Hill: University of North Carolina Press, 2002).

10. Corinne A. Kratz and Ciraj Rassool, "Remapping the Museum," in Karp et al., *Museum Frictions, 347–56.*

11. Randolph Starn, "A Historian's Brief Guide to New Museum Studies," *American Historical Review* 110, no. 1 (Feb. 2005). An encouraging development was the creation of the *Museum History Journal* by Left Coast Press in 2008. Several edited collections provide useful overviews of the history and theory of museums. See, for example, Macdonald, *A Companion to Museum Studies,* and Gail Anderson, ed., *Reinventing the Museum: The Evolving Conversation on the Paradigm Shift,* 2nd ed. (Lanham, Md.: Altamira Press, 2012).

12. George Brown Goode, "Report of the Assistant Director of the United States National Museum, for the Year 1881," in *Annual Report of the Board of Regents of the Smithsonian Institution, 1881* (Washington: Government Printing Office, 1883), 84. On Goode's ideas and ambitions, see also Edward P. Alexander, *Museum Masters: Their Museums and Their Influence* (Nashville: AASLH, 1983), 277–309.

13. Penny, *Objects of Culture,* 2.

14. Special issue of the *Journal of American History* 82, no. 3 (Dec. 1995); Martin Harwit, *An Exhibit Denied: Lobbying the History of* Enola Gay (New York: Springer-Verlag, 1996); Edward T. Linenthal and Tom Engelhardt, eds., *History Wars: The Enola Gay and Other Battles for the American Past* (New York: Henry Holt, 1996); Steven C. Dubin, *Displays of Power: Memory and Amnesia in the American Museum* (New York: New York University Press, 1999), 152–226; Roger D. Launius, "American Memory, Culture Wars, and the Challenge of Presenting Science and Technology in a National Museum," *The Public Historian* 29, no. 1 (Winter 2007): 13–30. On the recent challenges Smithsonian curators have faced in presenting exhibitions of history and culture, see Amy Henderson and Adrienne L. Kaeppler, eds., *Exhibiting Dilemmas: Issues of Representation at the Smithsonian* (Washington: Smithsonian Institution Press, 1997).

15. The Museum of History and Technology opened in 1964, and the Anacostia Neighborhood Museum in 1967. The National Collection of Fine Arts was moved to the Old Patent Office Building in 1968, along with the National Portrait Gallery, which had been chartered by Congress in 1962. The NCFA was renamed the National Museum of American Art in 1980 and, in 2000, became the Smithsonian American Art Museum. The Renwick Gallery opened in 1972, the Hirshhorn in 1974, and the National Air and Space Museum in 1976. The Smithsonian acquired the Museum of African Art in 1979. It became the National Museum of African Art and moved to its present location on the Mall in 1987. The Arthur M. Sackler Gallery for Asian and Near Eastern Art opened in 1987. Congress authorized the National Museum of the American Indian in 1989, and it opened in 2004. The Smithsonian Festival of American Folklife was founded in 1967 and continues today as the Smithsonian Folklife Festival. *Smithsonian* magazine debuted in 1970. Outside of Washington, D.C., the Cooper-Hewitt, National Design Museum in New York City became part of the Smithsonian in 1968.

1. The Universal Museum

1. "Thoughts Regarding the Mall," July 1848, in *The Papers of Joseph Henry,* 11 vols., ed. Nathan Reingold et al. (vols. 1–5) and Marc Rothenberg et al. (vols. 6–11) (Washington: Smithsonian Institution Press, 1972–2007), 7:369–70; John Michael Vlach, "From Slavery to Tenancy: African American Housing in Washington, D.C., 1790–1890," in *Housing Washington: Two Centuries of Residential Development and Planning in the National Capital Area,* ed. Richard Longstreth (Chicago: Center for American Places at Columbia College Chicago, 2010), 11–12.

2. "History of the British Museum," The British Museum, www.britishmuseum .org/about_us/the_museums_story/general_history.aspx; Edward Miller, *That Noble Cabinet: A History of the British Museum* (Athens, Ohio: Ohio University Press, 1974).

3. Gary Nash, *The First City: Philadelphia and the Forging of Historical Memory* (Philadelphia: University of Pennsylvania Press, 2002), 14–16, 154, 161. In addition,

the National Institution for the Promotion of Science, or National Institute, was founded in Washington in 1840. Its founders attempted unsuccessfully to secure the money from Smithson's will before the founding of the Smithsonian. Hinsley, *The Smithsonian and the American Indian*, 17–18.

4. "James Smithson's Will," Smithsonian Institution, www.si.edu/oahp/Smithsons %20Crypt/James%20Smithsons%20Will.html.

5. For an excellent biography of Smithson, see Heather P. Ewing, *The Lost World of James Smithson: Science, Revolution, and the Birth of the Smithsonian* (New York: Bloomsbury, 2007).

6. For details on Henry's personal life and career, see Thomas Coulson, *Joseph Henry: His Life and Work* (Princeton: Princeton University Press, 1950); and Albert E. Moyer, *Joseph Henry: The Rise of an American Scientist* (Washington and London: Smithsonian Institution Press, 1997). Historians interested in the first Smithsonian secretary are extremely fortunate to have the eleven-volume *Papers of Joseph Henry* to consult.

7. Joseph Henry, "Programme of Organization of the Smithsonian Institution," December 13, 1847, *Papers of Joseph Henry* 7:244–48, plus unnumbered pages with reproduction of original document. See also the following, all in *Papers of Joseph Henry:* Louis Agassiz to Joseph Henry, Jan. 2, 1847, 7:3–4; Asa Gray to Joseph Henry, Jan. 4, 1847, 7:6–7; Introduction, 8:xxv; Joseph Henry to Alexander Dallas Bache, Oct. 17, 1853, 8:484–85; Joseph Henry to Felix Flugel, Aug.17, 1868, 11:202–3; Joseph Henry to Asa Gray, Jan. 12, 1876, 11:557–59. Curtis Hinsley argues that historians have overestimated Henry's opposition to a museum for the Smithsonian. Although I recognize that Henry's feelings about the museum changed over time and that he became more convinced of the efficacy of museum work toward the end of his career, it is clear from his writings and correspondence that he was largely opposed to the institution operating a museum. Hinsley, *The Smithsonian and the American Indian*, 64–65.

8. Introduction, *Papers of Joseph Henry* 7:xiii–xl.

9. "An Act to Establish the Smithsonian Institution," Aug. 10, 1846, editors' notes in *Papers of Joseph Henry* 6:463–71.

10. Introduction to *Papers of Joseph Henry* 9:xxix; Henry, "Programme of Organization of the Smithsonian Institution."

11. Editor's note, *Papers of Joseph Henry* 7:244.

12. Henry, "Programme of Organization of the Smithsonian Institution"; Introduction, *Papers of Joseph Henry* 8:xiii–xxxii.

13. Henry to Bache, Oct. 17, 1853, 484–85.

14. Henry to Flugel, Aug. 17, 1868, 202.

15. Joseph Henry to George Jarvis Brush, Apr, 29, 1868, *Papers of Joseph Henry* 11:182.

16. Henry, "Programme of Organization of the Smithsonian Institution," 248–49. See also *Annual Report of the Board of Regents of the Smithsonian Institution, 1876* (Washington: Government Printing Office, 1877), 7.

17. Editor's note, *Papers of Joseph Henry* 7:246.

18. Henry, "Programme of Organization of the Smithsonian Institution," 248–49.

19. Henry to Flugel, Aug. 17, 1868, 202.

20. "An Act to Establish the Smithsonian Institution," 466–68.

21. Introduction, *Papers of Joseph Henry* 8:xxiv–xxv; and Pamela M. Henson, "Spencer Baird's Dream: A U.S. National Museum," in *Cultures and Institutions of Natural History: Essays in the History and Philosophy of Science,* ed. Alan Leviton (San Francisco: California Academy of Sciences, 2000), 108–9.

22. Jacob Thompson to Joseph Henry, June 20, 1857, *Papers of Joseph Henry* 9:452–53.

23. "United States Exploring Expedition," *American Journal of Science and Arts* 44 (April 1843): 398–408; Introduction, *Papers of Joseph Henry* 9:xxix.

24. Introduction, *Papers of Joseph Henry* 9:xxx–xxxi.

25. Introduction, *Papers of Joseph Henry* 11:xlv–xlvi.

26. For an overview of the exhibition, see the Free Library of Philadelphia's online exhibit "The Centennial Exhibition, Philadelphia 1876," http://libwww .library.phila.gov/CenCol/index.htm. See also Robert Rydell, *All the World's a Fair: Visions of Empire at American International Expositions, 1876–1916* (Chicago: University of Chicago Press, 1984), chap. 1.

27. Spencer Fullerton Baird to Joseph Henry, Nov. 9, 1876, *Papers of Joseph Henry* 11:588.

28. Joseph Henry to Asa Gray, Jan. 12, 1876, *Papers of Joseph Henry* 11:558. Around the same time, Henry lobbied Congress for funds to maintain the collections, and he received sizeable increases in 1870 and 1872. Hinsley, *The Smithsonian and the American Indian,* 74.

29. Joseph Henry, "Report of the Secretary," *Smithsonian Annual Report, 1876,* 11–12.

30. Ibid., 12.

31. Abt, "The Origins of the Public Museum," 116–17.

32. William J. Rhees, *Visitor's Guide to the Smithsonian Institution and National Museum* (Judd and Detweiler, 1880), 14.

33. Extensive lists of artifacts appear in Rhees, *Visitor's Guide,* 17–95.

34. Ibid., 76.

35. Ibid., 13.

36. Frederick W. True, "An Account of the United States National Museum," in *Annual Report of the Board of Regents of the Smithsonian Institution, 1896* (Washington: Government Printing Office, 1898), 304.

37. *Annual Report of the Board of Regents of the Smithsonian Institution, 1879* (Washington: Government Printing Office, 1880), 131.

38. "Baird's Dream: History of the Arts and Industries Building," Smithsonian Institution Archives, http://siarchives.si.edu/history/exhibits/arts/index.htm.

39. *Annual Report of the Board of Regents of the Smithsonian Institution, 1889* (Washington: Government Printing Office, 1890), 5.

40. Ibid., 5–6.

41. *Report of the United States National Museum, 1900* (Washington: Government Printing Office, 1902), 9.

42. Goode, "Report of the Assistant Director of the United States National Museum, for the Year 1881," 84.

43. Introduction, *Papers of Joseph Henry* 8:xxiv–xxv; Henson, "Spencer Baird's Dream," 109.

44. Henry Fairfield Osborn, "Goode as a Naturalist," in *A Memorial of George Brown Goode, Together with a Selection of his Papers on Museums and on the History of Science in America* (Washington: Government Printing Office, 1901), 17–21.

45. Edward P. Alexander, *Museum Masters: Their Museums and Their Influence* (Nashville: American Association for State and Local History, 1983), 279–82. See also Henson, "Spencer Baird's Dream," 119; Gary Kulik, "Designing the Past: History–Museum Exhibitions from Peale to the Present," in *History Museums in the United States: A Critical Assessment,* ed. Warren Leon and Roy Rosenzweig (Urbana: University of Illinois Press, 1989), 7–12; and Pamela M. Henson, "'Objects of Curious Research': The History of Science and Technology at the Smithsonian," *Isis* 90 (1999): S252–S254.

46. George Brown Goode, "Museum-History and Museums of History," a paper read before the American Historical Association in Washington, D.C., December 26–28, 1888 (New York: Knickerbocker Press, 1889), 267–68.

47. Goode, "Report of the Assistant Director of the United States National Museum, for the Year 1881," 89.

48. Ibid.

49. Ibid., 84.

50. Ibid., 89.

51. Ibid., 85.

52. Penny, *Objects of Culture,* 18–29.

53. Conn, *Museums and American Intellectual Life,* 4–6.

54. Goode, "Report of the Assistant Director of the United States National Museum, for the Year 1881," 89.

55. *Oxford English Dictionary,* 2nd ed., s.v. "anthropology."

56. On the development of museum anthropology, see essays in George Stocking, ed., *Objects and Others: Essays on Museums and Material Culture* (Madison: University of Wisconsin Press, 1988).

57. Goode, "Museum-History and Museums of History," 272. See also William Ryan Chapman, "Arranging Ethnology: A.H.L.F. Pitt Rivers and the Typological Tradition," in *Objects and Others,* 15–48; and "Pitt Rivers Museum: The Website of the 'Relational Museum' Project 2002–2006," http://history.prm.ox.ac.uk/index.php.

58. Goode, "Report of the Assistant Director of the United States National Museum, for the Year 1881," 89.

59. Ibid., 86.

60. Ibid.

61. George Brown Goode, *Virginia Cousins* (Richmond, Va.: J.W. Randolph & English, 1887), xiii.

62. On the scientific racism of the late nineteenth century, see Matthew Frye Jacobson, *Whiteness of a Different Color: European Immigrants and the Alchemy of Race* (Cambridge: Harvard University Press, 1998), chap 2.

63. Conn, *Museums and American Intellectual Life,* 5.

64. Report of O. T. Mason, Curator of the Department of Ethnology, National Museum, for the year 1884, box 3, folder 4, RU 158, United States National Museum, Curators' Annual Reports, Smithsonian Institution Archives (SIA).

65. Hinsley, *The Smithsonian and the American Indian,* 85.

66. Ibid., 86.

67. Otis T. Mason, "The Leipsic 'Museum of Ethnology,'" in *Annual Report of the Board of Regents of the Smithsonian Institution, 1873* (Washington: Government Printing Office, 1874), 390–410. On Klemm, see also Penny, *Objects of Culture,* 167–70.

68. Mason, "The Leipsic 'Museum of Ethnology,'" 396–97.

69. Otis Tufton Mason, "Influence of Environment Upon Human Industries or Arts," in *Annual Report of the Board of Regents of the Smithsonian Institution, 1895* (Washington: Government Printing Office, 1896), 639.

70. Rev. William Guthrie, *The Christian's Great Interest* (Glasgow, 1828), 134–38.

71. Penny, *Objects of Culture,* 170–71.

72. Report of the Curator of the Department of Ethnology, 1885–1886, Otis T. Mason, box 3, folder 6, RU 158, SIA.

73. Annual Report of the Department of Ethnology, 1895, Otis T. Mason, Curator box 3, folder 15, RU 158, SIA.

74. Hinsley, *The Smithsonian and the American Indian,* 98, 121n.

75. William H. Dall and Franz Boas, "Museums of Ethnology and Their Classification," *Science* 9, no. 228 (June 17, 1887): 589.

76. Annual Report of the Department of Ethnology in the U.S. National Museum, Otis T. Mason, Curator, 1888, box 3, folder 8, RU 158, SIA.

77. Report of the Curator of the Department of Ethnology, 1885–1886.

78. Report on the Department of Anthropology for the Year 1898–99, by William H. Holmes, Head Curator (Division of Mechanical Technology), box 26, folder 11, RU 158, SIA; Photograph of "Boat Hall, U.S. National Museum," c. 1890s, neg. #2964, SIA. The Smithsonian Institution Archives has many photographs, including this one, available digitally on its website: siarchives.si.edu/collections/.

79. Report on the Department of Anthropology for the Year 1898–99, by William H. Holmes, Head Curator (Division of Ethnology), box 26, folder 11, RU 158, SIA; Photograph of "Ethnology Exhibit in West Hall of A&I Building," 1904, neg. #16245 (MNH) & 18955, SIA.

80. Report on the Operations of the Department of Anthropology for the Year 1897–1898, by William H. Holmes, box 26, folder 10, RU 158, SIA.

81. Report on the Operations of the Department of Anthropology for the Year 1897–1898; and Photograph of "Installing Totem Poles in U.S. National Museum," 1890, neg. #5792, SIA.

82. Report on the Operations of the Department of Anthropology for the Year 1897–1898.

83. *Annual Report of the Bureau of Ethnology, 1883–1884* (Washington: Government Printing Office, 1887), xvii.

84. Hinsley, *The Smithsonian and the American Indian*, 126, 136–37.

85. Ibid., 138.

86. J. W. Powell and Franz Boas, "Museums of Ethnology and Their Classification," *Science* 9, no. 229 (June 24, 1887): 612–14.

87. Annual Report of the Department of Ethnology, 1897, Otis T. Mason, Curator, box 4, folder 2, RU 158, SIA.

88. Report on the Operations of the Department of Anthropology for the Year 1897–1898, By William H. Holmes, box 26, folder 10, RU 158, SIA.

89. Statue of Freedom, U.S. National Museum Rotunda, c. 1902–1910, neg. #18942, box 38, folder 7, RU 95, SIA.

90. Copp Family Collection on Display in National Museum, c. 1900, neg. #9098 and MAH-9098, box 42, folder 10, RU 95, SIA. For detailed information on the Copp Family Collection, see Briann Greenfield, *Out of the Attic: Inventing Antiques in Twentieth-Century New England* (Amherst: University of Massachusetts Press, 2009), 174–77.

91. Kulik, "Designing the Past," 3–12.

92. *Report of the United States National Museum, 1895* (Washington: Government Printing Office, 1897), 7.

93. *Annual Report of the Board of Regents of the Smithsonian Institution, 1888* (Washington: Government Printing Office, 1890), 14.

94. Ibid., 15–16.

95. At the turn of the twentieth century, the American Museum of Natural History encompassed 294,000 square feet—196,000 square feet of which was reserved for exhibitions. *Report of the United States National Museum, 1898* (Washington: Government Printing Office, 1900), 11.

96. *Report of the U.S. National Museum, 1900,* 12.

97. *Report of the U.S. National Museum, 1898,* 7.

98. Ibid., 12–13; Richard Rathbun, *The United States National Museum: An Account of the Buildings Occupied by the National Collections* (Washington: Government Printing Office, 1905), 263.

99. Report on the Section of Transportation and Engineering in the U.S. National Museum for the year ending June 30, 1891, J. Elfreth Watkins, Curator, box 2, folder 18, RU 158, SIA.

100. Report on Historical Collections, 1893, A. Howard Clark, curator, box 2, folder 4, RU 158, SIA.

101. Report on the Department of Anthropology for the Year 1898–99, by William H. Holmes, Head Curator (Division of History), box 26, folder 11, RU 158, SIA.

102. Report on the Operations of the Department of Anthropology for the Year 1897–1898.

103. *Report of the United States National Museum, 1903* (Washington: Government Printing Office, 1905), 13.

104. Nathan Glazer and Cynthia R. Field, eds., *The National Mall: Rethinking Washington's Monumental Core* (Baltimore: Johns Hopkins University Press, 2008). See especially Michael J. Lewis, "The Idea of the American Mall," 22–23; and Cynthia R. Field, "When Dignity and Beauty Were the Order of the Day: The Contribution of Daniel H. Burnham," 42–45. See also Henry, "Thoughts Regarding the Mall."

105. *Annual Report of the Board of Regents of the Smithsonian Institution, 1910* (Washington: Government Printing Office, 1911), 41.

106. George W. Stocking Jr., *Race, Culture, and Evolution* (New York: The Free Press, 1968), 195–233. In 1905, Boas left the American Museum of Natural History to begin teaching at Columbia University.

107. Franz Boas, "Some Principles of Museum Administration," *Science* 25, no. 650 (June 14, 1907), 929.

108. "An Introduction to the Field Museum," Field Museum, www.fieldmuseum .org/museum_info/.

109. *Smithsonian Annual Report, 1910*, 41.

110. Richard Rathbun, *A Descriptive Account of the Building Recently Erected for the Departments of Natural History of the United States National Museum*, United States National Museum Bulletin 80 (Washington: Government Printing Office, 1913), 115.

111. Ibid., 116.

112. In 1937, this National Gallery of Art became the National Collection of Fine Arts, later the National Museum of American Art, and then finally the Smithsonian American Art Museum. It is distinct from the National Gallery of Art, which was opened in 1941.

113. Lois Marie Fink, *A History of the Smithsonian American Art Museum: The Intersection of Art, Science, and Bureaucracy* (Amherst and Boston: University of Massachusetts Press, 2007), chap. 1.

114. *Smithsonian Annual Report, 1910*, 41. Walcott was the fourth secretary of the Smithsonian. He succeeded Samuel Pierpont Langley.

115. Ibid., 29–33; Richard Rathbun, *The National Gallery of Art*, United States National Museum Bulletin 70 (Washington: Government Printing Office, 1909).

116. Hinsley, *The Smithsonian and the American Indian*, 100–101.

117. Ibid., 103.

118. Ibid., 108–9; Walter Hough, "Racial Groups and Figures in the Natural History Building of the United States National Museum," in *Annual Report of the Board of Regents of the Smithsonian Institution, 1920* (Washington: Government Printing Office, 1920).

119. Constance McLaughlin Green, *The Secret City: A History of Race Relations in the Nation's Capital* (Princeton: Princeton University Press, 1967), 165–66.

120. James Borchert, *Alley Life in Washington: Family, Community, Religion, and Folklife in the City, 1850–1970* (Champaign: University of Illinois Press, 1980).

121. Report of the Department of Anthropology for the year 1911–12, by William H. Holmes, Head Curator, box 27, folder 4, RU 158, SIA.

122. Report of the Department of Anthropology, 1919–1920, by W. H. Holmes, Head Curator, box 28, folder 6, RU 158, SIA.

123. Ibid.

124. Goode, "Report of the Assistant Director of the United States National Museum, for the Year 1881," 86.

125. Kulik, "Designing the Past," 9.

126. Report of the Department of Anthropology, 1919–1920.

127. Photograph of "War Collection in the Natural History Building Rotunda," neg. #2003-19521, SIA; Annual Report of the Division of History for 1929, box 51, folder 2, RU 158, SIA, 60.

128. Report on the Department of Anthropology for the year 1910–11, by William H. Holmes, Head Curator, box 27, folder 3, RU 158, SIA.

129. Report of the Department of Anthropology, 1919–1920.

130. Annual Report of the Division of History for 1929.

131. Report of the Department of Arts and Industries and Division of History, by William de C. Ravenal, Director of Arts and Industries, 1927–1928, box 51, folder 1, RU 158, SIA.

132. *Smithsonian Annual Report, 1920*, 49; *Annual Report of the Board of Regents of the Smithsonian Institution, 1921* (Washington: Government Printing Office, 1922), 17.

2. History and Technology

1. Use of the term "Nation's Attic" in the media when referring to the Smithsonian was widespread, and it continues to be used on occasion today. See, for example, "Sweep in the Nation's Attic," *Time*, Nov. 2, 1942, 74; "'The Nation's Attic,'" *New York Times*, Aug. 4, 1946, 101; "The Nation's Attic: Smithsonian's Huge Collections Make a Rich Clutter of Culture," *Life*, Sept. 28, 1953, 110; Bil Gilbert, "New Look for the National Attic," *Nature Magazine*, Dec. 1958, 512; Maureen Dowd, "Cleaning the Nation's Attic," *Time*, Feb. 8, 1982, 13; M. Horn, "A Mess in the Nation's Attic," *U.S. News and World Report*, Aug. 13, 1990, 57; Emmet Meara, "The Lure of the 'Nation's Attic,'" *Bangor Daily News*, Aug. 19, 2011.

2. *Annual Report of the Board of Regents of the Smithsonian Institution, 1946* (Washington: United States Government Printing Office, 1947), 10–12; Leonard Carmichael, "Needed: A New National Museum," *Coronet* 38 (May 1955): 53–56.

3. Guide to the Carl W. Mitman Papers, SIA; Smithsonian Organizational Charts, box 12, folder "SI Org Charts," RU 294, Smithsonian Institution, Management Analysis Office, Records, SIA.

4. Division of Mechanical Technology Annual Report, 1919–1920, Carl W. Mitman, Curator, box 54, folder 13, RU 158, SIA; Frank A. Taylor, interview (#4) by Miriam S. Freilicher, March 13, 1974, RU 9512, Frank A. Taylor Interviews, SIA, 90–91 in transcript; Marilyn Sara Cohen, "American Civilization in Three Dimensions: The Evolution of the Museum of History and Technology of the Smithsonian Institution" (Ph.D. diss., George Washington University, 1980), 22; Pamela M Henson, "'Objects of Curious Research': The History of Science and Technology at the Smithsonian," *Isis* 90, Supplement, Catching up with the Vision: Essays on the Occasion of the 75th Anniversary of the Founding of the History of Science Society (1999): S259–S261.

5. Retrospect, Bulletin of the National Museum of Engineering and Industry, vol. 1, no. 1 (July 1927), box 81, folder "National Museum of Engineering and Industry (Porter)," RU 334, National Museum of American History, Office of the Director, Subject Files, SIA; Brief statement of the history of the movement to establish a National Museum of Engineering and Industry, Jan. 12, 1932, box 9, folder "Background and History, 1922–1932," RU 297, United States National Museum, Division of Engineering, Records, SIA.

6. National Museum of Engineering and Industry To be Under the Direction of the Smithsonian Institution, Washington, D.C., 1924, box 81, folder "National Museum of Engineering and Industry (Porter)," RU 334, SIA.

7. Carl W. Mitman to H. F. J. Porter, October 31, 1922, box 8, folder "Correspondence 1922–1925, 1927–1928," RU 297, SIA; Carl W. Mitman to H. F. J. Porter, Nov. 29, 1922, box 8, folder "Correspondence 1922–1925, 1927–1928," RU 297, SIA.

8. Brief statement of the history of the movement to establish a National Museum of Engineering and Industry.

9. Carl W. Mitman to H. F. J. Porter, Sept. 30, 1925, box 8, folder "Correspondence 1922–1925, 1927–1928," RU 297, SIA.

10. Tentative Classification of the Museum of Engineering and Industries of the United States National Museum, Proposed by Carl W. Mitman, Head Curator, 1934, box 66, folder 3, RU 158, SIA; Division of Engineering Annual Report, 1933–1934, Frank A. Taylor, Curator, box 65, folder 19, RU 158, SIA.

11. *Annual Report of the Board of Regents of the Smithsonian Institution, 1928* (Washington: United States Government Printing Office, 1929), 31–33.

12. *Annual Report of the Board of Regents of the Smithsonian Institution, 1930* (Washington: United States Government Printing Office, 1931), 26–27.

13. Cohen, "American Civilization," 39, 119–11; Review of the Efforts Made to Obtain a Building for the Department of Engineering and Industries, Talk to the staff of the Department, August 1949, to start detailed planning for new building requirements, box 81, folder Mr. Taylor's National Museum of Science and Industry Background, RU 334, SIA. Interestingly, the National Zoological Park was able to obtain funds from the federal government to erect several buildings during the 1930s: "WPA Provides Money for Zoo Buildings," Smithsonian Institution Archives, http://siarchives.si.edu/collections/.

14. Review of the Efforts Made to Obtain a Building; Carl W. Mitman to Alexander Wetmore, June 16, 1944, Appendix to Frank A. Taylor, interview (#12) by Pamela M. Henson, Sept. 17, 1980, RU 9512, Frank A. Taylor Interviews, SIA.

15. A Bill to Provide for the Construction of Public Buildings, and for Other Purposes, H.R. 4276, 79th Cong. (1945), Appendix to Taylor interview (#12).

16. For a detailed history of the museum, see Michael J. Neufeld and Alex M. Spencer, eds., *Smithsonian National Air and Space Museum: An Autobiography* (Washington, D.C.: National Geographic, 2010). On the history of legislation pertaining to the museum, see chap. 3: Dominick A. Pisano, "The Long Road to a New Museum." See also Michael McMahon, "The Romance of Technological Progress: A Critical Review of the National Air and Space Museum," *Technology and Culture* 22, no. 2 (April 1981): 281–96.

17. For extensive information on Taylor's career at the Smithsonian, see the almost twenty hours of oral history interviews conducted by the Smithsonian Institution Archives: Frank A. Taylor Interviews, 1974, 1979–1980, 1982, RU 9512, SIA.

18. Henson, "'Objects of Curious Research,'" S260–S261; Patricia Sullivan, "Frank Taylor; Founding Director of American History Museum," *Washington Post,* June 30, 2007.

19. Frank A. Taylor, "A National Museum of Science, Engineering and Industry," *Scientific Monthly* 63, no. 5, Smithsonian Centennial Issue (Nov. 1946): 359–65; Frank A. Taylor, "The Background of the Smithsonian's Museum of Engineering and Industries," *Science,* New Series, vol. 104, no. 2693 (Aug. 9, 1946): 130–32; Cohen, "American Civilization," 20–39, chap. 4.

20. Taylor, "A National Museum of Science, Engineering and Industry," 359.

21. Ibid. See also Taylor, interview (#4), 91 in transcript.

22. Taylor, interview (#4), 96 in transcript. A similar suggestion had been made to Smithsonian officials in 1944, but it was rejected. See also Marie Plassart, "Narrating 'America': The Birth of the Museum of History and Technology in Washington, D.C., 1945–1967," *European Journal of American Studies* (2007), http://ejas.revues .org/1184.

23. Taylor, interview (#4), 97 in transcript.

24. Ibid., 99.

25. Additional notes at end of Review of the Efforts Made to Obtain a Building for the Department of Engineering and Industries.

26. Taylor, interview (#4), 99–100 in transcript.

27. Kulik, "Designing the Past," 10–12.

28. Taylor, interview (#4), 100–101 in transcript.

29. "Wanted—A name for proposed museum to house the departments of anthropology, engineering and industries and history and the Bureaus of American Ethnology and the Astrophysical Observatory," n.d., box 75, folder "Committees," RU 50, Smithsonian Institution, Office of the Secretary, Records, SIA.

30. L. B. Aldrich to Mr. Graf, Dec. 2, 1952, box 81, folder "Museum of Man, Space Requirements," RU 334, SIA.

31. Taylor, interview (#4), 102 in transcript.

32. Peter Novick, *That Noble Dream: The "Objectivity Question" and the American Historical Profession* (New York: Cambridge University Press, 1988), 283.

33. Edward Steichen and Carl Sandburg, *The Family of Man* (1955; Reprint, New York: The Museum of Modern Art, 2002); Eric J. Sandeen, *Picturing an Exhibition: The Family of Man and 1950s America* (Albuquerque: University of New Mexico Press, 1995); David Hollinger, "How Wide the Circle of 'We'? American Intellectuals and the Problem of Ethnos since World War II," *American Historical Review* 98, no. 2 (April 1993): 318; "Edward Steichen at *The Family of Man,* 1955," Museum of Modern Art, www.moma.org/research/archives/highlights/06_1955.html.

34. Digest of minutes of meeting of the Smithsonian Institution Planning Committee, Nov. 7, 1952, box 81, folder "Museum of Man, Space Requirements," RU 334, SIA.

35. "Background Note," finding aid, Leonard Carmichael Papers, American Philosophical Society, Philadelphia.

36. Review of the Efforts Made to Obtain a Building for the Department of Engineering and Industries.

37. Taylor, interview (#4), 107–8 in transcript.

38. Frank Taylor to Leonard Carmichael through Remington Kellogg, May 19, 1953, box 75, folder "Committees," RU 50, SIA.

39. In 1958, Congress did finally appropriate funds for the construction of wings for the Natural History Building. *Annual Report of the Board of Regents of the Smithsonian Institution, 1963* (Washington: United States Government Printing Office, 1964), 3–4.

40. *Hearings before House of Representatives Subcommittee on Buildings and Grounds of the Committee on Public Works,* 84th Cong. (April 29, 1955), box 81, folder "Mr. Taylor's National Museum of Science and Industry and Background," RU 334, SIA. See also *Senate Committee on Public Works, Subcommittee on Public Buildings and Grounds, Construction of a Building for the Smithsonian Institution,* 84th Cong. (June 14, 1955); and "Legislative History of MHT," n.d., box 30, folder "MHT Basic Info," RU 190, United States National Museum, Office of the Director, Records, SIA.

41. *Hearings before House of Representatives Subcommittee on Buildings and Grounds of the Committee on Public Works,* 6–7.

42. Ibid., 16–18.

43. Taylor, interview (#4), 107–8 in transcript.

44. Kai Bird and Martin J. Sherwin, *American Prometheus: The Triumph and Tragedy of J. Robert Oppenheimer* (New York: Vintage, 2006), 498.

45. Frances Stonor Saunders, *The Cultural Cold War: The CIA and the World of Arts and Letters* (New York: The New Press, 1999), 1–6.

46. Legislative History of MHT. On June 13, 1956, Congress appropriated the remaining $33,712,000. Museum of History and Technology: A Description, Sept. 1968, box 47, folder 2, Daniel J. Boorstin Papers, Manuscript Division, Library of Congress, Washington, D.C.

47. Division of History Annual Report, 1932, box 63, folder 12, RU 158, SIA; Greenfield, *Out of the Attic,* 177.

48. *Exhibits in the Museums of the Smithsonian Institution,* n.d. [late 1950s?], box 6, folder Booklet: Exhibits in the Museums of the Smithsonian Institution, Acc. 02-187, Silvio A. Bedini Papers, SIA.

49. Division of Ethnology Annual Report, 1932–1933, box 64, folder 6, RU 158; Division of Ethnology Annual Report, 1936–1937, box 67, folder 11, RU 158. See also C. Malcolm Watkins, "Some New Geneva and Greensboro Glass," *Antiques 63,* no. 2 (Feb. 1953): 136–37; and Greenfield, *Out of the Attic,* chap. 5.

50. Division of Ethnology Annual Report, 1954–1955, box 87, folder 12, RU 158, SIA.

51. Leonard Carmichael to Heads of Bureaus, Offices, and Divisions, June 27, 1955, box 81, folder "Committee for MHT 1955," RU 334, SIA.

52. "Minutes of first meeting of the Ad Hoc Committee on Cultural History," box 101, folder 21, RU 276, SIA.

53. For detailed background information on Ewers, see William S. Walker, "John C. Ewers and the Problem of Cultural History: Displaying American Indians at the Smithsonian in the Fifties," *Museum History Journal* 1, no. 1 (Jan. 2008): 51–74.

54. C. Malcolm Watkins, interview (#1) by Pamela M. Henson and Susan H. Myers, 1992, RU 9586, C. Malcolm Watkins Interviews, SIA, 1–38 in transcript. Watkins was curator at the Wells Historical Museum and then Old Sturbridge Village from 1936 to 1949, except for a brief period of military service during World War II. For a detailed study of Watkins, see Greenfield, *Out of the Attic,* chap. 5.

55. John C. Ewers, "Museums for Indians in the United States," *Fundamental Education* 4, no. 1 (Jan. 1952): 3–9.

56. William N. Fenton, "The Training of Historical Ethnologists in America," *American Anthropologist,* n.s., 54, no. 3 (July–Sept. 1952): 328–39; William C. Sturtevant, "Anthropology, History, and Ethnohistory," *Ethnohistory* 13, no. 1/2 (Winter–Spring 1966): 1–51; Kerwin Lee Klein, *Frontiers of Historical Imagination: Narrating the European Conquest of Native America, 1890–1990* (Berkeley: University of California Press, 1997), 183–86.

57. John C. Ewers, *The Horse in Blackfoot Indian Culture, With Comparative Material from Other Western Tribes,* Smithsonian Institution Bureau of American Ethnology, Bulletin 159 (Washington: Government Printing Office, 1955), 338.

58. Ibid., xii.

59. John C. Ewers, "A Century of American Indian Exhibits in the Smithsonian Institution," in *Smithsonian Report for 1958* (Washington, D.C.: United States Government Printing Office, 1959), 520–22; John C. Ewers, interview (#3) by Pamela M. Henson, Jan. 28, 1975, RU 9505, John C. Ewers Interviews, SIA, 97 in transcript; William Henry Holmes, "Classification and Arrangement of the Exhibits of an Anthropological Museum," in *Annual Report of the United States National Museum, 1901* (Washington: Government Printing Office, 1903), 268–69.

60. Clark Wissler, *North American Indians of the Plains* (New York: American Museum of Natural History, 1941), 3.

61. Ewers, "A Century of American Indian Exhibits in the Smithsonian Institution," 523.

62. "Photographs of New Exhibits in the U.S. National Museum, Indians of California, the Southwest, and Latin America," box 45, folder "Indian Halls," RU 50, SIA.

63. John C. Ewers to S. Dillon Ripley, May 22, 1969, box 10, folder "Ripley Exhibits—Memo (Museum of Man)," Series IX, Papers of John Canfield Ewers, National Anthropological Archives (NAA), Smithsonian Institution, Washington, D.C.

64. Ibid.

65. Candace Green, email correspondence with author, Nov. 6, 2006.

66. C. Malcolm Watkins, "Old Sturbridge Village," *American Collector* 16, no. 3 (April 1947): 8.

67. C. Malcolm Watkins to Leonard Carmichael, April 9, 1953, includes a draft "Prospectus for Smithsonian Fund for Early American Arts and Crafts," box 220, folder "C. Malcolm Watkins," RU 50, SIA.

68. For the fruits of this research see C. Malcolm Watkins and J. Paul Hudson, "The Earliest Known English Colonial Pottery in America," *Antiques* 71, no. 1 (Jan. 1957): 51–54; C. Malcolm Watkins, "The Three Initial Cipher: Exceptions to the Rule," *Antiques* 73, no. 6 (June 1958): 564–65; C. Malcolm Watkins, "North Devon Pottery and Its Export to America in the 17th Century," United States National Museum Bulletin 225 (Smithsonian Institution, 1960), 17–59; C. Malcolm Watkins and Ivor Noel Hume, *The "Poor Potter" of Yorktown*, United States National Museum Bulletin 249 (Washington: Smithsonian Institution Press, 1967), 73–112; C. Malcolm Watkins, *The Cultural History of Marlborough, Virginia* (Washington: Smithsonian Institution Press, 1968).

69. James Deetz, *In Small Things Forgotten: An Archaeology of Early American Life* (Garden City, N.Y.: Anchor Books, 1977), 5.

70. W. Fitzhugh Brundage, *The Southern Past: A Clash of Race and Memory* (Cambridge: Harvard University Press, 2005), 291–92.

71. Department of History Annual Report, [1948?], box 84, folder 6, RU 158, SIA.

72. Department of History Annual Report, 1955, box 88, folder 7, RU 158, SIA.

73. Division of Civil History Annual Report, 1950–1951, box 84, folder 8, RU 158, SIA.

74. *Annual Report of the Board of Regents of the Smithsonian Institution, 1952* (Washington: Government Printing Office, 1953), 20.

75. Minutes of first meeting of the Ad Hoc Committee on Cultural History.

76. Department of Civil History Annual Report, 1958–1959, box 93, folder 21, RU 158, SIA.

77. Department of Arts and Manufactures Annual Report, 1958, box 92, folder 1, RU 158, SIA.

78. Robert P. Multhauf, The Museum of History and Technology: An Analysis, Feb, 6, 1968, box 47, folder 2, Boorstin Papers.

79. "Modernization of Exhibits," n.d., box 13, folder "Museum-Wide Exhibits Study 1950–1956," Series IX, Ewers Papers, NAA; Gilbert, "New Look for the National Attic," 512.

80. In the late forties, Frank Taylor and Jack Ewers visited museums in the Midwest, including the Field Museum in Chicago and the Public Museum in Milwaukee, to examine what kinds of changes these museums had made to their exhibits in recent years. "A Survey of Recent Experience in Development of Anthropological Exhibits in Some Mid-Western Museums," box 13, folder "Museum-Wide Exhibits Study 1950–1956," Series IX, Ewers Papers, NAA.

81. Grace Morley, "Museums and UNESCO," *Museum* 2, no. 2 (1949): 1–35.

82. *Annual Report of the Board of Regents of the Smithsonian Institution, 1954* (Washington: Government Printing Office, 1955), 25; "Exhibits Modernization Committee Created," SIA, http://siarchives.si.edu/collections/.

83. Memorandum with attached Preliminary Report on Exhibitions from Frank A. Taylor, chairman, Subcommittee on Exhibits, to Dr. Schmitt. Mr. Foshag, Mr. Pope, Dr. Stewart, and Capt. Carey, Oct. 13, 1948, box 89, folder "Exhibits Modernization 1948," RU 190, SIA.

84. Report of the Committee on Exhibits, March 31, 1950, box 89, folder "Exhibits Modernization 1950," RU 190, SIA.

85. Digest of talk on "Modernizing Exhibits—the U.S. National Museum" given at the dinner of the Southeastern Museums Conference by Herbert Friedmann, Williamsburg, Virginia, Oct. 26, 1956, box 76, folder "Lectures," RU 334, SIA.

86. John C. Ewers, "Problems and Procedures in Modernizing Ethnological Exhibits," *American Anthropologist* 57, no. 1 (1955): 1.

87. Ibid., 5.

88. For attendance figures see *Smithsonian Annual Reports* from 1946 to 1964.

89. Dedication of the Museum of History and Technology of the Smithsonian Institution, Jan. 22, 1964, box 75, folder "Dedication Ceremony," RU 50, SIA.

90. Herman Schaden, "New Smithsonian Unit to Be a Palace of Progress," *The Evening Star*, May 25, 1962, A16. See also "Smithsonian Gets Praise—And Money," *Washington Post*, June 9, 1955, 17; and Paul Sampson, "President Asks $2,288,000 More for New Museum," *Washington Post*, June 30, 1955, 17.

91. Michael E. Latham, *Modernization as Ideology: American Social Science and 'Nation Building' in the Kennedy Era* (Chapel Hill: University of North Carolina Press, 2000); David C. Engerman, Nils Gilman, Mark H. Haefele, and Michael E. Latham, *Staging Growth: Modernization, Development, and the Global Cold War* (Amherst: University of Massachusetts Press, 2003).

92. Carmichael, "Needed: A New National Museum," 55.

93. Multhauf, The Museum of History and Technology: An Analysis.

94. *Exhibits in the Museum of History and Technology* (Washington, D.C.: Smithsonian Institution Press, 1968), 106–9.

95. This overview of the museum is based on *Exhibits in the Museum of History and Technology*.

96. Ibid., 36, 37.

97. All of my descriptions of exhibits in "Everyday Life in Early America" come from photographs of the exhibit, "Hall 26, Everyday Life in Early America Photos,"

Division of Domestic Life, National Museum of American History, Smithsonian Institution, Washington, D.C.

98. Tour script for "Everyday Life in Early America," box 1, folder "Docents, 1957–71," RU 261, National Museum of History and Technology, Division of Domestic Life, Records, SIA, 4.

99. Ibid., 8; Bess Furman, "Old Farmhouse Starts New Life," *New York Times*, Jan. 27, 1957, 56; and "Everyday Life in Early America" photographs.

100. Tour script for "Everyday Life in Early America," 15; "Everyday Life in Early America" photos.

101. On the paucity of African American materials in the Smithsonian's collections see Michele Gates Moresi, "Exhibiting Race, Creating Nation: Representations of Black History and Culture at the Smithsonian Institution, 1895–1976" (Ph.D. diss., George Washington University, 2003).

102. "A Preliminary Analysis of the Growth of America Series," Series IX, box 3, folder "Growth of America General," Ewers Papers, NAA.

103. Ibid.

104. "Notes on Philosophy of our Growth of America Series," "J. C. Ewers. June 1, 1956," Series IX, box 3, folder "Growth of America General," Ewers Papers, NAA.

105. John C. Ewers to Mendell [*sic*] Peterson, Chairman, Growth of America Planning Committee, n.d., Series IX, box 3, folder "Growth of America," Ewers Papers, NAA. Ewers did redeem himself to some extent in a 1960 memorandum to Anthony Garvan by recommending that a display case on "The Indian and Negro" suggest some similarities between early Euro-American colonial culture and Native culture. John C. Ewers to Anthony Garvan, Sept. 2, 1960, box 98, folder "GOUS, 1956–1960," RU 276, National Museum of History and Technology, Office of the Director, Records, SIA.

106. Account of Trip to Recruit Garvan, no date, no author (possibly C. Malcolm Watkins), box 2, folder "Anthony Garvan," RU 7322, C. Malcolm Watkins Papers, SIA; Garvan bio, no author, box 2, folder "Anthony Garvan," RU 7322, SIA.

107. Biographical materials come from Murray G. Murphey, *Anthony Garvan: Culture, History, and Artifacts* (Philadelphia: Library Company of Philadelphia, 1992); Curriculum vitae of Anthony Garvan, box 13, folder "Consultants—Garvan," RU 334, SIA.

108. Anthony Garvan, *Architecture and Town Planning in Colonial Connecticut* (New Haven: Yale University Press, 1951).

109. Murphey, *Anthony Garvan: Culture, History, and Artifacts*, 6; and Robin W. Winks, *Cloak and Gown: Scholars in the Secret War, 1939–1961* (New York: William Morrow, 1987), 106–7.

110. George P. Murdock, Clellan S. Ford, Alfred E. Hudson, Raymond Kennedy, Leo W. Simmons, and John W. M. Whiting, *Outline of Cultural Materials* (New Haven: Human Relations Area Files, Inc., 1950), xii.

111. For overviews of the Cross-Cultural Survey and the Human Relations Area Files see ibid., xi–xxiii; and John W. M. Whiting, "George Peter Murdock,

(1897–1985)," *American Anthropologist,* n.s., 88, no. 3 (Sept. 1986), 683–85; Wendell Phillips, "American Anthropology in the War and in the Future," *Man* 46 (Sept.–Oct. 1946): 109–11. During the war a copy of the Cross-Cultural Survey was maintained at the Smithsonian Institution under the auspices of the Ethnogeographic Board, which existed from 1942 to 1946 to assist the United States military by providing scientific and cultural information about areas in the world where it was engaged. Pamela M. Henson, "The Smithsonian Goes to War," in *Science and the Pacific War,* ed. Roy M. MacLeod (Great Britain: Kluwer Academic Publishers, 2000), 31–36. See also Joseph Tobin, "The HRAF as Radical Text?" *Cultural Anthropology* 5, no. 4 (Nov. 1990): 473–87.

112. Garvan, *Architecture and Town Planning,* 149–51.

113. Murray G. Murphey, "American Civilization at Pennsylvania," *American Quarterly* 22, no. 2 (Summer 1970): 491. In 1960, he became the chairman of Penn's newly created Department of American Civilization.

114. Curriculum vitae of Anthony Garvan.

115. Philip Gleason, "World War II and the Development of American Studies," *American Quarterly* 36, no. 3 (1984): 343–58.

116. Henry Nash Smith, "Can 'American Studies' Develop a Method?" *American Quarterly* 9, no. 2, part 2 (Summer 1957): 197–208; Linda K. Kerber, "Diversity and the Transformation of American Studies," *American Quarterly* 41, no. 3 (Sept. 1989): 415–31; Gregory M. Pfitzer, "Resurrecting the Fathers: The Revisionist Movement in American Studies Historiography," *American Quarterly* 43, no. 3 (Sept. 1991): 534–40.

117. Richard E. Sykes, "American Studies and the Concept of Culture: A Theory and Method," *American Quarterly* 15, no. 2, part 2: supplement (Summer 1963): 253–70.

118. Ironically, as historian Kerwin Lee Klein has noted, Smith had in fact promoted a compromise position between literary scholarship and the social sciences in an earlier essay in *American Quarterly.* Klein, *Frontiers of Historical Imagination,* 227–29.

119. Alfred Kroeber, *An Anthropologist Looks at History* (Berkeley: University of California Press, 1963), 136.

120. Peter C. Welsh to Silvio A. Bedini, July 8, 1965, box 1, folder "Dr. Garvan Correspondence," Acc. 03-071, National Museum of History and Technology, Division of Preindustrial Cultural History, Curatorial Records, SIA; "Index of American Cultures," n.d., box 32, folder 3, Anthony Nicholas Brady Garvan Papers, University of Pennsylvania Archives.

121. Anthony Garvan, "Historical Depth in Comparative Culture Study," *American Quarterly* 14, no. 2, part 2: supplement (Summer 1962): 264; Murdock et al., *Outline of Cultural Materials;* see Table of Contents for list of categories and subcategories.

122. Garvan, "Historical Depth in Comparative Culture Study," 273.

123. Ibid.

124. Anthony Garvan, "Proprietary Philadelphia as Artifact," in *The Historian and the City,* ed. Oscar Handlin and John Burchard (Cambridge: MIT Press and Harvard University Press, 1963), 177–201.

125. Ibid., 199–201. On structuralism and Lévi-Strauss see Sherry B. Ortner, "Theory in Anthropology Since the Sixties," in *Culture/Power/History: A Reader in Contemporary Social Theory,* ed. Nicholas B. Dirks, Geoff Eley, and Sherry B. Ortner (Princeton: Princeton University Press, 1994), 372–411.

126. Garvan, "Proprietary Philadelphia as Artifact," 199.

127. Frank H. Sommer (head of libraries, Winterthur) to Anthony Garvan, January 23, 1964, box 32, folder 3, Garvan Papers.

128. "Original concept statement for the exhibit *The Growth of the U.S.* drafted by Anthony Garvan," box 1, folder "Original Concept Statement GOUS," Acc. 03-070, National Museum of History and Technology, Division of Preindustrial Cultural History, Exhibition Records, SIA.

129. "Re: GOUS—Statement written by Anthony Garvan," box 1, folder "Original Concept Statement GOUS," Acc. 03-070, SIA.

130. Ibid.

131. "Original concept statement for the exhibit *The Growth of the U.S.* drafted by Anthony Garvan," box 1, folder "Original Concept Statement GOUS," Acc. 03-070, SIA.

132. Ibid.

133. Anthony Garvan to Frank Taylor, Aug. 1, 1958, box 1, folder "Meetings on Growth of U.S.," Acc. 03-070, SIA.

134. C. Malcolm Watkins to Anthony Garvan, n.d. [1958], box 1, folder "Meetings on the Growth of US," Acc. 03-070, SIA.

135. Ibid.

136. Eugene Kingman notes on Growth of the United States, Nov. 6, 1958, box 1, folder Meetings on Growth of the United States, Acc. 03-070, SIA.

137. John C. Ewers to Frank A. Taylor, Feb. 20, 1959, box 78, folder "Organization of the GOUS, 1958–1967," RU 276, SIA.

138. John C. Ewers to Anthony Garvan, March 18, 1959, box 78, folder "Organization of the GOUS, 1958–1967," RU 276, SIA.

139. Ibid.

140. Peter C. Welsh, telephone interview by author, Aug. 2, 2005, RU 9619, SIA.

141. Garvan, "Historical Depth in Comparative Culture Study," 260–74. Other historians wrestled with this problem in this period; see Caroline F. Ware, introduction to *The Cultural Approach to History* (New York: Columbia University Press, 1940), 11. For background on Ware and the publication of *The Cultural Approach to History,* see Ellen Fitzpatrick, "Caroline F. Ware and the Cultural Approach to History," *American Quarterly* 43, no. 2 (June, 1991): 173–98.

142. "Fellows Celebrate UD-Hagley Program's 50th Year," University of Delaware, www.udel.edu/PR/UDaily/2004/hagley051304.html; Welsh, interview.

143. See Peter C. Welsh, "Brandywine: An Early Flour-Milling Center," in *Annual Report of the Board of Regents of the Smithsonian Institution, 1959* (Washington: Government Printing Office, 1960), 677–86; and Peter C. Welsh, *Tanning in the United States to 1850: A Brief History,* United States National Museum Bulletin 242 (Washington: Smithsonian Institution, 1964).

144. For examples of Garvan's progress reports see box 1, folder "Dr. Garvan Correspondence," Acc. 03-071, SIA; Welsh, interview.

145. "Smithsonian's 'Museum within a Museum' Tracing United States Growth to Open," June 2, 1967 (Press release), box 40, folder "GOUS, 1965–1974," RU 276, SIA.

146. For photographs of the exhibit cases see photo binders in the Division of Domestic Life, National Museum of American History (NMAH). For *Outline of Cultural Materials* categories see Murdock et al., *Outline of Cultural Materials*, iii–ix.

147. Briann G. Greenfield, "Old New England in the Twentieth-Century Imagination: Public Memory in Salem, Deerfield, Providence, and the Smithsonian Institution" (Ph.D. diss., Brown University, 2002), 233–36.

148. Murdock et al., *Outline of Cultural Materials*, Table of Contents.

149. "Smithsonian's 'Museum within a Museum' Tracing United States Growth to Open."

150. "GOUS Hall II, Communications, Education, Exact Knowledge" (photo binder), Division of Domestic Life, NMAH.

151. "GOUS Hall III, Communication, Costume, Education, Exposition of 1851" (photo binder), Division of Domestic Life, NMAH.

152. "John Bull Locomotive," History Wired, http://historywired.si.edu.

153. "GOUS Hall II, Geography, Indian and Negro, Ipswich House, Law and Government, Living Standards, Medicine" (photo binder), Division of Domestic Life, NMAH.

154. Moresi, "Exhibiting Race, Creating Nation," 3.

155. "Entrance to 'George Catlin's Indian Gallery' in the National Collection of Fine Arts," SIA, http://siarchives.si.edu/history/exhibits/pictures/smithsonian-american-art-museum-and-renwick-gallery.

3. Open Education

1. S. Dillon Ripley, *The Sacred Grove: Essays on Museums* (London: Victor Gollancz, 1969), 140. Tony Bennett is quite critical of Ripley's notion that one could pass easily from a museum environment to a fair-like space. He argues that only a member of the privileged elite such as Ripley could have enjoyed such freedom of movement. Bennett, *The Birth of the Museum*, 12. I argue that Ripley made such an experience accessible to all with the changes he instituted at the Smithsonian.

2. Larry Van Dyne, "The Sun King Ambitions of Dillon Ripley," *The Washingtonian* 15, no. 3 (Dec. 1979): 213–14.

3. S. Dillon Ripley, "Appraising the Prospects for Science and Learning," Oct. 26, 1964 ("Remarks upon the occasions of the fiftieth anniversary of the founding of the Alumni Chapter of the Society of Sigma Xi, Washington, D.C., delivered at the Freer Gallery of Art, October 26, 1964"), 2.

4. President Johnson's Remarks on International Education, Cong. Rec., United States Senate, 89th Congress, 1st Session, Sept. 17, 1965, 24217.

5. On attitudes toward exhibition in the museum profession in these years, see Ripley, *The Sacred Grove*, 82–96; Henry D. Brown, "Intrigue Before You Instruct,"

Museum News 42, no. 7 (March 1964): 28–33; Kenneth M. Wilson, "A Philosophy of Museum Exhibition," *Museum News* 46, no. 2 (Oct. 1967): 13–17; and *Museums: Their New Audience: A Report to the Department of Housing and Urban Development by a Special Committee of the American Association of Museums* (Washington: American Association of Museums, 1972).

6. Ellen C. Hirzy, "The AAM after 72 Years," *Museum News* (May/June 1978), American Association of Museums, www.aam-us.org/aboutaam/aamafter72years .cfm; *Annual Report for the National Endowment for the Arts and National Council on the Arts, 1969*, 8–9; and "National Museum Act Implemented," SIA, http://siarchives .si.edu/collections/.

7. Ripley, "Appraising the Prospects for Science and Learning," 4.

8. S. Dillon Ripley, "Museums in Today's Changing World," Sept. 27, 1965, box 20, folder "Mr. Ripley's Speeches," Acc. T90055, Smithsonian Institution, Division of Performing Arts, Records, SIA.

9. Gaylord P. Harnwell, "Houses of Knowledge," *Museum News* 44, no. 2 (Oct. 1965): 37–38; Otto Wittmann, "Museums at the Crossroads," *Museum News* 44, no. 1 (Sept. 1965): 15–20. In the late nineteenth and early twentieth centuries, several pioneering museum leaders, including George Brown Goode and John Cotton Dana, offered practical and theoretical recommendations concerning museums' educational role. By the mid-twentieth century, however, museum professionals had lost touch with these foundational thinkers. See George Brown Goode, "The Relationships and Responsibilities of Museums," and John Cotton Dana, "The New Museum," in *Museum Origins: Readings in Early Museum History and Philosophy*, ed. Hugh H. Genoways and Mary Anne Andrei (Walnut Creek, Calif.: Left Coast Press, 2008), 111–24 and 137–41.

10. Marshall McLuhan, quoted in Linda Lichtenberg, "McLuhanism in the Museum," *Museum News* 46, no. 7 (March 1968): 11–18.

11. Jacques Barzun, "Museum Piece, 1967," *Museum News* 46, no. 8 (April 1968): 17–21.

12. S. Dillon Ripley, "Foreword" in *The Cultural Drama: Modern Identities and Social Ferment*, ed. Wilton S. Dillon (Washington: Smithsonian Institution Press, 1974), 21.

13. Brown, "Intrigue Before You Instruct," 29.

14. Ibid., 33.

15. Clark Kerr, *The Uses of the University* (Cambridge: Harvard University Press, 1963).

16. Ripley, "Foreword," 21–22.

17. Smithsonian Organizational Chart, July 30, 1971, box 48, folder 1, RU 137, Smithsonian Institution, Office of the Under Secretary, Records, SIA.

18. "Proposal for 'Music Making—American Style,'" Dec. 1966, box 76, folder "Folklife Festival," RU 99, Smithsonian Institution, Office of the Secretary, Records, SIA.

19. Ralph Rinzler, interview by Robert Cantwell, Jan. 20, 1986, tape 4, SI-FP-1989-CT-0039, Ralph Rinzler Folklife Archives and Collections, Center for Folklife

and Cultural Heritage (CFCH), Smithsonian Institution, Washington, D.C. Ralph C. Rinzler and Roger D. Abrahams, interview by Marc Pachter, July 9, 1993, RU 9569, Ralph Rinzler Interview, SIA. For Morris's account of these events see James Morris, *Smithsonian Impresario: A Memoir by James Morris* (James Morris, 2010), chap. 4.

20. On the Newport festival see Ronald D. Cohen, *Rainbow Quest: The Folk Music Revival and American Society, 1940–1970* (Amherst: University of Massachusetts Press, 2002), 145–48, 160–62, 208–10, 219–22, 235–39; and Benjamin Filene, *Romancing the Folk: Public Memory and American Roots Music* (Chapel Hill: University of North Carolina Press, 2000), 183–84.

21. Cohen, *Rainbow Quest*, chaps. 1–3; Michael Denning, *The Cultural Front: The Laboring of American Culture in the Twentieth Century* (London: Verso, 1996), 284.

22. Cohen, *Rainbow Quest*, chaps. 4–7; Ben A. Botkin (moderator), "The Folksong Revival: A Symposium," *New York Folklore Quarterly* 19, no. 2 (June, 1963): 83–142.

23. On the concept of authenticity in the study of folk culture see Regina Bendix, *In Search of Authenticity: The Formation of Folklore Studies* (Madison: University of Wisconsin Press, 1997).

24. Cohen, *Rainbow Quest*, 172; Botkin, "The Folksong Revival," 131–32; Curriculum vitae for Ralph Rinzler, n.d., box "History of Festival Docs," folder "Correspondence to/from Rinzler," CFCH; Curriculum vitae for Ralph Rinzler, n.d., box 8, folder "Rinzler: Vitae," Ralph Rinzler Papers, CFCH.

25. Ralph Rinzler, interview by Robert Cantwell, Jan. 19, 1986, tapes 1–2, SI-FP-1989-CT-0036 and SI-FP-1989-0037, CFCH; Ralph Rinzler, interview by Robert Cantwell, Jan. 20, 1986, tape 5, SI-FP-1989-CT-0040, CFCH; Richard D. Smith, "Ralph Rinzler: Preserving American Folk Arts," *Pickin'* 6, no. 10 (Nov. 1979): 11.

26. Liner notes to "Old Time Music at Clarence Ashley's Volume Two," *Folkways Records* Album No. FA2359, 1963; Cohen, *Rainbow Quest*, 172–73.

27. Ralph Rinzler, "The Background of These Recordings," liner notes to "The Original Folkways Recordings of Doc Watson and Clarence Ashley, 1960 through 1962," *Smithsonian/Folkways* CD SF 40029/30, 1994; Rinzler and Abrahams, interview, 25–26 in transcript.

28. Liner notes to "Old Time Music at Clarence Ashley's Volume Two"; Ralph Rinzler, interview by Robert Cantwell, Jan. 19, 1986, tape 3, SI-FP-1989-CT-0038, CFCH; "The Friends of Old Time Music" pamphlet, box 42, folder "FOTM," Rinzler Papers, CFCH.

29. Curriculum vitae for Ralph Rinzler, CFCH; Ralph Rinzler, "Festival Supports Year-Round Projects," in *Newport Folk Festival, July 22–25, 1965* (program), box 2, folder "Newport Folk Festival Programs," Rinzler Papers, CFCH, 7, 49.

30. Ralph Rinzler, "The Newport Folk Foundation: Keeping the Roots of Music Alive," in *Newport Folk Festival, 1964* (program), box 2, folder "Newport Folk Festival Programs," Rinzler Papers, CFCH, 7.

31. I borrow this term from Richard Kurin, *Reflections of a Culture Broker: A View from the Smithsonian* (Washington: Smithsonian Institution Press, 1997).

32. Ralph Rinzler, "Festival Supports Year-Round Projects," in *Newport Folk*

Festival, July 22–25, 1965 (program), box 2, "Newport Folk Festival Programs," Rinzler Papers, CFCH, 7.

33. Rinzler and Abrahams, interview, 31 in transcript.

34. On Alan Lomax see Filene, *Romancing the Folk*, 42–75, 133–82.

35. Alan Lomax, "Appeal for Cultural Equity," *The World of Music, Quarterly Journal of the International Music Council (UNESCO)* 14, no. 2 (1972): 3–17.

36. David Whisnant, *All That Is Native and Fine: The Politics of Culture in an American Region* (Chapel Hill: University of North Carolina Press, 1983).

37. Filene, *Romancing the Folk*, chap. 2.

38. Paula Cronin, "The Crafts Curators," *Boston Sunday Globe*, Sept. 17, 1967, 35–36, 38, box 3, folder "Country Roads," Rinzler Papers, CFCH.

39. "Ralph Rinzler Speech to A.F.S. Bicentennial Session, Nov., 1972," RR-357, box 23, folder "Speeches, Appearances, etc.," Rinzler Papers, CFCH.

40. Ibid.; Rinzler, interview by Cantwell, tape 4; and Letter from unidentified author to Doyle, Feb. 7, 1966, Ralph Rinzler Historical Documents, folder "Crafts," CFCH.

41. Don Yoder, *Discovering American Folklife: Essays on Folk Culture and the Pennsylvania Dutch* (Mechanicsburg, Pa.: Stackpole Books, 2001), 4–5.

42. Don Yoder, "The Folklife Studies Movement," *Pennsylvania Folklife* 13, no. 3 (July 1963): 26.

43. "Ralph Rinzler Speech to A.F.S. Bicentennial Session, Nov., 1972."

44. Ralph Rinzler to Alan Lomax, March 16, 1966, RR-357, box 23, folder "Alan Lomax Correspondence," Rinzler Papers, CFCH.

45. This has in fact happened in Cape Breton, which is now an internationally recognized center of traditional music and dance.

46. Ralph Rinzler to Monique and Peter Goodwin, June 14, 1966, Rinzler Historical Documents, folder "Goodwin," CFCH.

47. "Ralph Rinzler Speech to A.F.S. Bicentennial Session, Nov., 1972"; Rinzler, interview by Cantwell, tape 4; American Folklife Conference abstract, n.d., box "History of Festival Docs," folder "1968 Papers—Folklife Institute," CFCH.

48. Rinzler, interview by Cantwell, tape 4; Richard Kurin, *Smithsonian Folklife Festival: Culture Of, By, and For the People* (Washington: Center for Folklife Programs and Cultural Studies, Smithsonian Institution, 1998), 113.

49. Kurin, *Smithsonian Folklife Festival*, 99–147. After 1976, the festival returned to the modest size of its early years. In the eighties and nineties, however, it expanded again. Renamed the Smithsonian Folklife Festival in 1998, it continues to attract large audiences each summer and play an important role in educating Americans about the cultures not only of the United States but of the world in the twenty-first century.

50. See Festival of American Folklife programs held at the Center for Folklife and Cultural Heritage for the locations of the festivals.

51. This general impression of the festival is drawn from photos, videos, and sound recordings of the festival as well as my own reactions as a visitor and volunteer at recent festivals.

52. Loud conversations and other impolite audience actions can clearly be heard on a number of the festival recordings held at the Ralph Rinzler Folklife Archives and Collections, CFCH. See, for example, Festival Recording: Mono dub of 68.101.13: Lightning Hopkins, July 7, 1968, FP-1968-RR-0037, CFCH; and Festival Recordings, July 3, 1969, FP-1969-RR-0022, CFCH.

53. Ernest B. Ferguson, "Nice Young Tradition," July 2, 1975 (article printed in a number of different papers), Grand Forks, North Dakota *Herald*, Miami, Florida *Herald*, St. Paul, Minn. *Pioneer Press*, Portland, Oregon *Oregonian*, Minneapolis, Minn. *Tribune*, box 9, folder "1975 A.D. Publicity," Acc. T90055, SIA.

54. Paul Richard, "Folk Art Show Opens at Mall," *Washington Post*, July 2, 1967, D1.

55. Mary McGrory, "Folk Festival Attracts the Folks," *Washington Star*, n.d. (clipping), box 64, folder "Performing Arts Division, 1968–1971," RU 276, SIA.

56. "In Praise of the Smithsonian July Fourth Folk Festival," 103 Cong. Rec. 1995–96 (1967).

57. Robert W. Mason to S. Dillon Ripley, July 3, 1967, box 76, folder "Folklife Festival," RU 99, SIA.

58. A number of scholars have detailed how folklorists stereotyped and otherwise mistreated "tradition bearers." See, for example, Filene, *Romancing the Folk* and Whisnant, *All That Is Native and Fine*. Rinzler and the organizers of the festival were seeking to move folklore study in a new direction that focused on the involvement of tradition bearers in their own interpretation. See Robert Baron and Nicholas Spitzer, eds., *Public Folklore* (Washington, D.C.: Smithsonian Institution Press, 1992). On the complex cultural dynamics of folk festivals, see Barbara Kirshenblatt-Gimblett, *Destination Culture: Tourism, Museums, and Heritage* (Berkeley: University of California Press, 1998), 55–78.

59. See, for example, the essays in Bill Adair, Benjamin Filene, and Laura Koloski, eds., *Letting Go?: Sharing Historical Authority in a User-Generated World* (Walnut Creek, Calif.: Left Coast Press, 2011).

60. "It's a Festival as American as All Get Out," *New York Times*, July 4, 1969, 12.

61. James Clifford, *The Predicament of Culture: Twentieth-Century Ethnography, Literature, and Art* (Cambridge: Harvard University Press, 1988), 21–54.

62. Kirshenblatt-Gimblett, *Destination Culture*, 75–76.

63. Festival Recordings, July 4, 1969, Reel 1, FP-1969-RR-0032, CFCH.

64. Festival Recordings: Discussion of Dairy Industry, July 2, 1970, FP-1970-RR-0036, CFCH.

65. Festival Recordings, July 4, 1969, Reel 1, FP-1969-RR-0032, CFCH.

66. Festival Recordings, July 4, 1969, Reel 2, FP-1969-RR-0033, CFCH.

67. Festival Recordings: Cheese Making Discussion, July 2, 1970, FP-1970-RR-0027, CFCH.

68. For lists of participants see festival programs, CFCH.

69. Richard Bauman, Patricia Sawin, and Inta Gale Carpenter with Richard Anderson, Garry W. Barrow, William J. Wheeler, and Jongsung Yang, *Reflections*

on the Folklife Festival: An Ethnography of Participant Experience (Bloomington: Indiana University Press, 1992).

70. Sound roll recordings for film of 1968 Festival of American Folklife, July 16 [6th?], 1968, FP-1968-RR-0040, CFCH.

71. "Talk on Race Irks Festival Performer," *Washington Post,* July 9, 1968, B2; Festival Recording: Mono dub of 68.101.13: Lightning Hopkins, July 7, 1968, FP-1968-RR-0037, CFCH.

72. "Program for Poor People's Culture," "Reverend Kirkpatrick and Alan Lomax," box 3, folder "Poor People's March 1968," Rinzler Papers, CFCH.

73. "Talk on Race Irks Festival Performer."

74. Festival Recordings: Baca Band, Tigua Indians, July 7, 1968, FP-1968-RR-0035, CFCH.

75. See Festival Recordings and Native American Learning Center Tapes, CFCH.

76. "It's a Festival as American as All Get Out."

77. Richard, "Folk Art Show Opens at Mall."

78. Roger L. Welsch, English Dept., Univ. of Nebraska–Lincoln, "A Critical Examination of the 1974 Smithsonian Folklife Festival on the Mall," box 8, folder "FAF '74 Reports," Acc. T90055, SIA.

79. Mason to Ripley, July 3, 1967.

80. "It's a Festival as American as All Get Out."

81. "In Praise of the Smithsonian July Fourth Folk Festival."

82. Letter from Mrs. William M. Weinbach Jr. to Robert W. Mason, July 5, 1967, box 76, "Folklife Festival," RU 99, SIA.

83. Letters from the Fendricks of Chevy Chase, Md., to S. Dillon Ripley, Aug. 8, 1967, box 76, "Folklife Festival," RU 99, SIA.

84. Letter from Commander and Mrs. S. Tanner, U.S.N., of Falls Church, Va., to "the Directors of the Smithsonian Institution, July 5, 1969, box 76, "Folklife Festival," RU 99, SIA.

85. Letter from Commander and Mrs. Sylvan Tanner of Falls Church, Va., to James R. Morris, July 5, 1969, box 76, "Folklife Festival," RU 99, SIA.

86. Martin Weil, "Divergent Views Mingle Happily at Folklife Festival," *Washington Post,* July 5, 1970, 21.

87. Discussion of Festival (FAFs '67–'69) (Ralph and Kate Rinzler with Tony Seeger), tape recording, no date, CFCH. I found this recording in an uncatalogued box deposited at the Center for Folklife and Cultural Heritage by Kate Rinzler, Ralph Rinzler's widow.

88. James Morris to Charles Clapp, Feb. 3, 1967, box 76, folder "Folklife Festival," RU 99, SIA; Richard E. Ahlborn to Dr. Uta C. Merzbach, June 26, 1967, box 64, folder "Performing Arts Division, 1968–1971," RU 276, SIA; Richard E. Ahlborn to Frank Taylor, July 13, 1967, box 64, folder "Performing Arts Division, 1968–1971," RU 276, SIA.

89. Silvio A. Bedini to Robert A. Brooks, March 6, 1972, box 11, folder "Division of Performing Arts II," RU 367, Smithsonian Institution, Assistant Secretary for Public Service, Subject Files, SIA.

90. W.W.W. [William W. Warner?] to Silvio [Bedini], May 10, 1972, box 11, folder "Division of Performing Arts II," RU 367, SIA.

91. Archie Green, "Public Folklore's Name: A Partisan's Notes," in *Public Folklore,* ed. Robert Baron and Nicholas R. Spitzer (Washington: Smithsonian Institution Press, 1992), 49–63. See also Richard Bauman and Patricia Sawin, "The Politics of Participation in Folklife Festivals," in *Exhibiting Cultures: The Poetics and Politics of Museum Display,* ed. Ivan Karp and Steven D. Lavine (Washington, D.C.: Smithsonian Institution Press, 1991), chap. 16; and essays in Burt Feintuch, ed., *The Conservation of Culture: Folklorists and the Public Sector* (Lexington: University Press of Kentucky, 1988).

92. On "culture workers" see Whisnant, *All That Is Native and Fine,* xiii.

93. Green, "Public Folklore's Name," 57.

94. On the declining faith in objectivity in the sixties see Howard Brick, *The Age of Contradiction: American Thought and Culture in the 1960s* (London: Prentice Hall International, 1998), 24–42.

95. Ibid., 39.

96. Festival of American Folklife Presentation-Oriented Fieldwork Guidelines, n.d., box 3, folder "Old Ways . . . ," Acc. T90055, SIA; Ralph Rinzler, interview by Robert Cantwell, January 20, 1986, tape 6, SI-FP-1989-CT-0041, CFCH.

97. "Proposal, A Festival of American Folk Life, July 1–4, 1967," box 76, folder "Folklife Institute," RU 99, SIA.

98. Ralph Rinzler and Robert Sayers, *Meaders Family: North Georgia Potters* (Washington, D.C.: Smithsonian Institution Press, 1980); "Meaders Family: North Georgia Potters" (film) (Smithsonian, 1978).

99. American Folklife Conference abstract; "Proposal, A Festival of American Folk Life, July 1–4, 1967."

100. "Proposal for an American Folklife Institute," Feb. 8, 1968, box "History of Festival Documents," folder "1968 Papers," CFCH; Robert W. Mason to Participants in the Folklife Institute Discussion, Feb. 29, 1968, box "History of Festival Docs," folder "1968 Papers—Folklife Institute," CFCH.

101. S. Dillon Ripley, "The Folk Festival Program," in *Festival of American Folklife, 1968* (program), 3.

102. Archie Green, "P.L. 94-201—A View from the Lobby: A Report to the American Folklore Society," in *The Conservation of Culture,* 269–79.

103. Ralph Rinzler, "A Festival to Cherish Our Differences," *Festival of American Folklife, 1976* (program), 7.

104. Staff of the Division of Performing Arts, Smithsonian Institution, "Celebrating America's Folk Heritage," *International Educational and Cultural Exchange* X, no. 1 (Summer 1974): 28–29.

105. "Notes on meeting on Italian fieldwork in NYC," Dec. 13, 1974, box 3, folder "Old Ways," Acc. T90055, SIA.

106. See Dell Hymes, *Foundations in Sociolinguistics: An Ethnographic Approach* (Philadelphia: University of Pennsylvania Press, 1974); Jan H. Brunvand, ed., *Readings in American Folklore* (New York: W. W. Norton, 1979).

107. Rinzler, "A Festival to Cherish Our Differences."

108. "Report and recommendations from Alan Lomax subsequent to his observation of the 1975 festival and his continuing relationship as folklore consultant," Oct. 18, 1975, box 2, folder "Lomax, Alan," Acc. T90055, SIA.

109. Festival of American Folklife Presentation-Oriented Fieldwork Guidelines.

110. "Report on Sunday Jan. 26th Screening Held in N.Y.C.," box 3, folder "Old Ways . . . ," Acc. T90055, SIA.

111. "Fieldwork Guide—Regional America," n.d. [1974?], FP-027, folder "Fieldwork Manuals and Guides," CFCH.

112. "Interview report Form" (James Kinney Hulsey), Oct. 15, 1975, FP-027, folder "Participant Questionnaire," CFCH.

113. Festival of American Folklife, 1976 (program), 26.

114. Letter from Sarah Lewis, Folklife Programs, DPA, to Mrs. Thomas Hunter Farrow, Ellicott City, Md., Oct. 22, 1974, FP-019, folder "General Correspondence," CFCH. There are numerous letters similar to this one in the folklife center's archives. See, for example, Letter from William McNeil, administrator, Regional America, to Ms. Karen Skipp, Columbia, Md., Jan. 16, 1976, FP-027, folder "'76 Aspirants (Music)," CFCH.

115. Rayna Green, "Evaluation of the Festival of American Folklife, 1974," box 8, folder "FAF '74 Reports," Acc. T90055, SIA.

4. Inclusion or Separation?

1. Ripley, "Statement by the Secretary," in Smithsonian Year, 1968 (Washington: Smithsonian Institution, 1968), 3.

2. Ibid.

3. Manning Marable, Malcolm X: A Life of Reinvention (New York: Viking, 2011). On the debates with Rustin and Farmer, see 185–204.

4. The literature on Black Power has flowered in the past decade and has led to a wholesale reevaluation of this aspect of the black freedom struggle. For an overview of the field, see Peniel E. Joseph, "The Black Power Movement: A State of the Field," Journal of American History 96, no. 3 (Dec. 2009): 751–76.

5. Paul Chaat Smith and Robert Allen Warrior, Like a Hurricane: The Indian Movement from Alcatraz to Wounded Knee (New York: The New Press, 1996).

6. "The Making of a Museum," box 46, folder 2, Boorstin Papers, LOC. See also John Kinard and Esther Nighbert, "The Smithsonian's Anacostia Museum," Curator XI, no. 3 (1968): 190–205; Caryl Marsh, "A Neighborhood Museum That Works," Museum News 47, no. 2 (Oct. 1968): 11–16; and John R. Kinard and Esther Nighbert, "The Anacostia Neighborhood Museum, Smithsonian Institution, Washington, D.C.," Museum XXIV, no. 2 (1972): 103–9.

7. On the demographics of Smithsonian visitors, see Carolyn H. Wells, Smithsonian Visitor: A Survey Directed by Mrs. Carolyn H. Wells from October 1968 to October 1969 in the National Museum of History and Technology and the National Museum of Natural History, Smithsonian Institution (Washington, D.C.: Smithsonian Institution, 1970).

8. *Museums: Their New Audience* (Washington: American Association of Museums, 1972), 6.

9. Ibid., 8, 10.

10. Moresi, "Exhibiting Race, Creating Nation," 147.

11. In contrast, look at the controversy surrounding the Metropolitan Museum of Art's 1969 exhibition, "Harlem on My Mind." Dubin, *Displays of Power,* 29.

12. "The Making of a Museum," 3; Moresi, "Exhibiting Race, Creating Nation," 148.

13. "The Making of a Museum," section on exhibits.

14. "Anacostia Community Museum," SIA, http://siarchives.si.edu/history/exhibits/historic/anacost.htm.

15. "The Making of a Museum," 4–7.

16. Moresi, "Exhibiting Race, Creating Nation," 164–65; "Anacostia on Display," *Washington Post,* March 6, 1972, A20.

17. Keith E. Melder, "Social Issues and Historical Museums," attached to memorandum, Keith Melder to Silvio Bedini, April 17, 1968, box 3, folder "AR—Exhibit Proposals 1967–1974," RU 277, SIA.

18. William Yeingst and Lonnie Bunch, "Curating the Recent Past: The Woolworth Lunch Counter, Greensboro, North Carolina," in *Exhibiting Dilemmas,* ed. Henderson and Kaeppler, 144–45.

19. Frank A. Taylor for distribution through Charles Blitzer and Silvio Bedini, July 24, 1968, box 45, folder 10, Boorstin Papers, LOC. On Carroll Greene, see "A Greene Path to Journey's End," The Acacia Collection, www.acaciacollection.com/history3.html.

20. Peter C. Welsh to Silvio Bedini, March 10, 1969, box 45, folder 10, Boorstin Papers, LOC. See also Peter C. Welsh to Silvio Bedini, Feb. 4, 1969, and Silvio Bedini to Peter C. Welsh, Feb. 17, 1969, box 45, folder 10, Boorstin Papers, LOC.

21. Vernon C. Thompson, "Anacostia Museum Seeks New Status from Smithsonian," *Washington Post,* March 6, 1980, DC1; Leah Y. Latimer, "Anacostia Museum: A Mixture of City, National Culture," *Washington Post,* Sept. 22, 1982, DC3; *Hearings before a Subcommittee of the Committee on Appropriations, House of Representatives,* 100th Cong., 155–57 (March 22, 1988); Michael Welzenbach, "Lion of the Anacostia Museum: Director John Kinard and his Lifetime Mission of Conscience," *Washington Post,* July 19, 1989, D1; Patrice Gaines Carter, "Anacostia Honors Memory of a Man with a Mission," *Washington Post,* Aug. 12, 1989, B1; and John R. Kinard, interview by Anne M. Rogers, July 30, 1987, RU 9538, John R. Kinard Interview, SIA, 14–15 in transcript.

22. "Anacostia Community Museum."

23. "Anacostia Museum Seeks New Status"; *Hearings before a Subcommittee of the Committee on Appropriations, House of Representatives,* 101st Cong. 416–20 (March 16, 1989).

24. Indians of All Tribes, "Planning Grant Proposal to Develop an All-Indian University and Cultural Complex on Indian Land, Alcatraz," in *Great Documents in*

American Indian History, ed. Wayne Moquin with Charles Van Doren (New York: Da Capo Press, 1995), 374–79; Smith and Warrior, *Like a Hurricane,* 1–35, 60–83; Troy R. Johnson, *The Occupation of Alcatraz Island: Indian Self-Determination and the Rise of Indian Activism* (Urbana: University of Illinois Press, 1996); Philip Q. Yang, *Ethnic Studies: Issues and Approaches* (Albany, N.Y.: SUNY Press, 2000), 3–6. See also Novick, *That Noble Dream,* 469–521.

25. For general information on the Smithsonian Folklife Festival, see Richard Kurin, *Smithsonian Folklife Festival: Culture Of, By, and For the People* (Washington: Center for Folklife Programs and Cultural Studies, Smithsonian Institution, 1998).

26. George Horse Capture, "From the Reservation to the Smithsonian via Alcatraz," *American Indian Culture and Research Journal* 18, no. 4 (1994): 135–49.

27. Lonetree and Cobb, *The National Museum of the American Indian*—see, especially, Ira Jacknis, "A New Thing? The National Museum of the American Indian in Historical and Institutional Context," 3–42; Patricia Pierce Erikson, "Decolonizing the 'Nation's Attic': The National Museum of the American Indian and the Politics of Knowledge-Making in a National Space," 43–83; and Judith Ostrowitz, "Concourse and Periphery: Planning the National Museum of the American Indian," 84–130. See also Amanda J. Cobb, "The National Museum of the American Indian as Cultural Sovereignty," *American Quarterly* 57, no. 2 (2005): 485–506.

28. The phrase "a living exhibition" comes from S. Dillon Ripley, "The Folk Festival Program," *Festival of American Folklife, 1968* (program), 3.

29. For the "midway" comment, see [S. Dillon] Ripley to Mr. [James] Bradley, memorandum, June 27, 1967, box 76, "Folklife Festival," RU 99, SIA.

30. Robert F. Berhofer Jr., "White Conceptions of Indians," and Rayna Green, "The Indian Popular American Culture," in *Handbook of North American Indians,* vol. 4, *History of Indian-White Relations,* ed. William C. Sturtevant (general editor) and Wilcomb E. Washburn (series editor) (Washington: Smithsonian Institution, 1988), 522–47, 587–606. See also Philip J. Deloria, *Playing Indian* (New Haven: Yale University Press, 1998).

31. Thomas W. Cowger, *The National Congress of American Indians: The Founding Years* (Lincoln: University of Nebraska Press, 1999); Christopher K. Riggs, "American Indians, Economic Development, and Self-Determination in the 1960s," *Pacific Historical Review* 69, no. 3 (Aug. 2000): 436.

32. Smith and Warrior, *Like a Hurricane,* 42–46; Paul McKenzie-Jones, "'We are among the poor, the powerless, the inexperienced and the inarticulate': Clyde Warrior's Campaign for a 'Greater Indian America,'" *American Indian Quarterly* 34, no. 2 (Spring 2010): 224–57.

33. Rachel A. Bonney, "The Role of AIM Leaders in Indian Nationalism," *American Indian Quarterly* 3, no. 3 (Autumn 1977): 209–24; Russell Means with Marvin J. Wolf, *Where White Men Fear to Tread: The Autobiography of Russell Means* (New York: St. Martin's Press, 1995), 149–393; Smith and Warrior, *Like a Hurricane,* vii–ix.

34. Vine Deloria Jr., *Custer Died for Your Sins: An Indian Manifesto* (New York: Macmillan, 1969), 13. The 1970 census recorded 827,000 American Indians, Eskimos,

and Aleuts in the United States. By 1990, this number had reached almost 2 million. Edna L. Paisano, "The American Indian, Eskimo, and Aleut Population," United States Census Bureau. See also Gary D. Sandefur, Ronald R. Rindfuss, and Barney Cohen, eds., *Changing Numbers, Changing Needs: American Indian Demography and Public Health* (Washington, D.C.: National Academy Press, 1996); "American Indian and Alaska Native Areas," United States Census Bureau, www.census.gov/geo /www/GARM/Ch5GARM.pdf.

35. Smith and Warrior, *Like a Hurricane*, 124.

36. Deloria, *Custer Died for Your Sins*, 213.

37. Ibid., 224.

38. Heather A. Diamond and Ricardo D. Trimillos, "Introduction: Interdisciplinary Perspectives on the Smithsonian Folklife Festival," *Journal of American Folklore* 121, no. 479 (Winter 2008): 5.

39. *Hatch Act of 1939*, Pub. L. No. 76-252, http://en.wikisource.org/wiki/Hatch _Political_Activity_Act.

40. On the politics of space on the National Mall and the phrase "monumental core," see Kirk Savage, *Monument Wars: Washington, D.C., the National Mall, and the Transformation of the Memorial Landscape* (Berkeley: University of California Press, 2009).

41. Judy Scott Feldman, "Turning Point: The Problematics of Building on the Mall Today," in *The National Mall*, 136.

42. For lists of participants see festival programs, CFCH. The 1967 festival included approximately twelve Native singers, dancers, and craftspeople—among them were Marie Chino, an Acoma potter, Mrs. Ambrose Roanhorse, a Navajo rug weaver, and Mr. and Mrs. Jochim Koyuk, King Island Eskimo dancers. Alongside these Native participants were approximately one hundred other cultural practitioners of all races from twenty-three different states. At the festival, for example, Marie Chino demonstrated her skills along with Mr. and Mrs. Norman Miller, white potters from Alabama; while Mrs. Ambrose Roanhorse wove rugs and Taft Greer, a white man from Tennessee, practiced overshot weaving.

43. Discussion of Festival (FAFs '67–'69) (Ralph and Kate Rinzler with Tony Seeger); Rinzler, interview by Cantwell, tape 6.

44. Ibid.

45. Festival Recordings: Grandpa Jones; Lummi Indians, July 5, 1968, FP-1968-RR-0022, CFCH.

46. Discussion of Festival (FAFs '67–'69) (Ralph and Kate Rinzler with Tony Seeger); Rinzler, interview by Cantwell, tape 6.

47. Clydia Nahwooksy, telephone interviews by author, Aug. 18 and 26, 2006, RU 9619, SIA.

48. Festival History De-briefing with Rinzler, Kalcik, Vennum, McCarl, Proschan, Holt, Dec. 6, 1976, FP-1988-CT-0647-0649, CFCH; Nahwooksy, interviews.

49. Nahwooksy, interviews. It is important to note that Reaves later legally changed his name from Nahwooksy to Nahwooks, the spelling that his grandfather had used. Clydia retained the spelling Nahwooksy.

50. Smith and Warrior, *Like a Hurricane,* 47–51; Letter (with enclosed newspaper clipping) from Pauline H. Blum, secretary, Mid-America All-Indian Center, Inc., Wichita, Kansas, to Clydia Nahwooksy, Feb. 21, 1970, FP-121, folder "Letters and Memos FAF '70," CFCH.

51. Smith and Warrior, *Like a Hurricane,* 159–60.

52. Cleve Mathews, "Indian Is Named to Indian Bureau," *New York Times,* Aug. 8, 1969, 16; "A Voice for the Indian: Louis Rooks Bruce, Jr.," *New York Times,* Aug. 8, 1969, 16; Smith and Warrior, *Like a Hurricane,* 146; Joseph H. Cash, "Louis Rooks Bruce, 1969–73," in *The Commissioners of Indian Affairs,* ed. Robert M. Kvasnicka and Herman J. Viola (Lincoln: University of Nebraska Press, 1979), 333–40.

53. San Stanley, program coordinator, Center for the Study of Man, to S. Dillon Ripley, July 31, 1970, box "History of Festival Documents," folder "Historic Documents," CFCH.

54. Blum to Nahwooksy.

55. Minutes of National Council on Indian Awareness meeting, Jan. 12–15, 1970, FP-121, folder "Letters and Memos FAF '70," CFCH.

56. James R. Morris to William Warner, Nov. 5, 1969, box 10, folder "Folklife Fest 1969," RU 145, Smithsonian Institution, Assistant Secretary for Public Service, Subject Files, SIA.

57. Discussion of Festival (FAFs '67–'69) (Ralph and Kate Rinzler with Tony Seeger).

58. John C. Ewers, "The Emergence of the Plains Indian as the Symbol of the North American Indian," in *Annual Report of the Board of Regents of the Smithsonian Institution, 1964* (Washington: United States Government Printing Office, 1965), 531–44.

59. *Festival of American Folklife, 1968* (program).

60. Tom O'Brien, "Genuine Indians," *Washington Post,* July 2, 1970, E1, E2.

61. Clydia Nahwooksy, quoted in O'Brien, "Genuine Indians."

62. *Festival of American Folklife, 1970* (program), 24–25.

63. *Festival of American Folklife, 1968* (program).

64. Festival Recordings: Indian Crafts Workshop; Indian Rights Workshop, July 3, 1970, FP-1970-RR-0077, CFCH. This is most likely the Thomas Tointigh who is identified in the festival program.

65. Ibid.

66. Ibid.

67. *Festival of American Folklife, 1970* (program), 22.

68. On Browning Pipestem, see William Greider, "Hickel Asks Legal Unit to Back Indian Claims," *Washington Post,* Sept. 22, 1970, A2; William Greider, "Uprising in the Indian Agency," *Washington Post,* Aug. 1, 1971, 1.

69. Festival Recordings: Indian Crafts Workshop; Indian Rights Workshop.

70. "Apostle Islands National Lakeshore," *Washington Post,* Oct. 5, 1970, A20; Loretta V. Ellis, "Letter to the Editor: Indian View of Park," *Washington Post,* Oct. 9, 1970, A27.

71. *Beneath the Wings of an Eagle* (video), a WRC-TV Community Affairs Presentation of NBC in Washington, CFCH.

72. Clydia Nahwooksy to William Warner, with attached overview of Indian Awareness program, Jan. 20, 1971, box 11, folder "Division of Performing Arts," RU 367, SIA; "Smithsonian Sets Up Program to Promote Indian Awareness" (press release), box 1, folder "Indian Awareness Program," RU 367, SIA.

73. Memorandum for the Record, Subject: Indian Awareness Program—BIA Contract, May 11, 1971, box 11, folder "Division of Performing Arts," RU 367, SIA.

74. Clydia Nahwooksy, quoted in Earl Arnett, "Smithsonian to Sponsor Indian Awareness Program," *Baltimore Sun*, May 17, 1971, B1.

75. Clydia Nahwooksy, quoted in Aileen Jacobson, "Folklife-Indian Style," *Washington Post*, July 5, 1971, D1, D3.

76. Festival Recordings: Panel Discussion, Alaskan Land Claims part 1, July 1, 1971, FP-1971-RR-0098, CFCH.

77. For more background on Paddock and Borbridge see "Central Council, Tlingit and Haida Indian Tribes of Alaska, www.ccthita.org/about/history/pastpresidents .html. See also LaDonna Harris, *LaDonna Harris: A Comanche Life* (Lincoln: University of Nebraska Press, 2000).

78. Spencer Rich, "Alaska Land Settlement Plan Told," *Washington Post*, Feb. 19, 1969, C10; "Our Neglected Alaskan Natives," *Washington Post*, May 6, 1969, A18; "The Alaskan Natives," *Washington Post*, Sept. 18, 1969, A18; Phillip D. Carter, "Senate Backs $1 Billion Alaska Native Payment," *Washington Post*, July 16, 1970, A4; Carroli Kilpatrick and Elsie Carper, "Nixon Asks Big Settlement of Alaskan Natives' Claims," *Washington Post*, April 7, 1971, A3; "Land for Alaska's Natives," *Washington Post*, May 4, 1971, A16; "This Land Is Our Life," *Washington Post*, Nov. 13, 1971, A14; Elsie Carper, "Alaskan Native Land Payment Passed," *Washington Post*, Dec. 15, 1971, A3.

79. Paul C. Rosier, "'They Are Ancestral Homelands': Race, Place, and Politics in Cold War Native America, 1945–1961," *Journal of American History* 92, no. 4 (March 2006): 1300–1326.

80. Festival Recordings: Panel Discussion; termination Part 1, July 2, 1971, FP-1971-RR-0105, CFCH.

81. Festival Recordings: Laguna Dances; Women in the Indian Community; Southwest Cooking, July 4, 1972, FP-1972-RR-0113, CFCH.

82. Festival Recordings: Dance Music, July 2, 1971, FP-1971-RR-0101, CFCH. Because this and other statements from the festival have not been published elsewhere, I have included long quotations taken from my transcriptions of the original sound recordings. I felt that it was important to hear the participants in their own words, so I have not corrected grammar or regularized figures of speech.

83. Ibid.

84. Festival Recordings: Panel Discussion; Indian Organizations part 1, July 3, 1971, FP-1971-RR-0107, CFCH.

85. Smith and Warrior, *Like a Hurricane*, 142, 149–65; Vine Deloria Jr., *Behind the Trail of Broken Treaties: An Indian Declaration of Independence* (New York: Delacorte Press, 1974).

86. Smith and Warrior, *Like a Hurricane,* 202–71.

87. Ibid., 159; Nahwooksy, interviews; Thomas Kavanagh, telephone interview by author, Nov. 3, 2008, RU 9619, SIA.

88. Festival Recordings: Cultural Programs Workshop, 1972, FP-1972-RR-0107, CFCH.

89. Memo (with attached proposal) from Tom Kavanagh to Julian Euell, Feb. 1973, box 1, folder "Indian Awareness Program," RU 367, SIA; Cash, "Louis Rooks Bruce," 338; Jack Anderson, "Indian Bureau Chief Is Outflanked," *Washington Post,* Dec. 14, 1972, K15; Internal Division of Performing Arts Memo, Nov. 20, 1975, FP-122, folder "Funding Sources," CFCH. According to this memo, Indian Awareness asked for $56,085 in 1973 and got nothing.

90. Final Report—Indian Awareness Program, Sept. 21, 1971, FP-015, folder "Final Reports," CFCH; Indian Awareness Program Final Report, 1972–1973, box 1, folder "Indian Awareness Program," RU 367, SIA.

91. "First draft of letter thru JRM, J Euell to Mr. Ripley re Indian participation FAF '73," [March 23?] 1973 FP-123, folder "Indian Awareness Panels," CFCH.

92. Ibid.

93. *Festival of American Folklife, 1973* (program).

94. Festival Recordings: Mandan, Hidasa, Arickara Day, July 6, 1973, FP-1973-RR-0151, CFCH.

95. Festival Recordings: Mandan, Hidasa, Arickara Day, July 1973, FP-1973-RR-0157, CFCH.

96. Festival Recordings: Panel Discussion with Mr. Bruce, Ada Deer, Louis LaRosa and Reaves Nahwooksy, 1973, FP-1973-RR-0162, CFCH.

97. "Former National Ministries Board Member Clydia Nahwooksy Dies," *American Baptist News Service,* Jan. 20, 2010; "Reaves Fred Nahwooksy," SiskiyouDaily. com, Oct. 6, 2009.

98. Kavanagh, interview.

99. Synopsis of N.A.A.G. Meeting Discussions and Decisions, Oct. 18 and 19, 1974, box 3, folder "Native Americans" [1], Acc. T90055, SIA.

100. A report on Field Survey Trip to the Six Nations Communities of New York State, Dec. 2–16, 1974, box 16, folder "Old Ways in the New World," Acc. T90055, SIA; Kavanagh, interview.

101. Native Americans Advisory Group Meeting, Jan. 11, 1975, FP-005, folder "NAAG Meeting 1976," CFCH.

102. Resolution, Oklahoma Plains Apache Tribe, March 26, 1976, FP-124, folder "NA Proposal Book Part I," CFCH.

103. Native American Learning Center Tapes, CFCH.

104. Boris Weintraub, "Indians Make It to Center Stage: Folklife Festival Lets Native Americans Break the Stereotypes," *Washington Star,* n.d., box 14, folder "Press and Clippings 1," Acc. T90055, SIA. See also "Dennis Sun Rhodes—Professional Resume," http://greathorsegroup.com/node/19/.

105. Native American Learning Center Tapes, CFCH.

106. Native American Learning Center Tapes, July 5, 1976, SI-DPA-NA-77-306.18, CFCH. See also Kelly Haney's personal website, www.kellyhaney.com.

107. Native American Learning Center Tapes, Aug. 25, 1976, SI-DPA-NA-77-322.03, CFCH.

108. Native American Learning Center Tapes, Aug. 11, 1976, SI-DPA-NA-77-318.02, CFCH.

5. Finding National Unity through Cultural Diversity

1. Kevin P. Phillips, "President Should Consider Festival of U.S. Folklife and History for '76," *Washington Post*, July 10, 1970, A19.

2. Phillips wrote, for example, "For a century, the prevailing cleavages in American voting behavior have been ethnic and cultural. Politically, at least, the United States has not been a very effective melting pot." And "Substantial Negro support is not necessary to national Republican victory in light of the 1968 election returns. Obviously, the GOP can build a winning coalition without Negro votes." Kevin P. Phillips, *The Emerging Republican Majority* (New Rochelle, N.Y.: Arlington House, 1969), 39–40, 468.

3. James T. Patterson, *Restless Giant: The United States from Watergate to Bush v. Gore* (New York: Oxford University Press, 2005), 13–107. See also Bruce J. Schulman, *The Seventies: The Great Shift in American Culture, Society, and Politics* (New York: Da Capo Press, 2002); David Farber, "The Torch Had Fallen," in *America in the Seventies*, ed. Beth Bailey and David Farber (Lawrence: University Press of Kansas, 2004), 9–28; Christopher Capozzola, "'It Makes You Want to Believe in the Country': Celebrating the Bicentennial in an Age of Limits," in *America in the Seventies*, 29–49; William Graebner, "America's *Poseidon Adventure*: A Nation in Existential Despair," in *America in the Seventies*, 157–80; and Lyn Spillman, "Imagining Community and Hoping for Recognition: Bicentennial Celebrations in 1976 and 1988," *Qualitative Sociology* 17, no. 1 (Spring 1994): 3–29.

4. On the politics of race and ethnicity during the 1970s, see Thomas J. Sugrue and John D. Skrentny, "The White Ethnic Strategy," in *Rightward Bound: Making America Conservative in the 1970s*, ed. Bruce J. Schulman and Julian E. Zelizer (Cambridge: Harvard University Press, 2008), 171–92; and Patterson, *Restless Giant*, 15–32. On the challenges of presenting difficult issues at the festival, see Diamond and Trimillos, "Introduction: Interdisciplinary Perspectives on the Smithsonian Folklife Festival," 5.

5. Matthew Frye Jacobson, *Roots Too: White Ethnic Revival in Post–Civil Rights America* (Cambridge: Harvard University Press, 2006), 56.

6. *The Bicentennial of the United States of America: A Final Report to the People*, vol. 1 (Washington, D.C.: American Revolution Bicentennial Administration, 1977), 9.

7. Christopher Lasch, *The Culture of Narcissism: American Life in an Age Diminishing Expectations* (New York: W. W. Norton, 1979), 4–5. My idea of therapeutic pluralism is also influenced by T. J. Jackson Lears's argument that a therapeutic antimodernism

emerged in fin de siecle American culture, which, he argues, helped Americans ease their transition from an ordered, tradition-bound society into a modern, commercial society. T. J. Jackson Lears, *No Place of Grace: Antimodernism and the Transformation of American Culture, 1880–1920* (1981; Reprint, Chicago: University of Chicago Press, 1994), xi–xii. Here, I modify Lears's idea to suggest that a therapeutic conceptualization of diversity developed in the Bicentennial era, which eased people's anxiety over persistent cultural differences in American society.

8. The other major Bicentennial exhibitions were *We the People* in the Museum of History and Technology, which focused on American political history, and *1876: A Centennial Exhibition* in the Arts and Industries Building, which was a partial reconstruction of the displays at the Philadelphia Centennial Exhibition.

9. Ralph Rinzler, "A Festival to Cherish Our Differences," *Festival of American Folklife, 1976* (program), 7.

10. David Whisnant to Ralph Rinzler, August 27, 1973, FP-017, folder "Report FAF 1973," CFCH.

11. *Bicentennial Source Book* (Washington, D.C.: Hawkins and Associates, Inc., 1973), I-1; Susan Dworkin, "The Bicentennial: Is It Slowly Sinking into the Potomac?" *Ms.*, July 1974, 47.

12. Spilman, "Imagining Community," 6; Capozzola, "It Makes You Want to Believe," 31–32. The chairmen of the ARBC were: Carlisle Humelsine (1967–1969), Dr. J. E. Wallace Sterling (1969–1970), and David J. Mahoney (1970–1973). *Bicentennial Final Report*, vol. 1, 240–44.

13. Donald Janson, "76 Fair Disputed in Philadelphia," *New York Times*, April 11, 1971, 38; Edwin C. Hutter, "Letter to the Editor: Bicentennial Plan: POLIS '76," *New York Times*, Nov. 20, 1971, 30; Donald Janson, "Philadelphia Gets Deadline for Bicentennial Plan," *New York Times*, Feb. 11, 1972, 8; Donald Janson, "Vote by '76 Panel Perils a U.S. Expo," *New York Times*, May 17, 1972, 1; and Julius Duscha, "An American Tragicomedy," *Saturday Review*, July 1, 1972, 28–33.

14. Jill Lepore, *The Whites of Their Eyes: The Tea Party's Revolution and the Battle over American History* (Princeton: Princeton University Press, 2010), 117–18.

15. Capozzola, "It Makes You Want to Believe," 39–43; Margot Hornblower, "Bicentennial Fever Spreads Across U.S.," *Washington Post*, Feb. 16, 1975, 1.

16. "Grass Roots Were Heart of Observance," *Bicentennial Times*, American Revolution Bicentennial Administration (ARBA), December 1976, 1, 4.

17. "Bicentennial America Was a Nation of Participants," *Bicentennial Times*, Dec. 1976, 2.

18. *The Birthday Party*, prod. and dir. Joseph L. Gyovai, 26 min., National Park Service, 1976, videocassette. Motion Picture, Sound, and Video Records LICON, National Archives at College Park, call number 452.17.

19. Patterson, *Restless Giant*, 69.

20. "Black History, Contributions Brought into Sharp Focus during Bicentennial," *Bicentennial Times*, Dec. 1976, 13.

21. *The Birthday Party*.

22. On the Afro-American Bicentennial Corporation, see United States Senate Committee on the Judiciary, Subcommittee on Federal Charters, Holidays, and Celebrations, *Legislative Oversight Hearings on the Programs and Activities of the American Revolution Bicentennial Commission, August 1 and 2, 1972,* 92nd Cong. 483–88 (1972). The quotation comes from 485 and 487.

23. On the Peoples Bicentennial Commission, see Lepore, *The Whites of Their Eyes,* 65, 72, 84. The Rifkin quotation comes from 65.

24. In 1974, Congress replaced the ARBC with the American Revolution Bicentennial Administration (ARBA). *The Bicentennial of the United States of America: A Final Report to the People,* vol. 2 (Washington, D.C.: American Revolution Bicentennial Administration, 1977), 9.

25. *Legislative Oversight Hearings on the Programs and Activities of the American Revolution Bicentennial Commission, August 1 and 2, 1972,* 16.

26. The African American members of the ARBC that I was able to identify were Ralph Ellison, Sen. Edward W. Brooke, president of Tuskegee Dr. Luther Foster, Roy Lavon Brooks, Vernon Jordan, and Charley Pride. *Bicentennial Final Report,* vol. 1, 10–12.

27. *Legislative Oversight Hearings on the Programs and Activities of the American Revolution Bicentennial Commission, August 1 and 2, 1972,* 5, 499.

28. *Bicentennial Final Report,* vol. 2, 22, 32–35. The Racial, Ethnic and Native American Advisory Committee consisted of nine members of non-Hispanic European ancestry, as well as four American Indian members, four Asian members, four Hispanic members, three black members, and one Pacific Islander member. Another advisory group, the National Bicentennial Ethnic/Racial Alliance, broke down along ethnic and racial lines in this way: non-Hispanic European 21 (30%), Jewish 1, Black 5 (7%), Asian 5 (7%), American Indian 4 (6%), Hispanic 1, Other/Unclear Affiliation 32 (47%).

29. "Ethnic America: Not a Melting Pot but a Salad Bowl," *Bicentennial Times,* Dec. 1976, 11, 13. Thirty-two (11%) of ARBA's 284 "Recognized Programs" showcased ethnic or racial groups. Of the total number of Bicentennial activities recorded by ARBA (64,338), 1,012 (1.5%) were directed toward blacks, 1,703 (2.6%) toward "Ethnic, Other," 331 (.5%) toward Mexican Americans, 1,041 (1.6%) toward Native Americans, 141 (.2%) toward Asians, and 291 (.4%) toward "Spanish-Speaking, Other." According to ARBA, overall 4,694 (7%) of Bicentennial activities were considered by their sponsors to be applicable to "Folk/Ethnic/Minority Culture." *Bicentennial Final Report,* vol. 2, 153–86, 261, 263.

30. "Ethnic America: Not a Melting Pot but a Salad Bowl," 11.

31. Howard R. Jerry III, "Spirit of '76 Bicentennial Pros & Cons," *The Skanner* (Portland, Ore.), July 1, 1976, 13.

32. Clarence Johnson, "BYE-BICENTENNIAL 1976: Painted White from the Start," *Sun Reporter* (San Francisco), Jan. 6, 1977, 6.

33. Bicentennial Meeting with DPA staff, July 30, 1972, tape 1, FP-1972-RR-0127, Festival Recordings, CFCH. The following is a partial list of attendees: Clydia

Nahwooksy, Lee Motah [sp?], Thomasine Hill, Sandy McNabb, Al Elgin, Ada Deer, Benjamin Labobe [sp?], Joseph Tomah [sp?], Ernest Stevens, Charles Blitzer, David Hansen, Harlowe Dean, James Morris, LaDonna Harris, Abby Watkins, Tom Kavanagh, Russell Means, and Ted Means.

34. *Legislative Oversight Hearings on the Programs and Activities of the American Revolution Bicentennial Commission, August 1 and 2, 1972,* 533–36.

35. Ibid., 534.

36. "To ask Indians to help us celebrate this Bicentennial is akin to asking the Japanese to share in celebrating the historical technical advance inherent in Hiroshima," *Akwesasne Notes,* Aug. 31, 1975, 36; "Indian Children Take Vote and Decide 'Yes' for Bicen," *Bicentennial Times,* Oct. 1976, 5; "Bicen Stirred New Perception of Native Americans," *Bicentennial Times,* Dec. 1976, 12.

37. "Stillaguamish and Siletz Try to Reverse Termination Nightmare," *Akwesasne Notes,* June 30, 1976, 29; Andrew H. Malcolm, "Wagon Train Gets Under Way on New Year's Trip to Valley Forge," *New York Times,* June 16, 1975, 37.

38. "Trail of Self-Determination Caravan Heads Toward U.S. Capital in Serious Effort to Bring Changes," *Akwesasne Notes,* June 30, 1976, 28.

39. "Indians Bar Train Attack," *New York Times,* June 22, 1975, 46.

40. "Human Historian," *Washington Post,* Jan. 28, 1969, B2.

41. Daniel J. Boorstin, *The Decline of Radicalism: Reflections on America Today* (New York: Random House, 1969), 123.

42. Ibid., 128, 133. It is ironic that Boorstin defended communism here since he had testified against alleged communists before the House Committee on Un-American Activities sixteen years earlier. A member of the Communist Party for a brief period in the late thirties, Boorstin had been a cooperative witness, who denounced communism and provided the committee with information about other Party members. Novick, *That Noble Dream,* 327–28.

43. Reply to Dillon Ripley Toast, by Daniel J. Boorstin, Sept. 30, 1969, box 43, folder 8, Boorstin Papers, LOC.

44. Daniel J. Boorstin to S. Dillon Ripley and Charles Blitzer, April 27, 1969, box 46, folder 5, Boorstin Papers, LOC.

45. Daniel J. Boorstin to S. Dillon Ripley and Charles Blitzer, May 5, 1969, box 7, folder "ANON-Bicent. 1969–1973," RU 331, National Museum of History and Technology, Dept. of Cultural History, Records, SIA.

46. Ibid.

47. Nathan Glazer, conversation with author, Jan. 24, 2007. Chermayeff, Geismar & Associates also designed the official Bicentennial logo.

48. Nathan Glazer and Daniel Patrick Moynihan, *Beyond the Melting Pot: The Negroes, Puerto Ricans, Jews, Italians, and Irish of New York City* (Cambridge: The M.I.T. Press and Harvard University Press, 1963), 1–23.

49. Alexander Bloom, *Prodigal Sons: The New York Intellectuals and Their World* (New York: Oxford University Press, 1986), 3–8, 331–32.

50. Nathan Glazer, *Affirmative Discrimination: Ethnic Inequality and Public Policy*

(1975; 2nd edition, Cambridge: Harvard University Press, 1987), 196–201, quotation from 197.

51. Ibid., 198, 201.

52. Dennis A. Deslippe, "'Do Whites Have Rights?' White Detroit Policemen and 'Reverse Discrimination' Protests in the 1970s," *Journal of American History* 91, no. 3 (Dec. 2004): 932–60.

53. Glazer, *Affirmative Discrimination*, 5.

54. Ibid., 3.

55. Ibid., x.

56. Ibid., 7.

57. "A People of Peoples—An Exhibition on the American Nation at the Smithsonian Institution, National Museum of History and Technology for the Bicentennial Year," June 28, 1972, box 1, folder "Bicent.—1973," Acc. T90055, SIA.

58. The exhibition design was Ivan Chermayeff's. Nathan Glazer, conversation with author, Jan. 24, 2007.

59. "A People of Peoples."

60. "A People of Peoples."

61. "A People of Peoples."

62. C. Malcolm Watkins to Harold Skramstad, Feb. 5, 1973, box 7, folder "ANON-Bicentennial 1969–1973," RU 331, SIA.

63. Carl H. Scheele to Silvio A. Bedini, Feb. 11, 1971, box 1, folder "Exhibition Script Development," Acc. 06-163, National Museum of American History, Division of Community Life, Exhibition Records, SIA.

64. C. Malcolm Watkins to Silvio Bedini, Sept. 17, 1971, box 7, folder "ANON-Bicent. 1969–1973," RU 331, SIA.

65. Scheele to Bedini, Feb. 11, 1971.

66. Nation of Nations, Comments by Committee, April 18, 1973, box 45, folder 15, Boorstin Papers, LOC. See also Carl H. Scheele to All people in the Department of Applied Arts, April 3, 1973, box 1, folder "Exhibition Script Development (Section 1) 1972–1976," Acc. 06-163, SIA.

67. Jacobson, *Roots Too*, 64 (emphasis in original).

68. Watkins to Skramstad, Feb. 5, 1973.

69. Daniel Boorstin to S. Dillon Ripley, Oct. 24, 1975, box 43, folder 8, Boorstin Papers, LOC.

70. Press Release, Historian Brooke Hindle Appointed Director, National Museum of History and Technology, Sept. 25, 1973, box 27, folder 14, Boorstin Papers, LOC.

71. The committee consisted of Carl H. Scheele, Bernard S. Finn (curator of electricity), Ellen Roney Hughes (coordinator in the Division of Community Life), Harold D. Langley, Otto Mayr, Richard S. Virgo (chief of design), C. Malcolm Watkins, Peter C. Marzio, John H. White Jr., Richard E. Ahlborn, and Grace R. Cooper. Fact Sheet for *A Nation of Nations*, March 22, 1976, box 3, folder News Releases, 1976, Acc. 06-163, SIA.

72. Exhibits Committee to Silvio Bedini, Oct. 19, 1973, box 1, folder Exhibition Script Development (Section 1) 1972–1976, Acc. 06-163, SIA.

73. Carl H. Scheele to Brooke Hindle, Feb. 10, 1974, box 1, folder Exhibition Script Development (Section 1) 1972–1976, Acc. 06-163, SIA.

74. Carl H. Scheele to All Divisions NMHT, March 6, 1974, box 1, folder Exhibition Script Development (Section 1) 1972–1976, Acc. 06-163, SIA; Script Outline, Oct. 1974, box 1, folder Exhibition Script Development (Section 1) 1972–1976, Acc. 06-163, SIA.

75. Script Outline, Oct. 1974.

76. Richard Ahlborn to Charles Blitzer, Oct. 8, 1974, box 1, folder Exhibition Script Development (Section 2) 1972–1976, Acc. 06-163, SIA.

77. Interestingly, historians in the late twentieth century and early twenty-first century have examined this very issue in great detail and have determined that it is possible, if challenging, to determine the origins of at least some of the enslaved African populations in the Americas. Such research was not available in the 1970s, however, and even the conclusions that contemporary historians have drawn are often speculative.

78. Wilbur Zelinsky to John Grady (Chermayeff, Geismar & Associates), Aug. 24, 1975, box 1, folder Exhibition Script Development (Section 2) 1972–1976, Acc. 06-163, SIA.

79. Labels for Specimens in "A Nation of Nations," box 1, folder Exhibition Script Development (Section 2) 1972–1976, Acc. 06-163, SIA.

80. Carl H. Scheele, chairman, ANON, to Susan Hamilton, Nov. 17, 1975, box 9, folder "NMHT 1972–1976," RU 337, Smithsonian Institution, Assistant Secretary for History and Art, American Revolution Bicentennial Records, SIA.

81. "How the Smithsonian Institution Melts Our Ethnics: A short survey of the long catalog for some reason called 'A nation of nations.'" From the Polish American Press Council, April 24, 1976, box 4, folder Public Comments, 1976–1977, Acc. 06-163, SIA; Christian F. Rendeiro to S. Dillon Ripley, Sept. 15, 1976, box 4, folder Public Comments, 1976–1977, Acc. 06-163, SIA.

82. Carl H. Scheele to Brooke Hindle, "List of persons who contributed major efforts to preparation of ANON," June 23, 1976, box 1, folder Exhibition Script Development (Section 1) 1972–1976, Acc. 06-163, SIA.

83. Fact Sheet for A Nation of Nations.

84. C. Malcolm Watkins to Mr. Lynford E. Kautz, Director Office of Development, June 24, 1974, box 7, folder "ANON-Bicent. 1974–78," RU 331, SIA.

85. Richard E. Ahlborn to Brooke Hindle, July 8, 1974, box 7, folder "ANON-Bicent. 1974–78," RU 331, SIA.

86. William C. Sturtevant, "Anthropology, History, and Ethnohistory," Ethnohistory 13, no. 1/2 (1966): 1–51; Shephard Krech, "From Ethnohistory to Anthropological History," in Anthropology, History, and American Indians: Essays in Honor of William Curtis Sturtevant, Smithsonian Contributions to Anthropology, no. 44, ed. William L. Merrill and Ives Goddard (Washington: Smithsonian Institution

Press, 2002), 85–90; Jason Baird Jackson, "William C. Sturtevant," Museum Anthropology, http://museumanthropology.blogspot.com/2007/03/william-c-sturtevant-1926-2007.html; William L. Merrill, "William Curtis Sturtevant, Anthropologist," www.sturtevant.com/wcs/william_curtis_sturtevant_anthropologist.html.

87. Wilcomb E. Washburn, *The Governor and the Rebel: A History of Bacon's Rebellion in Virginia* (Chapel Hill: University of North Carolina Press, 1957); Wilcomb E. Washburn, "Ethnohistory: History 'In the Round,'" *Ethnohistory* 8, no. 1 (1961): 31–48; Wilcomb E. Washburn, *The Indian in America* (New York: Harper and Row, 1975).

88. Scheele to Hindle, "List of persons who contributed major efforts to preparation of ANON."

89. Fact sheet for *A Nation of Nations*.

90. Jean M. White, "Nation of Nations, from 6,000 Perspectives," *Washington Post*, June 9, 1976, C1.

91. The following description of *A Nation of Nations* is based on photographs of the exhibit in box 1, folder Installation Photographs, 1976, Acc. 06-163, SIA, as well as the Fact Sheet for *A Nation of Nations* and *A Nation of Nations*, companion to slide show that included eighty slides of objects from the exhibit, box 3, folder Exhibition Brochure and Publications, 1976, Acc. 06-163, SIA.

92. "Akan Drum," The British Museum, www.britishmuseum.org/explore/highlights/highlight_objects/aoa/a/akan_drum.aspx.

93. *A Nation of Nations* press release, n.d., box 9, folder "NMHT 1972–1976," RU 337, SIA.

94. Robert L. Tripp to Brooke Hindle, Jan. 7, 1977, box 4, folder Public Comments, 1976–1977, Acc. 06-163, SIA.

95. Arabella Sparnon to Carl H. Scheele, June 13, 1976, box 4, folder Public Comments, 1976–1977, Acc. 06-163, SIA.

96. James R. Morris, director, DPA, to John Slocum, August 5, 1969, box 1, folder "Bicent.—'71," Acc. T90055, SIA.

97. "Labor Awareness: A Six-Year Program Proposal to the AFL-CIO by the Smithsonian Institution at the Festival of American Folklife 1971–1976 Culminating at the Bicentennial Celebration," Jan. 5, 1971, FP-017, folder "Working Americans '72," CFCH; Letter from Lane Kirkland, secretary-treasurer, AFL-CIO, to union members, Feb. 2, 1971, FP-017, folder "Working Americans '72," CFCH.

98. Smithsonian Institution Festival of American Folklife: A Bicentennial Presentation, box 9, folder "1975 A.D. Publicity," Acc. T90055, SIA.

99. Preliminary Proposal to American Revolution Bicentennial Commission, April 9, 1973, box 1, folder "Bicent. Memos/Corresp. FY 75/76," Acc. T90055, SIA.

100. See festival programs for details on festivals in the early seventies. The Bicentennial festival also included a program area called "Transportation," which was essentially a subset of "Working Americans."

101. "Smithsonian Institution Festival of American Folklife: A Bicentennial Presentation."

102. "A Proposal—African Diaspora: A Folklife Festival Concept (1974)," Division of Performing Arts, Smithsonian Institution, Dec. 1973, box 1, folder "DPA/FLF 1973–1974, RU 367, SIA.

103. Archie Green, "Industrial Lore: A Bibliographic-Semantic Query," in *Working Americans: Contemporary Approaches to Occupational Folklife,* ed. Robert H. Byington (Los Angeles: California Folklore Society, 1978), 71–102.

104. *Festival of American Folklife, 1976* (program).

105. "Smithsonian Institution Festival of American Folklife: A Bicentennial Presentation."

106. "Minutes of Program Coordinators and Festival Staff Meeting, February 5, 1975," FP-027, folder "Program Coordinators Meetings RA 75," CFCH.

107. Ruth Jordan to Program Coordinators, Feb. 5, 1975, box 8, folder "African Diaspora: Correspondence, Memos, Minutes," Acc. T90055, SIA.

108. "Field Report," Robert McCarl, FP-046, folder "WA Chron File 10/1/73–12/1/75 2 of 4," CFCH; Letter from Robert McCarl to Dominic Berta, administrative assistant, International Association of Machinists and Aerospace Workers, March 5, 1975, FP-046, folder "WA Chron File 10/1/73–12/1/75 2 of 4," CFCH; "Field Report—Bulk Freight Trucking, March 11–13, 1975," FP-046, folder "WA Chron File 10/1/73–12/1/75 1 of 4," CFCH; "Field Report, General Aviation and Commercial Aircraft Workers," FP-046, folder "WA Chron File 10/1/73–12/1/75 1 of 4," CFCH.

109. "Minutes of Program Coordinators and Festival Staff Meeting, February 5, 1975."

110. "DC Roadeo, Smithsonian Celebrate U.S. Trucklore," *Transport Topics Weekly,* July 7, 1975, and "Union Skills Keep U.S. Moving," *AFL-CIO News,* July 12, 1975. Clippings attached to "Festival of American Folklife Working Americans Program, The Smithsonian Institution, The National Park Service," FP-041, folder "Festival of American Folklife Working Americans Program," CFCH. See also Shirley Askew, Program Coordinator, DPA, to Mr. William A. Bresnahan, President, American Trucking Associations, Inc., July 21, 1975, FP-046, folder "WA Chon 10/1/73–12/1/75 4 of 4," CFCH.

111. See *Festival of American Folklife, 1975* (program) for detailed list of participants and activities.

112. Draft Overview of "The African Diaspora Program of the Festival of American Folklife," box 9, folder "A.D. Evaluation Dept: 1975," Acc. T90055, SIA.

113. Margaret Mead, "Our 200th Birthday: What We Have to Celebrate," *Redbook,* July 1975, 40. This article was reprinted in the 1976 festival program.

114. Mead was on the Century III Advisory Panel, the goal of which was to create "an awareness of the future needs of America as part of the Bicentennial observance and to consider the future of the United States in a world-wide context." *Bicentennial Final Report,* vol. 2, 22.

115. Mead, "Our 200th Birthday," 40.

116. See 1975 festival program for tour schedule.

117. Bess [Lomax Hawes] to Rayna, Shirley A., Shirley C., Ruth, Ralph, July 30, 1975, FP-027, folder "DPA—Memos—General RA—76, CFCH.

118. "Summary: Supervisory Group Review, Old Ways Program," Nov. 20, 1975, box 3, folder "Old Ways in the New World," Acc. T90055, SIA. The "priority countries" were: Germany, Italy, Great Britain, Ireland, Mexico, France, Japan, Yugoslavia, Spain, Israel, Egypt, Austria, Hungary, and Greece. The list also included "Benelux," which is shorthand for Belgium, the Netherlands, and Luxemburg, as well as "Scandinavia," for which it did not enumerate specific countries. In addition, the group decided to drop Lebanon, Panama, Korea, Turkey, Pakistan, India, and Bulgaria from consideration.

119. Bess [Lomax Hawes] to Supervisory Group, Program Coordinators, Dec. 1, 1975, box 3, folder "Old Ways in the New World," Acc. T90055, SIA.

120. Susan Kalcik and Bess Lomax Hawes, "In Celebration of Ethnicity," *International Educational and Cultural Exchange* 12, no. 1 (Summer 1976): 11.

121. Bess [Lomax Hawes] to Supervisory Group, Program Coordinators.

122. S. Dillon Ripley to various ambassadors, Nov. 10, 1976, box 3, folder "1976 Festival Wrap Up Correspondence," Acc. T90055, SIA.

123. "Summary of discussion of first meeting of Old Ways in the New World Advisory Committee on May 3, 1975," box 3, folder "Old Ways in the New World," Acc. T90055, SIA; List of fieldworkers' and staff members' assignments for OWNW, n.d., FP-047, folder "Fieldworker Kit Sample," CFCH.

124. "'Old Ways in the New World' Fieldwork Guidelines, 1976 Festival of American Folklife," FP-047, folder "Fieldworker Kit Sample," CFCH.

125. Interview with Jeffery Lariche, Sept. 20, 1976, FP-005, folder "Tour Reports and Other Staff Reports," CFCH; S. Dillon Ripley to D. P. Chattopadhyaya, Minister of Commerce, India, Oct. 27, 1976, box 3, folder "Fest Wrap Up Corres.," Acc. T90055, SIA. See also H. Y Sharada Prasad, "Mrs. G? Oh, We've Met Before," *Outlook India*, Sept. 26, 2005, www.outlookindia.com/article.aspx?228684; "'Old Ways in the New World' Fieldwork Guidelines, 1976 Festival of American Folklife."

126. "'Old Ways in the New World' Fieldwork Guidelines, 1976 Festival of American Folklife."

127. "Interview Report Form" (Lorence Le Roy Smith), Dec. 11, 1975, FP-027, folder "Participant Questionnaire," CFCH; "Interview Report Form" (Sidney Guidry), Dec. 18, 1975, FP-027, folder "Participant Questionnaire," CFCH; "Interview Report Form" (Nola Guidry), Dec. 18, 1975, FP-027, folder "Participant Questionnaire," CFCH.

128. "Fieldwork Guide—Regional America," FP-027, folder "Fieldwork Manuals and Guides," CFCH.

129. "Interview Report Form" (Robert C. Gelnett), Jan. 28, 1976, FP-027, folder "Participant Questionnaire," CFCH; "Interview Report Form" (Duane Coop), Feb 26, 1976, FP-027, folder "Participant Questionnaire," CFCH; "Interview Report Form" (Clara S. Meldrum), March 17, 1976, FP-027, folder "Participant Questionnaire," CFCH.

130. "Field Report, Amalgamated Meat Cutters/Furriers Joint Council, March 16–17," Robert McCarl, March 23, 1976, FP-046, folder "WA Chron File 12/1/75–6/15/75 3 of 4," CFCH.

131. "Festival of American Folklife Working Americans Program, The Smithsonian Institution, The National Park Service," FP-041, folder "Festival of American Folklife Working Americans Program," CFCH; "Unions Participating in the Festival of American Folklife," FP-046, folder "WA Chron 10/1/73–12/1/75 3 of 4," CFCH; "Fieldwork Assignment Summary, December 1, 1975–August 25, 1976," FP-046, folder "June 15–76 End 1 of 4," CFCH.

132. Mark Reeves to Charley Camp, Jan. 12, 1976, FP-027, folder "'76 Aspirants (Crafts)," CFCH; Alan Lester, program coordinator, Regional America, to Mark Reeves, Mark's Saddlery, Inc., New Carrollton, Maryland, Jan 22, 1976, FP-027, folder "'76 Aspirants (Crafts)," CFCH; Mark Reeves to Alan Lester, March 2, 1976, FP-027, folder "'76 Aspirants (Crafts)," CFCH; Alan Lester to Mark Reeves, March 15, 1976, FP-027, folder "'76 Aspirants (Crafts)," CFCH.

133. Festival Program Supplement, July 1–5.

134. Bill Robinson, "Sweet Grass Basketmaker," Havelock, N.C. *Progress,* Sept. 16, 1976, box 13, folder "Regional America," Acc. T90055, SIA.

135. Native American Learning Center Tapes, July 5, 1976, SI-DPA-NA-77-306.18, CFCH.

136. Festival Recordings: Dewey Balfa, Rodney Balfa, Will Balfa, Allie Young; Vinice Lejeune, Lionel LeLeux, Elton Quibodeaux, Nathan Abshire, FP-1976-RR-1256a, CFCH.

137. Festival Recordings: Vinice Lejeune, Lionel LeLeux, Elton Quibodeaux, Nathan Abshire, Lula Landry, Louise Reichert, Alma Barthelmy, Laurette Doiron, Dewey Balfa, FP-1976-RR-1256b, CFCH; Interview with Susie Cox, Sept. 24, 1976, FP-005, folder "Tour Reports and Other Staff Reports," CFCH.

138. Letter from Mary Carter Smith (Griot) to Ralph Rinzler, Aug. 13, 1976, FP-005, folder "Congratulations on FAF Well Done," CFCH.

139. Martin Weil, "Divergent Views Mingle Happily at Folklife Festival," *Washington Post,* July 5, 1970, A21.

140. Wendell V. Cohen and friends and family to Director: Folklife Festival, Aug. 19, 1976, FP-005, folder "Congratulations on FAF Well Done," CFCH.

141. Julie Du Bois to S. Dillon Ripley, Sept 7, 1976, FP-005, folder "Congratulations on FAF Well Done," CFCH.

142. John and Regina Tauke (Bath, Pa.) to S. Dillon Ripley, Sept. 10, 1976, FP-005, folder "Congratulations on FAF Well Done," CFCH.

143. Peter Harnik to Festival of American Folklife staff, Sept. 25, 1976, FP-005, folder "Congratulations on FAF Well Done," CFCH.

144. Ibid.

145. Bernice Johnson Reagon, "Singing for My Life," in *We Who Believe in Freedom: Sweet Honey in the Rock . . . Still on the Journey,* by Bernice Johnson Reagon and Sweet Honey in the Rock (New York: Anchor Books, 1993), 150–68.

146. Marvette Perez, "Interview with Bernice Johnson Reagon," *Radical History Review* 68 (1997): 7.

147. "Bernice Reagon's Report of 1973 Festival of American Folklife," FP-017, folder "Report FAF 1973," CFCH.

148. Festival Recordings: Working Americans, June 17, 1976, SI-DPA-WA-77.501.01, CFCH.

149. Most of the festival's presentations are preserved on tape at the Center for Folklife and Cultural Heritage. See, for example, Festival Recordings: Swedish and Swedish-Americans, 1976, FP-1976-RR-1170; Festival Recordings: De Dannan; O'Connor, McGreevy, Crehan, Mulvihill, Donnelly, Carroll, 1976, FP-1976-RR-1406; and Festival Recordings: Jimmy Walker Blues Band, 1976, FP-1976-RR-0142.

6. A Family of Humankind

1. Robert L. Farrell, "Looking Ahead: Museum of Man, Folklife, and Related Activities, Prepared for the Secretary and Executive Committee," July 21, 1976, box 27, folder "Museum of Man Proposed," RU 342, Smithsonian Institution, Assistant Secretary for Museum Programs, Records, SIA.

2. S. Dillon Ripley to Julian Euell, July 6, 1976, box 12, folder "DPA Future," RU 367, SIA. This option was discussed as early as 1974: Ralph Rinzler to Jim [Morris?] and Bob [Byington?], Nov. 11, 1974, FP-019, folder "1974 Chron," CFCH. Ralph Rinzler participated in a number of discussions during the early 1980s regarding folklife's role in a proposed Museum of Man.

3. S. Dillon Ripley, "The View from the Castle," *Smithsonian*, April 1974, 4.

4. An Act to Provide for a National Portrait Gallery as a Bureau of the Smithsonian Institution, Pub. L. No. 87-443, 76 Stat. 62 (1962). For the history of the National Collection of Fine Arts, see "About the American Art Museum and the Renwick Gallery," Smithsonian American Art Museum, http://americanart.si.edu/visit/about/history/.

5. "Cooper-Hewitt, National Design Museum—Agency History," SIA, http://siarchives.si.edu/research/ah00015chndm.html.

6. "History of the Hirshhorn," Hirshhorn Museum, www.hirshhorn.si.edu/collection/home/#collection=history-of-the-hirshhorn.

7. In her dissertation, "A Modest Show of Arms: Exhibiting the Armed Forces and the Smithsonian Institution, 1945–1976" (Ph.D. diss., George Washington University, 2000), Joanne M. Gerstein London detailed another failed Smithsonian museum project in this period: a National Armed Forces Museum. Interested readers are encouraged to consult her work.

8. S. Dillon Ripley, "Statement by the Secretary," in *Smithsonian Year, 1967* (Washington: Smithsonian Institution, 1967), 6.

9. Van Dyne, "The Sun King Ambitions of Dillon Ripley," 208–9.

10. David Challinor, "S. Dillon Ripley," *Proceedings of the American Philosophical Society* 147, no. 3 (Sept. 2003): 297–302; R. Harris Smith, *OSS: The Secret History of*

America's First Central Intelligence Agency (Berkeley: University of California Press, 1972), 314–15.

11. Van Dyne, "The Sun King Ambitions of Dillon Ripley," 209.

12. S. Dillon Ripley, "Commencement Address, Marlboro College, Marlboro, Vermont," June 6, 1965, box 4, folder "Addresses 1965–1967," Acc. 84-224, SIA.

13. S. Dillon Ripley and The Editors of Life, *The Land and Wildlife of Tropical Asia* (New York: Time Incorporated, 1964).

14. Christopher Bayly and Tim Harper, *Forgotten Armies: The Fall of British Asia, 1941–1945* (Cambridge: The Belknap Press of Harvard University Press, 2004), 462–64.

15. Ripley, "Statement by the Secretary," 1967, 6.

16. Draft letter from S. Dillon Ripley to Rep. Julia Butler Hanson (circulated to Bradley, Galler, Blitzer, and Warner for comment), Oct. 7, 1969, box 287, folder "Museum of Man," RU 99, SIA.

17. Ripley, "Statement by the Secretary," 1967, 6.

18. "History of the National Anthropological Archives," NAA, www.nmnh.si.edu/naa/history.htm.

19. Merrill, "William Curtis Sturtevant, Anthropologist"; William Fitzhugh, telephone interview by author, Nov. 3, 2009, RU 9619, SIA, 4–5 in transcript.

20. "Sol Tax," The University of Chicago News Office, July 15, 2011, www-news.uchicago.edu/releases/95/950201.sol.tax.shtml.

21. See, for example, Shirley Keith, Correspondent for Indians of All Tribes, Indian Territory Alcatraz Island, to Sam Stanley, Dec. 15, 1969, box 46, folder "Alcatraz Invasion," Records of Center for the Study of Man, NAA.

22. Saul H. Riesenberg to All SOA Staff, Feb. 5, 1968, box 129, folder Gordon Gibson–Museum of Man, Series 9 Museum of Man, Gordon Davis Gibson Papers, NAA.

23. S. H. Riesenberg, Chairman to Professional Staff, Department of Anthropology, Aug. 29, 1969, and T. D. Stewart to S. Dillon Ripley, Oct. 20, 1969, box 129, folder Gordon Gibson–Museum of Man, Series 9 Museum of Man, Gibson Papers, NAA. Quotation comes from the latter memorandum.

24. S. Dillon Ripley to Clinton P. Anderson, Dec. 2, 1969, box 287, folder "Museum of Man," RU 99, SIA.

25. James Bradley to S. Dillon Ripley, Dec. 5, 1969, box 287, folder "Museum of Man," RU 99, SIA; Frank T. Bow to S. Dillon Ripley, Dec. 29, 1969, box 287, folder "Museum of Man," RU 99, SIA.

26. Cong. Rec., 90th Cong., 2nd session, Dec. 23, 1969, H12983–H12984, box 371, folder "Museum of Man," RU 99, SIA.

27. "Address of S. Dillon Ripley to the Council of Fellows of the American Anthropological Association, Denver, Colorado," Nov. 20, 1965, box 4, folder "Addresses 1965–1967," Acc. 84-224, Smithsonian Institution, Office of the Secretary, Records, SIA.

28. "The Future of Environmental Improvement, by S. Dillon Ripley," May 31, 1966, box 4, folder "Addresses 1965–1967," Acc. 84-224, SIA.

29. Sol Tax to I. DeVore, D. Schwartz, M. N. Srinivas, S. L. Washburn, W. C. Sturtevant, Jan. 19, 1970, box 371, folder "Museum of Man," RU 99, SIA.

30. Irven DeVore, Acting Chairman of the Special Planning Committee, to Members of the Center for the Study of Man, box 10, folder "Museum of Man 1980–1982," RU 374, National Museum of Natural History, Office of the Director, Records, SIA. The meeting took place Feb. 15–16, 1970.

31. S. Dillon Ripley to Bradley, Galler, Blitzer, Tax, Evans, and Stanley, April 2, 1970, box 371, folder "Museum of Man," RU 99, SIA.

32. 116 Cong. Rec. 25414–19 (1970); 116 Cong. Rec. 28240–45 (1970).

33. Pisano, "The Long Road to a New Museum."

34. Farrell, "Looking Ahead: Museum of Man, Folklife, and Related Activities, Prepared for the Secretary and Executive Committee."

35. Frank A. Taylor, The Museum of Man and the Environment, Preliminary Discussion Paper, Nov. 24, 1971, box 9, folder "Museum of Man 1973," RU 257, National Museum of Natural History, Office of the Director, Records, SIA.

36. Edward C. Hromanik to James Bradley, Sept. 11, 1972, box 81, folder "Museum of Man Jul-Dec 1972," RU 137, SIA.

37. Phil Ritterbush to Ripley, June 3, 1969, box 287, folder "Museum of Man," RU 99, SIA.

38. Edward Kohn to Ripley, Jan. 19, 1973, box 3, folder "National Museum of Man, Center for the Study of Man," Acc. 84-195, Smithsonian Institution, Office of the Secretary, Special Consultant to the Secretary (James C. Bradley), Project Records, SIA.

39. James A. Mahoney to Robert Brooks, March 28, 1973, box 3, folder "National Museum of Man, Center for the Study of Man," Acc. 84-195, SIA.

40. Marvin S. Sadik to Robert A. Brooks, April 24, 1973, box 27, folder "Museum of Man Proposed," RU 342, SIA.

41. George M. Foster, "The New National Museum of Anthropology in Mexico City," American Anthropologist n.s. 67, no. 3 (June 1965): 734–36; Ignacio Bernal, "The National Museum of Anthropology, Mexico," Museum 19, no. 1 (1966): 1–7.

42. Marvin Sadik to S. Dillon Ripley, May 4, 1973, box 1, folder "Museum of Man, 1964–1974," Acc. 82-089, Smithsonian Institution, Office of the Secretary, Administrative Records, SIA.

43. Ibid.

44. Richard L. Ault to Dorothy Rosenberg, May 4, 1973, box 1, folder "Museum of Man, 1964–1974," Acc. 82-089, SIA.

45. Margaret Gaynor to Dorothy Rosenberg, May 7, 1973, box 1, folder "Museum of Man, 1964–1974," Acc. 82-089, SIA.

46. James Bradley to Ripley (cc. Brooks, Perrot, Blitzer, Challinor, Euell, Sadik, F. Taylor), May 10, 1973, box 1, folder "Museum of Man, 1964–1974," Acc. 82-089, SIA.

47. Paul N. Perrot to Dorothy Rosenberg, May 8, 1973, box 1, folder "Museum of Man, 1964–1974," Acc. 82-089, SIA.

48. Handwritten note signed "DR" [Dillon Ripley] on copy of memorandum from Charles Blitzer to S. Dillon Ripley, June 18, 1973, box 27, folder "Museum of Man Proposed," RU 342, SIA.

49. Charles Blitzer to S. Dillon Ripley, June 18, 1973, box 27, folder "Museum of Man Proposed," RU 342, SIA.

50. Robert L. Farrell to Ripley, June 26, 1973, box 1, folder "Museum of Man, 1964–1974," Acc. 82-089, SIA.

51. "Purposes of a Museum of Man," box 1, folder "Museum of Man, 1964–1974," Acc. 82-089, SIA.

52. Frank A. Taylor to Robert A. Brooks, July 5, 1973, box 27, folder "Museum of Man Proposed," RU 342, SIA.

53. Robert A. Brooks to Messrs. Taylor, Bradley, Euell, Perrot, with attached proposal, May 16, 1974, box 27, folder "Museum of Man Proposed," RU 342, SIA. See also Robert L. Farrell to Robert A. Brooks, 14 Dec. 1973, box 1, folder "Museum of Man, 1964–1974," Acc. 82-089, SIA; Robert A. Brooks to S. Dillon Ripley, Dec. 18, 1973, box 27, folder "Museum of Man Proposed," RU 342, SIA; Questions and Answers about Museum of Man, box 1, folder "Museum of Man, 1964–1974," Acc. 82-089, SIA; Paul N. Perrot to S. Dillon Ripley, Jan. 2, 1974, box 27, folder "Museum of Man Proposed," RU 342, SIA; Frank A. Taylor to Robert A. Brooks, March 12, 1974, box 27, folder "Museum of Man Proposed," RU 342, SIA.

54. Ripley, "The View from the Castle."

55. Robert A. Brooks to Messrs. Taylor, Bradley, Euell, Perrot.

56. Porter Kier to S. Dillon Ripley, Sept. 23, 1974, box 9, folder "Museum of Natural History," Acc. 84-219, Smithsonian Institution, Office of the Secretary, Records, SIA.

57. Fitzhugh, interview, 7 in transcript.

58. William C. Sturtevant, Notes Toward a New National Museum of Cultures, Sept. 25, 1974, box 27, folder "Museum of Man Proposed," RU 342, SIA.

59. Summary of ad hoc Museum of Man meeting, May 3, 1975, box 27, folder "Museum of Man Proposed," RU 342, SIA.

60. "President Signs Legislation Reserving Mall Site for SI," *The Smithsonian Torch*, Sept. 1975, box 5, folder General info re: NMHT Research Project ca. 1961–1971, Acc. 02-187, SIA.

61. Fink, *A History of the Smithsonian American Art Museum*, chap. 5.

62. Toward a Museum of Anthropology, Report of the Planning Group for a Strengthened Museum of Man, July 1, 1980, box 1, no folder, Rinzler Papers, CFCH; Memorandum by William C. Sturtevant [for the record?], Feb. 25, 1980, box 3, folder "Museum of Man (1980)," RU 477, Smithsonian Institution, Assistant Secretary for History and Art, Records, SIA; Museum of Man Planning Group, Summary of Meeting, April 29, 1980, box 3, folder "Museum of Man (1980)," RU 477, SIA; Ralph Rinzler's notes – Excon Meeting, May 7, 1980, box 3, folder "Museum of Man (1980)," RU 477, SIA; Department of Anthropology, Comments on the survey questions, n.d. [1980], box 10, folder "Museum of Man #3063," RU 374,

National Museum of Natural History, Office of the Director, Records, SIA; Wilcomb E. Washburn, Office of American Studies, to Gordon D. Gibson, Department of Anthropology, March 21, 1980, box 10, folder "Museum of Man 1980–1982," RU 374, SIA; First Interim Report, Arguments for a Museum of Anthropology, April 25, 1980, box 3, folder "Museum of Man (1980)," RU 477, SIA.

63. Kathryn Lindeman, "African Art Museum Joins Smithsonian," *The Smithsonian Torch,* September 1979, box 7, folder The Torch Archives, 1979–1980, Acc. 02-187, SIA.

64. Educational Opportunities: The Afro-American Tradition in Decorative Arts, A special exhibition at the National Museum of History and Technology, n.d., box 11, folder NMHT Office of the Director, Acc. 02-187, SIA.

65. Smithsonian Announces Appointment of Roger Kennedy, Historian and Foundation Executive, as Director of Museum of History and Technology, June 20, 1979, box 11, folder NMHT Office of the Director 1979 2 of 2, Acc. 02-187, SIA; Roger Kennedy, telephone interview by author, Sept. 7, 2009, 1–5 in transcript.

66. Claudia Kidwell, Chairman, Dept. of Cultural History, to NMHT Staff, Oct. 25, 1979, box 11, folder NMHT Office of the Director 1 of 2, Acc. 02-187, SIA.

67. Douglas Evelyn to All Staff, Jan. 31, 1980, box 11, folder NMHT Office of the Director 1980 3 of 3, Acc. 02-187, SIA.

68. Perez, "Interview with Bernice Johnson Reagon," 15.

69. Spencer R. Crew, telephone interview by author, July 9, 2012.

70. Smithsonian Welcomes Name Changes at Two Museums, Oct. 15, 1980, box 11, folder NMHT Office of the Director 1980 1 of 3, Acc. 02-187, SIA.

71. Robert M. Vogel to Roger Kennedy, Oct. 8, 1980, box 11, folder NMHT Office of the Director 1980 1 of 3, Acc. 02-187, SIA.

72. Fink, *History of the Smithsonian American Art Museum,* 129; Smithsonian Welcomes Name Changes at Two Museums.

73. Otto Mayr, Acting Director, NMHT, to All NMHT Division Supervisors, Aug. 18, 1978, box 11, folder NMHT Office of the Director, Acc. 02-187, SIA; Elaine Eff and Steven Hamp, Exhibition Coordinators, to All Collections / Curatorial Staff, June 12, 1979, box 11, folder NMHT Office of the Director 1979 2 of 2, Acc. 02-187, SIA.

74. The center was authorized in 1980 and opened in 1983; "Museum Support Center Opens," SIA.

75. Charles Blitzer to S. Dillon Ripley, July 23, 1980, box 53, folder "Indians, Native Americans," RU 334, SIA.

76. Roger G. Kennedy to Mr. Dino Deconcini, April 25, 1980, box 3, folder Native Americans (Exhibits), Acc. 86-155, National Museum of American History, Dept. of Social and Cultural History, Exhibition Records, SIA. Kennedy quotation comes from American Indian Initiative Meeting, National Museum of American History, June 7, 1984: A Report, box 3, folder LIA Iroquois, Acc. 86-155, SIA.

77. Sarah Booth Conroy, "Rooms with a View of History: A Smithsonian Exhibit on Everyday Life in America, 1780–1800," *Washington Post,* Nov. 16, 1985, G1.

78. Fath Davis Barfield to Roger Kennedy, Aug. 5, 1981, box 3, folder LIA Iroquois, Acc. 86-155, SIA.

79. Research Review and Evaluation, box 3, folder Hill: The Nundawaono, Acc. 86-155, SIA.

80. American Indian Initiative Meeting.

81. Rayna Green, telephone interview by author, Aug. 18, 2009.

82. Lon Tuck, "The Long Road North: NMAH's Powerful Images of a Black Exodus," *Washington Post*, Feb. 5, 1987, B1.

83. Crew, interview; Barbara McLean Ward, "'After the Revolution' and 'New and Different'—Exhibitions at the National Museum of American History, Washington, D.C.," *Technology and Culture* 29, no. 3 (July 1988): 613–18; Robert A. Gross, Review of "After the Revolution: The Smithsonian History of Everyday Life in the Eighteenth Century," *Journal of American History* 76, no. 3 (Dec. 1989): 858–61; James Oliver Horton and Spencer R. Crew, "Afro-Americans and Museums: Towards a Policy of Inclusion," in *History Museums in the United States*, 215–36.

84. Elizabeth Kastor, "Remembrance of Sorrows Past: The Smithsonian's Hard Look at WWII Internment of Japanese Americans," *Washington Post*, Oct. 1, 1987, C1; Selma Thomas, "Private Memory in a Public Space: Oral History and Museums," in *Oral History and Public Memories*, ed. Paula Hamilton and Linda Shopes (Philadelphia: Temple University Press, 2008), 87–100; Kennedy, interview, 23 in transcript.

85. Douglas H. Ubelaker through Richard S. Fiske and David Challinor to Robert Farrell, Dec. 11, 1980, box 53, folder "Indians, Native Americans," RU 334, SIA.

86. Douglas R. Ubelaker to Richard Fiske, draft, Sept. 22, 1982, box 51, folder "National Museum of Man 1981–82," RU 477, SIA.

87. Native American Museums Program/Office of Museum Programs, n.d., box 56, folder Anthropology, Dept. of (1986), RU 374, SIA.

88. JoAllyn Archambault, telephone interview by author, Sept. 9, 2009.

89. Narrative Questions, n.d., box 69, folder Exhibits Native American, RU 374, SIA.

90. Bill Merrill to James Tyler, through Adrienne Kaeppler, May 4, 1988, box 69, folder Exhibits Native American, RU 374, SIA; Native American Exhibit Hall, Aug. 30, 1988—NMNH, box 69, folder Exhibits Native American, RU 374, SIA.

91. Exhibits—Native American Indian Hall, n.d., box 69, folder Exhibits Native American, RU 374, SIA.

92. Archambault, interview.

93. Sara Lowen, "Grave Matters," *City Paper* (Washington, D.C.), April 15, 1988, box 66, folder American Indians Jan. 1988–June 1988, RU 374, SIA.

94. See, for example, "Native American Material in Museums," special issue of the Regional Conference of Historical Agencies newsletter, April 1981, box 3, folder LIA Iroquois, Acc. 86-155, SIA.

95. Adrienne L. Kaeppler to Robert S. Hoffmann, May 12, 1987, box 56, folder Anthropology, Dept. of (1986), RU 374, SIA.

96. Tom L. Freudenheim to Jim Tyler, Feb. 2, 1988, box 69, folder Exhibits Native American, RU 374, SIA.

97. Adrienne L. Kaeppler, Chair, Department of Anthropology, to James C. Tyler, Acting Director, NMNH/NMM, Feb. 9, 1988, box 69, folder Exhibits Native American, RU 374, SIA.

98. Robert McC. Adams to Representative Bill Green, July 23, 1987, box 56, folder American Indians July 1987–Dec. 1987, RU 374, SIA.

99. Dave Warren, Director, Cultural Studies Research and Resources Center, to Governor Frank Gutierrez (New Mexico), June 22, 1987, box 56, folder American Indians July 1987–Dec. 1987, RU 374, SIA; Audrey Shenandoah, Secretary of the Haudenosaunee, to Robert McCormick Adams, Oct. 7, 1987, box 66, folder American Indians Jan. 1988–June 1988, RU 374, SIA.

100. Douglas Ubelaker to Robert McCormick Adams, Oct. 23, 1987, box 56, folder Anthropology, Dept. of (1986), RU 374, SIA.

101. Frank Talbot to Secretary Adams, Oct. 30, 1988, box 66, folder American Indians July 1988–Dec. 1988, RU 374, SIA.

102. Associated Press, "Bush Signs Indian Museum Bill," *Washington Post,* Nov. 29, 1989, B10.

103. See Tamara L. Bray and Thomas W. Killion, *Reckoning with Dead: The Larsen Bay Repatriation and the Smithsonian Institution* (Washington, D.C.: Smithsonian Institution Press, 1994).

104. Judith Weinraub, "The Meeting on Sacred Ground," *Washington Post,* July 17, 1990, B1, B2. For a critical perspective on the early development of NMAI, see Jacki Rand, "Why I Can't Visit the National Museum of the American Indian," *Common-place* 7, no. 4 (July 2007). See also Ira Jacknis, "The National Museum of the American Indian in Historical and Institutional Context," in *National Museum of the American Indian: Critical Conversations,* 3–42.

105. Weinraub, "Meeting on Sacred Ground," B2.

106. For an excellent account of the early period of deliberations concerning an African American museum see Fath Davis Ruffins, "Culture Wars Won and Lost, Part II: The National African-American Museum Project," *Radical History Review* 70 (1998): 78–101, quotation from 89.

Epilogue: Is It Possible to See It All?

1. For a partial listing of these sources, see note 14 in the Introduction.

2. In April 2012, the Smithsonian hosted a symposium at the National Museum of the American Indian titled "(Re)Presenting America: The Evolution of Culturally Specific Museums." Smithsonian officials and prominent scholars participated in a wide-ranging discussion that was broadcast live via webcast. "Smithsonian to Host Symposium about 'Ethnic' Museums," Newsdesk, Newsroom of the Smithsonian, April 18, 2012, http://newsdesk.si.edu/releases/smithsonian-host-symposium-about-ethnic-museums.

3. "A Smithsonian Quest or How One Guy Resolved to See All the Museums," *Around the Mall,* April 22, 2011, http://blogs.smithsonianmag.com /aroundthemall/2011/04/a-smithsonian-quest-or-how-one-guy-resolved-to-see-all -the-museums/. The twenty sites are: the Castle, the Arts and Industries Building, the National Museum of Natural History, the National Zoo, the National Museum of American History, the Anacostia Community Museum, the Cooper-Hewitt National Design Museum, the Smithsonian American Art Museum, the National Portrait Gallery, the Hirshhorn, the Renwick Gallery, the National Air and Space Museum, NASM's Udvar-Hazy Center, the Freer and Sackler Galleries, the National Museum of African Art, the National Museum of the American Indian, NMAI-Heye Center, the National Postal Museum, and the National Museum of African American History and Culture (which is temporarily located in a gallery in the National Museum of American History), www.si.edu/Museums.

4. "Baseball as America," National Museum of Natural History, www.mnh .si.edu/exhibits/baseball/.

5. "Mission and Vision," Smithsonian Institution, www.si.edu/About/Mission.

Index

Page numbers in *italics* signify illustrations.

William S. Walker began his museum career in his hometown of Oyster Bay, Long Island, at Sagamore Hill National Historic Site, the home of Theodore Roosevelt. He attended Cornell and Brandeis Universities and was a Smithsonian pre-doctoral fellow. He currently resides in Cooperstown, New York, and is assistant professor of history at the Cooperstown Graduate Program (State University of New York–Oneonta). He is co-editor of the journal *New York History*.

CPSIA information can be obtained at www.ICGtesting.com
Printed in the USA
BVOW03*1148050114

340891BV00005B/85/P